Pissarro

HIS LIFE AND WORK

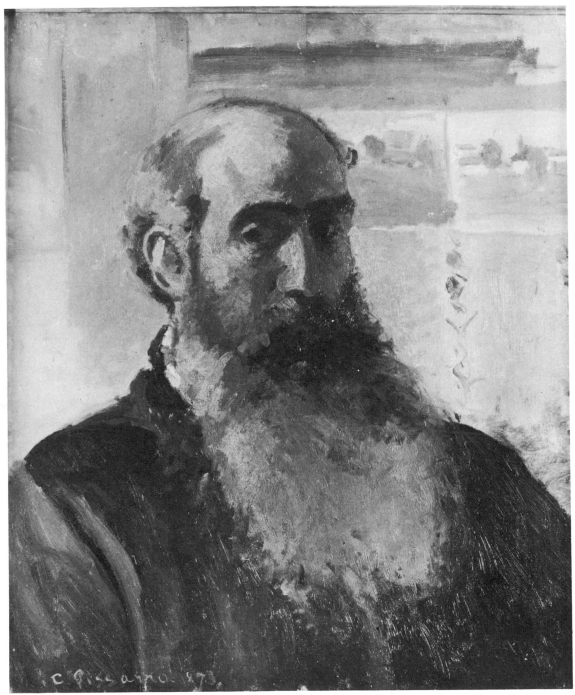

Self-Portrait, 1873. (200) 21¾ × 18¼. 55 × 46. Musée du Louvre (Jeu de Paume)

Pissarro

HIS LIFE AND WORK

BY
RALPH E. SHIKES
AND
PAULA HARPER

HORIZON PRESS · NEW YORK

Preface

CAMILLE PISSARRO, a founder and leader of the Impressionist movement, teacher of Cézanne and Gauguin and friend and supporter of Monet, Renoir, Degas, Seurat, Signac, Cassatt and van Gogh, was also a paradigm of the struggling artist, an anarchist and intimate of leading radicals, and the first major Jewish painter.

This biography is based in part on hitherto unpublished material—hundreds of letters from Pissarro's parents, his sister and brother, his close friend Ludovic Piette, his notary André Teissier, as well as letters he wrote to his son Georges. Other sources include unpublished letters or portions of letters to his son Lucien and his niece Esther Isaacson, the documents in the Pissarro family archives, and material, unpublished and published, at the Ashmolean Museum, Oxford, and in museums and libraries in Paris, London, Pontoise, Copenhagen and St Thomas.

This variety of sources has made it possible to examine Camille Pissarro's life more thoroughly than before. The conventional portrait of him as the gentle, idealistic patriarch of Impressionism has a firm core of truth, but his personality was in fact complex and contradictory. It is hoped that this biography will broaden our view of Pissarro as both man and artist.

Illustrations

*All paintings, drawings and prints are by
Camille Pissarro unless otherwise indicated.
All are oil paintings unless another medium
is noted. Size, location and other data are
given in the captions accompanying the pictures.*

Color Plates

Black and White

Pissarro

HIS LIFE AND WORK

All dimensions are in inches followed by centimeters, height first.
Location is given where known. Figure in parentheses is listing in
the catalogue raisonné by L. R. Pissarro and Lionello Venturi,
Pissarro: Sa Vie, Son Oeuvre. Parenthetical figure preceded by
"D" refers to listing in the catalogue raisonné of Pissarro's prints,
Loys Delteil, Le Peintre-Graveur Illustré, v. 17. All photographs
credited to New York Public Library are from S. P. Avery Collection,
Prints Division, New York Public Library; Astor, Lenox and Tilden Foundations.

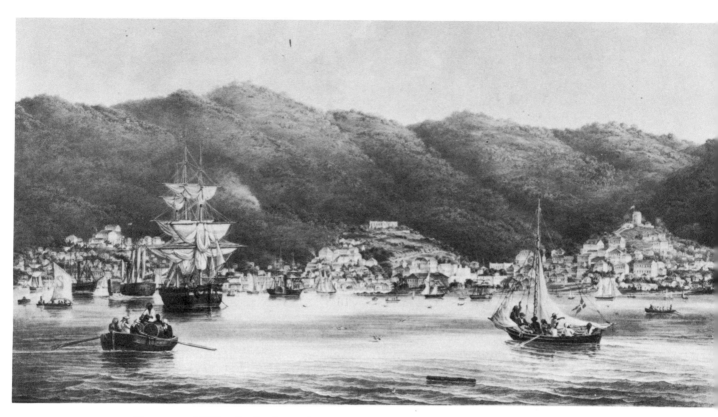

Tegner and Killendorf (after painting by Fritz Melbye): *St. Thomas,* 1851. Lithograph.
The Mariner's Museum, Newport News, Va.

1.

St. Thomas

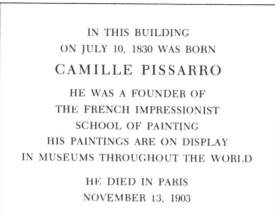

IN THIS BUILDING
ON JULY 10, 1830 WAS BORN
CAMILLE PISSARRO
HE WAS A FOUNDER OF
THE FRENCH IMPRESSIONIST
SCHOOL OF PAINTING
HIS PAINTINGS ARE ON DISPLAY
IN MUSEUMS THROUGHOUT THE WORLD

HE DIED IN PARIS
NOVEMBER 13, 1903

ERECTED IN HIS MEMORY
JULY 10, 1966

THE BUILDING which bears this tardily installed plaque stands on the main street of the Caribbean island of St. Thomas, at 14 Dronningens Gade. A sign swinging over the sidewalk announces that "The Camille Pissarro Building" houses the Tropicana Perfume Shoppe, Zora's Sandals, Kitchen Gourmet Health Foods, and the Cuckoo's Nest Boutique. This atmosphere of commercial exuberance is not a by-product of the mid-twentieth-century development of St. Thomas as a vacation paradise. It was a lively trading center from the early nineteenth century, and while Camille Pissarro was growing up there, his mother and father dealt in haberdashery, hardware, ship stores and general merchandise in their shop on the ground floor of this building.

In the 1830's, St. Thomas in the Danish West Indies was a tropical version of a California frontier town during the Gold Rush. Strategically located in the triangular trade route between Europe, Latin America and the United States, the island had flourished as a free port since the eighteenth century. It lay in the heart of the sugar-, molasses- and rum-producing areas. Merchant sailing ships from a dozen nations rode at anchor in the safe, broad harbor of Charlotte Amalie—almost a mile and a half wide—while small boats carried their cargoes to the wharves for storage or reloading. Black men and women, mostly freed, handled the cargo on the docks or in the

warehouses, while slaves worked the few plantations on the fringes of the island. Unlike the neighboring flat island of St. Croix, with its large plantations, mountainous St. Thomas was basically a commercial and trading center, not a slave economy. In the decade before 1830, harbor tonnage had doubled, with almost three thousand ships touching port each year. In 1859, Anthony Trollope described the island:

> Let it be understood by all men that in these latitudes the respectable, comfortable, well-to-do route from every place to every other place is via the little Danish island of St. Thomas. From Demerera to the Isthmus of Panama, you go by St. Thomas. From Panama to Jamaica and Honduras, you go by St. Thomas. From Honduras and Jamaica to Cuba and Mexico you go by St. Thomas. From Cuba to the Bahamas you go by St. Thomas St. Thomas is an emporium, not only for the islands but for Central and South America, Guiana, Venezuela. It is a depot for cigars, light dresses, brandy, boots and Eau de Cologne.

Trollope concluded that men came to St. Thomas for only one reason: to make money.

The island attracted men and women of all nationalities and had a special appeal for the Jewish community, since the Danish tradition of religious tolerance was extended to St. Thomas from its earliest days as a Danish colony. A few Sephardic Jewish families are listed in its rolls in the seventeenth century, others prospered during the eighteenth century. A Frenchman visiting St. Thomas reported: "They have the best and largest houses here. They send their children to the best schools in France." But it was during the early nineteenth century that the Jewish community grew most rapidly. At the turn of the century, there were nine Jewish families in St. Thomas; in 1824, the new synagogue, called "Blessing and Peace and Acts of Piety," built to replace the older, smaller one, had a congregation of sixty-four families. When it burned down in 1833, the entire community contributed to building a handsome synagogue that still stands. By 1837, 400 of the 1,832 whites on St. Thomas were Jewish (of several nationalities: French, Portuguese, Dutch, Spanish, Danish), and they played an important role in the life of the island. Sephardic Jewish names famous in Portuguese, Spanish and Caribbean history—Cardoze, Da Costa, Fonseca, Henriques, Pereira, Robles, Toledano—were to be found on the rolls of the synagogue.

From his birthplace of Bordeaux Pissarro's father, Frédéric Pissarro, a French Jew, arrived in 1824. He was listed on the synagogue rolls as Abraham Gabriel Frédéric Pissarro, but the first two Biblical names were a religious formality and rarely used. A venturesome bachelor, twenty-two years old, he had come to Charlotte Amalie to act as executor of the will of his uncle, Isaac Petit, who had died in May of that year.

Frédéric's family had originated in Portugal, where for 300 years they had been "Marranos"—Jews who had adopted the externals of Christianity to avoid the Inquisition. His grandfather, Pierre Rodrigues Alvares Pissarro, had fled from his native Braganza in 1769 and settled in Bordeaux, where his sons became merchants and civil servants; and in 1802, Frédéric was born there of the marriage of Joseph Gabriel Jean Pissarro and Anne-Félicité Petit, daughter of a Bordeaux Jewish family originally from Avignon.

Isaac Petit's young widow, née Rachel Manzana-Pomier (or Pomié), was a strong-willed and vigorous woman, born in St. Thomas and descended from a French-Jewish

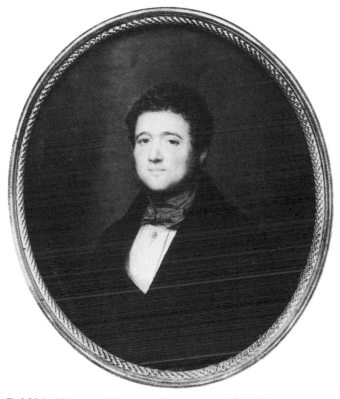

Frédéric Pissarro. Photograph courtesy André Pissarro, Paris

family. She bore Isaac three children and was pregnant with the fourth when he died. When Frédéric arrived in St. Thomas, he eagerly stepped into his uncle's shoes, took some of the business responsibilities off Rachel's shoulders, helped her run the Petit haberdashery store and eased her loneliness. The scandal which followed split the Jewish community for the next eight years. She became pregnant in the late spring of 1825, and in September the pair signed a statement of their intention to marry in the presence of two officials of the St. Thomas synagogue. But the Elders objected that it was against Jewish law for a man to marry his aunt, even an aunt by marriage. In February 1826, a son, Félix, was born to the couple, and in November they were married in a private home attended by a "minion" (ten males over the age of thirteen). The Elders promptly published a notice in the newspaper stating that the marriage had been performed "without the knowledge of the rulers and wardens of the synagogue, nor was the ceremony performed according to the usual custom." For the next eight years, a five-sided controversy simmered among the two factions of the synagogue, the Danish government of St. Thomas, the Synagogue of Copenhagen, and Isaac Petit's brother, David, in Bordeaux. The local Danish government approved a civil marriage, "notwithstanding that she shall be his mother's brother's widow." The Synagogue of

Copenhagen condemned the marriage on the advice of the St. Thomas Elders. David Petit opposed the marriage vigorously, probably not completely on religious grounds but partly out of pique at seeing his young nephew gain control of the business, valued in 1827 at $7,224. (Rachel's inventory of the property owned by Isaac and herself, in addition to the contents of the clothing store, included a house and two slaves.)

It was not until after the birth of four sons that Frédéric and Rachel won the fight; the marriage was finally recognized by the synagogue in 1833. Their place in the religious community was clearly important to them. They registered the birth of their sons with the synagogue, giving each the traditional Biblical names which preceded the names by which they were more familiarly known. Joseph Gabriel Félix was born in 1826 (and died while still a boy), Moses Alfred in 1829, Jacob Camille in 1830 and Aaron Gustave in 1833.

The family lived above their shop in a two-story stone-and-stucco building with a sixty-foot front on the north side of Dronningens Gade, the main commercial street of Charlotte Amalie. The household was large and lively. In addition to Camille and his three brothers, Félix, Alfred and Gustave, there were the four older children of Rachel's marriage to Isaac Petit: Joseph, Emma, Delphine and Isaac. Rachel, volatile, practical, devoted to her children, had—like many island-born women—only a limited education but took a keen interest in running both business and household. (Her later letters to Camille, expressive and precise, were dictated because she had never learned to write easily.) Frédéric's concerns were narrowly focussed on his family and his business; he was balanced in his judgments, indulgent with his children, tolerant of his wife's temper.

The business expanded from clothing into general merchandise. Frédéric and Rachel were hard-working people committed to achieving financial security and building a close-knit family which preserved Jewish traditions. The "frontier" nature of the community (and the constant threat of tropical disease) bound them even more closely together. The family was the secure center of social life and the focus of intimate relationships, especially because of the long isolation when the synagogue Elders would not recognize the marriage.

Like many other middle-class families of St. Thomas, the Pissarros kept two slaves until 1848, when slavery was abolished. They took household servants for granted and frequently found them deficient. "It is inevitable that domestics must be the torment of our existence," Frédéric later wrote Camille. "Despite the best will in the world on my part, most of the time the wrongs come from the servants's side, toward whom we are too indulgent. . . ."

Life for the children was comfortable and secure. Later, during Camille's long battle to establish himself as a painter, there was often a conflict between his emotional and financial dependence on the family and his yearning for independence. However firmly he opposed the bourgeois outlook in later years, certain middle-class attitudes and assumptions remained ingrained in his character. Although he later became an atheist and a radical, his Jewish—as well as his provincial—background was always to play a role in his emotional make-up.

As schooling in St. Thomas was haphazard (in 1850, St. Thomas spent $1,022 on

education, $1,779 on prisons), the Pissarros sent Camille to France in 1841, when he was eleven, to a boarding school on the outskirts of Paris. The "Pension Savary" was in Passy, then a wooded village on a hill overlooking the Seine, near the Bois de Boulogne. The boy followed a six-year course of study there and graduated when he was nearly seventeen. The usual fare of the French lycée of the time included French and Latin grammar and literature, a little Greek, arithmetic, geometry, algebra, trigonometry, physics, chemistry, natural history, rhetoric, philosophy. There were customarily a master who taught handwriting and a master who taught drawing. Charles Meryon, the ninetcenth-century printmaker, who had attended the school run by the Savary family a few years earlier, described it as a "large house in the middle of a field with a playing field behind it which allowed all sorts of free exercises and games. In time, with these gymnastics and the good diet provided I developed my health and strength."

After the casual ways of the West Indies, the strictly regulated life of a French student was confining. The boys rose at 6 A.M. and retired at 9 P.M., their days rigidly divided into work, play and meals; they slept in dormitories lighted at night and occupied by a master; their mail was opened to ensure that correspondents were on the approved list; they could not leave school without permission; they were required to wear the school uniform at all times— conformity and lack of privacy, standard features of the educational system. But the young Camille found one outlet for his private inclinations and mental life— his drawing lessons. He spent so much time drawing at the expense of his studies that he was forbidden by his father to draw until his marks improved.

Meryon related that he had "acquired some idea of the elementary arts relating to drawing" due to the "special care and affection of the second son of the family," who "felt a particular predilection for this art." Camille also received teaching and encouragement from this "second son of the family," and he often told in his later life the story of M. Savary's advice to him: "Draw from nature during your holidays—as many coconut trees as you can!" To draw simply from observation of the familiar world was not usual at a time when most students were allowed to draw from nature or a live model in the studio only when they had thoroughly learned to copy engravings after the paintings of old masters. After Savary's retirement, in 1844, his successors, Marelle and then Poncet, seem to have continued the Savary precepts, for one of Camille's earliest drawings to be preserved is of a coconut tree.

It was important to Frédéric that his sons learn French traditions and culture; looking to the future of the family business, he also wanted Camille trained in practical subjects such as arithmetic and accounting. But what affected the boy most during his first stay in France was his exposure to the art world of Paris. On Thursday and Sunday holidays from school, and during vacations, the students were taken on outings to the Louvre, where Fontaine's elaborate staircase, with its arches and painted ceilings and shining Doric columns, led directly to the grand gallery, full of students copying paintings.

Camille was also surely taken, as a student particularly interested in art, to the Salons, the enormous biennial exhibitions sponsored by the government. He may

also have visited the Ecole des Beaux-Arts, the government-sponsored training school that fed the Salon with artists. Beginning students drew from plaster casts of classical statuary, the more advanced from nude models. When Thackeray visited the Ecole, he fumed:

> Borrowed from statuary, in the first place, the colour of the paintings seems, as much as possible, to participate in it; they are, mostly, of a misty, stony, green, dismal hue, as if they had been painted in a world where no colour was. (In every picture there are, of course, white mantles, white urns, white columns, white statues,—those *obligés* accomplishments of the sublime.) . . . There are the endless straight noses, long eyes, round chins, short upper lips, just as they are ruled down for you in the drawing books, as if the latter were the revelations of beauty, issued by supreme authority, from which there was no appeal.

Camille also had the chance to visit the studio of a moderately successful landscape painter, Auguste Savary, a relative of the family who ran the school. He had entered the Ecole in 1819 and showed his picturesque views of the landscape around Versailles, Pontoise and Mayenne at almost every Salon. At Savary's studio, at 1 rue du Roule, the budding Pissarro could see all the materials and techniques of a conventional landscape painter of the 1840's: the preparatory drawings and watercolors made from nature, the folios of engravings copied from the masters, topographical views, perhaps even photographic views. Since landscape artists rarely completed a work out of doors, Savary built up his pictures by combining elements from all of those sources. He painted on a canvas prepared with a tan or peach undercoat, which gave the finished painting the mellow brown tone, like the color of an old violin, which appealed to connoisseurs, for the greens of nature were considered raw and unrefined.

On many of Camille's sorties, he visited his grandparents, Joseph and Anne-Félicité Pissarro, who lived in Paris and gave their grandson a glimpse of comfortable bourgeois life. After dinner on a springtime Sunday, the custom was to take a carriage down the Champs-Elysées. On both sides of this fine broad avenue, bordered with lofty trees, people sat in chairs to watch the carriages go by or formed little knots to discuss the latest news and conditions under the bourgeois monarch, Louis-Philippe. Beneath the apparent tranquillity of his reign—a veneer of stability and prosperity—there was growing discontent. The advice of Louis-Philippe's government to its subjects was famous: "Enrich yourselves!"—an ethic which the anarchist P.-J. Proudhon had challenged in 1841 with his book *What is Property?* His answer, "Property is theft," terrified respectable citizens. Paris in the 1840's was a haven for every kind of political refugee and revolutionary thought—intense intellectual activity which boded ill for the government. Crop failures, inflation and the stock market collapse in the mid-forties widened the cracks in the regime, and when young Camille completed his course and sailed for St. Thomas in the summer of 1847, Paris was in ferment. When the Revolution finally erupted and deposed Louis-Philippe in February 1848, Camille was working in the family store and reading about the Revolution in the local newspaper, the *Sanct Thomas Tidende*, along with the shipping news. Camille's later consistent interest in politics was stimulated by the excitement of the period leading up to the Revolution in France, and his compassion for the exploited was fostered by events

in the Virgin Islands in 1847, when the slaves of St. Croix revolted and eventually won freedom for the slaves in all the Virgin Islands.

No longer the provincial Creole boy, his education had made him French; he had seen something of the world of art and of French politics. He had also learned to draw. Théodore Duret, the art critic and friend of the Impressionist painters, remarked that Pissarro's artistic tastes were fully developed when he returned to St. Thomas and that he had already received sufficient instruction in drawing to enable him to continue his studies by himself. Although his drawing technique was still tentative, the subjects he chose for his earliest drawings were those that claimed him for the rest of his life.

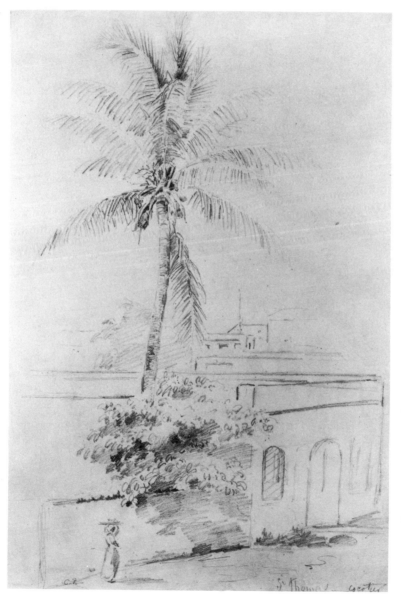

Coconut Tree, St. Thomas.
Pencil. Photo
Galerie Motte, Geneva

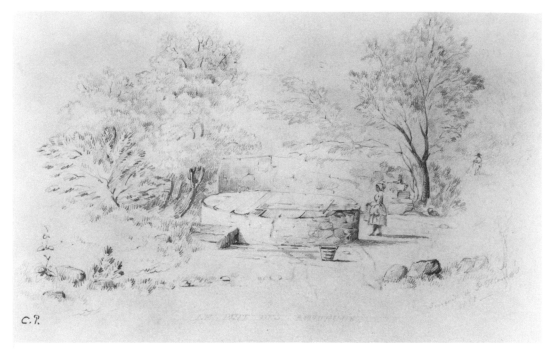

Lovers' Well, 1851. Pencil. Photo courtesy M. Knoedler & Co., Inc., New York

Black Woman Washing, St. Thomas, 1852. Pencil. Photo courtesy John Rewald

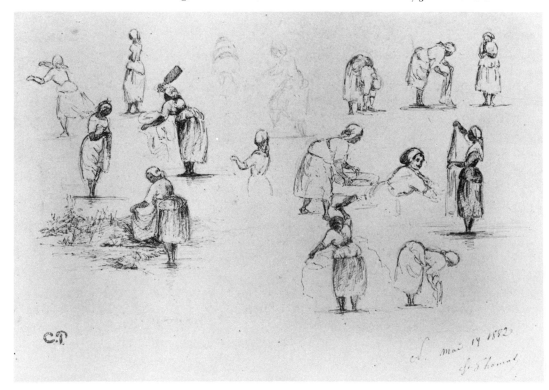

2.

Venezuela

*"and so . . . I quit and ran off to Caracas,
finally breaking the ties that bound me to the
bourgeois life."*
—Pissarro to Eugène Murer, 1878

For FOUR YEARS, the boy's life followed the pattern cut by his father. He and his brother Alfred, one year older, waited on customers, helped with the bookkeeping and the inventories, and supervised the unloading of merchandise from boats which arrived frequently from Europe, the United States and South America.

Liberated from school discipline, Pissarro was back once again in the pleasant routine of family life, but the cultural life of St. Thomas was limited. There was a private library, the "Athenaeum," with about five thousand books and the latest newspapers and periodicals from Europe and the United States. Local drama groups presented vaudevilles and comedies in French and English. The "Grand Balls" given by leading merchant families, such as the Rothschilds and Monsantos, were not always attractive to the Pissarro boys; Alfred once escaped having to attend by shaving his head bald "on the pretext," as his father wrote, "that his hair was falling out." The most important social event was the Danish governor's yearly open house, at which the white population met to eat, drink, inspect each other's best clothes, and be entertained by the black population playing tambourines, fiddles and drums.

Camille's tiny intellectual circle included his brother Alfred, who played the violin, his cousin Jules Cardoze and Raoul Pannet, both of whom shared with Pissarro the remote dream of an artist's life in Paris. They were from French families and admirers of French culture. Alfred had also been educated in France. They must have bolstered each other's hopes of escaping from—as Alfred melodramatically put it—"this cursed hole, good at best to amass a fortune."

Pissarro's drawings were his one distraction. A few survive from the early fifties, including tentative landscapes, coconut trees, a sheet of studies of a black woman washing clothes, a detailed combination of genre and landscape, *The Lovers' Well*. His drawing at this stage is precise, somewhat cramped. The figures are almost all blacks, sketched straightforwardly, without condescension; they seem to have been of much greater visual interest to him than whites were. Young Pissarro's attitude toward slavery is unknown, but he pictured blacks sympathetically, and later, in his political maturity, he was consistently opposed to colonialism and exploitation of natives.

He was settling into a life limited by the thirty-seven square miles of St. Thomas when fate sent a catalyst in the person of Fritz Georg Melbye, a young Danish painter only four years older than Camille, who had already had some success as an artist. He

25

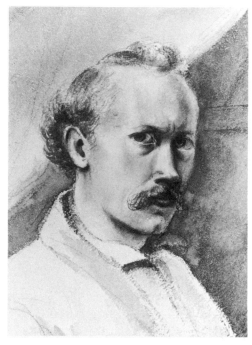

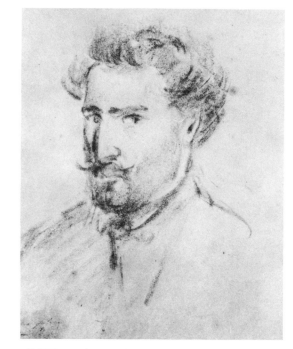

Fritz Melbye, 1853-54. Watercolor. (Possibly a self-portrait.) Nationalhistoriske Museum, Frederiksborg, Denmark

Self-Portrait, 1853-54. (Detail) Royal Museum, Copenhagen

had exhibited his paintings in Copenhagen in 1849 and since then had travelled in the New World, drawing and painting these foreign landscapes for the European market. Some time during 1851, while working on a painting of the harbor of Charlotte Amalie, he met Pissarro. Fellow artists, they had English as a common language and inevitably formed a friendship. Anyone who saw them sketching together near the harbor would have been struck by the contrast—Pissarro small, slender, dark, with calm brown eyes, an arched nose and thick, black, curly hair; and Melbye tall and fair, with fine blonde hair already thinning, a high, round forehead and intense blue eyes. Although Melbye was only twenty-five, he was a professional with a firm grounding in the techniques of drawing and painting and the ways of earning a livelihood from art. Coming from a family of painters, the best known of whom was his brother, Anton, who exhibited regularly at the Paris Salon, he could talk about art and ideas and was a hard worker, determined and methodical, with an adventurous spirit and full of enthusiastic plans. He was just what Pissarro needed, a friend and ally to help him break loose from his father's expectation that he would become a respectable bourgeois businessman. The friends plotted a trip to Venezuela together as soon as Camille could make the arrangements. In the meantime, Melbye went on to the neighboring island of St. Croix to work, and wrote on April 29, 1852, in his stilted school English:

My dear Pissarro!
 With great anxiety I received at last your kind letter dated April 17 and was glad to be

informed that when I again is in St. Thomas I may find you *clear and ready* for our start, what circumstances rather too long has hindered us in. Although you don't mention so, I still with confidence live in that expectation and feel myself convinced about a good result for our mutual progress. I should have been glad if you only a little more detailed had spoken about yourself, I mean what you have finished of studies and what you have worked for the *crowd* of—Portraits, etc.—as you very well know that I take an interest in your affairs as did it concern my brother. A propos, did you get besides your callours, canavas, pencils, papier pelle, etc. and how much of each? Safe it well or rather use it well as we will have perhaps difficulties to provide us with such materials where we go . . .

Write me now soon and tell me how it goes. Have you heard from Alfred? . . . And be so kind my dear friend to look out for a room though not quite so dark and dirty as that I left. I directly could occupy it when I arrive in St. Thomas and from which we will arrange the necessary future departure, and believe me as ever your

<div align="right">True friend,
Fritz Melbye</div>

Melbye returned to St. Thomas later that year and they made secret plans to leave the island, preparing their stock of "callours and canavas" and waiting for a vessel bound for Venezuela. Their chance came some time in late October. They slipped aboard the French bark "Caraqueña" on its way from Bordeaux to La Guaira, the port of Caracas, carrying cargo and a few passengers. Pissarro later described his crucial decision:

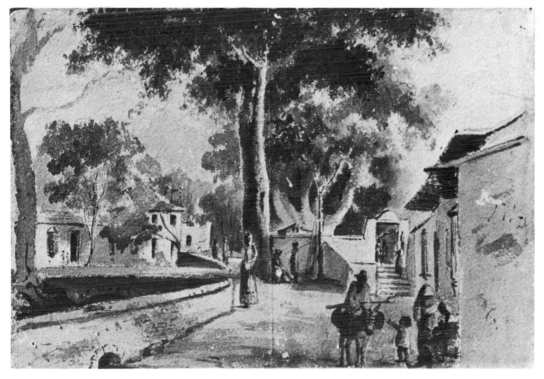

View of La Guaira,
1852. Watercolor.
Photo courtesy
Alfredo Boulton,
Caracas

I was in St. Thomas in 1852, a well-paid clerk. But I found I couldn't stand it, and so without thinking any more about it, I quit and ran off to Caracas, finally breaking the ties that bound me to the bourgeois life.

He knew he was not cut out to be a businessman. As he wrote later: "The fact that I can't find an audience for my art doesn't prove at all that I would have been a successful businessman; Hell, I know how I would have made out, I would have gone bankrupt 2 or 3 times."

On November 12, 1852, they disembarked at La Guaira. The landscape, vaster and more savage than any Pissarro had seen before, promised adventure and new experiences. They lodged in a boarding house and began to work, sketching the open harbor, the town, the local fishermen, the peasants. Melbye intended his sketches as studies for paintings to be finished in the studio. His drawings from this period, like his paintings, are panoramic and picturesque, with sweeping vistas of sea, shoreline, mountains and sky. The grandeur of nature is emphasized by small figures in the foreground, usually peasants who are rather self-consciously "colorful."

Pissarro's vision is more intimate. His drawings close in on smaller segments of nature, on homelier details. Later, he complained of a district in France, "The country doesn't suit me; it is too panoramic, while I am in search of nooks and corners."

Melbye took charge of organizing their trip. When he had made enough sketches of the area around La Guaira to serve as the basis for a group of paintings, it was time to move on to Caracas and set up a studio. It was not Paris, but compared with Charlotte Amalie it was a cosmopolitan center, with a university, a college, a drawing and music academy, a small theater, a sizeable group of Europeans, a population of a quarter-million people including provincial satellites, an agreeable climate and low living costs. But houses of the middle and upper classes were shuttered and people cautious. The

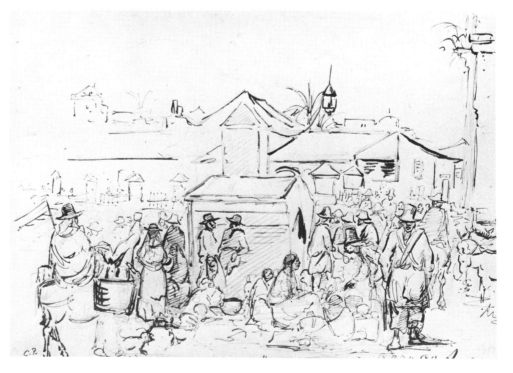

Marketplace, Caracas,
c. 1853. China ink
and pencil. Concejo
Municipal de Caracas

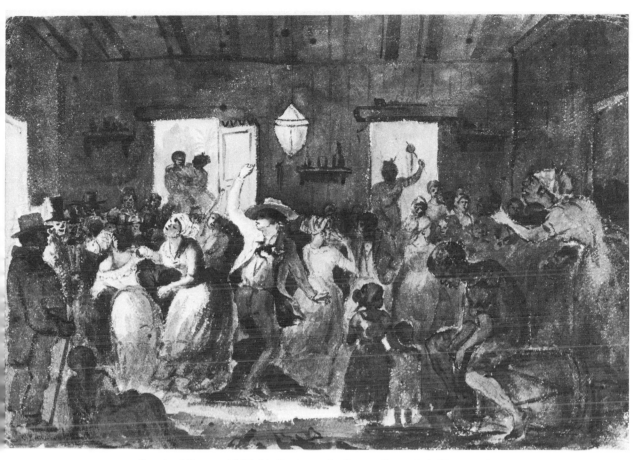

Carnival Dance, 1853-54. Sepia wash. Banco Central de Venezuela

country had gone through a period of civil war, unsettling the economy and accentuating the gap between rich and poor. Slavery was abolished while Pissarro was there, in 1854, but the measure had little practical meaning for the slaves, since their economic and political suppression continued. Once again Pissarro was thrust into a situation where the most critical issue of the day reached boiling point, and where the social structure was one of extreme contrasts.

On arriving, they rented a house near the Plaza Major, the central market and meeting place of the city, where dozens of motifs were available to them daily. One of Pissarro's earliest drawings, done at the end of December 1852, was of the marketplace near their house, a lively scene sketched with vigor and humor: the peasants down from the hills, vendors and customers bargaining in broad-brimmed hats, newcomers arriving astride donkeys with baskets, dozens of deals being worked out on the prices of fruits and vegetables. Over the next two years, in Caracas and outlying towns, he made intimate, sympathetic pencil and pen sketches and wash drawings—women preparing food in an outdoor kitchen, a peasant family eating outdoors, a group of men in a saloon playing cards by lamplight, Indian women carrying water jugs on their heads or washing clothes in a stream in a leisurely, companionable way. He

Native Woman,
c. 1854. Pencil.
Ashmolean Museum,
Oxford

confronted these simple people unpretentiously and felt his way into the rhythms of
their daily lives. In *Carnival Dance,* a sepia wash drawing, the rhythm is exuberant:
wild dancers drink and whirl to the beat of drums and maracas, two young women
dance, hips tilting and turning like *majas* in a "Caprice" of Goya. Rhythmic energy is
created by the gestures and movement of the figures, and by a skillful pattern of
shadows and bright accents. The vigor and extravagance of this drawing testify to his
feeling of freedom in Venezuela and his full response to the gaiety of the carnival.

The Venezuela drawings are as interesting for what he did not portray as for the
subjects he chose. At this early stage of his career, he was sketching, with few
exceptions, Indians, mestizos and peasants, people in humble circumstances, the class
to which he was consistently attracted most of his life. He seemed to have no interest in
the middle or upper classes, except as subjects for commercial portraits, none of which
survive.

Unlike academically trained artists who drew the figure by formula, Pissarro
sketched his figures sometimes clumsily but always conscientiously, attempting to
catch the natural movements and positions of his subjects without imposing any
preconceptions on them. In appreciation of Pissarro's honestly observed figure
drawings, Paul Cézanne was to comment: "Pissarro had the good luck to be born in the
Antilles. There he learned to draw without masters."

This statement is true in the sense in which Cézanne meant it—that Pissarro was not
trained in an art academy. But Fritz Melbye guided him in these early days and gave
him technical advice. In some of his landscape drawings from Venezuela, Pissarro
builds up the planes and shadows with pencil crosshatchings in a way similar to that of
Melbye, the acknowledged leader of the small band of artists in Caracas who went on
sketching trips together and assembled to talk about their work. Later, after Pissarro

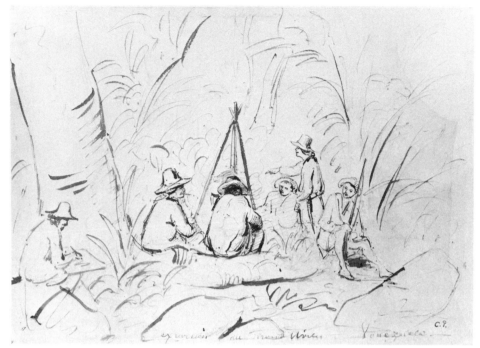

Excursion to Monte Avila, Venezuela, 1854. China ink. Ashmolean Museum, Oxford

had arrived in Paris, Mariano Palacio, one of the members of this group, wrote him an affectionate letter, addressed to "Pizzarini," referring to Melbye as "our master," and recalling: "I can still see you looking, over and over again, at countless studies done by Melbye, who so touched your inflamed imagination." In his letters to Camille from Venezuela, Melbye's strong personality is evident. In one letter he wrote: "I have no masters. My school I do not know—either it will be considered belonging or bending to the antique or modern, pale or vivid, low or high—as I have had none."

Miguel A. Romer: ***Pissarro,*** 1853. Pencil and ink. Collection Alfredo Boulton, Caracas

Fritz Melbye: ***Pissarro,*** 1853. Pencil. Collection Alfredo Boulton, Caracas

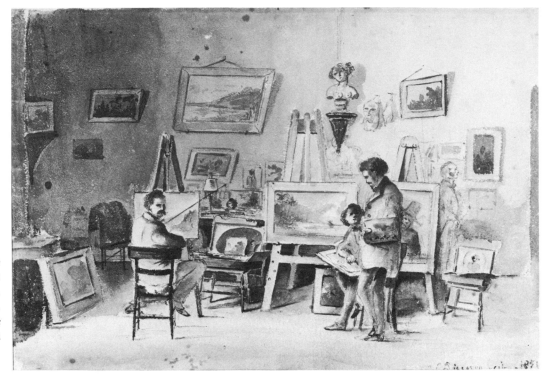

Studio of Melbye and Pissarro in Caracas, c. 1854. Watercolor. Banco Central de Venezuela

With Palacio, Raphael Herrera, Miguel Romer and Melbye, Pissarro made excursions to the mountains of Gabilán and Galipán, to the Río de Maiquetía, with its magnificent waterfalls, and to the mountain forest of Avila. Pissarro made drawings of the group seated around their campfire under the giant trees and ferns of Avila, in which he included himself as the sketcher, on the left. Melbye drew Camille drawing, as did Romer. These first portraits of Pissarro, at twenty-three, show him dressed for the tropical climate and concentrated on his work, his young face adorned with a pointed mustache and a jaunty Van Dyke beard, signs of manhood and of enjoyment of self. He recalled, "As a young man I found myself free, absolutely free, left to my own resources in a foreign land, and . . . I had the luck never to fall into misfortune."

He and Melbye worked and exhibited together in their studio in Caracas. In one of Pissarro's watercolors, Melbye, with a landscape before him, perches on his chair, walrus mustache bristling, and beside another easel, Pissarro stands, a palette in his hand, on his easel a gentleman's portrait prominently signed "Pissarro," indicating that he may have done some portraits in Venezuela to earn money. Possibly the two artists gave lessons; in this sketch the relationship between Pissarro and the seated boy at the easel seems that of teacher and pupil.

Pissarro's joy in his new surroundings was struck down in August 1853 by tragic news from St. Thomas. His younger brother, Gustave, had died, at twenty. Alfred was shattered by Gustave's death; he wrote this letter to Camille on August 30, 1853, confiding his feelings:

Dear Camille,

I received your dear letter and know how deeply you share our pain. How can I describe the sadness here in the house—it will be a long time before things are normal again. Every day, every moment, we are reminded of the absence of our dear brother and Maman walks up and down in front of the room where he died as if she hoped that he would appear there again. Torrents of tears run down her cheeks and the most poignant sobs rack her. Yes, dear Camille, our mother must go through a profound emotional crisis before she accepts the death of our poor brother . . .

The mourning that I feel has engendered profound thoughts in me that are far from gay . . . black presentiments rise up in me, phantoms. I would find consolation in confiding my thoughts and ideas to you, bizarre as they are—I would find comfort in having a friend, a companion who would be indulgent and respect my foolishness, pardon my extravagances. Come Camille, come quickly to keep me company, for the pain and the solitude are killing me . . .

Rocks and Tropical Forest with Seated Figure, c. 1854. Pencil. Collection Alfredo Boulton, Caracas

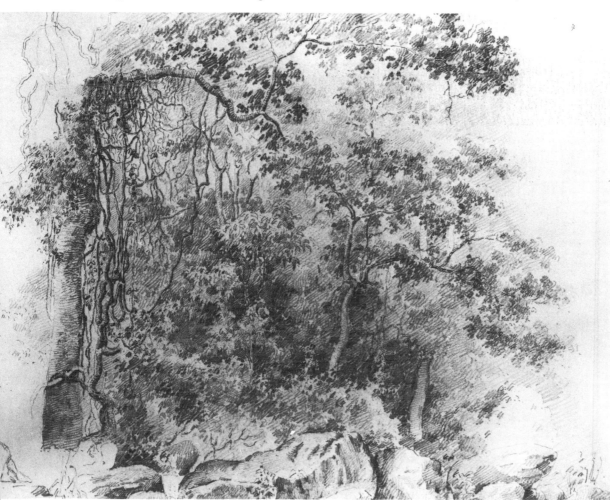

I have told Papa about my idea to go to France to work, but he wants me to stay here, promising me a secure future in business with him, for I have made myself so useful to him recently that he can't do without me. But he promised me a vacation of four or five months next year to go to France and I am planning on this . . .

The whole family is well, they join me in sending you their remembrances.

Your affectionate brother,

Alfred

P.S. Tell me if you received the linen that I sent to M. Harrazowitz.

How Pissarro replied to Alfred's moving appeal to come home is unknown—but he did remain in Venezuela for another year, determined to continue the studies that were proving so fruitful. Painful conflicts must have stirred in him, especially since Alfred was so obviously devoted to him, so conscientious about sending paints and fresh linen. But his description of the disturbed and gloomy house in St. Thomas must have been distressing to Camille, who had so recently escaped from it. He was just beginning to find his way as an artist; to leave Venezuela was impossible for him. During his time there, he developed his powers of observation and memory, and two of his qualities as an artist began to emerge. He had a gift for intense concentration—a black-and-white pencil drawing of tree foliage shows an immense patience in rendering subtle lights and shades. For hours he lost himself in the careful recording of light falling on the tree's thousands of leaves, sensitive to the variety of tones and the unity of the whole organism. And he was also developing as a colorist. Watercolor studies of trees and vegetation reveal his gift for creating, with muted hues of green and brown, a sense of airy depth as well as a pleasing pattern of color. This skill with color was Pissarro's own. Fritz Melbye was relatively clumsy and heavy-handed as a colorist.

The letters exchanged with his family during this period are now lost. At some point his father made a compromise with him: if he returned to the business to take the place of Alfred, who would then have his promised "four or five months" in France, Camille would be supported in his plan to go to France and try a career as an artist. On August 9, 1854, he sailed for St. Thomas on the Danish packet boat "Isabel," leaving Melbye in Venezuela until the two could meet in Paris. His departure was duly reported by the *Diario De Avisos:* "Camilo Pizarro leaves for overseas."

He hoped to stay in Charlotte Amalie for only a short time, but as it turned out, he spent more than a year there. The delay was upsetting, but his father needed his help. Camille must have written to Alfred impatiently more than once; still in Paris in June of 1855, Alfred replied: "I received your letter of May 15 in which you told me again of your desire to come to France. Just a few months more of patience. . . ."

Camille marked his time, working in the store again, saving his salary toward his Paris expenses, continuing to draw the landscape, the people, and the animals of St. Thomas. Eventually, Alfred was persuaded to return. On September 1, 1855, he was "aboard the steamer 'Magdalena' within sight of St. Thomas," writing back to his half-sister, Delphine, in England:

Finally, after days of travelling, we are in sight of St. Thomas. I hope to have the happiness of embracing my father and Camille in 5 or 6 hours. . . . The voyage was good—a sea like glass and no bad weather. I miss roast beef and plum pudding.

3.

Paris and the Exposition Universelle

"Go into the country. The muse is in the woods."
 —Corot to Pissarro

BY THE middle of September, Pissarro was aboard a trans-Atlantic steamer (probably the same "Magdalena") bound for Europe. He never returned. He has often been pictured as striking out for Paris on his own, but the fact is that the whole Pissarro family was gradually breaking ties with St. Thomas—his mother was already in Paris, where Emma and Delphine, daughters by her first husband, were staying with her. Emma had married Phineas Isaacson, a merchant from an English-speaking St. Thomas family, who had set up a firm in London and St. Thomas which traded with the West Indies and South America. Frédéric Pissarro, who had an interest in the firm, was also making plans to return to France. Perhaps he was weary of exile. His mother and father, his brothers and sisters and their families all lived in France. Perhaps he also saw a bleak prospect for St. Thomas; steamships were the vessels of the future and it was obvious that they would soon sail directly from Europe and North and South America, by-passing Charlotte Amalie.

As the steamer approached Southampton harbor after a two-week voyage, Pissarro was anticipating a brief interlude in London. But at dockside a tense letter from his half-sister Emma awaited him, urging him to come immediately to Paris. Delphine was critically ill:

> We want very much to see you as soon as possible for I do not know if you will find your poor sister alive. The doctor has told us that she cannot live very long. So, my dear brother don't take the time to go to London . . . we are alone here without a man to help us.

He went directly to Paris. His arrival was a relief to the distraught family. Delphine was alive but in critical condition; on December 24, she died. Emma had borne the brunt, for their mother, a deeply emotional woman, always collapsed when illness struck her children. She dominated them perhaps most when she was at her weakest emotionally. Finding herself suddenly, after a lifetime in the tropics, in the atmosphere of a large city with a vastly quicker tempo and with a daughter seriously ill, she needed support. In an affectionate sketch of his mother made during this period, Pissarro shows a strong, broad face with heavy eyebrows and pensive eyes reflecting the sadness and strain of her daughter's illness. With hair only beginning to gray at sixty, despite having borne eight children, Rachel was obviously stronger physically than emotionally.

35

Rachel Pissarro, 1856. Pencil.
Photo courtesy John Rewald

Emma's husband was working in St. Thomas with Frédéric and Alfred Pissarro. So instead of being the carefree artist in a garret, Camille was unexpectedly the central figure in a busy household, with an emotionally dependent mother, a critically ill sister, and Emma's small, undoubtedly noisy children. Nevertheless, he was in Paris—a different Paris from the one he had known as a youth.

He had left a city on the brink of revolution, with thousands unemployed and a middle class clamoring for an extension of suffrage, and returned to a city that was prospering, had adjusted to a counter-revolution, and had suppressed suffrage. During the interval, a kaleidoscope of events had changed France from monarchy to republic to empire: the overthrow of Louis-Philippe, the election to the presidency of Louis Napoléon, his *coup d'état* when the constitution forbade his reelection, the plebiscite endorsing his coup, his assumption of the Imperial title. Once again, as in 1789, a French revolution had resulted in a Napoleonic empire.

The city Camille had left was combed with large sections of narrow, winding streets, dark alleys, medieval slums. Sewage was appallingly deficient; water supply and housing were inadequte for a population that had doubled in two decades. Traffic in the congested streets was frustratingly slow. Now, for the greater glory of the Empire, Paris was undergoing a reconstruction aimed at making it the resplendent capital of Europe. "I want to be a second Augustus," Louis Napoléon had dreamed in 1842, "because Augustus . . . made Rome a city of marble." Napoléon did not make Paris a city of marble, but he did create a model for cities throughout the world.

Under Louis Napoléon's personal direction, the formidable Baron Haussmann had undertaken to beautify the city, open it up for traffic and sunlight, provide housing, a sufficient water supply, and a vast network of sewers—and to protect the government by making any future uprisings in the workers's quarters more controllable. The key to Haussmann's ambitious program was his replacement of the labyrinth of narrow streets with panoramic sweeps of broad, tree-lined boulevards. Barricades and ambushes would be difficult when government troops had room to maneuver and could even march abreast.

Though Louis Napoléon eventually made Paris a joy to the visitor and succeeded in making revolt more difficult, the root cause of social discontent remained—the gap between poor and rich, even between poor and middle class. Although the reconstruction of the city provided thousands of jobs, it was ill-paid work: the average wage was 3 francs for an eleven- or twelve-hour day, and it intensified class divisions. As their quarters were torn down, the workers were forced to crowd even more into the eastern part of the city. Neither the petit bourgeois nor the clerks, and certainly not the workers, could afford to pay the high rents of the new apartment buildings. Thousands of the displaced were forced to live in hovels on the outskirts of Paris.

Pissarro's identification with the philosophy of anarchism had its roots during the Second Empire and grew stronger as events seemed to confirm his fundamental beliefs. For much of his life he regarded France as "a rotten society ready to fall apart."

The workingman earned barely enough to afford wretched housing, and his relaxation was often limited to drink or vice. Working-class women earned even less; shopgirls in the "better" establishments—couturiers, confectionary shops, florists—often made less than 3 francs a day; laundresses also scraped by with 2½ to 3½ francs a day; thousands of women were saved from starvation by taking in sewing; thousands barely subsisted on jobs which paid even less. Widespread prostitution was inevitable: the official figure of 30,000 prostitutes—including girls of thirteen and fourteen—was probably low. More than half had syphilis or gonorrhea. "The poor use their daughters to avenge themselves upon the rich," the Goncourt brothers observed.

Although the gap between bourgeois and aristocracy was unbridgeable, there was a degree of mobility within the ranks of the bourgeois. Speculators and suppliers to the construction industry and the new railroad network were rising in status. The middle class occupied the new apartment houses on the boulevards and tried to do the fashionable thing by buying small country homes. Their comforts were attended to by servants, their sexual needs often by mistresses or the easygoing "lorettes."

At the top, politicians, military leaders, bankers, industrial magnates and some of the old aristocracy vied for honors and luxuriated in the splendor of the Empire. Louis Napoléon had restored the trappings of his uncle's imperial court and had reopened the palaces of Saint-Cloud, Compiègne and Fontainebleau. Grand balls were held at the Palace of the Tuileries, where guests, sometimes thousands of them, danced to the music of Waldteufel, Strauss and Offenbach. The *haut monde* of the Empire entertained continuously—dinners, balls, masquerades, held nightly by the five or six thousand élite of Paris. The Emperor and his chief aides flaunted their mistresses; powerful and wealthy courtesans presided at brilliant salons.

Extravagance, the pursuit of pleasure, an obsession with clothes and decoration, an apathy toward genuine beauty characterized the high society of the Second Empire in an age of display rather than taste, of ostentatious luxury rather than elegance. When Delacroix was invited to the Tuileries in 1854, the garden was illuminated by colored lanterns and Bengal lights. "That is beauty to them!" he observed in his *Journal*. "An April afternoon leaves them indifferent."

The Empire was still insecure, despite the ratification of the *coup d'état*, and repressive, at least in 1855. Political activity was almost nonexistent, unorthodoxy suspect, the press tightly censored. Of some twenty-five thousand persons arrested

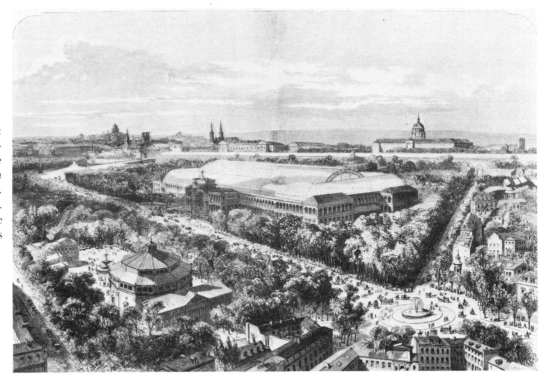

Artist unknown:
View of Champs-Elysées at Time of Exposition Universelle.
Engraving.
Bibliothèque
Nationale, Paris

during the coup, nine thousand had been deported. Writers such as Victor Hugo had gone into voluntary exile in protest against the death of the Republic; social reformers such as Louis Blanc had fled to England to avoid persecution. Within two years, Flaubert was placed on trial for writing *Madame Bovary*; Baudelaire was found guilty of offending public morality with his *Flowers of Evil*; and Théophile Gautier, poet and novelist, burst out to the Goncourts: "For the very small sums which I am obliged to earn because otherwise I would starve to death, I allow myself to say half of a quarter of what I think—and even then I risk being hauled into court with each sentence I write."

If the cultural climate was restrictive for a young artist, at least the economic situation was favorable. The decade of the fifties was a prosperous one for France. Railroads tripled, steel production multiplied, foreign trade expanded. To glorify the material achievements of the Empire and to demonstrate to the world the great strides France had taken toward industrialization, in 1855 Napoléon III staged an imposing *Exposition Universelle* at the Palais de l'Industrie and other buildings near by. It was a spectacular success, surpassing in splendor the Great Exhibition of 1851 in London. In intentional contrast with the London exhibition, which had neglected the arts, it offered a huge display of contemporary painting and sculpture.

Pissarro arrived in Paris a few days before the *Exposition Universelle* closed, in November, and spent "three or four days," as he later recalled, at the Fine Arts building on the Avenue Montaigne. Almost five thousand works by 2,176 artists from twenty-eight countries were crowded into the three main exhibition halls, the twenty

galleries and the sculpture pavilion. The paintings covered the walls from eye level to the ceilings; small pictures hung in the top row could hardly be seen. (It was to avoid this kind of invisibility that many artists of the period painted dramatic scenes on enormous canvases.) The crowds were gathering around Cabanel's *Christian Martyr* and his *Glorification of Saint Louis;* Couture's *The Romans of the Decadence;* Gérôme's *Century of Augustus;* Boulanger's *St. Jerome and the Roman Fugitives.* Critic Edmond Duranty, a spokesman for the new school of realism in art, later lamented that most artists who were popular with the public painted "visions of Greece, visions of Rome, medieval visions, visions of the sixteenth, seventeenth and eighteenth centuries, but were forbidden to see the nineteenth century at all."

Genre scenes also abounded, for the triumphant bourgeois of the Second Empire liked vignettes of daily and domestic life provided they were moralistic, uplifting and told a "story." Military pictures were another well-represented category.

The painter who dominated the exhibition, as he dominated the academic art world, was Jean-Louis Dominique Ingres, who showed forty-three paintings and twenty-five cartoons for stained-glass windows in a special gallery. He exhibited "grand" themes from the classics—*The Birth of Venus, Oedipus Explaining the Enigma of the Sphinx*—and subjects that glorified the heroes and heroines of French history—*Joan of Arc, The Vow of Louis XIII, The Apotheosis of Emperor Napoléon I.* His extraordinary portraits included the famous image of a bourgeois businessman, M. Bertin, seated solidly in his chair, every detail of his hands, facial features, hair and clothing finely and plausibly painted. Ingres's exotic, elongated nude *Odalisque* was there, too, perfectly sublimating her sexuality to the artist's beauty of line.

Eugène Delacroix, Ingres's rival and leader *malgré lui* of the romantic camp, had also been given a large retrospective. Thirty-five of his paintings were exhibited, many of them on religious and historical themes: *Dante and Virgil, Justice of Trajan, Christ on the Cross.* He also painted "romantic" subjects from literature—*Hamlet* and the *Farewell of Romeo and Juliet*—and a sprinkling of exotic themes—*The Women of Algiers in Their Apartment, The Arab Family.*

It was the work of the landscape painters which most interested Pissarro. After years of neglect, most of the Barbizon painters—Daubigny, Rousseau and Diaz—received a modicum of official recognition as a result of their modest triumphs at the *Exposition Universelle,* and Corot was awarded a first-class medal. Although landscapes became more popular with the public during the 1850's, landscape painting was still considered near the bottom of the artistic hierarchy. The Superintendent of Fine Arts, Comte Alfred-Emilien de Nieuwerkerke, disdained the landscapes of the Barbizon School. "This is the painting of democrats," he snorted, "of people who don't change their linen . . . this art disgusts me." The lucrative government commissions, which he to some extent controlled, were almost exclusively awarded for paintings with historical, mythological or classical themes.

The work of Corot made a vivid impression on Pissarro. In four large paintings, he had placed nude classical figures—Diana, Venus, Cupid—in lyrical imaginary landscapes. The small figures were dominated by the landscape settings, which were

painted in muted, delicate colors and bordered by massive, misty trees. As one critic commented: "These landscapes are not like those we see, but they are surely those we dream of." In sharp contrast with these poetic pictures, there were two other Corot paintings, fresh observations of humble subjects. In one, a boatman and his craft rest near the edge of a lake, a cow grazes near by; in the other, a country hillside glows in late-afternoon summer light under a pure, clear sky and a horse and cart move tranquilly along a road that curves off into the horizon. These paintings made such a strong impact on Pissarro that he remembered them forty years later. "Old Corot, didn't he make beautiful paintings in Gisors; two willows, a little stream, a bridge, like the paintings at the *Exposition Universelle?* What masterpieces! Happy are the artists who see beauty in the modest places where others see nothing."

Paris in 1855 was filled with art. Near the Palais de l'Industrie was another hall, Gustave Courbet's Pavillon de Réalisme. Although ten of his paintings were part of the official exhibition, the jury had refused two that were particularly dear to him. In a fury, the stormy Courbet had built his own hall to display forty more of his works. His realistic paintings of commonplace subjects outraged the art establishment. Ingres had advised a student: "To form yourself in beauty, see only the sublime; walk with your head raised to the sky instead of keeping it toward the earth like pigs searching in the

A Cove at St. Thomas, 1856. Oil on panel. (6) 9½ × 12¾. 28 × 41.

From the collection of Mr. and Mrs. Paul Mellon

Self-Portrait as a Young Man, c. 1856-57. Crayon.
Photo courtesy Sotheby Parke Bernet & Co., London

Pissarro's visiting card.
Private collection, New York

mud." To such painters, Courbet was only rooting in the mud. That he had also affronted the political establishment was pointed out by the critic Champfleury: "M. Courbet is seditious for having represented in good faith bourgeois, peasants, village women in natural size. . . . No one wants to admit that a stone-breaker is equal to a prince. The aristocracy is infuriated to see so many feet of canvas devoted to common people; only sovereigns have the right to be painted full-size. . . ."

The Fine Arts exhibition was a valuable experience for Pissarro. In one unprecedented display, he had seen a retrospective of the major artists then working in Europe and a survey of the most important styles and schools. He was most drawn to the landscape painters, particularly to Corot and Courbet. But he assimilated the lessons of the exhibition in his characteristically unhurried way so that his work shows no immediate influence. The first paintings he completed in Paris were scenes of St. Thomas remembered, often including the coconut trees M. Savary had urged him to study a decade before. Possibly he was most comfortable with this subject, but it is more likely that he was emulating Melbye and hoping that these "exotic scenes" would appeal to a European market. Although the paintings were of the tropics, the coloring was influenced by contemporary French landscape practice, with conventionally subdued browns and greens, and they are far more interesting for their subjects than for their execution. He signed them with the Spanish version of his name, "C. Pizarro." Not until 1858, when he was painting the French countryside, did he sign his work "Pissarro." His calling card even had a discreet "St. Thomas" printed below his name and over his local address, perhaps to stress his authenticity as a tropical painter.

Of the half-dozen paintings still surviving from 1856, three were bought by or given to Anton Melbye, the older brother of Fritz, who was a friend of Corot and an exhibitor

at the Salon for many years. His dramatic naval scenes and quieter studies of ships in harbor were popular; his patrons included King Christian VII of Denmark and Napoléon III. For several years Pissarro brought his work to him for criticism and possibly made some money by painting the skies in some of Melbye's seascapes. Anton probably introduced Pissarro to the man whose landscapes he most admired, Camille Corot, who had a reputation for kindness to young artists and was sympathetic to Pissarro. He, too, had worked in a family business until he was twenty-six. A modest man with little interest in material things, Corot had lived on a small stipend from his father. After years of public indifference, he was beginning to achieve some success and the approval of some of the leading critics. When Pissarro showed him his work, he was encouraging, generously inviting Pissarro to return for discussions and advice, and permitting him to examine his sketches, full of light and air. He even gave him a drawing, *Le Martinet near Montpellier,* a delicate study of trees. "I have only a little flute," Corot told him, "but I try to strike the right note."

Pissarro studied Corot's techniques for painting atmosphere and light, particularly in his sketches, and benefited from the general strictures he was prone to give rather than specific criticism. Corot had jotted in his diary just a few years before: "A man ought to embrace the profession of artist only after recognizing within himself a strong passion for nature and a disposition to pursue it with a perseverance that nothing could stop. Don't have a thirst for approbation or for financial profit. Don't be discouraged by the criticism that could fall on one's works; one must be armored with a strong conviction and march straight ahead, not fearing any obstacle."

Two of his basic convictions made a lasting impression on the young Pissarro: "If we have really been touched, the sincerity of our feelings will be communicated to others," he said, and encouraged Camille to be guided by his initial response to the landscape he wished to paint. And the second was Corot's advice to his disciple, "Go into the country. The muse is in the woods."

Camille Corot.
Photograph Bibliothèque
Nationale, Paris

4.

Acceptance at the Salon

"I am upset that you are doing nothing to exhibit this year."
—*Frédéric Pissarro to Camille, 1857*

INSPIRED by Corot, Pissarro took his sketchbook to the fringes of Paris to study nature, returning at the end of each day to the apartment where he lived with his family in the heart of fashionable bohemia, south of the base of Montmartre, at 49 rue Notre Dame de Lorette in 1855, and across the street, at 16, in 1856. Delacroix's studio was near by, at 54.

The stereotype often presented of Pissarro as a lonely artist in Paris is not true. The household was large, crowded with three generations. In addition to Rachel, Emma Isaacson and her five children—Rodolphe, Alfred, Alice, Amelie, and, after 1857, the baby Esther—there were a cook and a maid. From time to time, Frédéric's uncle Moïse—who had married his niece—stayed with them, along with his two daughters. Frédéric's parents lived in Paris and visited frequently. The family was close-knit, emotionally as well as physically. Living at home was distracting for the young painter, but it was also supportive.

Frédéric had accepted his son's decision to be an artist and exhorted him to follow the practical path of enrolling at the Ecole des Beaux-Arts. Camille balked at spending so much time indoors, drawing from engravings and plaster casts before being allowed to draw from a live model. Father and son compromised: Camille enrolled in private classes conducted by Ecole teachers, studying first with François Edouard Picot, then with Isidore Dagnan, and finally with a German academician, Henri Lehmann, a former pupil of Ingres. As late as November 1856, Alfred, writing from St. Thomas, inquired whether he was still studying life drawing with Dagnan. If he was, it seems he was proceeding in his own way, with one eye cocked toward Courbet. One of these early life drawings of a nude woman is strongly sensual and realistic in detail, with the pubic hair straightforwardly included, unlike the classically smooth nudes of the Ecole drawing classes.

In the summer of 1856, Frédéric's arrival from St. Thomas for a visit with his family freed Camille of his obligations and gave him his first full-time opportunity to explore the countryside in search of motifs. With easel, canvas and brushes strapped on his back, he set out for the forest of Montmorency, fifteen kilometers north of Paris, and stayed with a family at the baths in the town on a hill overlooking the forest, famous as the birthplace of Jean Jacques Rousseau. Now he was weaning himself from his

pictorial memories of the Antilles and finding fulfillment in the woods, fields and forests near Paris.

In September or early October, Fritz Melbye arrived in Paris. He had written from Venezuela of his hopes for a reunion and of his confidence in Pissarro, to whom he lectured in thunderous tones:

> I hope to God we will meet and begin to work as in former days together, but under better auspices and toward a higher aim. I am glad that you are in Paris and under circumstances where you may realize loves and long now-wished thoughts that nobody understood with the exception of the few that acknowledge and appreciate your natural talents and good disposition. I know that you will be diligent and pay less attention to amusements than the serious task you have to meet and conquer in the difficult field of the Arts. It is necessary to have courage and let me see that you do justice to yourself—show there is no fear for the consequences and only your hopes for the result of the battle.

While Fritz was still in Paris, Camille probably painted a self-portrait as a gift to the Melbyes. He is depicted as a thoughtful man, with sensuous lips, more mature than in the Venezuela sketches, and somewhat wary and aloof. Pissarro and Melbye were often joined by another Danish painter, David Jacobsen, whom Camille met that year. Nine years older than Pissarro, he had studied painting and sculpture in Copenhagen. He painted Frédéric's portrait—a competent portrait of a competent, self-assured bourgeois, still handsome in late middle age.

A clue to possible topics of conversation among the young artists appears in a letter Melbye had written Pissarro from Venezuela: "The romantic, moderate and realistic or idealistic parties, that you mention are fighting for the cepter [sic] and disputing their rights must give a most animating impulse to the artists when it does not corrupt or make them loose [sic] the peculiar primitive instinct—that each has got from nature and what we call originality—or genius—when it freely is emancipated in works of art."

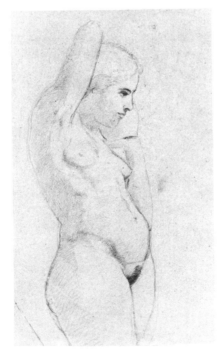

Academic Nude.
Pencil. Ashmolean
Museum, Oxford

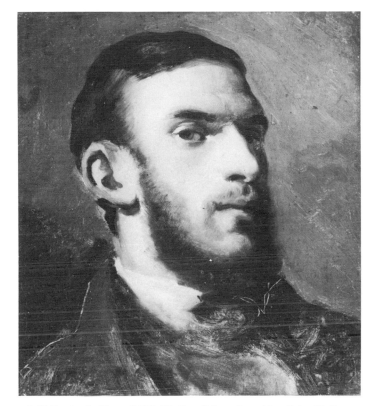

Self-Portrait (?), c. 1857-58. Possibly painted by Fritz Melbye.
Photo courtesy Sotheby Parke Bernet & Co., London

Melbye's companionship was brief, however. Uninterested in city scenes, he left for New York in the summer of 1857, on his way to the more exotic Far East.

Although Fritz Melbye's enthusiasm and faith bolstered him, Pissarro's time at the easel had to yield almost completely to home responsibilities in the winter of '56-'57, when there was much illness in the family, after Frédéric's return to St. Thomas. Rachel required special attention, since her emotional state, never very "calm," became more unstable in periods of stress. After crises, Camille would report to Frédéric that his mother was "calmer." Later Frédéric wrote to Camille that Rachel was "calm." Alfred wrote his brother that their mother was "calmer." The storms that preceded the calms were not chronicled.

Although Camille fulfilled his responsibilities to his family, he must have felt engulfed by them. He had given up his room to the children when they were sick. Work was impossible. In desperation he wrote to his father about his pressing need for a studio. Frédéric's reply of March 1, 1857, was sympathetic: "I understand how all the sickness in the house interferes with your work, since you have had to give up your room to the children, and that it's not good for your health to sleep in such a small room and that in order to paint you would like to rent an atelier with a friend for 400 francs [a year] from April onwards—"

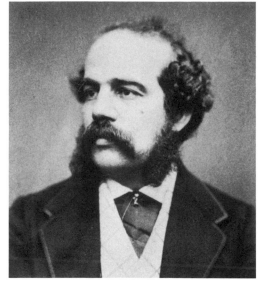

Alfred Pissarro.
Photograph by Carjat,
courtesy André Pissarro

And then the needle of the anxious parent—"But, then, you would have to work seriously to make some profit from your work. I am upset that you are doing nothing to exhibit this year, as M. Melbye was advising you. Well, let's hope that will happen next year and that then you will be strong enough to do something good which will be attractive to buyers."

It was a familiar conflict, the father impatient with his son's unorthodoxy, hopeful that he would follow the conventional and safe path and "do something good."

Undoubtedly Frédéric was being criticized back in St. Thomas by his middle-class friends and relatives who disapproved of Camille's break with the traditional path of commerce and were skeptical of his plunge into so impractical a career. The St. Thomas bourgeois's criterion of financial success was reflected in a letter to Camille from the faithful Alfred:

> I have received your letter of the first, filled with interesting details, your success in the world, your work, your progress, your diversions. I hope you can progress and earn your living. I would welcome that with so much pleasure! Do you expect to see your career become profitable? I beg you, don't belie the opinion I have always expressed that you would achieve a position and would make your fortune by your industry. Try to the contrary to give the lie to certain opinions being expressed by certain people who claim you are an idler or at least that you have the profession of one that will make you die of hunger.

The need to "earn your living." Nothing was clearer from the start.

Alfred's letter must have stirred up conflicts within Camille—pressure to exhibit at the Salon immediately, against his judgment that told him to wait until he was ready with a painting that would win the jury's approval. The Salon was the *sine qua non* of success in the mid-nineteenth-century Parisian art world, the El Dorado of the artistic Gold Rush. The Salon exhibition, open for six weeks in the Palais de l'Industrie every other year at this time and annually after 1863, was dominated by members of the

conservative Academy of Fine Arts, which selected the Ecole faculty, awarded medals and commissions, played a key role in official state purchases, and in innumerable ways determined the fate of artists.

Exhibition assured exposure to a large audience (in 1875, a record was broken when 75,000 viewers came on free-admission Sunday). An artist selected also had the official approval essential for the uncertain bourgeois buyer, anxious to decorate the walls of his new apartment on one of Haussmann's boulevards with "acceptable" art.

Pissarro felt he was not ready. He decided to wait two years until the Salon of 1859. If Pissarro disappointed his father, at least he was filling Frédéric's shoes during his absence. In the late spring he found a residence in Montmorency for the family—Rachel, Emma, Emma's children, and Uncle Moïse—so that they could escape the summer heat of Paris. Frédéric approved of the arrangement—his son could paint his landscapes, yet the whole family was together.

Pissarro set out on his own in late August for the Norman town of LaRoche-Guyon and for a brief visit to Fourges. But Frédéric worried that his twenty-seven-year-old son could not look after himself. "It may not be wise to be out on the highways under a tropical sun. I urge you to be careful to avoid an illness, you being away from your family."

In the town square of LaRoche-Guyon, the farms and rural scenes near by, the caves dug into the chalk hills, Pissarro found a rich source of motifs. Several times over the next decade, he returned to paint both valley and town, journeys which enabled him to soak up the peace and sunshine of rural France, the reflective silence, the beauty. Alfred de Marton, a friend from the tropics now living in France, wrote him in August, picturing him "crossing fields and hedgerows to which you, quite rightly, devote yourself during the summer, because the artist is a variety of lizard: . . . sloth and sunlight is their motto. Don't be upset by the word 'sloth'; I know better than anyone that you are not guilty of this capital sin, but on the other hand you do love the sunshine. . . ."

In the summer of '58, Frédéric returned to Paris and settled his family in the fashionable suburb of Passy at 12 rue de Pompe; but Camille stayed in the artists's quarter, moving closer to professionalism by renting his own studio, at 54 rue Lamartine. He still had close family ties. As Frédéric wrote "Thetis" (as he called Rachel) on August 31, on his way back to St. Thomas: "Camille has promised me to do for the family everything necessary to make my absence painless. I count on him to represent me and it will be pleasing to me to learn that he acquits himself of this responsibility with zeal and good will."

A month later, he returned to the theme: "I hope that Camille is sleeping at home and is giving you all the attention you need to bear my absence with patience and that he is replacing me with dignity in all that is in his power."

Gauguin later asserted that Pissarro was a mixture of "stubbornness and softness." It is quite likely that his "softness" and his family attachment enabled him to perform his duties with the good will Frédéric expected, if not with zeal. Since there are no further references in Frédéric's letters, Camille probably slept at home often enough to reassure Rachel. But he was stubbornly determined to be a professional artist, impossible without his own studio. Inching toward his goal of financial independence,

he received "two orders," according to a congratulatory letter from Alfred, who also had sent him 75 francs "on account" in June.

Although these first years in Paris were busy ones for Pissarro, with family responsibilities and long hours at the easel, they were also the most carefree days of his life in France. "I have met a young and pretty blonde who is now a widow," a friend, Eugène Warburg, wrote to him at Melbye's studio on March 27, 1856. "I spoke to her of you in such complimentary terms that she has only one desire, and that is to see you. If you would like some details, come to my house at nine o'clock tonight. . . ."

He had plenty of companionship. Two friends from St. Thomas who had shared his dreams of Parisian life, Raoul Pannet and his cousin Jules Cardoze, arrived in Paris in search of careers and were reunited with him and with Alfred de Marton. Cardoze lived on the same street and joined in occasional parties, one of which Pissarro recalled years later: "Mlle. Jenny Berliner was pretty, gracious and alluring. We danced, played little games, it was charming. . . ."

Pissarro's friendships ripened in the cafés, which were the clubhouses, the debating societies, the fellowship centers of mid-nineteenth-century Paris. Sometimes the talk was in Spanish, with his friends from St. Thomas, Raphael Herrera from Venezuela, and a new Puerto Rican friend, Francisco Oller y Cestero, who studied under Couture, then Courbet. The Brasserie Andler, where Courbet presided noisily over a table of notables, was especially magnetic, for he was beginning to join Corot as a major influence on Pissarro. Among Courbet's occasional companions were the socialist Jules Vallès and his mentor, the anarchist J.-P. Proudhon, who had exercised an influence on him since they had met in 1848. Within three years, Courbet announced that he was "not only a socialist but also a democrat and a republican, and above all a realist, that is, a sincere friend of the real truth." This widely quoted statement may have been one reason Pissarro was drawn to him.

Proudhon's name was very much in the air in 1858: his theories were fiercely debated in the cafés, and his new work, *Justice in the Revolution and the Church*, sold quickly. The edition was almost gone when the police seized the remaining copies and charged him with "attacking the rights of the family, outraging the public and religious morality and disrespecting the law." His reasoned advocacy of equal justice for all appealed strongly to Pissarro, who years later urged his eldest son to read every word of it. Camille had of course observed the violent social contrasts in Paris and could agree with Proudhon's statement that poverty caused vice and crime, not the reverse, as French society conveniently rationalized cause and effect.

By 1859, Pissarro felt he had made sufficient progress to submit a painting to the Salon. Daumier, Doré and others had often satirically sketched the ordeal of submitting work to the Salon: artists feverishly jamming the entrance on the last day for submitting pictures, carrying their art on their backs and on friends's shoulders, pulling it in carts, retouching on the spot. During the few weeks after the deadline for submission, the jury chose the pictures while tension mounted in the entire artistic community.

Selection of the paintings carried to perfection the art of logrolling in a society where status was important and substance incidental. For twenty days, the jury went the rounds of the entire floor of the galleries to begin the winnowing from thousands of

paintings. Attendants set out the canvases, some flat on the floor, others propped against walls. At one o'clock, the chairman of the committee rang his bell and the procession started through the cold, drafty rooms. Attendants followed behind, to sort out the rejected pictures, lying like corpses after a battle. On-the-spot verdicts eliminated the obvious without the formality of a vote. Occasionally disputes would hold up the procession. At times, when arguments grew hot, only a rope barrier held by attendants kept the jury from unintentionally trampling on the paintings. At three o'clock, a welcome collation was served and the bargaining and back-scratching began. Occasionally the foreman would draw the chairman aside to point out that a painting unanimously rejected was the work of a distinguished member of the Academy, hence *hors-concours*, outside the competition and automatically eligible. To the sneers of the younger members of the jury, the chairman would hastily restore it. Frequently the catcalls which greeted some paintings turned to embarrassed mutterings when an obscure signature was deciphered to be that of a member of the committee. New members learned to look at signatures before voting. When a particularly bad portrait of an especially wealthy patron of the arts was displayed, it usually managed to find its way into the Salon.

Emile Zola wrote that on the jury "there are the nice fellows who reject and accept with indifference, there are the successful ones who are above the battle, there are the artists of the past who cling to their beliefs, who deny all novel attempts, and finally there are the artists of the present whose little style has its little success and who hold onto this success with their teeth while scolding and threatening any approaching colleague."

The preliminary selection was completed in about three weeks of balloting. Then the jury faced the task of selecting, from the two to three thousand rejects, the few

Daumier: *Le Dernier Jour de la Reception des Tableaux.* Lithograph. Bibliothèque Nationale, Paris

Daumier: *Marche funèbre!!* Lithograph. Bibliothèque Nationale, Paris

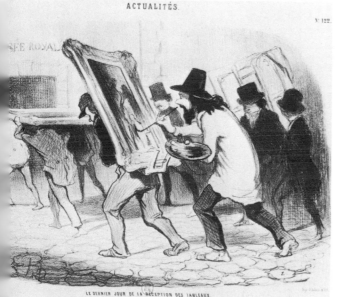

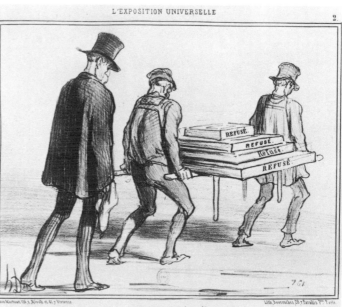

hundred necessary to complete the exhibition. While they rested for two days, the attendants set the rejects side by side on the floors of all the galleries, where they "lay in stagnant pools, separated by tiny pathways," according to Zola, through which the bewildered jury wandered "like a conquered army in retreat." In one desperate six-hour session, the jury stumbled through the maze, haphazardly selecting pictures as in a lottery, grabbing almost any to fill the quota. In this final free-for-all, each juror had the right to select one canvas, however bad, of a protegé or friend, and the pictures thus chosen at the last moment, said Zola, "were like the beggars who were allowed to slip in and pick up the crumbs of the banquet."

Finally, the lists of those accepted were posted, to the relief of some and the groans of hundreds of disappointed artists who had to collect their pictures, stamped on the back with the ignominious "R," and in the privacy of their studios reline the back to remove all trace of the mark of shame.

On the night of the posting, Pissarro joined hundreds of other hopefuls at the Palais de l'Industrie. To his immense joy, he saw his name posted. His *Landscape at Montmorency* (since lost) had been accepted by the same jury that had rejected Manet, Whistler and Fantin-Latour. In less than four years since his arrival from St. Thomas, he had achieved his goal—and Frédéric's.

The painting was hung so high and in such an obscure location that probably few noticed it; but Zacharie Astruc, in his review, listed it. Pissarro hoped that his victory might lead to financial independence, but there were no immediate results. At the end of the summer, spent at La Roche-Guyon with Francisco Oller, Frédéric sent him 100 francs to pay his bills before returning to the city.

Emma wrote him that his father had hung one of his paintings in the place of honor in the parlor. Frédéric, she reported, was happy to hear that his son was in good health and working hard, two essentials in the Pissarro family creed. With Rachel in a chronic state of fatigue, Emma had to do all the cooking, which she reported with both complaints and wry humor, also family characteristics. After warning him not to drink cold water, she added, "If you need money, write me."

Pissarro's exhibition card,
Salon of 1859.
Pissarro family documents

5.

Pissarro, Monet and Cézanne

"Here are those first-rate recruits!"
—*Frédéric Bazille, 1863*

Frédéric, now permanently settled with Rachel in genteel, suburban Passy, was delighted to be free of St. Thomas but regretted Camille's not living with them. In October, he wrote: "Your mother asks me to write you come dine with us today. Because this is the evening when we celebrate 'la fête de Kipur' and on this solemn occasion the whole family should be together—and tomorrow not work, we should pass that day together."

Probably Pissarro joined them; his nature was kindly, he hated to offend. But the explanations Frédéric felt impelled to give indicate how far away the son had drifted. In his world there was little place for religious formalities. Perhaps he had already been convinced by Proudhon's dictum: "Man is destined to live without religion." He was still trying to "break the ties from the bourgeois life," ties weakened further in 1860, when he fell in love with Julie Vellay, the woman who became his wife, bore their eight children and helped him keep the lively Pissarro household afloat through many thin years.

When they met, Julie, twenty-one years old, was working as the cook's helper in the home of Camille's parents in Passy. Her parents lived in Grancey-sur-Ource, near Dijon, where her mother had two small vineyards and a few acres of land. Julie and her sister, Félicie, like many other enterprising country girls, were drawn to Paris by the opportunities to find work, learn new skills and make new friends. She had little formal education; her letters were written with her own fearlessly phonetic method of spelling. Julie was lively, direct, healthy, capable and pretty, with long, thick brown hair which she wore pulled up in a loose knot, a high round forehead, thick eyelashes, broad cheekbones, and a full strong body.

According to the reminiscences of their eldest child, the pair kept their relationship secret until Julie became pregnant, late in 1860. At that point Pissarro confronted his parents with the news and his request that they approve of a marriage. Frédéric and Rachel were aghast. They had hoped that their son would make a "good" marriage with a woman of position and fortune who could help him in the impractical career he had chosen. Julie was their servant, far from a suitable match for their son. Rachel had owned slaves in St. Thomas before the practice was abolished, and when she came to France, she brought a freed slave as her handmaid. To her, Julie was little more than a slave, with whom a liaison was tolerable but marriage out of the question. She

was not only a servant but a peasant and a Christian. Frédéric and Rachel adamantly refused to bless such a union, which they considered anathema to society and to God. Camille and Julie, both of age, could have married without their permission, but a marriage without the approval of parents could not include a contract concerning property and inheritance rights. Although Pissarro was now thirty, he was still financially dependent upon his parents, who were certainly not willing to approve a marriage contract which would give a servant girl a right to inherit their property.

Julie was proud, and hurt by their disdain. In Grancey-sur-Ource her family was known as respectable peasant landowners. To her, a position as cook's assistant had not seemed any more servile than a job in a shop. But she had come up sharply against ingrained middle-class social prejudices. She left the household in Passy and found work at a florist's shop. When her pregnancy ended in miscarriage, Frédéric and Rachel probably hoped their son would come to his senses; but the lovers continued to see each other. Camille's two portraits of Julie that remain from these years are tender and affectionately painted.

Camille's union with Julie and his loyalty to her in defiance of his parents's wishes marked the widening of a breach with his family's strong religious tradition and middle-class values. Perhaps he had originally been attracted to Julie because she represented a world to which he felt drawn. He may have idealized her and felt unconsciously that a liaison with a peasant girl was a further act of rebellion against a society he was beginning to despise.

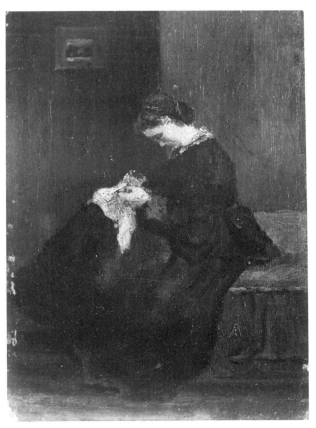

Julie Pissarro Sewing,
c. 1858. (14)
6¼ × 4¼.
16 × 11.
Ashmolean Museum, Oxford

But the break with his family was not, and could not be, complete. Not earning enough to support himself and Julie, he was at thirty-one still dependent on his parents for financial help. He had strong emotional ties to his family; he was basically a "family man," with a need for family relationships. Though he strove to sever "bourgeois" ties, his break was with their values and social attitudes, not with them.

Julie Vellay's social milieu was a world apart from that of Jenny Berliner or the other middle-class young ladies whom he had entertained a few years earlier. Possibly Julie's principal attraction was sexual; but his relationship with her indicated that in only five years he had moved far from his background.

Often at night in the late fifties Camille walked to a ramshackle building on the corner of Boulevard du Palais and Quai des Orfèvres that bore a huge sign, "SABRA, dentiste du peuple." It housed the *Académie Suisse*, a studio run by Père Suisse, a former artists's model. For 10 francs a month, Pissarro could draw from a male model for three weeks, a female the fourth week, from early morning until ten at night, with meal breaks. He went only at night, so that he could be free to paint during the day.

The *Académie Suisse* was a venerable if undisciplined institution—Delacroix, Bonington, Manet and Courbet were among its distinguished "alumni." No instruction was given; no attendance was required; no examinations were inflicted. The room was large, well-lighted, bare, its walls smoke-begrimed, the only "adornment" the nude model. The less serious students were rowdy and bawdy, acting out what they assumed was the bohemian tradition, shouting to each other, teasing the female model, tossing charcoal about, sending clouds of pipe smoke billowing to the ceiling. They made concentration imperative for Pissarro.

Some of the students seemed to have impressive talents. "I recall that at the *Académie Suisse* there were students who were remarkably skillful and could draw with surprising sureness," he later wrote. But too much ease in drawing, he realized, had its traps. From the experience painfully gained in those formative years, he gave this advice: "Do not be taken in by the facility of beginners, it is often an obstacle later on. . . . Those who have more facility make less progress because they do well right away, with ease and without reflection; they are like students with good memories."

One of the genuinely talented students whom Pissarro met there was Claude Monet. Monet was nineteen, ten years younger than Pissarro, and already showing exceptional gifts, working with enormous concentration, drawing firm and solid figures. Photographs show him clean-shaven, handsome, with brown hair brushed straight back from his high forehead and falling to his collar, a sensual mouth and an appraising expression in his brown eyes. He could already paint a still life representing objects of varying textures—feathers, wood, glass, straw, paper, leather—and meet this traditional challenge with perfect competence. Judging from the few pictures that remain, Pissarro was not nearly so technically proficient nor so aware as Monet of the conventional problems presented to the art student. Perhaps he felt these weaknesses when he registered at the Louvre on April 16, 1861, as a copyist to improve his knowledge of techniques and composition. He seemed to be patiently seeking his own

Severac: *Monet,* 1865.
Photo Herlingué-Viollet.
Musée Marmottan, Paris

Rue St. Vincent, Montmartre, 1860. Black chalk heightened with white.
Photo courtesy M. Knoedler & Co., Inc., New York. Private collection

path. His blunt way of seeing could be interpreted as amateurishness or as originality and faithfulness to his own vision. Monet was perceptive enough to recognize Pissarro's qualities.

They were drawn to each other by their commitment to landscape painting and their ideal of working from nature in the open air as much as possible, both believing that what they saw deserved to be painted, whether or not it was "beautiful." As his career progressed, Monet moved away from such realist principles and became more involved with the visual excitement of form and color. But in the early sixties, he was under the same influences as Pissarro, who in 1861 painted a disheveled yard in Montmartre, with a shabby wooden fence straggling across the very center of the picture. Around the same time Monet painted a bleak *Factory Landscape.* This kind of realism smacked of insurrection to the official art schools, committed to an art in which nature must be "improved."

Monet later remembered that when he first met Pissarro, he "was working tranquilly in the manner of Corot." Camille had visited the distinguished old man and related that Corot had told him, "Since you are an artist, you don't need advice. Except for this: above all one must study values. We don't see in the same way: you see green and I see gray and 'blond'! But that is no reason for you not to work at values, for they are the basis and the background of painting. In whatever way one may feel and express oneself, one cannot do good painting without them." By values, Corot meant the tonal relationships within a painting. In addition to finding the right colors, a painter had to find the exact degree of lightness for his sky and exactly the right, slightly darker tone for a pond which reflected the light of the sky. Only in this way could he hope to capture the subtle and complex effects in nature. Corot had a true sense of tone, a natural gift

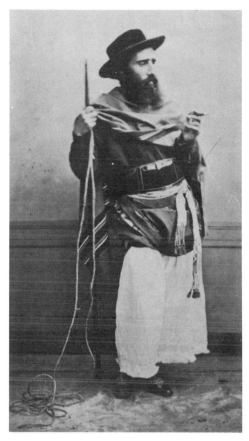

Cézanne, c. 1860

Pissarro in gaucho costume.
Photograph courtesy John Bensusan-Butt

something like perfect pitch in music. Retaining the memory of the first impression of a landscape was important to him; it is only at the moment of our first impression, he believed, that we are aware of the totality of the "envelope of light" which suffuses the scene. For himself, he wanted only to submit with sincere humility to his sensations and let *le bon Dieu* do the rest.

Monet, in his landscapes of the early sixties, was influenced more by Charles Daubigny, whose landscapes were executed with brighter colors, stronger contrasts, and rougher, more visible brushwork than the subtle Corot's. Through Monet, Pissarro seems to have grown closer to Daubigny's style. The two friends probably painted side by side in the fields at Champigny-sur-Marne and in the forest of Fontainebleau. In the mid-sixties, their landscapes are similar, often picturing rural roads leading into the distance and small, isolated figures walking, working or riding in horse-drawn carts. Even Monet's seascapes of this period include small figures of men working on the beach or in fishing boats, rather than the vacationers he later painted at the seaside. Along with their visual truth, the landscapes painted by Monet and Pissarro in the mid-sixties are sensitive to the loneliness and harshness of country life dominated by impersonal nature.

They lived in the same part of Paris, that lively triangle between the Place Clichy, the Place Pigalle and the church of Notre Dame de Lorette, due north of the Opéra. In

1860, Pissarro moved from Fontaine St. Georges to 39 rue de Douai (where Manet took a studio in 1860); Monet lived at 18 rue Pigalle, just a short distance away. This area and its cafés—the Brasserie des Martyrs, at 9 rue des Martyrs, and the Café Guerbois, at 11 Grand rue des Batignolles, near the Place Clichy—were the favorites of bohemian poets and writers. After 1859, realist painters began to gravitate there from the Left Bank in a historic migration which displaced the artistic center of gravity toward the Right Bank of the Seine; it was in the orbit of the Gare Sainte-Lazare that the naturalists and the Impressionists established themselves. Monet later declared that he had wasted far too much time in his youth at the Brasserie des Martyrs, drinking Bavarian beer, flirting with the pretty artists's models and drawing caricatures of the other customers.

The first photograph we have of Pissarro was taken around this time on some convivial occasion. He posed in the costume of a *llanero,* or Venezuelan cowboy, that Alfred had brought from South America for him. A round-rimmed black hat is pushed back rakishly from his high forehead; he wears white loose "pantalon bombacha" pants, a black peasant blouse with an elaborate belt and a striped poncho. With a long cattle-goading spear and lasso in one hand and a cigarette in the other, he has a tentative air of casual swagger, the swashbuckling costume clashing with his sober, reflective face.

When Monet was conscripted into the army in 1861, his friendship with Pissarro was interrupted. He left Paris for his home in Le Havre in April, was sent to Algeria in June and because he did not return to Paris until the autumn of 1862, he missed the arrival at the *Académie Suisse* of an eccentric young art student from Aix-en-Provence named Paul Cézanne.

Pissarro's friend Oller evidently met Cézanne first and then made a point of introducing Camille, who later remembered going with him "to see the curious Provençal at the *Académie Suisse* where Cézanne's figure drawings were ridiculed by all the important artists, including the famous Jacquet. . . ." Cézanne was tall and round-shouldered, with short black hair, swarthy skin and a black bandit's mustache drooping over his sullen mouth. A photograph of that year shows him with a startling intensity in his expression, a look of wild suspicion in his dark eyes. He must have attracted attention with his touchiness and anxiety, his clumsy, careful drawing. The mockery of the other artists in the studio was no doubt painful for him, even though they may have meant it merely as rowdy good fun. After years of opposition he had finally convinced his father, a banker, to back him in his career as an artist; but his confidence was shaky and criticism something he could not deal with easily. Pissarro must have sensed and sympathized with Paul's anguish; here was another provincial outsider like himself who had defied his businessman-father and was pursuing his art doggedly, in spite of self-doubts. They sketched together occasionally at the *Académie Suisse* and perhaps they went to the Louvre together to copy. No such copies exist now, but Cézanne's would have astounded any passing museum-goers, since he was painting in a wild, slashing style in those years.

An obstinate, contrary, suspicious man who was terrified that people would take advantage of him, "get their hooks into me," as he said, Cézanne grew to trust and

depend on Pissarro. His childhood friend Emile Zola, who had encouraged him to come to Paris, described him vividly in a letter to a mutual friend of June 10, 1861:

> To convince Cézanne of anything is like wanting to persuade the towers of Notre Dame to dance a quadrille. He might say yes, but he wouldn't budge a fraction. And note that age has developed his obstinacy, without giving him rational bases on which to be obstinate. He is made in one piece, rigid and hard under the hand. Nothing bends him, nothing can draw a concession out of him. He won't even discuss what he's thinking; he has a horror of argument. Firstly, because talk is tiring, and also because he may have to change his mind if his adversary is proved right.

Obstinacy had become habitual to Cézanne; for years he had stubbornly opposed his father's harsh condemnation of his ambition to be an artist with his own massive conviction that he could be one. When anyone else intruded or tried to impose an idea on him, however well-intentioned, he reacted furiously as if against an alien will seeking to destroy him.

But Pissarro—tolerant, approving, tactful—must have seemed to Paul a "good" father. And Pissarro's tranquil, objective paintings doubtless appealed to him not only because of their aesthetic qualities but also because they offered calm and rest from his confusion and agitation. Pissarro, for his part, with his moderate, even temper, was probably stimulated by Paul's emotionalism. Since he was much more controlled, he may also have responded vicariously to the open expression of sexuality in Cézanne's early paintings. Moreover, Cézanne was well-educated, a Latin scholar and an amateur poet, with a keen mind and an ironic wit, and could think and talk with Pissarro about the aims and future of painting. So their friendship grew and proved in the end to be invaluable for the development of their art and, in fact, for the development of modern painting.

In the late fifties, Pissarro had also met a man who became his closest friend, Ludovic Piette de Montfoucault. Four years older than Camille, he was a well-to-do Breton whose family owned a large country estate at Montfoucault, near Mayenne, which provided a welcome haven for Pissarro in hard times. Piette kept a studio in the quarter of Notre Dame de Lorette and owned a building in the neighborhood. He and his Jewish wife, the former Adèle Lévy, developed an intimate relationship with the Pissarros. The two men had many common interests and corresponded regularly: Piette's letters, sometimes sardonic, sometimes romantically enthusiastic, reveal a shared radical outlook and a constant admiration of Pissarro as man and artist. Pissarro's portrait of him, painted in his studio in 1861, shows his full-bearded friend at the easel, sturdy, stocky, and snub-nosed, working with a good-humored and casual air.

In 1863, when Pissarro was sharing a studio with David Jacobsen on the rue Nueva Breda on the southern fringe of Montmartre, a son, Lucien, was born to Camille and Julie on February 20. The godparents were Pissarro's cousin, Alfred Nunes, and Antoine Guillemet, a painter whom he had met at the *Académie Suisse*. Guillemet was twelve years younger than Pissarro and shared his admiration for Corot and especially for Daubigny. He came from a well-to-do family, was handsome, dapper, good-natured, full of amusing ideas, and even Cézanne managed to relax a little in his company.

Camille and Julie set up housekeeping on the rue Hyacinthe in La Varenne-Saint-

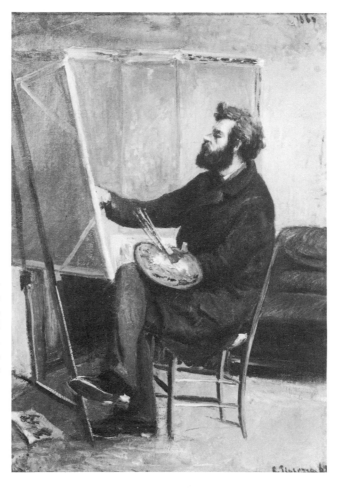

Piette in His Studio, 1861.
(25) 21 × 14¼. 52 × 36.
Photo Sotheby Parke Bernet, New York.
Agent: Editorial
Photocolor Archives.
Collection Dr. and Mrs.
Jordan H. Trafimow

Maur, about twenty-five kilometers outside Paris, where a second child, Jeanne (Minette), was born in 1865. This first home must have given them a sense of stability, though money was short and their union irregular. Pissarro received some money from his mother, Julie a little from her family; but they recalled later that during the sixties they kept house on an average of 20 francs a week. Julie, used to hard work, planted her own vegetable garden, kept rabbits and chickens, and occasionally helped farmers harvest their crops in La Varenne, taking her pay in potatoes she had helped to dig. She was capable and thrifty and kept the household afloat on a minimum budget, hoping for the day when Pissarro would begin to sell his work.

From 1863 until his old age, Pissarro was never again to have a lengthy stay in Paris. For all sorts of reasons, the semi-rural and rural areas were more congenial to him. Rent was lower and food available at much lower cost, factors important to a family man living on a minimum income. Pissarro seems to have been a born money-worrier; he worried about it even when he had it. His experience in the sixties, when income was minimal, his reputation modest and his future uncertain, intensified this innate

tendency. But there were other, perhaps more fundamental reasons Pissarro was lured to the countryside, much as he missed the stimulation of his friends in Paris. The subjects that interested him most were at hand—country landscapes and village scenes, rural lanes and unhurried streets.* He was, as he said, "rustic" by nature. In his gradually evolving anarchist philosophy, with its nostalgic yearning for a simpler society, life in the village or countryside was more appealing than an urban existence. Paris was the cultural mecca—and the potential market for his paintings—but it was also repellent in its extremes of wealth and poverty, in the contrast between the comfortable bourgeois and the homeless and helpless. Farm laborers worked long hours for subsistence pay, but apparently their lot never seemed to Pissarro as oppressive as that of the city worker. As he later remarked, he never felt he had to be a peasant in order to paint one, but he could not paint peasant life without living in its milieu.

A letter from Piette in August 1863 speaks of a visit Pissarro was planning to make to Montfoucault in September. Julie and the infant Lucien must have been coming along, since Pissarro was evidently concerned about overburdening his friend. Piette replies: "It will be done to your liking concerning the little contribution that you wish to make

* Color plate on page 65.

Julie Pissarro and Jeanne,
1865. Charcoal.
Private collection

to my household expenses—since you will then feel more comfortable and extend your stay." The presence of Julie and the baby might cause some difficulty in Piette's respectable family and in his provincial village. He solved this difficulty by writing to Camille: "In order to avoid gossip . . . I must believe you are married and you must make me believe this. It is stupid but necessary." Julie must have enjoyed these visits to Brittany as Madame Pissarro. While Pissarro and Piette painted together, she could relax and enjoy a holiday from the constant needs of the household and from her lack of social status.

In May 1864, Piette again urged Pissarro to come to Montfoucault if only for two weeks, even though Alfred was ill in Paris and Pissarro reluctant to leave.

> You cannot imagine how much everything has changed, what varied, tender greens nature displays. Everything has become resplendent in the last few days. You could make a well-finished masterpiece and other studies that would be precious for color and delicacy. Now that would be enough, with what you have, so that you can paint during your forced stay in Paris until your brother's recovery. I am giving you this advice in all seriousness, for it would be a loss for you if you did not do anything with this green spring. Do come. I know that it will put you to expense, and that you may be called back to Paris after you started working. But let's take the chance. Around the 20th, you will receive your allowance and will be able to start on your way.

Piette's letter tells us not only that Pissarro received a regular allowance on the twentieth of each month but that he was in the habit of making studies out of doors and then finishing them in his studio, in this case during a "forced stay in Paris." And it points up how important it was for landscape painters to capture in sketches the fugitive effects of nature before they disappeared. As Piette wrote about that sudden spring: "Two weeks' work would be tremendous, especially if we work with the energy of despair."

Pissarro renewed his friendship with Monet, who had returned to Paris in the autumn of 1862 and entered the studio of Charles Gleyre, an academician described by the Goncourt brothers as "a wooden personage with the appearance of a third-rate workman . . . and a dreary and boring spirit." But Gleyre served a unique historical function: his studio brought Monet together with Frédéric Bazille, Auguste Renoir and Alfred Sisley, the gifted young painters who formed the "Gleyre group" and later, with Pissarro, the core of the Impressionist movement.

Bazille was born in 1841, son of a wealthy Montpellier wine-grower, tall, handsome, haughty, "a little the style of Jesus, but virile," according to Zola. Renoir, slender and high-strung, son of a poor tailor, had to earn his own way from his early apprenticeship to a porcelain painter. He could be nervous and irascible but was witty and carefree as long as he was free to paint. He laughed at theoretical discussions; to him painting sprang not from theory but from sheer sensual response to color, light and movement. His indifference to aesthetic theory, to social concern, to anything except rendering an untroubled, pleasure-filled, middle-class world made him, in some ways, the antithesis of Pissarro; the two were never very close. Renoir was much more intimate with Sisley. Parisian-born in 1840 of English parents, he appears in Renoir's portrait of him as genial, solid and relaxed, with a curly reddish-brown beard and mustache, and narrow pale-blue eyes.

Pissarro met the members of the Gleyre group through Monet, who was the link with the artists working at the *Académie Suisse*, and who introduced him first to Bazille, in 1863, when Bazille was sharing a small studio with Renoir in the Batignolles quarter. One day, as Renoir recalled, Bazille turned up at the studio announcing, "Here are those first-rate recruits!" The two "recruits" were Pissarro and Cézanne. Late in 1864, when Bazille moved into a studio with Monet at 6 rue de Furstenberg, on the Left Bank near Saint Germain, Pissarro and Cézanne continued to visit, along with Renoir and Sisley and, a little later, Courbet. By the mid-sixties, Pissarro had met and worked with many of the future Impressionists; by the end of the decade, the group was almost complete. In the anti-Semitic France of that period, his Jewish background was apparently not an obstacle to the friendships, at least at that time.

The decade of the 1860's was a period of great growth for Pissarro. One reason may have been that he, like Proudhon, "cherished the idea of a household and paternity" and agreed with him that "fatherhood filled an enormous emptiness in my life, gave me a ballast I lacked and energy such as I never knew." His growth was also stimulated by the camaraderie and mutual support of his new group of artist friends. He, as a late starter, had much to learn from their precocious gifts, and they respected his experience—he had already shown at the Salon—his good will, loyalty and interest in their work.

Fields, c. 1861. Oil on wood. (18) 6¾ × 11⅞. 17 × 30. Musée de Bagnols-sur-Cèze (Gard). Gift of M. M. Durand-Ruel

6.

Seeds of Revolt and Success

*"A beautiful picture by this artist is the work
of an honest man."*
—Zola on Pissarro, 1868

IN 1863, the Salon jury refused three-fifths of some five thousand paintings submitted. Not only were the paintings of Pissarro, Guillaumin and Cézanne rejected, but also those of Jongkind, Manet, Whistler and Fantin-Latour. At this massacre, resentment against the jury system exploded so loudly that it even penetrated the walls of the Imperial residence. Napoléon III, always sensitive to public disapproval and anxious to reassure the intellectuals that he was "liberal," appeared at the Palais de l'Industrie and demanded of a shaken de Nieuwerkerke to see some of the rejected paintings. He decided on the spot that some of them were not much different from those accepted and issued the surprising decree that rejected artists who wanted to do so could exhibit in another part of the Palais.

The "rejects" were at first exultant at this "Salon des Refusés"—and then somewhat apprehensive: to exhibit would incur the wrath of the official jury and risk future reprisals; not to appear would imply agreement with the jury's decisions. As a matter of principle, Manet and Whistler decided to exhibit and Pissarro did not hesitate to enter three canvases, listed in the hastily prepared, incomplete catalogue as *A Landscape*, *A Study* and *A Village*. Cézanne and his friend Guillaumin also seized the chance to exhibit, though their names did not appear in the catalogue. Pissarro had met Armand Guillaumin, ten years younger than he, at the *Académie Suisse*. A socialist, an irascible loner, ill at ease with other students who came from more middle-class backgrounds, he and Cézanne nevertheless got along well together and he and Pissarro became very friendly. He was almost penniless and worked nights as a clerk for the Paris-Orléans railway so that he could paint during the day.

The official Salon jury, whose authority had been challenged by the Emperor's decree, did everything it could to make sure the Salon des Refusés was a failure. They hung the worst paintings in the most conspicuous places, trying to create an atmosphere which would prejudice the public against the exhibition and justify their selections. They succeeded: the public came by the thousands to hoot and jeer.

In his novel *L'Oeuvre*, Zola later recreated the scene:

> The crowd's mockery finally became so open that the women had stopped stifling their merriment with their handkerchiefs, and the men, completely unrestrained, were holding their sides and roaring with laughter. It was the contagious hilarity of a crowd bent on amusement, gradually working itself up to the point where it would laugh loudly at nothing and be just as convulsed at beautiful things as by ugly ones. . . .

Manet's painting *Le Déjeuner sur l'herbe* and Whistler's *The White Girl* enjoyed a particularly sensational *succès de scandale*. As a result of the ridicule he suffered at the hands of the public, Manet's stature as the leader of a new generation of painters grew tremendously.

The three paintings Pissarro exhibited at the Salon des Refusés are now lost, but they must have shown evidence of Corot's teaching. Jules Castagnary, well known as sympathetic to the landscape painters, commented on Pissarro's work: "Since I cannot find his name in the catalogue of the preceding Salon, I suppose that this artist is a young man. Corot's style seems to please him. That is a good master, Monsieur. One should be careful, however, not to imitate him." Perhaps because of this friendly notice of Pissarro's admiration of him, Corot gave Camille permission to list himself as "pupil of Corot" for the first time in the Salon catalogue of 1864. It was an honor for Pissarro and a graceful tribute to his mentor.

By Imperial decree, the Salons were now to be held each year instead of every other year, a measure Louis Napoléon hoped would placate the artists while retaining the authority of the official academic system. At the same time, the government curbed the power of the Academy, which controlled the Salon juries, by taking from the Academy supervision of the Ecole des Beaux-Arts.

The jury of 1864 was more generous to the younger painters, including Manet, Renoir and Berthe Morisot, but not to Cézanne, to whom rejection was becoming routine. Pissarro had two landscapes accepted, both now lost, one a scene painted near La Varenne-Saint-Maur and one from La Roche-Guyon.

He had two landscapes accepted again in 1865, *At the Edge of the Water* (now lost) and *Banks of the Marne at Chennevières*, which depicts a small village nestled on both banks of the river, whose broad waters reflect a breezy bright-blue sky. The painting is vigorous with fresh color, vivid contrasts and free brushwork. Even though Pissarro listed himself again as "pupil of MM. A. Melbye and Corot," his painting is not so much like Corot as it is like Daubigny, closely resembling the composition of a river landscape, *Banks of the Stream at Orgivaux*, which Daubigny had exhibited in 1855. It was, in fact, Daubigny who exercised prerogative as a member of the Salon jury to have this painting admitted, which other members of the jury had rejected precisely for its brightness and rough "unfinished" surface.

In the 1865 catalogue Pissarro listed his address as "La Varenne and Paris, chez M. Guillemet, Grand-Rue, 20 (Batignolles)." He was evidently using that studio, perhaps only when Guillemet was out of town, as he often was. They corresponded that year, Guillemet writing from a port on the Channel coast near Le Havre, where he was painting with Monet. In August, he invited Pissarro to spend a month as his guest at La Roche-Guyon, "if your little wife will not be angry. . . . Assure her that it is in your interest and that you will find beautiful motifs—three weeks or a month are not a century." Guillemet knew that Julie often stayed at home while Camille was painting in the country. It was not easy for her to be left alone with the responsibility of the children and the household, but Pissarro accepted the invitation of his friend, who wrote him again in September 1865: "It will be good to see good painting again and to do it with a real worker like you. I am stupefied by the painters I meet here—they are all grocers and dandies. Cézanne will probably come with us. I wrote him after

Corner of a Village,
1863. (27)
15¾ × 20¾. 40 × 52.
Photo courtesy
Christie's, London

receiving your letter." Guillemet also mentioned, in response to Pissarro's letter, "I have read Proudhon's book. . . . Proudhon makes some very high-flown remarks that unsettle me a little. He doesn't speak to me as a painter but as a thinker." He was referring to *On the Principles of Art and its Social Use,* which had recently been published. Courbet's monumental posthumous portrait of Proudhon and his family also appeared in 1865 at the Salon; the anarchist philosopher and his ideas were a topic of lively dispute among artists that year. Many criticized him on the same grounds as did Guillemet, that he seemed to know little about the creative process of painting itself; others found his social theories stimulating.

In his book, he had used Courbet's paintings of peasants and workers to illustrate his conviction that "art must see us as we are and not in some fantastic, reflected image which is no longer us." Proudhon believed that the mission of art was to educate the public to an understanding of social reality and its injustices. Pissarro experimented with these ideas in his own art at about this time, in the one painting of his career which has an obvious social message. *Donkey Ride near La Roche-Guyon* shows a pretty, well-dressed little girl sitting side-saddle on a donkey while her mother or governess steadies a boy astride another donkey. Wistfully watching are two ragged, untended children, who provide a clear contrast with the young bourgeois. Although Pissarro never again included such overt criticism of the class system in his painting, he

Entering a Village, c. 1863. (32) 13 × 16⅛. 33 × 41. Collection S. John Hernstadt and Robert Darwin

Banks of the Marne, Winter, 1866. (47) 36⅛ × 59⅛. 91 × 150.
The Art Institute of Chicago, Mr. and Mrs. Lewis L. Coburn Fund

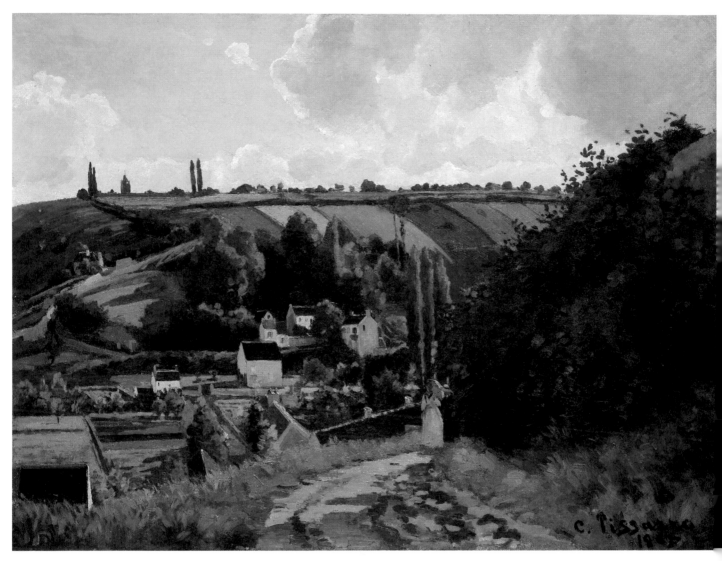

Côte du Jallais near Pontoise, 1867. (55) 35 × 45⅝. 89 × 116.
The Metropolitan Museum of Art, bequest of William Church Osborne, 1951.

expressed his social and political ideas in other ways—not in criticism of specific injustices but in exaltation of the positive values of work and the simple life on the land.

He was sympathetic to Proudhon's definition of the role of the artist: "To paint men in the sincerity of their nature and their habits, at their work, accomplishing their social and domestic duties, with their actual countenances, above all, without posturing . . . such seems to me the real starting point of modern art." He was responsive to Proudhon's stress on individual freedom and his attacks on an exploitative society: government meant repression; liberty could be attained only by economic equality, by "mutualist" associations of producers, preferably in small communities where the individual's voice could be heard. Proudhon regarded the peasant who owned his own farm as the stalwart barrier to an oppressive state. In painting the rural life just as it existed, even without an obvious social message, Pissarro was in a sense engaging in a revolutionary act without necessarily thinking of it as revolutionary; but the authorities and the forces they represented instinctively and quite correctly felt that any art presenting life realistically constituted a challenge to them. Pissarro was of course aware of this challenge; as he later noted, "Proudhon says in *La Justice* that love of earth is linked with revolution, and consequently with the artistic ideal."

Donkey Ride at La Roche-Guyon, c. 1864-65. (45) 14½ × 21. 37 × 53.
Photo courtesy Sotheby Parke Bernet & Co., London. Collection Tim Rice, England

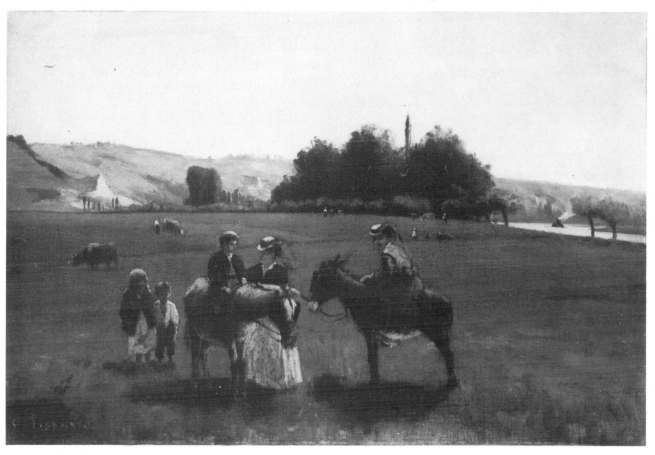

His commitment to anarchism developed as he matured. There is no evidence that he was a dedicated anarchist in the mid-sixties. The letters of his confidant, Piette, indicate a growing radicalism rather than a specific commitment to anarchism, which was an inchoate and isolated movement at the time. But Pissarro's letters to Lucien indicate that the seeds of his anarchism were probably planted in this early period. Throughout his life, he was guided by Proudhon's basic theme—distrust of centralized authority. "Authority, government, power, the State," Proudhon wrote, "all denote the same thing—each one has within it the means of oppressing and exploiting his fellow men."

Twenty-five years later, Camille urged Lucien to read Proudhon: "His book *La Justice dans la Revolution* must be read from beginning to end . . . it is amazing how contemporary this book on *Justice* is. Every young man ought to read it."

Both external and internal circumstances seem to have propelled Pissarro toward radicalism. His compassionate feeling for the less fortunate, his pleasure in cooperative endeavor, his responsiveness to new ideas—all could have turned him into a radical of some sort, not necessarily an anarchist. His Jewish background may have bred an insecurity that found outlet in social protest. He mistrusted all authority, especially that of the state, but he was basically an optimist, with faith in the future, convinced, as he later expressed it, that "the movement of ideas in present society tends with extraordinary energy toward the elaboration of new philosophical and scientific systems destined to become law in the societies of the future."

In 1864 and 1865, Pissarro continued to work with his friends. Accompanied by Monet, he probably went to the Fontainebleau forest to paint with Renoir and Sisley, who were staying in the little village of Marlotte. His shy friend, Cézanne, drew closer, writing him in March of 1865, "If you should wish to see me at any time I go every morning to *Suisse* and am at home in the evenings, but give me a rendezvous that suits you and I shall come and say how do you do when I return from Oller's." Cézanne reported that he and Oller were bringing their paintings to the Salon, and added characteristically that they would "make the Institute turn red with rage and despair." He had no illusions about his chances there. His agitated, violent figure studies and his use of the palette knife to apply pigment in slabs thick as plaster on his canvases outraged those members of the jury who did not laugh. His paintings provoked the vehement reaction he expected—rejection despite Daubigny's defense of him. Oller did succeed in having one painting accepted.

These were transitional years for Pissarro. His father had fallen ill in 1864, and died on January 28, 1865. Frédéric's suffering and death were distressing to his son. For all their differences over Camille's relationship with Julie and his approach to painting, his father had backed him at the crucial moments and had made the launching of his career possible. In his will Frédéric left a bequest to the synagogue in St. Thomas and an equal amount to the Protestant church there, possibly in resentment of the synagogue's objection to his marriage to Rachel, possibly because Charlotte Amalie had been remarkably ecumenical.

Pissarro sent the news of his father's death to Eugène Petit in St. Thomas, in grave, formal words that showed his deep feeling for his father and for the religious tradition of his family.

I have the painful duty of announcing to you the death of my poor father the 28th of this month at 4:30 in the afternoon after a prolonged agony of ten months. God is good, He has taken from us that which was most dear in the world, we must bow our heads and believe in His providence.

We would have wished, egoists that we are, to keep him for a longer time in spite of his sufferings—to see him, to cherish him, to care for him. But this was not bearable for him; that broke our hearts. Later, with an astonishing strength and will, he was able to master his pain and remained calm and strong, with all his mental clarity, until his last breath. My mother is in despair; Emma and all of us are plunged into sadness.

Pissarro asked Petit to write to Rachel and set her mind at rest about the care of the property in St. Thomas. Petit did so, assuring the family that he would continue to look after the property and administer the income from it for Rachel, now seventy years old. Pissarro's financial pressures had increased with the birth of his second child, and Rachel agreed to help him when she could, but it was limited and uncertain aid.

Their father's death left Camille and Alfred with the responsibility for their mother, complicated for Camille by his commitment to art and by Rachel's continued refusal to speak to Julie. Her tendency to dramatize her complaints must have tested his devotion; she always hoped that his ties would be stronger to her than to Julie.

"I asked you to come because I need to see you," Rachel wrote him at one time. "Unfortunately you write me that you have a sick family on your hands. You must be upset and tired out. I fear that you will fall sick in turn with so much fatigue in addition to the annoyances that you must feel from not being able to do as you would like."

And then the familiar lamentation:

"You are never near me when I need consolation and advice from you; I may never be able to have it."

Although Camille was accustomed to her mixture of concern and reproach, his loyalties were stronger to the demands of his art and to Julie and his children; but his dependency upon his mother continued. He stored some of his paintings at her apartment and often stayed there on his visits to Paris, a convenience for him and a welcome change for her.

After Frédéric died, Rachel fell ill and for several months needed care. Camille called Dr. Paul Gachet, a homeopathic physician, whose successful treatment of Rachel resulted in her lifelong devotion to him and Pissarro's lifelong devotion to homeopathic medicine, the treatment of disease by small doses of herbal remedies which when given to healthy persons produce symptoms of the same disease.

In the summer of 1865, Rachel moved from Passy to an apartment on the Boulevard des Martyrs. Emma Isaacson, who had meanwhile settled in London in a "very large house on the banks of the Thames," wrote to Pissarro inquiring about their mother: "Tell me if you go to dine with her and if you sleep there sometimes or if it is Alfred who stays with her, and if she has a good servant. I am worried about her because she doesn't know how to make herself happy."

Cézanne had sent condolences to Pissarro on his father's death. Having spent most of 1865 in Paris, he was in the habit of attending the Thursday night dinners given by his childhood friend Emile Zola. He began to take along Pissarro and Guillemet to visit Zola, who lived with his mother and his mistress in a large flat near the Luxembourg

Gardens. He had recently published a novel, *The Confessions of Claude*, was grinding out serials for periodicals, writing book reviews for *L'Evénement* and looking forward to reviewing the Salon of 1866 for the same newspaper. Among Zola's boyhood friends from Aix who attended the dinners was Anthony Valabrègue, also a writer and friend of Cézanne.

A recurrent theme in their discussions was state control of the arts, Zola denouncing police censorship of literature and journalism and Cézanne in particular attacking the Salon system with broad jokes. The paintings he submitted in 1866, including a portrait of Valabrègue, were, as usual, rejected. Valabrègue wrote: "A philistine on the jury exclaimed on seeing my portrait that it was painted not only with a knife but with a pistol as well. Many discussions have broken out. Daubigny defended my portrait. He declared that he preferred pictures full of boldness to the nullities that appear in every Salon. He didn't succeed in convincing them." Daubigny also attempted, without success, to have a painting by Renoir admitted. He did succeed in getting one Pissarro accepted, a landscape called *Banks of the Marne in Winter**, a bleak, blunt picture, solidly and sparely constructed. The fields in the foreground on the right are a bright, almost solid green. Leading into the landscape from the left in a steep diagonal are the river and beside it a road lined with bare, spindly poplars whose regular spacing marks a steady recession into depth. A black-clad woman with a tiny child walks down the road, her small figure seeming to diminish as the trees do under a pale-gray blustery sky. A hill and the white windowless side of a farm building abruptly stop the eye. There is nothing here of the dreaming, delicate Corot.

At the Salon of 1866, Pissarro was listed as the pupil of "M. A. Melbye," no longer as the pupil of Corot, who, Pissarro recalled, had spoken "severely" to him, probably feeling that Camille had moved away from him in style and too much toward the bolder color and stronger tonal contrasts of Daubigny and Manet.

For the first time, Pissarro was reviewed by the critics. Emile Zola, making his initial venture into art criticism and already friendly to Pissarro, wrote in *L'Evénement:*

> M. Pissarro is an unknown and probably no one will talk about him. . . . Thank you, Monsieur, your winter landscape refreshed me for a good half hour, during my trip through the great desert of the Salon. I know that you were admitted only with great difficulty and I congratulate you on that. Besides which, you ought to know that you please nobody and that your painting is thought to be too bare, too black. So why the devil do you have the arrant awkwardness to paint solidly and study nature so honestly!
>
> Look, you choose wintertime, you have there a simple bit of a road, then a hillside in the background and open fields to the horizon. Not the least delectation for the eye. A grave and austere kind of painting, an extreme care for truth and rightness, an iron will. You are a clumsy blunderer, sir—you are an artist that I like.

Pissarro also received praise from the critic of *L'Univers Illustré*, Jean Rousseau:

> Surely there is nothing more vulgar than this view and nevertheless I challenge you to pass by without noticing it. It becomes original by the abrupt energy of execution which underlines these uglinesses, instead of seeking to conceal them. One sees that M. Pissarro is not banal by inability to be picturesque. On the contrary, he employs a robust and exuberant talent to reveal the vulgarities of the contemporary world. . . .

* *Color plate on page 65.*

Pissarro was elated by this first critical approval, but there is no evidence that it helped with buyers. The public, in general, did not want "austere, bare, vulgar" paintings on the walls of their homes.

In the Salon catalogue, Pissarro listed an address in Pontoise for the first time. He and Julie and the two children had now left La Varenne-Saint-Maur and had rented a house on rue du Fond-de-l'Hermitage. This section of Pontoise, known as the Hermitage, was especially appealing to Pissarro. Steep hills rose from the river, capped by a half-hidden chateau set back from a curving road. During the next sixteen years, Pissarro returned to this area again and again to paint its small orchards and back gardens, "the wood of old palings, the modest houses built of soft stone called *moellon*, diapered with black smoke and with white by the droppings of pigeons, tinged with green by lichen, the linen hung out to dry by homely women in faded blue cotton gowns." The place gave him enormous pleasure and stimulation, and he preserved the particular look of the people and places of Pontoise in some of his most beautiful paintings.

The area around it was appealing to landscape painters; in 1860, Daubigny had built a home in near-by Auvers, with the help of Corot; in 1863, Berthe Morisot summered in the Hermitage section. Only about an hour and a half northwest of Paris by train, it was a world apart, bucolic and simple, and remarkably varied in terrain and motifs. Small farms and orchards dotted the steep hillsides, peasants labored in the fields and

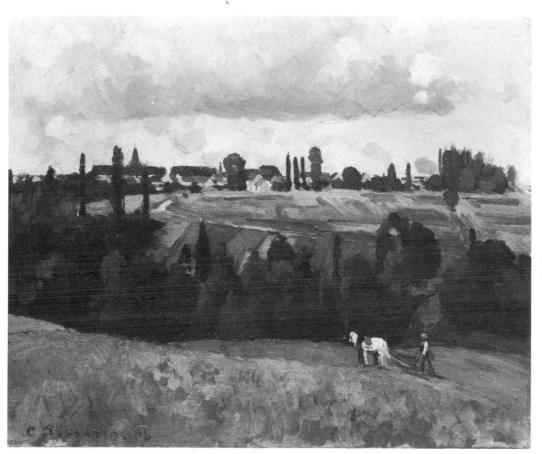

Landscape at Ennery, near Pontoise, 1868. (67) 15 × 18¼. 38 × 46. Kunsthalle, Bremen

orchards. Barges bound north to Belgium or south to Paris plied the Oise, on whose shores laundresses scrubbed and fishermen beached their boats. From time to time they might have seen a flat boat drift by, with Daubigny in the cabin of his floating studio, painting his impressions of life on the river and its banks. In the river Oise, facing the Hermitage, was the Isle du Pothuis, where the tall chimneys of a distillery and a starch factory stood out against the sky. Parallel to the river, horses and carts plodded along the road to Auvers, six kilometers away.

Pontoise, famous for its cabbages, was the major market center for the whole area of the Vexin. As in Caracas, the bustling crowd provided another fascinating subject for Pissarro. On weekdays, the town was busy with shopping and trading activities; on Sundays, families promenaded in the public garden and along the river bank in their best clothes.

Over the next three years, the Pissarros lived in Pontoise, whence Camille could travel back and forth to Paris from time to time. They were productive, exciting years,

Still Life, 1867. (50) 31⅞ × 39¼. 81 × 100. Toledo Museum of Art, gift of Edward Drummond Libbey

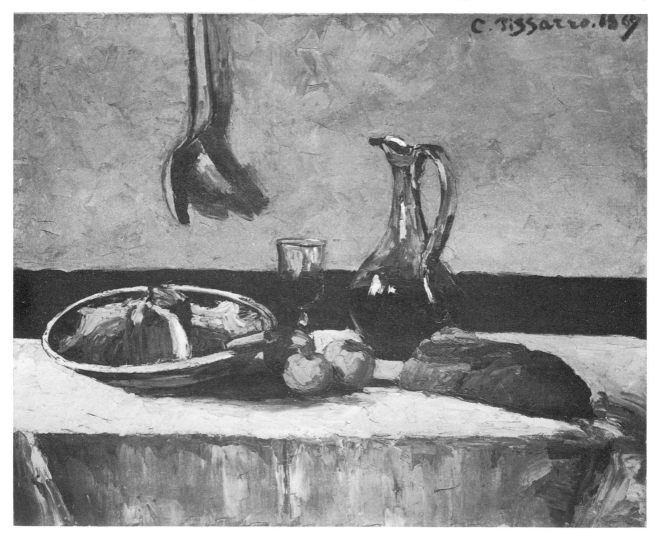

but in 1867, in spite of the praise he had received at the previous Salon, his paintings were rejected. Zola's praise was of no help, for his criticism of the jury had infuriated them. Monet, Renoir, Sisley, Bazille and, of course, Cézanne were also refused.

The jury was especially intent on eliminating disturbing influences that year, refusing two-thirds of the works submitted. To bolster his fading international prestige, the Emperor staged another resplendent World's Fair in Paris in 1867. Military bands played in the Gardens of the Tuileries; people danced in the parks; balls and receptions filled the social calendar. The Princess de Metternich called the occasion the "Grand Tra-la-la." The academic art establishment wanted to put its best foot forward at the Salon for the many visitors the Fair attracted—a foot which could not wear the shapeless, plebian boot of the rebel painters.

By-passing the Salon, Courbet and Manet built their own pavilions at the World's Fair, and when it was over, Courbet's decision to maintain and rent his pavilion gave the group of "rejects" an opportunity. Pissarro, Sisley, Renoir and Bazille had signed an unsuccessful petition for a new Salon des Refusés, and now, seeing the chance to organize their own exhibition, together with Monet, Manet, Guillaumin, Guillemet, Berthe Morisot, Fantin-Latour and possibly Degas, they banded together to raise money, encouraged by promises of participation from Courbet, Corot and Daubigny. They gathered only 2,500 francs, not enough to meet the expenses of such a show, but the concept of group action had been born: the idea of a joint exhibition free of a hostile jury's restrictions was exhilarating. Though their individual approaches to painting differed, they were united in rejecting the standards of officialdom, what Zola had called an "art with its face washed, its hair carefully combed; like a worthy bourgeois in a clean white shirt." Nevertheless, the Salon was still their only opportunity to exhibit.

In spite of his setbacks, 1867 was a year of extraordinary progress for Pissarro. Whether stung by rejection or spurred by determination, he completed five large, Salon-size landscapes of the Hermitage section of Pontoise, from spring through autumn. When forced inside by bad weather, he painted a large still life almost entirely with a palette knife, its heavy impasto and bold execution showing the effects of his interaction with Cézanne as well as the influence of Courbet.

When Pissarro's half-sister, Emma Isaacson, died in January 1868, he went to London for her funeral and stayed for over a month, writing to Alfred to intercede with Rachel for a monthly allowance for Julie. The judicious, helpful Alfred agreed but suggested that it would be better to wait a little; Rachel had only begun to recover from the death of her daughter. Whether Rachel acceded to his request is unknown. Though she acknowledged the grandchildren, to her Julie did not exist. At thirty-seven, Camille was still dependent on his mother. Rachel must have often made this a bitter pill to swallow.

At the Salon of 1868, his hard and inspired work bore fruit: two of the large landscapes of Pontoise, *The Côte du Jallais near Pontoise* and *The Hills of the Hermitage,* were accepted, as Daubigny informed him in a note. The Salon was far less restrictive than in the previous year, and M. de Nieuwerkerke was blaming it on Daubigny, who had used his influence to have the young painters admitted. Castagnary was delighted:

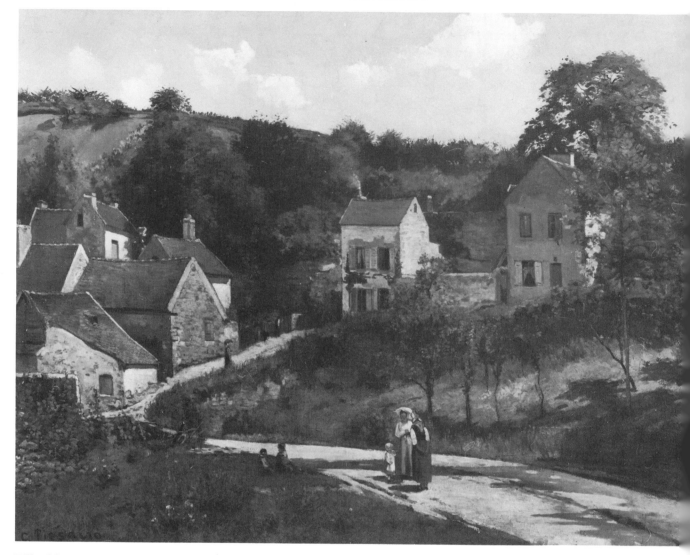

Hills of the Hermitage, c. 1867. (58) 59½ × 78¾. 150 × 200. Solomon R. Guggenheim Museum, New York, Thannhauser collec

If the Salon of this year is what it is, a Salon of newcomers; if the doors have been opened to almost everyone who asked to be admitted; if it contains 1,378 more works than last year's Salon; if in this overflow of free painting, official State painting has made a rather poor showing; it is all Daubigny's fault. . . . I do not know if Daubigny has done everything that M. de Nieuwerkerke has attributed to him. I would gladly believe it, for M. Daubigny is not only a great artist, but a decent man as well, one who remembers the hardships of his own youth and would wish to spare others the severe trials to which he himself submitted.

Though Pissarro, Manet, Monet, Degas, Renoir and Bazille were accepted,

Cézanne was rejected yet again. The jury's generosity had other limits, too: Pissarro's paintings were hung near the ceiling. "They are placed too high . . ." Castagnary complained, "but not high enough to prevent art lovers from observing the solid qualities that distinguish him."

The two large landscapes are now in New York museums, *The Côte du Jallais near Pontoise** at the Metropolitan Museum of Art and *The Hills of the Hermitage* at the Guggenheim Museum. In both, a road curves into the painting and houses nestle against the summer hillside under a lazy, late-afternoon sun. Small figures of women stroll serenely or cluster companionably, talking, and children play quietly near by. White clouds drift over green fertile fields and tidy gardens in these pictures of the rural life of Pontoise that exude tranquil stability. Time moves slowly there, for little change occurs, and people occupy themselves with simple things every day. Pissarro loved this life centered around the continuity of family and land. His past had been one of constant travel and change, both geographical and psychological; these landscapes fuse his wish for peace with the actuality of life in Pontoise. The emotional tone of the two paintings is similar, but the technique of *The Côte du Jallais near Pontoise* is more innovative. Seen close up, the brushstrokes are broad and patchy in the foreground; each of the fields on the distant hillside is a long, thick stroke of a single flat color: green, brown, tan, rust. When viewed from a few steps back, the visible strokes and marks disappear because of the "perfect pitch" of the tones and colors, and the illusion of a sunstruck landscape coalesces. A complexity of forms—houses, gardens, trees, fences—are controlled within the strong, simple shapes of the total composition.

He received more critical praise than any other painter of his group that year. Castagnary, Astruc, Zola, Jean Ravenal, and the painter Odilon Redon, temporarily turned critic, all gave his work favorable notices.

"Never have pictures seemed to me of a more authoritative dignity," wrote Zola. "Camille Pissarro is one of the three or four painters of our time. He has solidity and breadth of execution, he paints generously, following the traditions, like the masters. Only rarely have I encountered a more profound science. A beautiful picture by this artist is the act of an honest man. I cannot better define his talent."

Redon perceived his special qualities:

> Several years ago we noticed this intense and austere personality, who reminded us somewhat of the picturesque roughness of the Spaniards. *L'Hermitage* and *La Côte du Jallais* are things strongly seen, and they do not lack character. The color is somewhat muted, but it is simple, large, and well felt. What a singular talent, which seems to brutalize nature! He treats it with a technique which, in appearance, is very rudimentary, but this denotes, above all, honesty. M. Pissarro sees things simply: as a colorist, he makes sacrifices that allow him to express more vividly the general impression, and this impression is always strong because it is simple. We are certain that public opinion will soon pronounce itself in favor of this authentic personality who, for a long time, has pursued his aim with an impassive conviction and all the marks of what is called "temperament."

The high praise and predictions of success capped his most productive period thus far. He no longer listed himself as a "pupil" of either Corot or Melbye, but simply as "né à St. Thomas."

* *Color plate on page 66.*

7.

Pissarro and the Birth of Impressionism

*"I did not have the slightest idea . . . of the
profound aspect of the movement which we
pursued instinctively. It was in the air."*
—Pissarro to Lucien, 1895

IN 1869, Pissarro moved to the middle-class suburb of Louveciennes, south of Paris
on the road to Versailles, within easy reach of the city by train. Monet was near by at St.
Michel, Renoir in Voisins, a hamlet of Louveciennes. The three artists went to Paris
regularly to join the "Batignolles group," as they were known then, that met Thursday
evenings at the Café Guerbois. Manet had been going there for years, his friends began
to meet him there, gradually the circle expanded, and other painters and writers joined
them intermittently.

Manet and company always reserved two tables at the left of the entrance of the café,
which was furnished in Empire style, with gilded mirrors and marble-topped tables.
Since Auguste Guerbois, a man of commanding presence and strong personality, had
grown up in La Roche-Guyon and knew the Seine intimately, the artists often
consulted him about painting sites.

Manet, Degas, Bazille, Guillemet and Fantin-Latour were at the café most often;
Pissarro, Monet, Renoir and Cézanne came when they were in the city. Zola often
attended the Thursday night sessions, as did the critics Duret, Duranty, Armand
Silvestre, Philippe Burty and Zacharie Astruc; the fascinating engraver and writer
Marcellin Desboutin, probably the most brilliant conversationalist of them all; the
novelist Léon Claudel; Dr. Paul Gachet, Rachel's physician and friend of artists; the
photographer Félix Nadar, and others.

"Nothing could have been more interesting," Monet recalled, "than these *causeries*
with their perpetual clash of opinions. You kept your spirits going there, you got
encouragement there in disinterested and sincere research, you got in a supply of
enthusiasm which for weeks and weeks sustained you until you put the idea into
definite form. From there we emerged with a firmer will, our thoughts clearer and
more distinct."

The discussions were intense: the stupidities of the Salon, the new art of photogra-
phy, the pleasures of Japanese prints and objects, the oppressiveness of the au-
thorities. Although in recent years the artists had all been accepted by the Salon more
often than not, they could show at most two paintings in one year and the jury had
rejected what they considered their best work, and they were united by their
resentment of the official jury system.

Manet's stylistic innovations and his attempt to defy the Salon by holding his own

Manet.
Photograph Durand-Ruel, Paris

Manet: *Paris Café*, 1869. Pen and ink. Fogg Museum of Art,
Cambridge, Mass., Paul J. Sachs collection

exhibition in 1867 made him the natural leader of the group. Silvestre has left us a vivid portrait of the elegant and acidulous Manet:

> This revolutionary—the word is not too strong—had the manner of an accomplished gentleman. With trousers intentionally gaudy, short jacket, flat-brimmed hat perched on the back of his head, always irreproachably gloved in lemon-yellow suede, Manet had nothing of the bohemian and was bohemian in nothing. His style was that of a dandy. Light-haired with a sparse and thin beard which tapered to a double point, he had in the extraordinary vivacity of his eyes—pale gray eyes, small and very star-like—in the expression of his mocking mouth—a mouth with thin lips and irregular teeth—a strong dose of Parisian mischievousness. Basically generous and kind, he was intentionally ironic in his conversation and often cruel. His remarks were sarcastic, cutting and slashing with one blow. But how striking his expressions and often how just his ideas!

The other dominant personality was Degas, a man of delicate refinement, slender, with a high forehead, dark, liquid, southern eyes, and a sensitive mouth. He was always bantering, confounding others in the discussions by changing the subject abruptly, introducing tangential ideas, and then leaving before the argument was ended. Degas's acerbity was even more pronounced than Manet's, his talent for the *mot injuste* even more developed. Some of his quips through the years are memorable, if hardly accurate. Of Berthe Morisot, "She paints as if she were making hats." Of Gustave Moreau, "He is a hermit who knows all the train schedules." Of Emile

Bernard, "He is a man who tries to dance with leaden shoes." When Whistler came one night dressed in a bohemian costume, Degas's greeting was, "You behave as if you have no talent." But Degas was capable of kindly acts. He took an interest in younger artists, and the veneer was only a form of protective coloration used to clothe his insecurity and his touchy impatience with anyone or anything that interfered with his painting.

Manet and Degas shared a common background and education, their upper-middle-class elegance and Parisian sophistication setting them apart from Monet, Renoir and Pissarro.

In background, politics and personality, there could hardly be more contrast than that between Degas and the gentle Jew from St. Thomas. Yet despite the differences that separated them, Pissarro and Degas began to develop in the late sixties and early seventies a relationship of mutual respect. Just as the distrustful Cézanne was drawn to Pissarro, so was the aloof, seemingly arrogant Degas. When he went to New Orleans, he sent greetings to Pissarro, and in 1872 bought a painting of his.

A frequent topic of discussion was *plein-air* painting, with Pissarro and Monet the most ardent advocates of its advantages. Not everyone agreed with its desirability. Degas was a studio man. "Gendarmes should shoot down those rows of easels which clutter up the countryside," he once remarked, but modified it to say that an occasional dose of birdshot would do. Whistler, too, rejected outdoor painting. He had tried it a few years before, but felt, as he wrote Fantin-Latour, "These pictures, painted . . . in *plein-air*, cannot be anything else than large sketches; a bit of floating drapery, a wave, a cloud; one sees it for a moment, then it disappears—the true tone has to be caught in flight just as one shoots a flying bird. But the public demands a finished product."

Renoir, instinctively wary of theorizing or generalities, recalled: "They held against Corot his reworking his landscapes in the studio. They found Ingres revolting. I used to let them talk. I thought Corot was right . . ."

Pissarro, Renoir and Monet tested the methods of *plein-air* painting along the Seine in 1869. The boating resort of La Grenouillère, now remembered as the "birthplace" of Impressionism, was about two miles from Louveciennes. There, Monet and Renoir both painted the quivering reflections of the water with dots and commas of color and large, visible brushstrokes. The swift, flickering brushwork caught the fleeting moment, the movement of holiday crowds. With vibrant color and sensuous brush they seemed to exult in the gay, carefree scene, the sparkle of water, the texture of clothing and overhanging foliage, the solidity of rowboats, all shimmering in brilliant light.

In paintings like *The Côte du Jallais near Pontoise*, Pissarro had used thick, juicy slabs of unmodulated greens and browns to represent distant fields. This way of painting, with large strokes of single colors juxtaposed, led naturally to his work along the Seine at Marly, Bougival and La Grenouillère with Monet and Renoir in 1869. A tragedy of Pissarro's career is that his place as one of the founders of Impressionism has been obscured by the destruction of almost all of his paintings of that year. Although the critic Armand Silvestre, writing about the first Impressionist exhibition, referred to Pissarro as "basically the inventor of this painting," his comments have often been published without that key phrase. Cézanne, in his recollections more than thirty years later, called Pissarro "the first Impressionist." Whether or not he was the "inventor" or

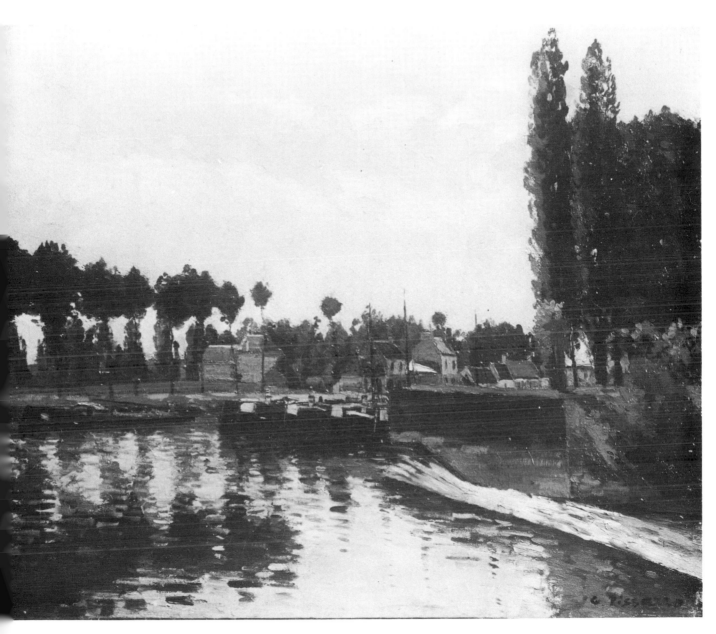

The Locks at Pontoise, c. 1869-70. (70) 23⅝ × 28¾. 60 × 73. Photo courtesy M. Knoedler & Co., Inc., New York

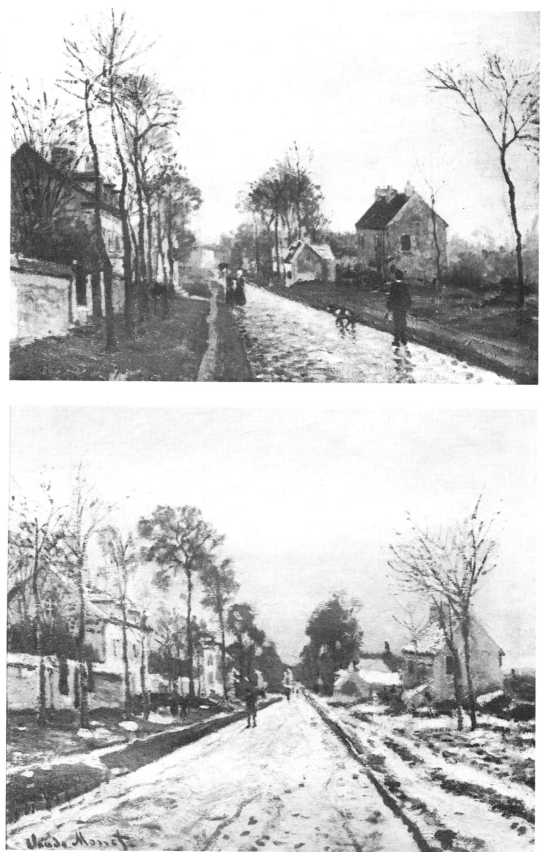

The Road to Versailles at Louveciennes—Rain Effect, 1870. (76) 15¾ × 22. 40 × 56. Sterling and Francine Clark Art Institute, Williamstown, Mass.

Monet: *The Road to Versailles at Louveciennes—Snow Effect,* 1870. Private collection, Chicago

the "first," the few paintings that have survived from this period show that his stroke had become unmistakably "Impressionist" by this time.

One of his paintings, *Banks of the Seine at Bougival*, assigned a date of "about" 1869 in the catalogue of his work, also captures the play of light on water with thick, broken brushstrokes, but the water and the houses are substantial, in contrast with Monet's and Renoir's images, where form dissolves in the experience of light. And Pissarro also painted La Grenouillère. A canvas wrongly listed in the catalogue as *The Oise at Pontoise* and assigned a date of "about" 1872 is actually a painting of La Grenouillère—a contemporary photograph confirms this—viewed from a spot across the river from where Monet and Renoir stood; its correct date therefore is more likely 1869, when Pissarro was in that area. While Monet and Renoir revelled in the holiday atmosphere, Pissarro's more distant viewpoint enabled him to contrast La Grenouillère with a factory across the river—an act characteristic of him in setting leisure on equal terms with labor. Probably on a visit to Pontoise in 1869, Pissarro painted *The Locks at Pontoise*, another canvas of shimmering reflections in the water and a subject he had not touched during his earlier stay there.

All of the group had experimented with colors of shadows and reflected light on

The Chalet, the Pink House, 1870. (82) 18⅜ × 21⅝. 46 × 55. Musée du Louvre (Jeu de Paume)

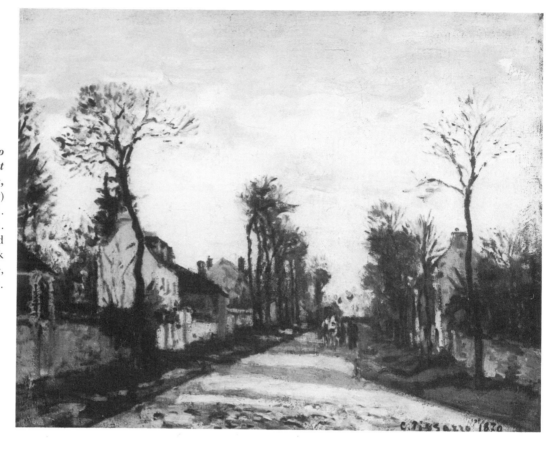

The Road to Versailles at Louveciennes, 1870. (77) 12⅞ × 16¼. 33 × 41. Sterling and Francine Clark Art Institute, Williamstown, Mass.

objects. Now they were meeting the challenge of the play of reflected light on the constantly changing surface of water. To capture that light, eye and hand must work together rapidly, unhesitatingly. Their discoveries were made without their being wholly aware of them. Camille wrote to Lucien: "I remember that although I was full of ardor, I did not have the slightest idea, even at the age of forty, of the profound aspect of the movement which we pursued instinctively. It was in the air."

He and Monet continued to paint together during the winter of 1869-70. Once they set up their easels at almost the same spot to paint the road to Versailles which passed in front of Pissarro's house, at number 22. Monet's roadway plunges dramatically into the distance; Pissarro's flows away gently, and he is more interested than Monet in the local people who use the road for their everyday business. Neither picture gives a hint of the difficulties of painting on a bone-chilling day when cold rain or snow and numbed fingers must eventually have forced the artists to retreat to finish their work in the studio.

The year 1870 was extraordinarily fruitful for Pissarro. He shared with his friends the elation of reaching a peak of discovery, of being with them like "mountaineers roped together at the waist." He averaged at least a painting a week, possibly more, since some may have been destroyed. Smaller than the Pontoise canvases, they are painted

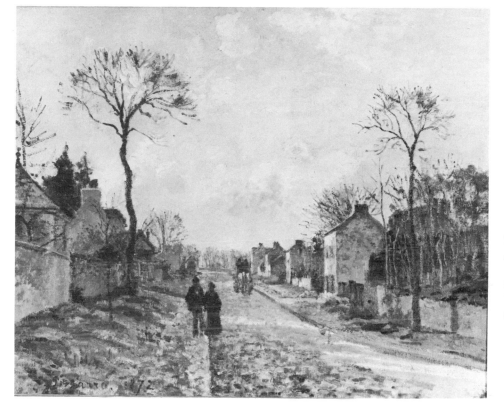

The Louveciennes Road, 1872. (138)
23⅝ × 29.
60 × 73.5.
Musée du Louvre
(Jeu de Paume)

rapidly, on the spot, integrating fugitive effects of light and atmosphere into the firm composition. He painted familiar scenes around Louveciennes: local residents strolling along the peaceful, tree-lined roads in all seasons and weather. The roadway seen in perspective fascinated him, as it had Corot, as a device for composition of the picture and a surface for reflecting the nuances of light and shade.

Pissarro's loyalty to the ideals of *plein-air* painting did not prevent him from altering nature when it suited the needs of his picture. Two views of *The Road to Versailles at Louveciennes* (from Clark Institute and Jeu de Paume) are seen from almost the same spot; the two tall trees and the angled wall on the right appear in both pictures. The point of view has shifted slightly to the left in the Jeu de Paume painting; but of greater interest is the absence of the two rows of trees bordering the road. Pissarro has eliminated these trees—which appear prominently in the other view—apparently to enhance the effect of cool evening light on the facades of the houses along the right side of the road and to give greater clarity and spaciousness to his picture. This example provides interesting proof of Pissarro's method in some instances: taking the broad outlines and effects of light and atmosphere from nature and then harmonizing, eliminating detail, rearranging and integrating the natural forms into his compositional idea as he reworked the painting in his studio.

Often he painted the people on the road broadly; he wanted to indicate their

movements and relationships rather than details of features or clothing. But he painted his buildings with clear outlines, unlike Monet, who inclined to render the mass effect rather than the detail. His palette was becoming lighter and his tonal relationships extremely subtle. His strokes became shorter but were not yet as free, open and broken as they were to become in the seventies. One of his aims was to strike a balance between the movement of light and the static solidity of the architecture. In the *Coach at Louveciennes**, he successfully combines structural firmness with evanescent patterns of light and shadow. The wet surface of the road is painted with touches of pink and green gleaming through predominant grays and browns. A solid house, its walls reflecting the interplay of light and shadow, is set off by fragile trees. An air of faint, inevitable melancholy pervades this late-fall scene of a muddy road at dusk on a rainy day.

Approaching forty, Pissarro was still dependent for survival upon Rachel's 100-franc handouts, supplemented by occasional sales, which were often not enough to enable him to support his family and buy paints, brushes and canvas. In 1868, he had reluctantly taken a job painting landscapes on canvas window blinds, working alongside Guillaumin, who immortalized this venture in a portrait of the bearded Pissarro in wide-brimmed hat and work clothes, brush in hand, applying a design to the blinds. By the end of the decade, he began to sell to collectors and dealers. The singer Jean-Baptiste Faure, one of his earliest, most discerning and consistent collectors, purchased Pissarro's large Salon painting *The Hills of the Hermitage* and his *The Locks at Pontoise*, and over the years he continued to add Pissarros to his collection, as did the banker Gustave Arosa. In addition, a friend from the *Académie Suisse*, Lecreux, sold some of his West Indies paintings in Lille, near the Belgian border, where Pissarro

* *Color plate on page 99.*

Guillaumin: ***Pissarro Painting Blinds,***
c. 1868. Musée Municipal, Limoges

Piette: ***Pissarro at His Easel,*** c. 1870. Gouache.
Photo courtesy André Bonin

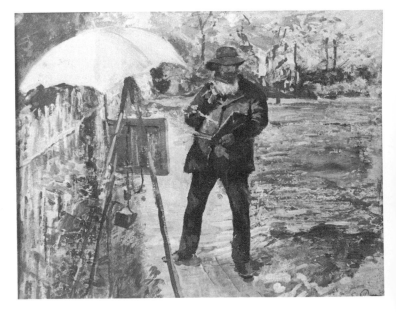

visited him in 1869. At about this time Pissarro also acquired his first dealer, P. F. "Père" Martin, a shrewd entrepreneur who had been one of the first to sell Corot's work and for a long time was the only dealer to handle Jongkind. The prices he paid to Pissarro were very modest—from 20 to 40 francs, according to the size of the canvas. Père Martin hoped to double the price when he sold them, but often settled for less. For Cézanne he asked even less; for Monet, a bit more. Miniscule as the payments were, they were important to Pissarro in the late sixties and early seventies, and he managed to scrape by.

Piette had the ideal solution: "Comes the good revolution, each bourgeois will be forced in perpetuity to buy at least two paintings per year from artists."

Monet and Renoir also had patrons of a sort but so inconstant that they faced recurring crises. In the summer of 1869, Monet was at the point of despair. When he failed to receive prompt response to a request to Bazille for money to buy paints, he wrote again, "Dear friend, do you want to know in what situation I am, and how I live, during the week I have waited for your letter? Well, ask Renoir who brings us bread from his mother's house so that we don't die of hunger. For a week, no bread, no wine, no fire for cooking, no light. It's terrible." Renoir managed to survive by living with his parents, but from time to time both he and Monet suffered the frustration of being unable to paint for lack of money to buy canvas or pigment.

In the late spring of 1870, Monet left for Trouville and the sea with Camille Doncieux and their son, Jean. They had formed a close personal relationship with the Pissarros. When Jean was baptized, Julie was chosen as his godmother (and Frédéric Bazille as godfather). On the way, the couple stopped to be married at the home of her parents in the Batignolles section of Paris. To prevent his creditors from seizing them, Monet left a number of paintings for safekeeping with Pissarro.

Armand Silvestre remembered that as the Salon of 1870 approached, discussions at the Guerbois grew feverish. The slate presented in the balloting for the jury included Millet, Daumier, Manet and several others, as well as Daubigny and Corot. The results, announced on March 24, were disheartening. Only Daubigny and Corot were elected. Although they received the highest number of votes in the election, their authority was diminished by their association with the dissident painters.

The jury was generous to all the Batignolles except Monet, rejected as a slap at Daubigny, who had sponsored him. Daubigny resigned in protest, as did Corot out of sympathy with Daubigny.

Two of Pissarro's paintings were accepted, *Autumn* and *Landscape*, both since lost or not identified. He gave his Louveciennes address and that of the dealer Père Martin, at 52 rue Lafitte, Paris. Duret hailed the paintings:

> . . . a great step forward . . . if Pissarro is a realist in his determination to reproduce exactly the scene before him, he is not a thoroughgoing realist in the sense that certain other painters are, who see no more than the externals of nature, without fathoming its soul and its innermost meaning. On the contrary, he stamps his every canvas with a feeling for life, and as we gaze at even the most ordinary scene painted by him, a highway lined with elms or a house nestling beneath leafy trees, we feel a sense of melancholy stealing over us, the same he must have felt himself as he stood before the scene.

8.

At Forty, the Urge to Enlist

"I beg of you, don't go fight. If a misfortune should strike you, what could I do?"
—Rachel Pissarro to Camille, 1870

WITH the approach of summer, as tensions rose between Prussia and France over succession to the Spanish throne, disturbing talk of war began to be heard in Paris. The drift toward war became rapid slide. On July 19, 1870, while the center and right cried "à Berlin!" Napoléon III, doubtful and ailing, was swept into war by an inept cabinet. The cries for victory quickly turned to despair. Within six weeks, Napoléon surrendered at Sudan, the Prussian troops raced on toward Paris, and their artillery was soon heard near Louveciennes. Forty years old and a Danish citizen, Pissarro had no desire to fight for a regime which he, like Monet and Cézanne, detested. He had little choice but to leave Louveciennes. One of the art magazines published this warning: "We think it is our duty to warn artists that it is dangerous at the present moment to make any drawings, sketches, or studies after nature in any part of the territory of France. The local people fancy they see Prussian spies everywhere. One of our friends, a highly esteemed artist, narrowly escaped passing a bad quarter of an hour recently one day in a village in Normandy. Fortunately he was rescued by an innkeeper who knew him. But the danger is too great to be pleasant."

Julie was eight months pregnant. It was important to find a secure place for her, away from the turmoil around Paris.

On September 4, the Republic was once again proclaimed, but the Prussian advance was so swift that there was no time to celebrate or even to pack. The Pissarros fled to Piette's farm in Brittany, leaving behind most of their belongings, hundreds of his paintings and those Monet had left with him for safekeeping. "It is unfortunate that you did not move your furniture from Louveciennes to Paris as very many people did who live in the country," Rachel later reproached him, with a mother's hindsight.

Penniless and exhausted, Camille, Julie and the two children arrived at the spacious, many-chimneyed stone house at Montfoucault. The waiting Piette was delighted. His ailing wife now had the companionship of Julie; he had the company of his closest friend; and the home of the childless Piettes was now filled with the sounds of children. He had a special affection for Minette, a beguiling child whom her father delighted to sketch and paint.

Short of help in the orchard, Piette enlisted Pissarro's aid in harvesting the crops of grapes, pears, apples and chestnuts. They worked side by side, talking incessantly of art and of the war. Piette, who had been fiercely against Napoléon, now turned all his

86

romantic passion against the Prussians, only a hundred miles away, claiming that he thirsted to fight, to defend the new Republic. He excoriated the troops who surrendered or retreated and fought the war daily by news bulletin. Pissarro, equally involved but more philosophic, teased his friend and lightened the household with his jokes.

The traditional picture of Camille Pissarro as a gentle pacifist is contradicted, however, by the revelation that, at forty, he too actually wanted to fight for the Republic. He was not at Montfoucault long when the military and political situation changed drastically, creating an equally marked shift in his attitude toward the war. When the encirclement of Paris was completed on September 19, the Republic was jeopardized and Pissarro felt a deep loyalty to the new democratic regime: according to a letter from Rachel on September 30, he apparently itched to enlist in the defense of the Republic. "You know that I absolutely have need of you, so don't do anything imprudent," she wrote. "You are not French, so don't go exposing yourself needlessly."

Pissarro's desire to fight for the Republic was contrary to the conventional anarchist attitude. The orthodox anarchist position was proclaimed at that time by Bakunin in Lyon, where he founded a "committee for the saving of France," calling for "an elemental, mighty, passionately energetic, anarchistic, destructive, unrestrained uprising of the popular masses." But the Republic *did* mean the end of the Empire, and as an artist who had suffered from the values and the artistic restrictions of the Empire, Pissarro was probably eager to help protect a government that could stand for artistic freedom. One of the first acts of the Republic was to proclaim freedom of the press—publishing, printing and bookselling. His pro-Republic feeling must have been profound, for his desire to enlist was an impulsive one, and he was not an impulsive man.

Rachel had fled to St. Valery with her granddaughter Amelie Isaacson when the Prussians advanced on Paris. As soon as she heard from Camille, she sent him 100 francs. In her letters, Rachel often expressed her need for Camille's counsel and companionship and complained of his absence, but she was not always humorless. After lamenting the uncertainties caused by the war, she asked rhetorically, "What to do? My God!!!" then added an uncharacteristic wry dig at herself: "Jeremiads of grandmother. You're familiar with them, aren't you?"

In all her letters she makes no reference to Julie. For her, as for several members of the family, Julie hardly existed: in Amelie's letters to her uncle at this period she always sent her love to Lucien and Minette, never a word about Julie; to avoid contact with Julie, Alfred's new wife, Marie, would not visit Camille. Rachel's antagonism toward Julie reached a peak in early October, when Camille wrote to her asking permission to marry. Perhaps he felt that if Julie became his wife, the family's hostility would lessen, perhaps that the imminent birth of a third child would make an irregular relationship ridiculous; probably because of the uncertainties of life in wartime, he wanted to provide Julie with his inheritance rights if he were killed.

At first Rachel assented; but the next day, October 10, she begged him to return her letter granting permission.

As a mother, to make you happy, and without reflection I have answered yes. That caused me to be ill the night long and I have decided to write to say that this consent distresses me very much. I rely on you then and if you have some consideration for me you will send me back the letter because I had it written without sufficient thought for a matter of importance. . . . Wait until all these events are over, then you could go to London and there marry without my consent and without anyone knowing about it. I will supply you with the money for this trip, God willing. . . .

Your brother knows nothing of all this. I have not written to him on this subject. It is I alone who beg this because it would be very painful to me, in my old age, to be blamed by my children. By doing it as I say there will be no one to blame and I will be satisfied myself.

A sad letter for both of them—Rachel a prisoner of her prejudices, Camille at forty still a prisoner of poverty. He apparently returned the letter, as she had requested.

Adèle Emma Pissarro, named after Madame Piette, was born on October 21, 1870. Julie was evidently unable to nurse her, for five days later Rachel suggested that Camille hire a wet nurse for the baby for a month or two and then put her on a bottle. No mention of Julie. The next day she sent a layette and her third remittance of 100 francs while he was at Montfoucault.

The noose of war was tightening. Julie's sister in Paris, Félicie Estruc, sent by balloon an anxious letter asking whether the baby was born yet and reporting that horsemeat was the only fare available in Paris. The fall of Metz was a bitter setback for the Republic. In Tours, Gambetta was desperately trying to organize an army to lift the siege of Paris. Pissarro, on tenterhooks over the fate of the Republic to which he was now devoted, was again eager to fight; and again Rachel urged him not to be rash. "Put the Republic aside and think of your family," she admonished him on November 6, saying in the same letter that she was leaving for England, fearful of spending the winter at St. Valery, afraid of the possibility of civil war, and unsure of the postal delivery of rental fees from St. Thomas on which she was dependent. The Isaacsons had found a house for her in the suburb of Lower Norwood, a few miles south of the Thames. Alfred had left for England in October with his family. Again a plea to Camille to stay out of the war: "I beg you not to go off to fight. . . . Here I am without protection and obliged to undertake such a voyage as this one without one of my sons with me."

Pissarro's urge to rally to the defense of the Republic—it was doubtless his only military compulsion—was cut short by an unexpected tragedy. The baby girl caught an intestinal infection from the wet nurse, was ill for three days, and died on November 5.

His infant daughter dead and Julie ailing, Pissarro lost all will to fight. He could think only of joining his family in England. He wrote Rachel of the loss of their child and asked for money for the trip. Her brief comment on the death of Adèle was that of a world-weary, fatalistic old lady: "You announce to me the death of the little girl Adèle. I am very upset for you but then one must console oneself in thinking that the poor little one is out of this world where there are very few pleasures for very many sorrows." No word for Julie. She was unable to help him financially, she said; but a friend of Piette's offered a loan of 300 francs for the trip. Rachel urged him to accept and promised to repay the friend as soon as she could; but she had second thoughts the next day: he

could not make a living in England and she could not support him. Perhaps she dreaded a confrontation with Julie, or even the necessity to recognize her. She reiterated that she had told Alfred nothing of her "affaires" with Camille—and had apparently not even mentioned the birth and death of his child. (To this day, the family tree does not list Adèle Emma Pissarro.)

A week later, Rachel reversed herself again: his absence had made her ill; she wanted him to come; she would help find him an apartment. Pissarro's desperation was reflected in her reference to the children: "I promise you to do everything for them in case of need; but I hope that it will not come to this point."

In early December, Camille and Julie packed what few belongings they had at Montfoucault, conveyed Rachel's thanks to the Piettes, and with Lucien and Minette boarded the train to Dieppe. A little after midnight they sailed, and at 7:30 in the morning they arrived in England.

Rachel had found quarters for them in Lower Norwood. During the carriage trip from the railroad station to their new home, Pissarro found Norwood "charming." The small one- and two-story brick and stucco "villas" seemed snug and comfortable. The pastel walls of the houses were splashes of color against the brown of the unpaved, muddy streets and the bare hedges and trees. The carriage drew up before Canham's Dairy, Westover Hill, Lower Norwood, a temporary haven for the refugees until they moved a few months later to 2 Chatham Terrace, Palace Road, in Upper Norwood. Their house was not far from the Crystal Palace, scene of the great 1852 Exposition. Rachel shared a house with Alfred and his family, within walking distance, and now had the best of all possible arrangements—one of her sons living with her, one near by.

Separated from his friends, Camille probably saw more of his family during his London sojourn than when he was in France. With his mother, brother, nephews and nieces all close by, he was by no means the lonely painter in a strange land, as he has been frequently portrayed. He particularly enjoyed visiting the Isaacsons, for his affection for the children, especially his favorite niece, Esther, now thirteen, was deepening. They in turn loved their genial uncle, with his jokes, his gentle teasing, his empathy and concern for the affairs of the young. They could communicate more easily with him than with their father.

Julie was miserable in England. She could not speak the language, nor would she try. "This succession of curious noises could not be a language" was her scornful recollection. So she had no one to talk to—Camille's relatives were cool to her, she could not gossip with her neighbors or bargain at the market. When Camille took the children to visit their grandmother, she was left alone with her frustration and resentment.

With the family settled, however tentatively, Pissarro almost immediately set out to do what he had been accustomed to do in Louveciennes before the war's interruption—set up his easel on the road. According to his son Ludovic Rodo, Pissarro, like his children, caused a sensation among the local people with the wooden shoes he wore to protect his feet from the mud and snow.

He was stimulated by the change of scene. In *Lower Norwood, Effect of Snow*, his perspective is familiar—a road winding off into the distance, a few passers-by strolling

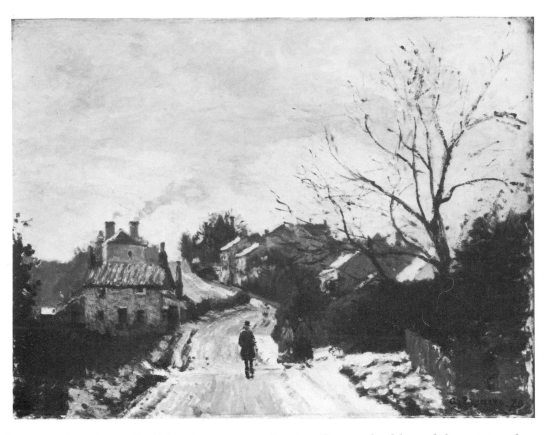

Lower Norwood,
Effect of Snow,
1870. (105)
31¾ × 18⅛.
35 × 46.
National Gallery,
London

homeward at the end of the day, snow reflecting the patchy blue of the winter sky, smoke curling from the chimneys of the warm, solid houses. It is a cheerful work, with gay colors among the browns, the palette light. Remarkably, in the short time he was there, he had succeeded in evoking a precise sense of time and place.

He had arrived in time for his first English Christmas. Throughout his life he often referred to the joys of that holiday season in England when he wrote to any of his sons who were living there. "Christmas will be coming soon," he later wrote Georges, "you are going to see one of the unusual holidays in England and especially very popular in London. The famous pudding which you are very fond of, it seems to me, is going to blaze up everywhere and Christmas trees (children's joy) will be set up in all the homes . . . if we could, through the power of a magic wand, be reunited in London, what a Christmas log, what a pudding, what joy it would be!!"

However much English customs enchanted him, he inevitably gravitated to the French quarter between Soho and Leicester Square, where there was congenial company at the Hotel de la Boule d'Or, on Percy Street, traditional gathering place of exiled French radicals, and at Audinet's Restaurant, on Charlotte Street, Fitzroy Square. Occasionally he encountered other French painters—Daubigny, Alphonse Legros, François Bonvin. London had not only a French quarter but a French gallery to which Pissarro could turn, the gallery at 168 New Bond Street, managed by Paul Durand-Ruel. The *Neuve internationale de l'art et de la curiosité,* of which he was editor, had commented favorably on Pissarro's work; it was quite natural for Camille to seek out its editor.

Paul Durand-Ruel was short, intense, shrewd, with hard, sparkling eyes. He was a paradoxical figure, a dedicated Catholic and monarchist, a conservative, who sup-

ported art that was a challenge to the artistic authorities. His father, Jean, who had founded the gallery, had handled the work of Delacroix, DeCamps and Diaz, other painters of the romantic school, and many printmakers. Paul Durand-Ruel developed a taste for the Barbizon school, and after he assumed direction of the gallery, in 1862, gradually became the principal dealer for Corot, Millet, Daubigny and Diaz, as well as Courbet. In 1869, he expressed rather loftily the principles that governed his purchases: "A true dealer in pictures should also be an enlightened collector, ready to sacrifice, if necessary, his apparent self-interest to his aesthetic convictions."

On December 10, Durand-Ruel opened the first exhibition in London of the Society of French Artists. It is unlikely, however, that Pissarro's paintings were actually on exhibition as early as December. When the *Art Journal* reviewed the exhibition on February 1, the reviewer made no mention of Pissarro, but found that there was "much to be learned" from French painting and concluded that the exhibition "will, no doubt, be added to from time to time." When the second hanging took place, on March 6, it is quite possible that Pissarro's work was added to the exhibition—and to the catalogue—but not until then. The catalogue lists paintings by the Barbizon school; one by Monet, *The Mouth of the Harbor at Trouville;* and two by Pissarro, *A Snow Effect,* entry 38, and *Upper Norwood,* entry 41. These were the first works of Pissarro and Monet to be exhibited outside of France; the relationship with Durand-Ruel that was to be so crucial to the Impressionists had begun.

The first of many transactions between Pissarro and Durand-Ruel is noted in a letter the dealer sent to Camille on January 22, 1871:

> You have brought me a charming picture and I regret not having been at my gallery to pay my respects in person. Tell me, please, the price you would want; be kind enough to send me others as soon as you can. I must sell a lot of your work here. Your friend Monet asked me for your address. He lives at 1 Bath Place, Kensington.

Eventually the dealer bought two paintings of Pissarro's at 200 francs each, considerably more than Père Martin had paid him. The paintings, entered in the firm's books as *Sydenham* and *Norwood,* cannot be identified specifically. Durand-Ruel paid Monet 300 francs for each painting he bought from him. The money was very important to both artists, cut off from collectors and their homeland; the boost to their morale was even more vital.

They could now take up their discussions where they had left off at Louveciennes and could study together the English landscapists and the old masters in the museums, copying what struck their fancy. Pissarro later described their admiration for Gainsborough, Lawrence and Reynolds. His electic taste embraced a wide range of artists in the London museums. He was especially attracted to the Holbein drawings and the bas-reliefs at the British Museum, but it was inevitably the landscape painters, especially Turner, Constable and to a lesser extent John Crome, who "have certainly had influence upon us," Pissarro acknowledged many years later in a letter to a British painter, Wynford Dewhurst. They "shared more in our aim with regard to 'plein-air' light and fugitive effects." At the South Kensington Museum they admired Constable's large oil sketches for his famous *The Hay Wain* and *The Leaping Horse.* Pissarro was excited by the spontaneous brushwork, rough textures, and flecks of light. Turner's

dramatic seascapes and landscapes, *Rain, Steam, and Speed, The Snowstorm, Fire at Sea*, and some of his more placid Venetian landscapes were also on view at the Kensington Museum and at the National Gallery.

Paul Signac, in his treatise on neo-Impressionism, *D'Eugène Delacroix au Néo-impressionisme*, recalled that about 1886 Pissarro had discussed his and Monet's impressions of Turner's paintings. "They marvelled at the delicate, magical colors; they studied his work, analyzed his technique. They were struck, above all, by his snow and ice effects."

How much "influence" the English painters exerted on the Impressionist movement became controversial in Pissarro's old age. After writing his letter to Dewhurst, Pissarro read an article by him that seemed to claim more of a link than he had meant to acknowledge. "I do not think, as you say, that the Impressionists are connected with the English school, for many reasons too long to develop here," he replied. "It is true that Turner and Constable have been useful to us, as all painters of great talent have, but the basis for our art is unquestionably the French tradition."

Turner and Constable doubtless contributed to the evolution of Impressionism. Their principal influence was to hasten a process that was already under way, to encourage Monet and Pissarro and reinforce their convictions. Pissarro subsequently painted with a lighter palette, with a looser, freer handling, and all his life admired Turner, whose work he recommended to London-goers. Monet was less enthusiastic and denied any influence; but as late as 1918 he admitted that at one time he had admired and studied Turner.

Both Pissarro and Turner made pictorial comment on the nineteenth-century phenomenon of the railroad, which had transformed the landscape of England. Turner's painting *Rain, Steam, and Speed* is a dramatically romantic treatment of the theme. His dark, clearly outlined locomotive comes hurtling out of a swirling mass of steam and fog, the future charging out of chaos. Pissarro used the same theme in the so-called *Penge Station, Upper Norwood*, 1871, but his painting does not have the symbolic qualities of Turner's. Though both trains head toward us, Pissarro's chugs placidly out of the station, linking the city to the comfortable suburban homes depicted in the background. The foreground is the slope of a green hillside—the country, too, is now affected by the railroad. In the Turner work, there is a restless tension; in Pissarro's, a calm acceptance of reality by an observer who notes the transformation of the English landscape by the railroad just as he had earlier recognized the intrusion of factories in the French countryside.

Constable, too, captivated Monet and Pissarro, who felt a particular kinship to the painter who had written: "The landscape painter must walk in the fields with a humble mind. No arrogant man was ever permitted to see nature in all her beauty."

But it was the London scene that most inspired them. Years later, Pissarro wrote, "Monet and I were very enthusiastic over the London landscapes. Monet worked in the parks, while I, living at Lower Norwood, at that time a charming suburb, studied the effects of fog, snow and springtime. We worked from nature, and later on Monet painted in London some superb studies of mist."

Pissarro also painted public buildings for the first time—the *Crystal Palace* (which Durand-Ruel bought) and *Dulwich College**, which his nephew Alfred Isaacson was to

* *Color plate on page 99.*

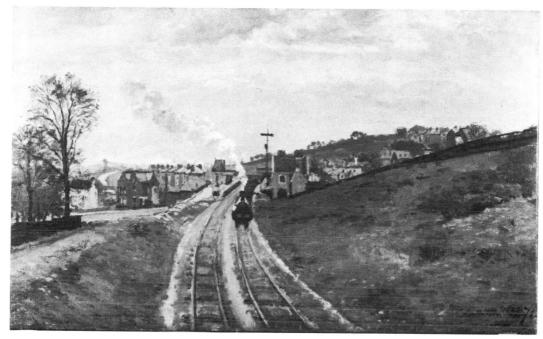

Lordship Lane Station (formerly called *Penge Station*), *Upper Norwood, London,* 1871. (111) 17¾ × 28¾. 45 × 73. Courtauld Institute Galleries, London

enter in the fall—both within walking distance. Pissarro felt comfortable in the world of the attractive English suburbs, counterparts of Louveciennes and Pontoise. The motifs may not have been spectacular, but all that he had learned of the qualities of light, the impact of broken brushwork, the use of natural colors, invested them with beauty. His delightful *Dulwich College* reflects the changes in his style: pinks and yellows enliven the picture; the brushwork is bold and free, the thick, broad strokes in the gleaming water similar to Monet's.

But the London critics and audience were indifferent. "You do not dare show your paintings; I have always shared that apprehension," Piette wrote him. "[The English] like small things, facial expressions, details which they call superbly finished." There was one institution, however, where acceptance would mean quick exposure to a large audience—the Royal Academy, English equivalent of the Salon. Pissarro and Monet submitted paintings to the 1871 annual exhibition and were rejected.

They were both represented, however, each by two paintings, in the French section of the International Exhibition at the South Kensington Museum. Since the two Pissarro paintings were probably the same that Durand-Ruel had exhibited, it is quite likely that the dealer had arranged for their presence. This time he received at least passing mention. The reviewer in *Art Journal* remarked, "By C. Pissarro are two winter subjects of much natural truth, 1276 and 1277."

Landscape painting was not fashionable in 1871 London, and a generation passed before the English realized that a revolution in landscape was under way. In John Ruskin's opinion, landscape painters were taught "to neglect outline and think only of colors. . . . Hence it is that landscape has become frivolous and justly despised."

Pissarro kept up a lively correspondence with his friends in France. Replying to a

request from him, Béliard sent a reassuring report: "All your friends are well. Manet went to the south a few days ago. Zola, who worked for a newspaper in Marseilles, then went to Bordeaux (to be secretary to a cabinet minister). . . . Guillemet is well, Guillamin also. Thompson has not changed and Duranty is always the same. Cezane [*sic*] is in the south, Degayes [Degas] is a little crazy, Duranty says. I haven't seen Fantin, Ciselet [Sisley], Renouard [Renoir] for ages. . . . Oudinot [Berthe Morisot's teacher] is working at the city hall and I am not working at all—no coal!" He did not mention that Bazille had been killed in November.

From Piette, Pissarro received a series of vivid, excited bulletins, reporting on every advance and retreat in his department of Mayenne. Shortly after Pissarro left, the Prussians approached within forty to fifty miles of Montfoucault and captured Le Mans, to the west. Piette's passionate "despatches" were full of eighteenth-century embellishments. Ferociously indignant at any who surrendered or retreated, he longed to fight the enemy, if only his wife were not ill. "If I did not fear for her, I should soon see the color of their blood with my little rifle," he vowed. And later, the embattled artist-warrior added that if the Prussians reached Montfoucault, "We shall roam the woods like savages, our rifles in our hands. If something happens to us, a lot of blood will have to flow before mine is exhausted. You never saw me angry: I am furious and ferocious, I am strong, I am a pretty good shot, and very cold-blooded in extreme danger. I do not think I shall be a coward if I am angry. I just invented a charming little easel, light, portable, practical; you see I am not a warrior and would easily be cowardly, but I shall have anger to make a man out of me, I am very prone to it. I embrace all of you, as does my wife. I hope I shall see you again, my dear friends." The Prussians never reached Montfoucault, and Piette did not have to test his anger.

His family missed the Pissarros and their children. With the enemy drawing nearer, amid reports of betrayal and atrocity, Lucien and Minette's playthings were souvenirs of a happier day. "We send our kisses to the poor children who would like to change countries again, no doubt. They would still find all the 'rich' toys lying around in the garden in the yard, on the benches; oyster shells, broken slates, pieces of wood with funny shapes, watercolors that water cannot fade, and all that charming debris."

The news from Louveciennes was increasingly bad. In January, Julie's sister had written from Paris reporting that the Prussian batteries were shelling Louveciennes, and promising to investigate when the trains were running again. Then Camille's painter friend Béliard, who had lived across the hall from Rachel in Paris, sent him an ominous warning on February 22: "I have no news of your house at Louveciennes! Your blankets, suits, shoes, underclothes, you may go into mourning for—believe me. Your sketches, since they are generally admired, I like to think will be ornaments in Prussian drawing rooms. The nearness of the forest will no doubt have saved your furniture."

A few weeks later, Pissarro heard from his next-door neighbor in Louveciennes, M. Retrou, that Béliard's fears had been justified. "I regret to tell you," Retrou wrote, "that your furniture and my house, like many others, have been really ruined by the enemy, who even kept their horses lodged there for several months. . . . Some pieces of furniture and various objects have been saved—they are with M. Ollivon."

Most worrisome was the absence of any mention by Retrou of Pissarro's paintings and those of Monet.

Their suspense was lifted when Julie received a letter from Félicie on March 10. The news was disastrous.

> Dear Julie:
>
> I went to Louveciennes yesterday and saw your house and M. Olivon [*sic*] who returned two days ago. The railroad only began operating yesterday. I caught the first train, which went only as far as the bridge. I went the rest of the way to Louveciennes on foot—the road is in bad condition and impassable by carriage.
>
> The houses are burned, the roofs broken, your front door, staircase, and floor—all that has disappeared.
>
> When I arrived in Louveciennes I didn't even recognize your house. I went to see M. Olivon who reassured me a little. He was able to save some things; your two beds but no mattresses, your wardrobe, wash stand, desk, about forty paintings, the small wooden bed. The Prussians lived for nearly four months in the house and searched it thoroughly, but they did not find the small closet on the second floor under the staircase. Everything was found by M. Olivon. . . . Your house is uninhabitable now, there is straw all over because the horses were kept on the ground floor and the Prussian soldiers lived upstairs.
>
> I am looking for a place where we can all stay together. Come back as soon as possible.

Her report was confirmed by a letter of March 27 from Mme. Ollivon, their neighbor and owner of their house.

> You are asking about your house; that is not the right word for it; you should say stables. There was a good two carloads of manure in your place. In the small room, next to the living room, there were horses; the kitchen and your cellar were sheep-pens, and the sheep were killed in the garden. . . .
>
> The former tenants set a fire in the bedroom, a beam will have to be replaced and several repairs are needed.

After cataloguing the pieces of furniture that were saved, she revealed that Pissarro's clock, which he had hidden under the second-floor staircase, had been overlooked by the Prussians and was ticking on in her home. She then chronicled the details of destruction to their neighbors's homes in Louveciennes and Bougival. Then, almost as an afterthought:

> I was forgetting to tell you that we have some paintings well preserved. Only there are some which these gentlemen, for fear of dirtying their feet, put on the ground in the garden to serve as a carpet. My husband picked them up and we have them, too.

To Félicie Estruc and Mme. Ollivon, mattresses and a clock seemed more important than paintings. Perhaps neither of them realized that Pissarro had left many more than forty paintings there, including those of Monet. One of those lost was a family group portrait that Lucien remembered well because of his discomfort during the posing. In a letter to his friend Duret, the disheartened Pissarro claimed there had been 1,500 paintings at Louveciennes. While the figure was probably exaggerated, there is no doubt that a substantial part of fifteen years' work was gone. The paintings represented his struggles, his growth, a major part of his life's work. And they also represented his inventory, so to speak, the assets he hoped would sustain him if his work ever began to sell more widely. The loss explains why hardly any paintings exist for 1866 and 1869, very few for 1868 and for the years 1857 through 1862.

As for Monet, some of his canvases were saved from destruction, but it is not known

how many. In a letter to Pissarro when they both had returned to France, Monet asked him to bring a "package of some canvases of mine that you have." A "package" does not imply many, and perhaps he had left only a few.

About the distressing news of the surrender of Paris Pissarro wrote, asking for details, to Félicie's husband, Louis Estruc, who characterized it as "a shameful capitulation," which is what Camille had felt. Even more upsetting was the bloody suppression of the Commune set up in Paris after the Thiers government had moved to Versailles and outraged the lower middle class and the Left of Paris by cancelling the moratoria on debts and rent. News of the slaughter of 20,000 Communards by the Versailles troops depressed the exiles even more. .

In a note to Pissarro, Monet burst out, "You have doubtless learned of the death of poor Courbet shot without trial. [An error in the dispatches; Courbet was confused with a Cournet.] What shameful conduct, that of Versailles, it is frightful and makes me ill. I don't have heart for anything. It's all heartbreaking."

Other members of the Batignolles group were equally bitter against the Versailles government and its successor. In several letters Cézanne expressed his hatred of the minister responsible for the slaughter of the Communards. Manet and even the conservative Degas had been horrified. Piette later wrote: "The ferocity of the Versaillais has gone beyond all previous killings, to my mind. The Jacques, the Saint Bartholomew, the massacres of the Vaudois, all those sinister rivers of blood were but babbling brooks compared to the torrent that flowed on account of the Versaillais reaction."

Pissarro seems to have shared Piette's feeling about the Versailles government. Until his death, he retained among his papers a moving personal chronicle of one of the Fédérés, those arrested and imprisoned for being Communards. In 1887, when two letters of Millet's were published denouncing the Commune for the destruction they had wrought in Paris, Pissarro angrily wrote Lucien that "these letters show the painter in a very peculiar light and clearly indicate the petty side of this talented man. It is very discouraging. . . . Because of his painting *The Man with the Hoe,* the Socialists thought Millet was on their side, assuming that this artist who had undergone so much suffering, this peasant of genius who had expressed the sadness of peasant life, would necessarily have to be in agreement with their ideas. Not at all."

Pissarro was eager to return to France, but with Paris besieged in May, he could only remain in London and read the dispatches painfully. He wanted to be where there were at least possible buyers for his paintings. Here there seemed to be none, and he chafed at the refusal of Alfred and the Isaacsons to help him and at his dependence upon what little his mother could give him. Piette, who had lost all income from his property in Paris and was working temporarily as a day laborer, touched upon his resentment: "So no one will come to our help," he wrote. "Your relatives are like mine; selfishness is their God. If you could succeed without them, I would be even more delighted." Pissarro's relatives felt that a man of forty should be able to support himself and his family; to him, who gladly shared with others what he had, their attitude seemed hard and insensitive. He felt his isolation all the more keenly when Monet, embittered by English indifference, decided to leave for Holland "in complete

discouragement." Monet's letters from a hospitable Holland heightened Pissarro's urge to flee England, as his letter to Duret in early June shows:

> I am here for only a very short time. I count on returning to France as soon as possible. Yes, my dear Duret, I shan't stay here, and it is only abroad that one feels how beautiful, great and hospitable France is. What a difference here! One gathers only scorn, indifference, and even rudeness; among colleagues there is the most egotistical jealousy and resentment. Here there is no art; everything is a question of business. As far as my private affairs, sales, are concerned, I have done nothing except with Durand-Ruel, who has bought two small paintings from me. My painting doesn't catch on, not at all; a fate that pursues me more or less everywhere.

And he ended on a wistful note shared by so many Frenchmen: "How I long for everything to be settled and for Paris to come into its own again."

His attitude toward England was mixed: he hated her political institutions and social

Dam on the Seine at Louveciennes, 1871. (125) 12⅝ × 18⅛. 32 × 46. Photo Sotheby Parke Bernet, New York. Agent: Editorial Photocolor Archives

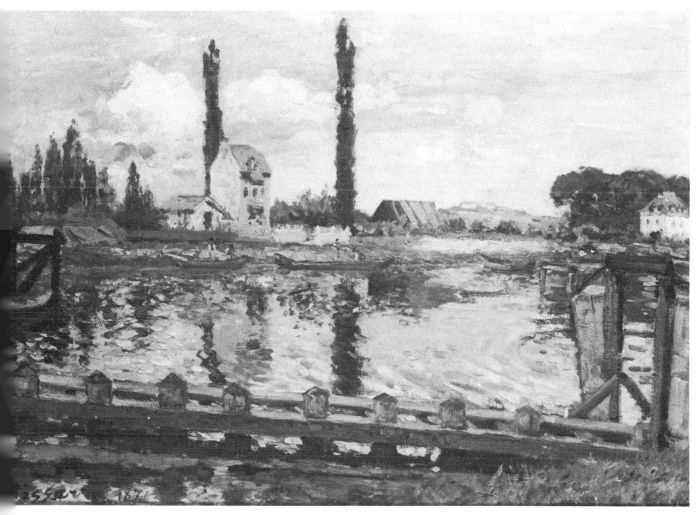

structure, and he resented the art establishment's persistent rejection of the Impressionists; yet he was attracted to the charms of the countryside and many of England's customs, and eventually expressed a desire to make his home there. In 1883, he wrote Lucien, "England, like France, is rotten to the core, she knows only one art, the art of throwing sand into your eyes." However, in the nineties, he not only visited England several times but told Lucien he would prefer to live there.

In June, Durand-Ruel bought two more paintings from him for 200 francs each, but

Entrance to the Village of Voisins, 1872. (141) 18⅛ × 21⅝. 46 × 55. Musée du Louvre (Jeu de Paume)

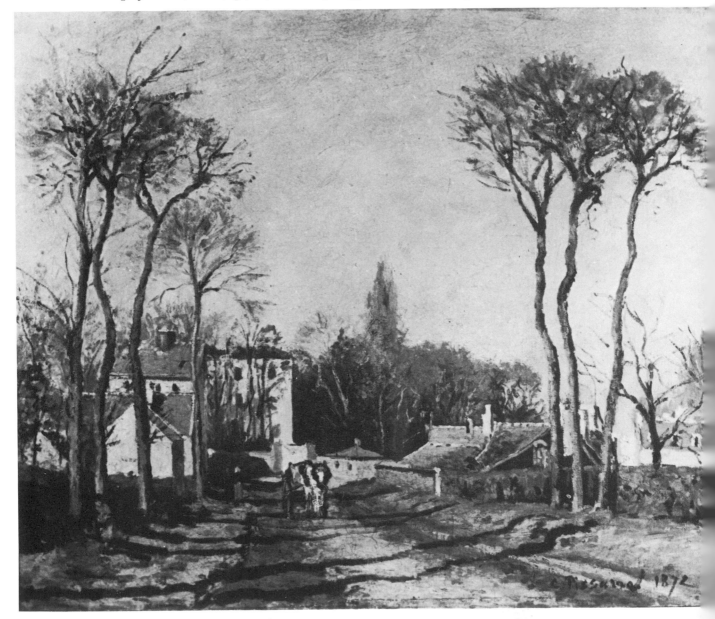

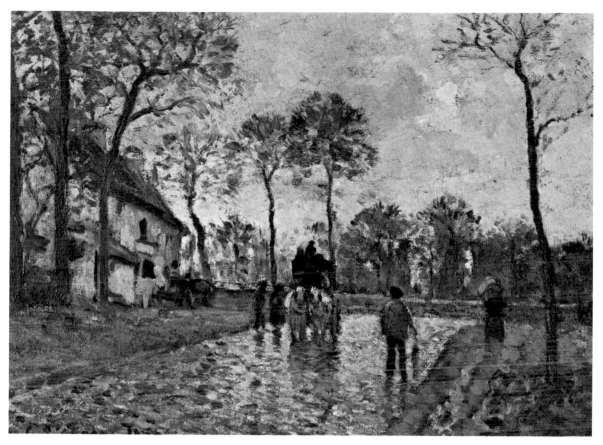

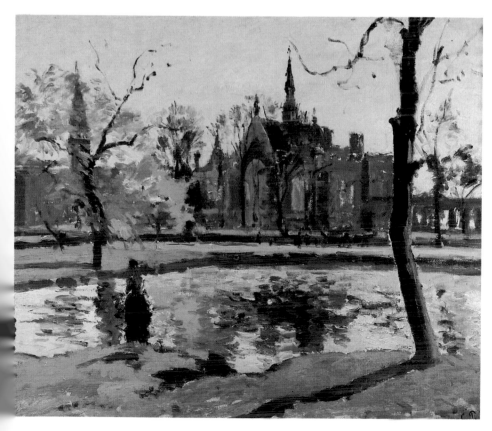

The Coach at Louveciennes,
1870. (80) 9⅞ × 13⅜. 25 ×
34. Musée du Louvre (Jeu
de Paume)

Dulwich College, 1871.
(116) 19⅝ × 24. 50 × 61.
Collection Mr. and Mrs.
Maurice Taylor, Santa
Barbara, California

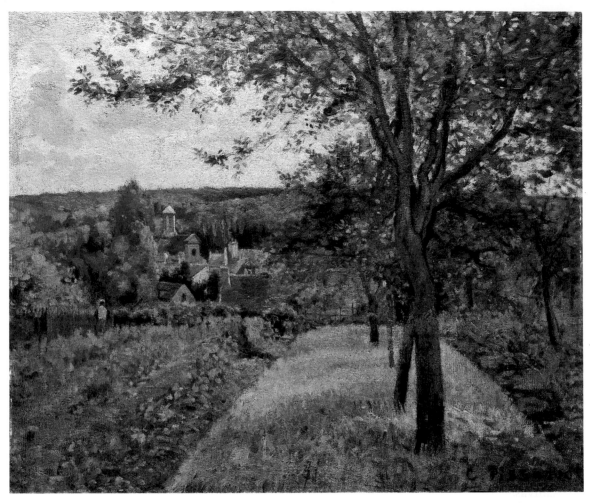

Orchard at Louveciennes, c. 1872. (not in catalogue raisonné) 18½ × 22⅛. 47 × 56⅛. Private collection, New York

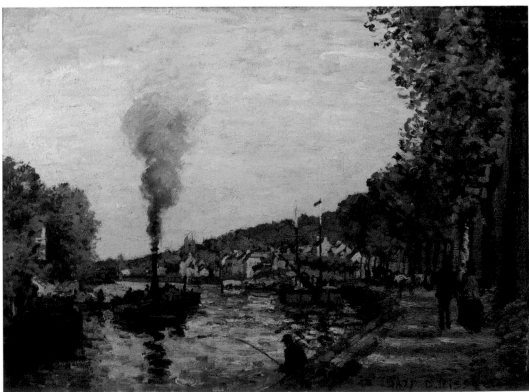

Banks of the Seine at Marley, 1871. (122) 17⅜ × 23⅝. 44 × 60. Photo courtesy Christie's, London

the dealer's interest was not strong enough to overcome Camille's urge to return to France. His home in Louveciennes was being repaired, and he learned from Louis Estruc that his mother's apartment in Paris had survived the bombing. It was time to return.

One pressing matter was still unresolved. "Go to London and marry there without my consent and without anyone knowing about it," Rachel had told him. They had been in England for six months. Julie was pregnant again, and they had not yet married. Perhaps he had delayed marriage in the hope that their sharing of exile would move his mother to accept Julie, however reluctantly. Perhaps he expected their proximity to develop some communication between the Isaacsons and Julie. Perhaps he hoped Alfred would intervene, although under the complicated French inheritance laws Alfred would lose by the marriage, for his inheritance would be reduced if Camille died before his mother but had married Julie, who would then inherit on behalf of the children.

Whatever his hopes or plans, no intimacy developed between Julie and the Pissarro family. Camille and Julie did finally marry, on June 14, in the Register office at near-by Croydon. No members of the family were present; the two witnesses were members of the French colony in London.

The Pissarros returned to Louveciennes in late June. One can imagine Julie, after spasms of indignation, plowing into the disorder, scrubbing, mending, repairing, retrieving, and replanting her garden. The violation and destruction of Camille's paintings were even worse than Mme. Ollivon had reported. He found that the Prussians had used his canvases as aprons when they slit the throats of poultry and skinned rabbits. There were scraps of these bloodied canvases on dung-heaps. Other soiled canvases, regarded as worthless by the local gendarmes when the Prussians retreated, were being used by local people for various "low and dirty tasks." When village women washed clothes at the laundry, some of them were wearing aprons of which the reverse sides were Pissarro's paintings.

Philosophical about his loss, Camille went back to work "serenely," according to his friend Lecomte. He could not have been as "serene" as Lecomte imagined thirty years later, but throughout his life, his response to a setback was usually to plunge into work. He was a curious mixture of passivity (his "Créole nature," he once called it) in the face of some circumstances, an acceptance of what he regarded as inevitable, and tenacity when adversity threatened. As he later expressed it to the critic and novelist Octave Mirbeau, "Work is a marvellous regulator of moral and physical health. All the sadnesses, all the bitterness, all the grief, I am unaware of them, in the joy of working."

The Louveciennes paintings, such as *Orchard at Louveciennes** and *Banks of the Seine at Marley**, are particularly beautiful. He had synthesized the new Impressionist techniques with his own delicate palette. His vision of the familiar scenes of France was fresher after his absence.

Monet wrote from his new studio on rue de l'Isly to urge Pissarro to be sure to see him on one of his trips and to inquire if his wife could visit Julie in her accouchement. Georges Henri Pissarro was born on November 22, 1871, almost at the same time that Alfred, too, had a son. Pissarro, raised in a large family, was now beginning to carry on

* *Color plate on page 100.*

the tradition. His and Julie's love of children was making it even more difficult for him to live the independent life he wanted as an artist. None of the other members of the Impressionist group had large families, and indeed, in Pissarro's era family responsibilities were generally considered incompatible with the creative life.

But by the end of 1872, support of his family was no longer his pressing concern; at forty-two, for the first time in his life, he earned enough to cover all their needs. Beginning in March 1872, Durand-Ruel began to buy steadily from him. By the end of the year, he had paid him 5,900 francs in eleven installments. It was steady, substantial income, a tremendous gain over the 20- to 40-franc sales to Père Martin. Seventeen years after his arrival in Paris, he was finally free of the need for his mother's support.

His relative affluence was reflected in a letter Piette wrote him in October expressing a desire to come to Paris to "see old Pissarro, and to enjoy his successes, which I predicted many a time to your detractors who shall remain nameless, although I know your unfavorable opinion about them. You do not say anything about yourself, my dear Pissarro; you are as modest in your victory as you were confident in your star in the times of painful fights and struggles. Now that you are about to become a great name—*and you fully deserve it*—money, that five francs coin that has such strong legs for escaping the pursuit of poor runners like us who are relentlessly tracking it . . . will not be lacking to you any longer; such is my hope."

The Batignolles group also began to enjoy this new prosperity. After Pissarro and Monet introduced them, Durand-Ruel took an interest in the work of Sisley and Degas, and in January 1872, he discovered Manet, buying all twenty-three paintings in his studio for 35,000 francs. During that year, Durand-Ruel was back in Paris but continued his exhibitions in London, including the display of thirteen paintings by Manet, nine by Pissarro, six by Sisley, four by Monet, three by Degas and one by Renoir. At that time, he took more interest in Pissarro than in any other member of the group except Manet.

A perceptive letter from Guillemet reflected this new prominence:

> I have *done* the rue Lafitte and have visited the galleries, including Durand-Ruel's. What I wanted to say is that everywhere I saw charming and really perfect things of yours and that I felt anxious to tell you this immediately. . . . Thus I saw especially at Durand-Ruel's bright and varied pictures, lively, in a word, which gave me the greatest pleasure. I also saw very fine Monets and Sisleys, though perhaps penetrating nature less intimately. . . . You must be well satisfied, now that in art you have rounded the cape of tempests. You are successful in what you do and your paintings please. So much the better and I am really happy for you.

An unexpected windfall added to his growing income in 1872, when he learned from a claims lawyer, writing at the instigation of Rachel and Béliard, that he was entitled to apply for indemnity from the state for the losses he had incurred during the Prussian war. Evidently the lawyer was successful, for Piette wrote a few months later, "You are certainly going to collect a good indemnity because you have lost more than a manufacturer. . . . It should put butter on your spinach."

9.

The First Impressionist Exhibition

"The critics are devouring us."
—*Pissarro to Duret, 1874*

IN NOVEMBER or December of 1872, Piette wrote Pissarro, "If a certain nucleus of painters plans not to exhibit at all in the Salon of 1873, above all if Courbet is excluded, and if the jury is still composed of reactionaries or Bonapartists, I also would join with pleasure."

Courbet was excluded from the Salon because of his participation in the Commune, and Monet, Pissarro and Sisley, convinced that their values and those of official art were unbridgeable, did not submit to the Salon that year. Their conviction was re-enforced when they learned that Renoir was rejected and that Manet's *Le Bon Bock* was accepted, for the Manet painting seemed to them a conventional portrait derivative of the Dutch masters.

The Third Republic had replaced the Second Empire, but the Salon jury system and the standards prevailing in official art circles were unruffled by the upheaval. If anything, they were more restrictive than before; now only medalists could be elected to the jury. As 1872 progressed, the Batignolles group revived the idea first proposed in 1867 to hold their own exhibition. The time had come to declare their independence from the jury system and to reach collectors and the public directly.

Monet and Pissarro took the initiative in organizing what became the first Impressionist exhibition. They were an effective team: Monet's aggressiveness, self-confidence, and forceful personality combined well with Pissarro's contagious faith in cooperative action and his confidence-inspiring integrity. The "Société" the Impressionists were to form resembled in miniature Proudhon's concept of a "mutualist" association of producers, the ideal "collective reason" that he preached.

Considerable progress had been made by April 22, 1873, when Monet invited Pissarro to come for lunch with Pissarro's cousin Alfred Nunes, who at Pissarro's urging was beginning to collect the paintings of the Impressionists. "You will tell me if you have seen Béliard and if we are getting ready to gather together again to bring things to a close," Monet wrote. "I also have a subscriber, and he will not have a place at the exhibition. It is my brother [Léon]. . . . Definitely, everyone approves very much, only Manet is opposed."

The first public proposal for an independent exhibition was made on May 5 in *L'Avenir National* by Zola's protegé, Paul Alexis, on the very day of the opening of the 1873 Salon. He undoubtedly based his article upon conversations with his friends at

103

the Café Guerbois. Summarizing the widespread discontent among artists, he pointed out that while some strong republicans were convinced that the fine arts administration was trying to discredit the Republic, others politically indifferent but equally bitter were almost longing for a return to de Nieuwerkerke. All joined in blaming the jury. "The jury is innocent," he declared, "because in art matters no jury can be other than ignorant and blind. Instead of attacking it—which doesn't help—let's be practical and abolish it." He called upon unknown artists—"the proletarians of art"—as well as famous ones to form their own syndicate and hold their own exhibitions. Having heard the suggestion that each member pay five francs a month and have the right to exhibit two works, he wrote:

> This powerful idea, the idea of association, is growing not only in the passionate and lively environment of artists, it is beginning to suffuse new blood into the anemic old world. The contemporary artist, to be truly worthy of his name, can no longer shut himself up in an ivory tower. He must descend from it.

His eloquent article had obviously been expected. Monet quickly picked up the cue:

> A group of painters assembled in my home have read with pleasure the article which you have published in *L'Avenir National*. We are happy to see you defend ideas which are ours, too, and we hope that, as you say, *L'Avenir National* will kindly give us assistance when the society which we are about to form will be completely constituted.

Alexis published Monet's letter on May 12, noting that "several artists of great merit" had already joined Monet, including Pissarro, Jongkind, Sisley, Béliard, Armand Gautier and Guillaumin. "These painters, most of whom have previously exhibited, belong to that group of naturalists which has the right ambition of painting nature and life in their large reality. Their association, however, will not be just a small clique. They intend to represent interests, not tendencies, and hope all serious artists will join them." A political note was struck from the start, since *L'Avenir National* was a radical newspaper, which was forced by the MacMahon government to suspend publication the following October.

The idea appealed eventually to a small group of "serious artists." A year later, by the opening of the exhibition, thirty artists representing a wide range of styles and attitudes had agreed to participate. At the insistence of Degas, the group included artists with conventional styles; he feared the reaction if a disproportionate number of the exhibitors were painters whose styles might antagonize critics and public. The Impressionists were in the minority. Many who joined with them wanted to see reforms in the system of Salon exhibitions and of government influence on art through the dispensing of awards and valuable commissions; but they wanted correction, not abolition. Not all the exhibitors were burning protestants—some sent paintings to the Salon as well as to the independents's exhibition. In contrast, most members of the Batignolles group, hopelessly frozen out of "the system," rejected its basic assumptions. In a sense, they were advocating separation of art and state as the only way to gain full freedom of expression. One conviction bound most of the group together, a belief in the necessity to free themselves from the jury system.

To those whom the Impressionists were challenging, their art was insultingly

"unfinished," self-indulgent, anarchistic, in a sense "subversive." The Commune was still fresh in the memories of the middle- and upper-class supporters of the state; any departure from the norm smacked of rebellion, and the Impressionists were regarded as rebels. The Salon jury, with some exceptions, reflecting the insecurity of the bourgeoisie or the unreconciled Bonapartists or royalists, related the Impressionists's stylistic changes of '70-'71 to the insurrection of '71. Rarely had academic principle been challenged so directly. "One step more and their paintings would have been handed over to the firing squads," said Gustave Geffroy, friend of the Impressionists. Their insistence on pursuing their individual styles, though it seemed politically revolutionary to the Academy, was political only in a philosophic sense, revolutionary only artistically. Not only their style but their subjects were objectionable—the "vie moderne" that Baudelaire had demanded: Monet's and Renoir's "common" holiday crowds, Pissarro's "vulgar" peasants, Pissarro's and Sisley's "unfashionable" suburban Louveciennes, Degas's "rats" of the corps de ballet. It was not that landscapes as such were rejected—Corot and Daubigny had been honored by the Academy, but they were stylistically more conservative than the Impressionists of the mid-seventies.

There was a perhaps crucial reason for the Impressionists's decision to exhibit together at that particular time. When the group was being formed in 1872 and 1873, all of them, with the exception of Renoir, were receiving for the first time regular, substantial incomes from Durand-Ruel, whose backing was the chief buttress of their confidence. He now supported them steadily and prices for their occasional sales were rising. In 1872, he paid Monet 13,200 francs, Sisley 5,350, Degas 8,945. As stated earlier, he paid Pissarro 5,900. Payments to Renoir were only 500 francs in 1872. By May 1873, when Alexis's article appeared, Monet had received 8,200 francs from Durand-Ruel, Sisley 3,250, Pissarro 2,800, Renoir 100. Evidently these sales emboldened them, while Renoir seemed to have had nothing to lose. By the end of 1873, Monet's sales to Durand-Ruel totaled 19,050, Sisley's 6,260, Degas's 6,400, and Pissarro's 5,300. All had extra income from collectors who bought from them directly.

Pissarro rallied to the cause, helping Monet with the recruitment and drafting the charter of the society to be formed, but his friend Piette, mordant observer of the scene from his isolation in Montfoucault, had become skeptical.

> Here are my impressions: You are trying to bring about a useful reform but it can't be done; artists are cowards. . . . Where are those who protested against the exclusion of Courbet from the exhibitions in Paris and Vienna? Should not all painters have protested by abstaining en masse? There is not a bit of solidarity in France. . . . I would say nothing against an association restricted to people of talent who work, are loyal and inspired by enlightened audacity, such as you and some friends around you. I would foresee good results from an association of this kind and do believe that it would be profitable and just to establish it, but I am distrustful of the mass of the idle and treacherous colleagues without moral or political convictions who only want to use others as stepping stones.

On another occasion, Piette wrote his old friend: "Bold and big-hearted like Christ, you invite even your enemies to the communal feast."

Despite his friend's reservations, Pissarro struggled with the formulation of the charter during the summer of 1873, basing it on the provisions of the bakers's union of

Pontoise. In one brief sentence he made emphatically clear the difference between their exhibitions and the Salon's: "The purpose of the society is firstly to organize independent exhibitions, without jury or juries, where each member could exhibit his work." No honors, no prizes, no awards. His proposal that minors be admitted and his provision for expulsion by secret vote were also rejected. To Renoir, his draft was "bristling with prohibitions and penalties" and he succeeded in eliminating those provisions.

Pissarro went over a version of the charter with Monet at Argenteuil during the summer (and, typically, also served as intermediary in a dispute between him and Duret over the price of a Monet painting), but a definitive resolution of the articles was still unattainable. On September 12, Monet invited Pissarro to Argenteuil again to clarify the articles, "since I have already found people who interpret them differently."

Pissarro's proposal eventually took the form of a joint stock company with shares, articles of partnership, and similar routine provisions. Each member was to contribute 60 francs, at the rate of 5 francs a month for a year; all had equal rights, with administration to be handled by a council of fifteen elected members, one-third to be renewed each year. The Société was to receive a commission of 10 per cent on all sales.

Pissarro had hoped that the organization would have a broad social purpose. Piette had written him confirming that conviction: "It seems to me that for the Société to function usefully it ought to take on a moral obligation to each member and to leave his family on his death either money or paintings. When a member dies leaving neither wife nor children, the Société should benefit." But from lack of funds or lack of interest, the Société remained narrower in scope than Pissarro had wished.

On the sensitive question of hanging procedure, as the critic Georges Rivière later paraphrased Renoir's recollections, "Pissarro especially, always imbued with his egalitarian theories, wanted them to proceed by drawing lots or by vote to determine the position of each painting; for him it was a matter of principle. They did not listen to him, fortunately." Renoir had found the proposal too unwieldy and time-consuming. Actually, the final arrangement did not differ drastically from Pissarro's democratic conception. Lot determined each artist's position within the exhibition space. The paintings were then arranged by size, the small ones hung beneath the larger.

A name for the organization was finally agreed on: the neutral "Société Anonyme Cooperative des Artistes, Peintres, Sculpteurs, Graveurs, etc." A "Société Anonyme Cooperative" was a joint stock company. The initial group comprised fifteen artists, but hoped to include many more, partly to spread the sharing of expenses, partly to broaden the range of painters.

Some artists were reluctant to associate with the group. In November and December, Monet wrote Pissarro of his difficulties in trying to recruit five more members. "It's harder than you might believe, each one has a different excuse. . . . It seems to me more difficult to obtain these five signatures than the first fifteen." Pissarro recruited Berthe Morisot, but Manet resisted all of Degas's efforts to convince him to join, citing Cézanne's inclusion as one reason for his refusal to participate, and Guillemet chose to stick by the Salon. His decision was hailed by Corot, now completely alienated by the brushwork and coloring of his former pupils: "My dear Antoine, you have done very well to escape from that gang."

While Pissarro was grappling with the exhibition problems, he was encouraged by a steady rise in his income. In December, Etienne Baudry sold a Pissarro painting for a good sum, 500 francs, and in a January auction of the Hoschedé collection, his paintings were sold for surprisingly high prices—270, 320, 350, 700 and 950 francs. Pissarro was startled and delighted. Although the money did not go to him, the sale could mean much higher prices for his own sales to dealers and collectors.

"The reactions from the sale are making themselves felt as far as Pontoise," he wrote Duret. "People are very surprised that a canvas of mine could go for as much as 950 francs. It was even said that this is astonishing for a straight landscape."

When Duret congratulated him, he responded even more optimistically in a letter of February 2. "You are right, my dear friend, we are beginning to make our break-through. We meet a great deal of opposition from certain masters, but we must expect these different points of view, since we come as intruders to plant our modest little banner in the midst of the fight!" And he expressed what was a key to his confidence and his determination to proceed with the exhibition: "Durand-Ruel holds steady, we have to march ahead without being bothered about opinion."

Durand-Ruel was standing firm in his support. In January 1874, he had paid Pissarro a record 1,835 francs, in three installments, and shortly after Pissarro's letter of February 2 to Duret, he began to make regular payments of 500 francs each, once or twice a month. By April he had paid him 3,875 francs. Pissarro felt that at last he was achieving what every artist dreams of—a *steady* income, without the wild gyrations of sales that meant periods of panic and pressing creditors. A guaranteed income of 5,000 to 6,000 francs, supplemented by other sales, was sufficient to cover basic needs. It did not provide for luxuries in a large family or for the savings essential for slack periods or illness; but reasonable comfort was assured, far above working-class levels.

But his situation, with the possible exception of Sisley's, had become unique. The financial crisis of 1873 had begun to affect the art market. Durand-Ruel, overstocked with Impressionist paintings, was finding it increasingly difficult to sell them. His purchases of Monet's work plummeted to 500 francs in the first three months of 1874; he paid only 200 francs to Renoir by that time, nothing to Degas. Only Sisley still received a modest income from Durand-Ruel: 1,700 francs by April.

Hence the group now had varying economic motivations: Monet and Renoir were propelled by economic stress in addition to principle; Pissarro and Sisley were proceeding out of confidence, since they still received Durand-Ruel's backing; Degas still had a private income.

As Pissarro seemed to be achieving a steady income and a widening circle of collectors, he was subjected to pressure from many friends, especially Duret, not to become identified with the group. In December 1873, Duret wrote him:

> I maintain my opinion that rustic nature, with animals, is what suits your talent best. You haven't Sisley's decorative feeling nor Monet's fantastic eye, but you have what they have not, an intuitive and profound feeling for nature and a powerful brush, with the result that a beautiful picture by you is something absolutely definitive. If I had a piece of advice to give you, I would say: don't think of Monet or Sisley, don't pay attention to what they are doing, go your own way, your path of rustic nature, you will be going along a new road, as far and as high as any master.

Two months later, Duret's anxiety about Pissarro's future burst forth with a plea that he withdraw from the proposed independent exhibition and return to the Salon:

> You have still one step to take, that is to succeed in becoming known to the public and accepted by all the dealers and art lovers. For that purpose there are only the auctions at the Hotel Drouot and the big exhibition in the Palais de l'Industrie. You now have a group of art lovers and collectors who are devoted to you and support you. Your name is known among artists, critics, a special public. But you must take one more step and become widely known. You won't get it by these exhibitions of private societies. The public doesn't go to these exhibitions, only the same nucleus of artists and art lovers who already know you.
>
> The Hoschedé sale did you more good and advanced you further along the way than all the private exhibitions imaginable. It brought you before a fixed and numerous public. I urge you strongly to complete all that by exhibiting this year at the Salon. Considering what the frame of mind seems to be this year, your name now being known, they won't refuse you. Besides you can send three pictures—of the three one or two will certainly be accepted. Among the 40,000 people who, I suppose, visit the Salon, you will be seen by 50 dealers, art lovers, critics who would never otherwise seek you out and discover you. Even if you only achieve that, that would be enough. But you will gain more because you are now in a special position in a group that is being discussed and that, with reservations, is beginning to be accepted.
>
> I urge you to select pictures that have a subject, something resembling a composition, pictures that are not too freshly painted, that are already a bit finished. . . .
>
> I urge you to exhibit; you must succeed in making a noise, in defying and attracting criticism, in coming face to face with the big public. You can't achieve all that except at the Palais de l'Industrie.

Pissarro was tormented by the letter. A fourth child was on the way, his needs were increasing, the outlook for sales was promising, the safe path was through the Salon. Duret had seen his friend Manet battle his way into the Salon, where he was now receiving considerable attention, and hence he agreed with Manet's decision not to sacrifice his hard-won position by exhibiting in relative obscurity with the independents. Now Duret was confident that Pissarro's moment was at hand for wide recognition at the Salon. But the philosophy of cooperative endeavor was by now so deeply ingrained that he could not desert his comrades. Loyalty and principle won out over prudence. The decision was painful, as he came to confide to Lucien:

> I well remember that around 1874 Duret, who is above reproach, Duret himself said to me with all sorts of circumlocutions that I was on the wrong track, that everyone thought so, including my best friends, those most interested in me. I admit that when alone, with nobody to prompt me, I reproached myself similarly—I plumbed myself—decision was terribly hard—should I, yes or no, persevere another way? I concluded in the affirmative, I took into account the risks of the unknown and I was right to stick.

Once the decision was made, there was no turning back for Pissarro; he was to "stick" for all eight of the exhibitions, the only Impressionist to do so.

They decided to hold the exhibition two weeks before the opening of the Salon so that it could not possibly be considered a miniature Salon des Refusés. The photogra-

pher Nadar, their friend from the Café Guerbois, lent quarters without charge, his premises on the rue Daunon, on the corner of the Boulevard des Capucines. It was agreed that the exhibition should run for a month and be open evenings as well as during the day to attract as many visitors as possible, at a one-franc admission charge.

The exhibition opened April 15, 1874. On the red-brown walls, visitors could see 165 works by thirty artists, among them Degas, with ten; Monet and Morisot, with nine; Renoir, with seven; Sisley and Pissarro, each with five; Cézanne, with three.

Along with the conventional paintings was a large number of masterpieces of the Impressionist period, including Cézanne's *Hanged Man's House* and *A Modern Olympia;* Degas's *Dance Class, Laundress, After the Bath;* Monet's *Boulevard des Capucines*, a scene of the Le Havre harbor, his *Impression: Sunrise;* Morisot's *The Cradle;* Pissarro's *Hoar-Frost* and *Chestnut Trees at Osny;* Renoir's *The Loge* and *The Dancer;* Sisley's *The Seine at Port Marly*—an exhibition which would in our time draw huge crowds. Parisians did come, especially when the show opened; during the four weeks, thirty-five hundred attended. But they came to laugh, to jeer, to ridicule, to display every kind of hostility except violence.

Why were so many viewers hostile? Was it a genuine, instinctive impulse, stemming from the unfinished look of the Impressionists's paintings, the bright colors? Were they whipped up by the critics, perhaps by jealous or fearful artists or by the official art circles, the defenders of the jury system which the exhibition attacked so frontally? Possibly the bourgeois reaction was a simple fear of the unknown, a sense that departure from the familiar and comfortable was a threat to their orderly existence.

Many, though not all, of the critics helped to stimulate the public response: The Intransigents, as some critics called them, "declare war on beauty." One commented, "When children amuse themselves with paper and colors they do better." Although the Impressionists's friends, Silvestre, Castagnary, Philippe Burty, and a few others, wrote generally favorable notices, some expressed reservations about the Impressionists's style and choice of subject. Even Castagnary predicted that most of them would abandon Impressionism as "too superficial." Some critics of the more liberal republican newspapers hailed the idea of an independent exhibition but attacked the Impressionists's techniques and concepts. Many of the conservative critics chose to ignore the show rather than give it publicity.

Louis Leroy of *Le Charivari* satirically dubbed the artists "Impressionists." It was not a new term, but he was the first critic to use it pejoratively, and the painters in defiance gladly accepted the epithet and bore it proudly. The form of Leroy's criticism was a "tour" through the exhibition with an imaginary conservative painter, M. Vincent:

> Then, very quietly, with my most naive air, I led him before the *Ploughed Field* [*Hoar-Frost*] of M. Pissarro. At the sight of this astounding landscape, the good man thought that the lenses of his spectacles were dirty. He wiped them carefully and replaced them on his nose.
>
> "In the name of Michalon [an early-nineteenth-century landscape painter]!" he cried. "What on earth is that?"
>
> "You see . . . a hoar-frost on deeply ploughed furrows."

"Those are furrows? That is hoar-frost? But those are palette-scrapings placed uniformly on a dirty canvas. It has neither head nor tail, neither top nor bottom, neither front nor back."

"Perhaps . . . but the impression is there!"

"Well, it's a funny kind of impression!"

Leroy's imaginary academic unwittingly put his finger on one of the extraordinarily original qualities of this painting when he said it had neither head nor tail, top nor bottom, front nor back. Pissarro's composition follows none of the traditional conventions about constructing a landscape painting. Instead of being weighted at the bottom with a dark foreground shading up to a light sky, the painting is pale in tone in both foreground and sky. Instead of being enclosed on the sides with vertical dark elements

Hoar-Frost, 1873. (203) 25⅝ × 36⅝. 65 × 93. Musée du Louvre (Jeu de Paume). Shown at first Impressionist exhibition

such as trees or buildings which would focus attention toward the center of the image, the composition is open at the sides; the furrows of the ploughed field deliberately pull the eye off the canvas at an angle. Pissarro also ignored the clear distinction between near and far (or "front and back"), which tradition dictated that the painter make by setting large, dark forms in the foreground and smaller, paler forms in the distance. He tips the plane of the painting toward us by extending his furrows up the side of the hill to a high horizon line; the small figure and tree in the field are at an unmeasurable distance from us; the painting seems to hover lightly in its own shimmering space. It is not surprising that such an original, eccentric composition seemed bizarre and offensive to Leroy, preventing him and his contemporaries from appreciating Pis-

Chestnut Trees at Osny, c. 1873. (236) 25⅝ × 31⅞. 65 × 81. © Arch. Phot. Paris/S.P.A.D.E.M. Shown at first Impressionist exhibition

sarro's achievement: the evocation of sparkling frost on ploughed earth on an October morning, at the moment when the whole earth and sky are suffused with the green and golden light of dawn.

Leroy later led M. Vincent before another painting:

> . . . the *Cabbages* of M. Pissarro stopped him as he was passing by and from red he became scarlet.
>
> "These are cabbages," I told him in a gently persuasive voice.
>
> "Oh, the poor unfortunates, are they caricatured! I swear not to eat any more for the rest of my life!"
>
> "Yet it's not their fault if the painter . . ."
>
> "Be quiet, or I will do something terrible."

The fondness for cabbages troubled even the friendly Castagnary:

> Pissarro is sober and strong. His synthesizing eye sizes up the whole at a glance. But he makes the mistake of reproducing on the soil shadows cast by the trees that are placed outside his subject and whose existence the viewer thus must deduce, not being able to see them. He also has a deplorable liking for truck gardens and does not shrink from any presentation of cabbages or other domestic vegetables. Yet these defects of logic do not detract from his fine technical qualities. In his *June Morning* one is forced to commend without reservations the force that grouped the various elements of the landscape and the masterful execution with which he has harmoniously balanced the values.

Reactions to his choosing cabbage fields to paint always amused him. Years later, when a symbolist writer was disdainful of his painting peasant women cutting cabbages, Pissarro was ironic: "After all, symbolists may not like cabbage," he commented. "Not everyone can make a good cabbage soup with pickled pork. . . . Our admirable ancestors, the Gothics, did not disdain that vegetable, neither in their ornamental nor in their culinary art. . . ."

He was at first philosophical about the attacks. "Our exhibition goes well," he wrote Duret with laconic irony. "It is a success. The critics are devouring us and accuse us of not studying. I am returning to my work—this is better than reading. One learns nothing from them."

The "success" was costly. The artists had hoped that the exhibition would expand the market for them and boost prices. Pissarro was particularly optimistic, for on April 20 at the Hotel Drouot auction one of his landscapes had been sold at the high price of 580 francs. Unfortunately, the exhibition produced exactly the opposite effect; sales were depressingly low. Although Sisley achieved a surprising total of 1,000 francs, Monet and Renoir sold 200 francs' worth or less, Pissarro only 130 francs'; Degas and Morisot sold none. Not only were potential buyers obviously influenced by the hostile atmosphere, but some of the dealers now became disaffected. Pissarro's relationship with Père Martin became strained as the dealer told everyone that the heavy approach "with that muddy style of his" doomed him, a surprising complaint since Pissarro's palette was now much brighter.

The most devastating blow came from Durand-Ruel. Shortly after the exhibition closed, he had to suspend all payments to them. The one sure source of income suddenly vanished, crushing their hopes for a real breakthrough. He had become a

The Flood,
Saint-Ouen-
L'Aumone, 1873.
(207) 17¾ × 21⅝.
45 × 55. Private
collection, Lausanne

victim of the world-wide depression of 1873 and the realities of the Parisian art world of
the seventies, and he was undoubtedly frightened by the critics's hostility. As he
recalled it, "Guilty of having presented and of daring to defend such works, I was called
a fool and a man of bad faith. Little by little, the confidence that I had managed to
inspire disappeared and I became suspect to my clients."

According to Durand-Ruel's memoirs, his inability to purchase their paintings
impelled the Impressionists to hold their exhibition in order to reach a public directly;
but he was recalling events after the passage of almost forty years and the facts collide
with his memory. They had begun to make plans for their exhibition as early as 1872,
when he was buying their canvases and displaying them in his showroom (where, he
relates, the public was indifferent but not hostile). His payments to Pissarro and Sisley
did not stop before the exhibition, but shortly after. On April 17, two days after the
opening, he paid Pissarro 500 francs, and on May 19, after it had closed, his account
books show a payment to Pissarro of 700. Then they stop.

It is likely that the hostility was clinching evidence to him that the market for
Impressionist paintings was limited and that he was overstocked. Short of funds, he
had to stop gambling on them. Except for a large payment to Pissarro of 1,140 francs on
January 30, 1875 (and a pathetic 50 francs on June 4, 1875), five arduous years passed

before Durand-Ruel could renew payments to the Impressionists.

With summer coming, sales nonexistent, Durand-Ruel's payments gone, and another child due shortly, the euphoria of February vanished. Pissarro had gambled all his hopes, emotional, philosophical and financial, in the cooperative effort, and it seemed to have failed. Sensing his friend's depression, Duret attempted in early June to induce him to be objective and positive about his situation, though he himself could not at the time buy any more paintings:

> Personally I would ask nothing better than to add to my collection of Pissarros. But I must finish paying for the 12 I already have before I acquire more. . . .
>
> You have succeeded after a very long time in acquiring a public of select and tasteful art lovers, but they are not the rich patrons paying high prices. In their small world, you will find buyers in the 300, 400 and 600 franc class. I am afraid that before getting to sell readily at 1500 and 2000, you will have to wait many years. Corot had to reach the age of 75 for his pictures to pass 1000 francs. . . .
>
> The public doesn't like nor understand good painting; the medal is given to Gérôme, Corot is left behind. People who understand it all and who defy ridicule and disdain are few, and very few of them are millionaires. That doesn't mean that you should be discouraged. In the end, everything is achieved, even fame and fortune, and in the meantime the judgment of the connoisseurs and friends compensate you for the neglect of the stupid.

The Société, launched so bravely and optimistically, had only a short life. At a membership meeting on December 14 at Renoir's studio, the members learned that with liabilities of 3,713 francs and cash on hand amounting to 278 francs, each exhibitor owed the Société 184.50. They unanimously voted to liquidate and appointed Renoir, Sisley and an artist named Bureau to supervise the process.

Marcelle Desboutins:
Paul Durand-Ruel,
1882. Etching.
Photo Durand-Ruel, Paris

Minutes of meeting
dissolving the Société.
Private collection,
New York

10.

Pissarro, Cézanne and the School of Pontoise

"As to old Pissarro, he was a father to me. He was a man to be consulted, something like 'le bon Dieu.' "—Cézanne to Jules Borely, 1902

IN 1872, the Pissarros had moved back to Pontoise, where they stayed for more than ten years. Attracted by the charm and variety of the landscape, by the people and by Pissarro's good company, his friends—Béliard, Oller, Dr. Aguiard from Cuba, Guillaumin, Piette, Cordey, Vignon, Zandomeneghi, Gauguin—often came to visit and paint with him in the town and the countryside around it. Most important for his own future, Paul Cézanne came. The relationship between the two was crucial for Cézanne: it changed his direction as an artist and set up deep conflicts in him which, when finally resolved, led to a new synthesis. His mature work would not have developed as it did without Pissarro's influence.

They first found themselves together as a result of a network of events beginning in April 1872, when Dr. Paul Gachet bought a house in Auvers, a village six kilometers southeast of Pontoise. According to the memoirs of Gachet's son, Pissarro asked the doctor to find a house in Pontoise for him and his family to rent as soon as he had liquidated his studio in Louveciennes. Gachet found one at 18 rue Malbranche (now the rue Revert), and later that year they moved into another one by the river's edge at 85 Quai de Pothuis.

Cézanne's mistress, Hortense Fiquet, had meanwhile given birth to a son, Paul, Jr., born on January 4, 1872, in Cézanne's apartment at 45 rue de Jussieu, a small flat in a noisy quarter of Paris opposite the wine warehouses and market. The couple and their new baby in such close quarters must have been wearing on the nerves of all: Cézanne was buffeted by the urgencies of claustrophobia, his feelings of responsibility toward his child, and his terror that his father would find out about the ménage and cut off his allowance (on the assumption that a married man should support himself). Pissarro's suggestion that Cézanne visit Pontoise and work with him was a perfect solution. He could hide Hortense and Paul, Jr., more safely in the country than in Paris, and Hortense would also have Julie's help with the baby. Cézanne knew he could depend on the kindness and understanding of Camille, just as he knew he could trust Dr. Gachet, who as a medical student had met the artist's father in Aix.

Cézanne moved to Pontoise probably late in the summer of 1872, staying about a twenty-minute walk from the Pissarro home, first at the Hotel du Grand Cerf, near the bridge of St. Ouen-l'Aumone, across the river Oise from Pontoise. The next year, the family moved to a house near Dr. Gachet in Auvers and remained there until early in 1874. Lucien, though he was only nine when Cézanne first came to Pontoise,

115

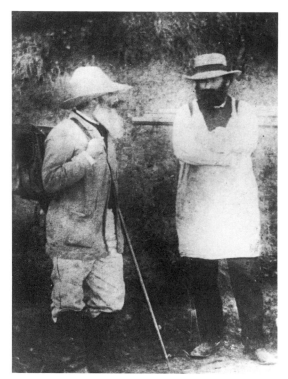

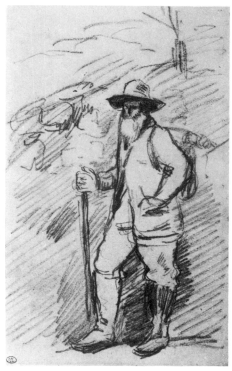

Pissarro and Cézanne.
Photograph Collection
Viollet, Paris

Cézanne: ***Pissarro on Way
to Motif,*** c. 1874. Pencil.
Musée du Louvre,
Cabinet des Dessins

remembered him clearly: "He wore a vizored cap, his hair was long, black and straggly in the back and he was bald in front. He had large, black eyes which rolled in their sockets at the least excitement. He used to walk armed with a long pikestaff which frightened even the peasants a little. . . . Cézanne lived at Auvers and walked three kilometers every day to work with Papa."

Julie and Cézanne, alike in their country ways, their bluntness and their emotional explosiveness, were especially close. In a letter dated December 11, 1872, to Pissarro, who was in Paris at the time, Cézanne shows how much he felt at home in this easygoing household:

> I take up Lucien's pen, at an hour when the railway should be transporting me to my penates. It's to tell you in a roundabout way that I missed the train. Useless to add that I'm your guest till tomorrow, Wednesday. Well then, Mme. Pissarro asks you to bring back from Paris some powder (Nestlé's Milk Powder) for little Georges, also Lucien's shirts from his aunt Félicie's.
>
> Good evening, Paul Cézanne

He liked to tease Julie and joke with the children. He was fond of puns and once called out to Lucien as he was coming down the street from school: "Well, were you roulé [slang for 'thrashed'] today?"—a reference to M. Rouleau, the schoolmaster in Pontoise, who on the recommendation of Dr. Gachet had bought several of Paul's paintings. His humor was mocking: Once he arrived at the house to find Julie presiding at what she obviously intended to be a fancy dinner party for a few local art collectors.

Invited by his embarrassed hostess to sit down in spite of his dirty work clothes, Paul proceeded to scratch himself vigorously and extensively as the other guests became increasingly uncomfortable. At length, he burst out: "Please forgive me, my dear Madame Pissarro, it's only these lice again."

Soon after settling in Pontoise, Julie also entertained her mother-in-law, who had been ill during the summer of 1872 and needed attention. In September of that year, Guillemet remarked in a letter to Pissarro, "I heard your mother was at Pontoise with you. You should be happy and your trips to Paris should be less frequent and disturb your work less." Rachel's first visit, which she could make respectably since they were now married, was a strain on Julie, who had to cope with her demanding and temperamental nature. Pissarro family history has it that Rachel sometimes flew into such a rage that she hit Julie with her cane.

Julie, thrifty and hard-working, helped to keep the family and all their guests fed with the vegetables from the garden she planted every year. From the very beginning of the family's stay in Pontoise, she raised chickens and rabbits for food; a letter from Camille to Emile Zola dated September 21, 1872, says: "My wife asks Madame Zola to take, with our compliments, the mother rabbit that we have at her disposition, who will soon give birth. If Madame Zola could come to Pontoise that would give us much pleasure and at the same time she could make arrangements with my wife for transporting the young mother rabbit."

That same month, Camille responded to an affectionate letter from Guillemet asking for news of his friends:

> Béliard is still with us. He is doing very serious work at Pontoise. . . . Guillaumin has just spent several days at our house; he paints in the daytime and in the evening works at his ditchdigging. What courage! Our friend, Cézanne, raises our expectations, and I have seen and have at home a painting of remarkable vigor and power. If, as I hope, he stays some time in Auvers, where he is going to live, he will astonish a lot of the artists who were too hasty in condemning him.

Evidently Cézanne had already begun to paint in the countryside around Auvers. He had painted landscapes before, making sketches from nature and finishing them in his studio, and had experimented with the styles of Corot and Courbet. But most of his paintings up to that time had been of figures, many in scenes of violence: murders, rapes, autopsies, sensuous imaginings in a dark dream space out of which the flesh of the figures rolled and spilled. He called his ferocious, savagely brushed style "couillarde"—painted with the balls—to acknowledge the intense sexual energy he fused with the act of painting. (Cézanne liked to say that there were two kinds of painting: "bien couillarde," like his, and "pas couillarde," like all the others. He put Corot in the second category and said to Guillemet, who admired Corot, "Don't you find him a little lacking in *temperament?*") But in Pontoise Pissarro persuaded Cézanne to move outside of the turmoil of his imagination and to paint entirely from observation of nature in the open air, to begin and finish a picture outdoors in natural light.

Although Cézanne's interest in the figure continued, he wanted to learn the new method of painting used by Pissarro, who warmly advised him to observe the appearance of the landscape and patiently translate it into dabs of paint on the canvas. Cézanne was determined to try, out of the admiration and trust he felt for Pissarro and

his intuition that this method of painting offered him a way out of his romantic, self-tortured imagery. He carefully copied one of Pissarro's earlier paintings from Louveciennes, which was owned by Dr. Gachet, to gain some insight into the older artist's techniques. He always remembered this experience and said much later in his life, "If Pissarro had continued to paint the way he did in 1870, he would have surpassed all of us." Under his friend's guidance, Cézanne lightened his palette and his touch. He experimented with close tones of grays and pale colors which were very different from the highly contrasting light-dark values in most of his previous work. "You are perfectly right," he wrote to Pissarro, "to talk about gray; it alone reigns in nature. But it is devilishly hard to capture."

The change and development in Cézanne's work as a result of his study of Pissarro's methods and subjects begin to show in his 1874 *View of Auvers*. In this broad vista of village houses and the plains beyond, Cézanne attacks, with some success, the problem of structuring and unifying a multiplicity of forms in deep space, a problem which was to preoccupy him for the rest of his career and which he solved with his late paintings of Mont Sainte-Victoire.

Cézanne's fight to harmonize his intuitions and powerful emotions with the careful recording of his responses to the objective world began in Pontoise with Pissarro, who was one of the first to recognize and encourage him. He later said that he had wasted his time until they met. "Only then, when I knew Pissarro, who was tireless, did the taste for work come to me," he remembered.

Pissarro not only taught his techniques to Cézanne but communicated some of his patience, his receptivity to nature, his willingness to be still and listen to his inner sensations. Influenced by this attitude, Cézanne learned to work beyond his initial violent responses and began to analyze his visual sensations while adopting the plain, familiar views which Pissarro favored. The registering of his minute "sensations" of color, tone, space and texture became a core of Cézanne's philosophy of painting.

When the weather was poor for painting outdoors, both men, joined by Guillaumin, spent many productive hours in Auvers at the house of Dr. Gachet, who had assembled the equipment for making etchings and was experimenting with his usual energy. Homeopathic physician, amateur painter and etcher, friend and patron of vanguard artists, and habitué of art cafés, he had installed himself, his wife and young child in a large three-story house on the rue des Vessinots overlooking the valley of the Oise. His little attic studio was reached by a ladder and a trap door and there he painted portraits, still lifes and heads of pigs and cats. The house was full of stray dogs and cats, a diabolical old goat and an ancient rooster whose feathers had been lost in repeated tussles with the swarm of cats. Gachet, a socialist and an eccentric, dyed his white hair bright yellow and was coquettish about his age, though he was only two years older than Pissarro. He claimed descent from the painter Jan van Mabuse and signed his paintings "Van Ryssel." Georges Rivière, the art critic, described him with affectionate humor:

> Doctor Gachet cut a rather original figure with his bony head, his aquiline nose and his bristly, flaming yellow hair. Involved in the art world, known in scientifico-republican circles, he had a firm belief that infallible science had conferred upon him a prophetic power and he used it at random. He knew how each of us was to die and had the kindness to

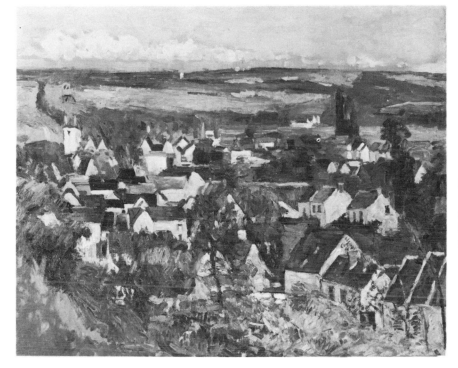

Cézanne: *View of Auvers,* 1873-75. The Art Institute of Chicago, Mr. and Mrs. Lewis L. Coburn Memorial collection

tell us about it. His predictions were only imperfectly realized. He condemned me, in 1875, to die at the age of 25 of a horrible illness; a sort of gangrene of the bones of the face—he believed it absolutely.

He had a mania for proselytizing. A member of the Society for Mutual Autopsy, he wanted everybody to join. Many times, he asked Renoir to sign up, trying to persuade him of the value to anthropology of a study of the heart and brain of an important artist. . . . Renoir was not convinced.

Gachet was warm-hearted and generous in his enthusiasms. He had founded a clinic in the Faubourg Saint-Denis, the working-class quarter, and cared for the poor of Auvers without charge. He helped his artist friends in whatever way he could, as doctor and patron. Early in 1872, while the family was still in Louveciennes, he had treated Pissarro's infant son, Georges, and, later, Minette in her illness. Doctor and artist bartered more than once, exchanging medical care for art, and on one occasion Pissarro wrote: "Would you kindly do me a favor if it is at all possible and go see a sick child in Pontoise? They are not rich people but very interesting. I offer you a little sketch for your trouble. These people have confidence in homeopathy. This is the address: M. Henot, lamplighter at the Pontoise station."

Gachet also helped Cézanne as best he could, buying several of his paintings at modest sums. This delighted the artist, who had never sold anything before but was in the habit of giving his canvases away to anyone who admired them. The doctor even wrote to Cézanne's father to persuade him to raise Paul's monthly allowance, without, of course, revealing that the extra money was to provide for Hortense and the child.

Pissarro had done some etching as early as 1863, but he took it up systematically

when he moved to Pontoise and could use Gachet's equipment. Soon he was joined by Guillaumin and then by Cézanne, the four working together to learn new techniques. Cézanne etched a quick, spontaneous portrait of Guillaumin seated casually on the ground in rough country clothes, neckerchief and soft-brimmed hat. Intimate and unself-conscious, it is without the distance and formality Cézanne usually put between himself and his portrait subjects. In it the tiny figure of a hanged man appears in the upper left, an image he used as a signature on his prints. Each of the others had a pictorial signature: Guillaumin a cat, Pissarro a floweret, Gachet a duck. In Auvers, Cézanne made five etchings, and a memento of his experience there: an intimate drawing of Gachet watching him, his etching pupil, at work.

Among the painters who worked with Pissarro in Pontoise during the 1870's was Victor Vignon, a young landscape painter (born in 1847), a solitary, reflective young man who hated the noise and rush of Paris and had settled in Auvers before Cézanne. His landscapes are austere and melancholy—winter was his favorite season—scenes which express a love of earth and silence, with none of the human comings and goings stirring in Pissarro's work. Vignon was consistently refused by the Salon during the seventies, and in 1880, Pissarro and Cézanne invited him to exhibit with the Impressionist group.

Another comrade in Pontoise was Frédéric Cordey, even younger than Vignon, one of a group of rebellious students who revolted against their master, Lehmann (Pissarro's former teacher), at the Ecole des Beaux-Arts and left the institution in a body when their request for a change of teacher was refused. Cordey had become a follower and friend of Renoir, through whom Pissarro met him. A Renoir painting of a group of friends in his studio in 1876 includes both Cordey and Pissarro, who had enthusiastically supported the young artist's action and his determination to experiment with the new style of landscape painting.

Ludovic Piette, also a frequent visitor to Pontoise, painted the same scenes that appealed to Pissarro: the marketplace, local fairs, the gardens of the Hermitage and the fields at harvest time. Having met Cézanne there, too, Piette inquired about him in a

Cézanne: *Cézanne Etching with Dr. Gachet.*
Pencil. Musée du Louvre, Cabinet des Dessins

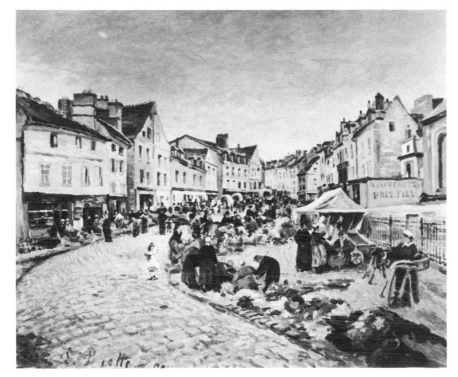

Piette: *Petit-Martroy Square, Pontoise,* 1877. Gouache. Musée de Pontoise

letter to Camille· "Has our friend Cézanne returned from the south? And has he brought back the blue skies the poets sing about, which our colored fogs and obedience to perspective don't allow us to be so familiar with?"

The painters who visited Pissarro in Pontoise experimented incessantly with effects of atmosphere, color and perspective. According to the memoirs of the others, Pissarro was the adviser and theoretician of the group. Lucien recalled endless discussions of theory. "I remember a sentence of great significance from these discussions," he wrote. "The important thing is not to paint a face or a figure, but to paint harmonies!"

The Pissarros and their children stayed regularly at the Piette farm in Montfoucault, where Lucien sometimes went alone to spend part of his summer vacation. Madame Piette sent butter and fruit from Brittany to the family. She and Julie exchanged plant cuttings and flower bulbs, and in her letters Julie always gave her news of the children and sometimes spoke of Camille as if he were one of them. Once she wrote: "Georges and Camille kick up a ruckus playing horse and rider and wear out their trousers, one as fast as the other. Now I have four boys in the house."

Montfoucault played a pivotal role in Pissarro's development as a lyrical painter of rural France. Not until 1874, on a visit to the Piette farm, does Pissarro's painting depict peasants at prosaic tasks in the fields or in the kitchen garden or farmhouse yard. A few tentative approaches were made in 1873 and early 1874, notably his *Ploughed Fields near Osny,* but the figures are so small as to play little role in the composition. From 1874, activity around the farm or in the fields remained basic motifs for the rest of his life.

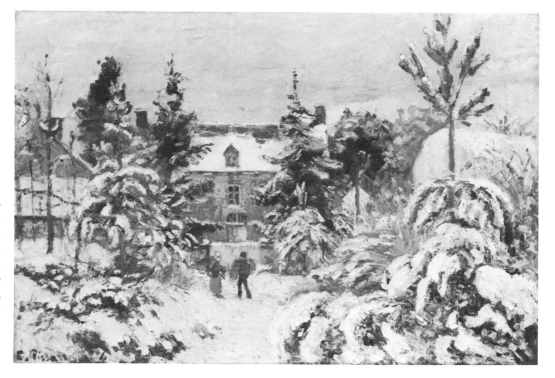

*Piette's House
at Montfoucault,
Snow Effect,* 1874.
(287) 18 × 26⅝.
45 × 68.
Sterling and Francine
Clark Art Institute,
Williamstown, Mass.

In the frequent correspondence between the men, Piette often despaired in the years following the Franco-Prussian War, in which he had lost his property in Paris. The decade of the seventies was a period of repression. The Communards were not amnestied until 1879; only in 1880 did the workers regain enough cohesion to form a political party. Piette's loss and the fading of his hopes for a more liberal government under the Republic left him bitter, depressed and prone to migraine headaches. He often apologized to Pissarro for writing such self-absorbed letters, full of bad news, hoping his friend would cheer him up with his enthusiasm and idealism. He missed Pissarro's "quolibets" when they were apart, his knack of kidding Piette out of depression with mocking jokes about his pessimistic nature. The letters talk of painting. Piette, extraordinarily sensitive to changes in the landscape, described them in a poetic, if somewhat self-conscious "literary" style. They also talk of politics, raging against the government, the clergy and the bourgeois. In one letter, Piette burst out with a half-mocking, half-serious tirade:

> Keep trying to find patrons, my dear Pissarro. The bourgeois of Paris are still buying. They are not like these rich idiots who live in the country. Not a painting, statue or bust can be sold here. They are as crude as the peasants, and as ignorant. Horses, carriages, dresses for the ladies, hunting in season—these are the serious occupations of this enlightened class of Frenchmen. . . . But don't mind my babbling on. I've been living quietly, like a lobster—therefore my excess verbiage.

Piette was painfully aware of the trap he and Pissarro were in as artists, opposing

bourgeois ethics, despising bourgeois aesthetics, and yet dependent on the bourgeoisie to buy their paintings.

Cézanne apparently shared their radical political opinions. He wrote to Pissarro on July 6, 1876, giving his regards to the Piettes and remarking: "Just imagine, I'm reading the *Lanterne de Marseille*, and I must subscribe to *Réligion Laique*. How's that? I'm waiting for Dufaure to be knocked out; but from now on to the partial renewal of the Senate there's lots of time for many dirty tricks." The *Lanterne de Marseille* was a radical paper, *Réligion Laique* an anti-clerical one; Cézanne obviously expected his friend to approve of his reading them. Dufaure, who had been Minister of Justice under Thiers and thus directly responsible for the murderous treatment of the Communards, was infamous among political insurgents.

In October 1873, the Pissarro family moved to another house, at 26 rue de l'Hermitage. On higher ground, above the river, it would not be so damp and cold in the coming winter.

Cézanne's first stay in Pontoise and Auvers ended early in 1874. Before he left for Paris, Pissarro painted his portrait, the earliest by another artist. In heavy winter clothing and a fur hat, he looks burly and hirsute, more like a country worker than a bourgeois artist. Behind him on the wall are two contemporary caricatures and one of Pissarro's landscapes of 1873: *Gisors Road, House of Père Galien*. The portrait is a parody, in a way, of Manet's famous portrait of Zola, in which the background includes artifacts characterizing their relationship and images that are mementoes of their influences. The caricature by André Gill in the upper left of the portrait of Cézanne appeared in *L'Eclipse*, a newspaper critical of official policies. It shows Thiers, the president of the Republic after the Commune, as a doctor delivering the infant France. On the right is a caricature of Courbet by Petit, which appeared along with an article championing Courbet as a martyr. He had been unjustly accused of taking part in the destruction of the Vendome Column during the Commune; fined a ruinous sum, he had fled to Switzerland to escape the judgment. He appears in this painting to be toasting Cézanne, and Thiers to be holding the infant France up to him. Cézanne is thus depicted as receiving acknowledgment from Courbet, an artist he fervently admired, and tribute from the new government in a painting which is a kind of talisman, expressing Pissarro's benevolent wishes for him. The fact is that Cézanne had few supporters apart from Pissarro.

At about the same time, and in a similar format, Pissarro painted his own portrait as a sort of pendant to his Cézanne portrait. At forty-three, with a full, flowing beard already turning white, he appears solid, patriarchal, a proud man with a philosophical look, his eyes wise and wary, a man whose experience has taught him that nothing is certain.

They also made drawings of each other. In Pissarro's, Cézanne is alert, confronting us squarely but still withdrawn, tense as a wound spring. His face is asymmetrical and "split," one side less defined than the other, one eye pale. A deep shadow seems less to fall than to be moving up one side of his neck. The drawing shows Pissarro's understanding and compassion for his friend's intense, erratic energy, conflicted nature, his fears and his need for a secret place to look out from. Cézanne's drawing of

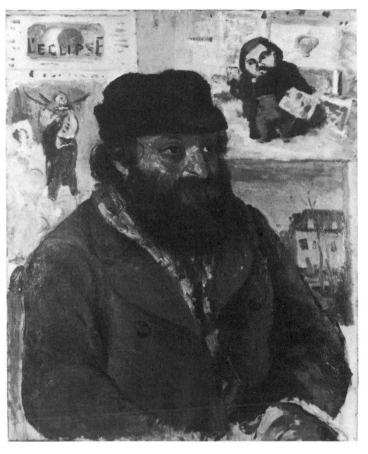

Portrait of Cézanne, 1874.
(293) 28¾ × 23½. 73 × 60.
Photo courtesy Sotheby
Parke Bernet & Co., London.
European private collection

Pissarro, not so psychologically acute, shows him in profile, looking intently in one direction, his eye opened wide. Cézanne seems to want to emphasize the activity of "seeing" in this quick sketch.

In March of 1874, soon after Cézanne left Auvers, the Pissarros's nine-year-old daughter, Minette, died of a respiratory infection, perhaps aggravated by the damp climate of the Val d'Oise. Camille had made five tender portraits of her when she was seven, showing a delicate, pretty child with huge, timid eyes, and had given one to the Piettes, whose favorite she was. She was the second daughter lost to the Pissarros and the tragedy shook them deeply. Julie was five months pregnant when Minette died. The new infant, Félix, also known as "Titi," born on July 24, was some consolation to them, but Julie was obsessed with the fear that the baby would be affected by her grief. Ludovic Piette wrote:

> . . . we share your anxiety with you. Mme. Pissarro has had so much sorrow, so much physical fatigue. We hope that the inevitable resignation, even calm, will give her the strength necessary to take up life again. Georges is so young—he is happy with a toy or a bonbon. Lucien has had a ruder blow. They will forget in time, but they will keep the memory of their little sister for a long while yet. Mme. Piette is sending a package to Mme. Pissarro soon. I will send the portrait of poor little Minette in the same box.

In spite of his mourning, Pissarro was obliged to make many trips to Paris that spring, heavily committed to organizing the first group exhibition of the Impressionists, which opened in April, flying back and forth between the Hermitage and his studio in Montmartre (at 21 rue Berthe), returning to Pontoise finally in May, with relief, to paint again with his friends.

Piette, who had been skeptical of the Société, was nonetheless writing frequently for details of the event. From him came another inquiry and a welcome invitation to the hard-pressed Pissarros:

> And you, my poor old fighter, young in spirit despite your hair turned white too early, what has become of your attempt so well begun, I mean your association and your exhibition? I want to know about the financial success since you were assured of the other. Have your receipts covered the expenses? . . . I hope, my dear Pissarro, that you are not as hard up as I am. . . . But if an unfriendly fortune is harassing you, too, then at least you should come here; we could make excursions in my horse-drawn buggy and find new motifs in the surroundings.

In October the Pissarros were glad to leave for Montfoucault. Guillaumin agreed to look after Camille's affairs and show his pictures to potential buyers in Paris at the studio on the rue Berthe.

Piette's admiration and affection for Pissarro were deep. There were few barriers between them: they shared a passionate interest in social and political affairs, a gift for language, a love of painting—and a mutual raillery—and Piette had a warm relationship with Julie as well. "Kiss the children for me, and without jealousy for an old 'pepper and salt,' kiss your wife if she is agreeable to it" was his closing of a letter written in December 1872. Usually Pissarro's friends sent her only formal greetings.

Delighted as he was to be at Montfoucault, Pissarro was badly shaken by his disappointment with the show and the harshness of the criticism. He was uncertain, convinced now that his painting had lost direction. Possibly Duret's strong advocacy of

LEFT.
Cézanne: *Portrait of Pissarro,* c. 1874. Pencil. Private collection, New York

RIGHT.
Portrait of Cézanne, c. 1874. Pencil. Musée du Louvre, Cabinet des Dessins

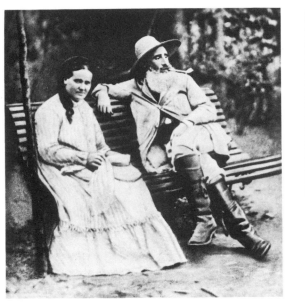

LEFT.
Julie and Camille,
c. 1875. Photograph
Pissarro family
documents

RIGHT.
*Portrait of Jeanne
(Minette) Holding
a Fan,* c. 1873. (232)
21¾ × 18¼. 55 × 46.
Ashmolean Museum,
Oxford

the Salon and "pictures that have a subject" had unsettled him more than he realized. He poured out his uncertainties to Guillaumin, who replied:

> Your letters are truly distressing, even more than your pictures which you say are so gloomy. What makes you always doubt yourself? You should rid yourself of this affliction. I know very well that times are hard and that it is difficult to look at things gaily, yet you should not give in to despair just when things are about to turn for the better. Don't worry, it won't be long before you will occupy the place you deserve. . . . I don't understand at all the disdain with which you speak of your canvases; I can assure you that they are fine and you are wrong to speak of them as badly as you do. That is an unfortunate frame of mind which can only lead to discouragement, and that, my dear Pissarro, is not right. The utmost anarchy reigns in the opposite camp and the day is near when our enemies will tumble.

He who was Cézanne's "bon Dieu," who had been the calm reservoir of strength upon which others could draw and had always found "the solace of work," was now disheartened by the reaction to the Impressionists's exhibition. The death of Minette intensified his depression.

Guillaumin himself was demoralized. A later letter indicated Pissarro's customary role of morale-builder to the school of Pontoise. "I am very anxious to see you and above all to talk to you," he wrote. "I feel that a few moments spent with you would cheer me up"—in view of Pissarro's depression, not a very likely prospect, but he repeated that he found Pissarro's recent work "truly beautiful" and again urged him not to be disheartened.

Pissarro's philosophical nature would not permit him to linger over the luxury of discouragement. He plunged into work again. In the few months that he stayed at Montfoucault he made some twenty paintings, a considerable output, attempting, in an apparent effort to reach a more popular market, some genre paintings. On

December 11, he wrote Duret, "I haven't worked so badly here; I have been tackling figures and animals. I have several genre pictures. I am rather chary about going in for a branch of art in which first-rate artists have so distinguished themselves. It is a very bold thing to do, and I am afraid of making a complete failure of it."

On visits to Montfoucault he painted a peasant woman sitting by the kitchen fire, another spinning wool in her home, a large figure carving wood, women feeding chickens and tending cows or sheep, among other subjects. They were by no means a "complete failure," but they did not suit a public used to sentimental anecdotes about peasants. Pissarro also painted the Piette farm and the Brittany countryside in autumn and in winter snow. Fascinated by the challenge of capturing the reflection of color in the snow, he particularly liked to paint winter scenes, sometimes until his fingers could no longer wield the brush. Gradually he found himself again in the exhilaration of experiment.

When Cézanne returned again to Pontoise in 1875 and 1877, he and Pissarro experimented with palette knives, described as "very long, flat and flexible, as wide as two fingers." Cézanne's influence on his mentor shows clearly at this time in Pissarro's *Effect of Snow at the Hermitage*, 1875, painted partly with a palette knife. Here, Pissarro has emphasized the geometric shapes of the shadows and turned the planes of the building at the left so that it appears to be seen from the front and the side simultaneously. The snow-capped roof of this building is separated from the snow-

Effect of Snow at the Hermitage, Pontoise, 1875. (297) 21¼ × 25⅜. 54 × 65. Photo courtesy Sotheby Parke Bernet & Co., London. Private collection

covered hill beside it by only a semi-transparent line, another device favored by Cézanne which merges two planes and flattens pictorial space. Lucien recalled of this period: "It was then, as I remember, that Cézanne began to paint with vertical divisions and Papa adopted the long brush to paint in little commas." A peasant who had watched them side by side at Auvers remarked that "M. Pissarro, in working, made little stabs at the canvas ['il piquait'] and M. Cézanne laid on the paint like plaster ['il plaquait']." Cézanne's *Small Houses at Auvers* is painted with some of the "vertical divisions" that Lucien noted, early signs of his characteristic parallel brushstroke. He was already applying the lessons of Impressionism in his own way. As he later said, "I, too, have been an Impressionist. Pissarro had an enormous influence on me, but I wanted to make of Impressionism something solid and lasting like the art in a museum."

Small Houses at Auvers is closely related to a Pissarro landscape of 1874, *The Potato Harvest,* which pictures the same hillside and homes, painted broadly and emphasizing the architectural structure of the steeply terraced slope as a backdrop for the figures. The interactions between Cézanne and Pissarro at this time were complex, but they seem to have shared an interest in the construction of pictorial space. However, Cézanne tends to flatten and geometricize space while Pissarro deepens it with perspective lines. Pissarro's later gouache, *The Potato Harvest,* 1886, is a copy of his own earlier oil painting, carrying over the influence of Cézanne in the further flattening and schematization of the landscape and also showing his new interest in the systems of Seurat.

Cézanne tried to persuade Pissarro to come south to Aix more than once, writing again from L'Estaque in July of 1876:

> How I should like not always to talk of impossibilities and yet I always make plans which are most unlikely to come true. I imagine that the country where I am would suit marvellously. . . . The sun here is so tremendous that it seems to me as if the objects were silhouetted not only in black and white, but in blue, red, brown and violet. I may be mistaken, but this seems to me to be the opposite of modelling. How happy our gentle landscapists of Auvers would be here.

Pissarro never visited Aix. He preferred the moist, diffused light of the Val d'Oise to the bright, hard sunshine of the south.

Pissarro acknowledged that he had been influenced by Cézanne. The similarity of their work in the early seventies was evidently the cause of some joking criticism from Zola and Béliard. Pissarro noted in a letter to Lucien:

> . . . he [Cézanne] was influenced by me at Pontoise and I by him. You may remember the sallies of Zola and Béliard about that. They imagined that artists are the sole inventors of their own styles and that to resemble someone else is to be unoriginal. Curiously enough, in Cézanne's show at Vollard's in 1895 there are certain landscapes of Auvers and Pontoise that are similar to mine. Naturally—we were always together! But what cannot be denied is that each of us kept the only thing that counts, the unique "sensation."

In the seventies, Pissarro's steady evolution as a colorist progressed. At the beginning of the decade, his landscapes were characterized by a muted, silvery tonality and a gray or subdued light. Then, in some of his early paintings of Pontoise—*The*

Cézanne: *Small Houses at Auvers*, 1874-75. Fogg Art Museum, Cambridge, Mass., bequest of Annie Coburn

The Potato Harvest, 1886. Gouache. (1405) 10⅝ × 15⅜. 27 × 39. Private collection

River Oise near Pontoise, and *Factory near Pontoise**, both 1873—he experimented with effects of reflected sunlight. He had observed that the noon sun neutralizes color, and he tried to reproduce the visual sensation of bright, diffused illumination by using a full range of values from black to white but hues of relatively low intensity. As he wrote Duret, "There is nothing more cold than the sun at its height in the summer, contrary to what the colorists believe. Nature is highly colored in winter and cold in the summer." When Duranty wrote *La Nouvelle Peinture* in 1876, he felt that the recognition of this phenomenon—that "great light" neutralizes all things—was the most important contribution of Impressionism to date.

By 1876 and 1877, Pissarro's spring and summer pictures were more often painted with clear, bright hues, and he had begun to use a red similar to Cézanne's. He used more pure colors in higher intensities applied with a small, comma-like stroke. In the mid-seventies, he also showed the influence of Cézanne in his greater interest in the complexity and compression of space. In *La Côte des Boeufs***, 1877, one peers through a dense screen of trees and foliage to see the homes and hillside beyond. It is a complex composition that contrasts sharply with the open, placid serenity of his *The Hills of the Hermitage*, painted a decade before.

Pissarro had reached a sense of resolution in his paintings of the Hermitage in 1868 and again in Louveciennes in 1870, and in Pontoise in 1873. In the late seventies, his style seemed to be in transition again. Perhaps to swing away from the influence of Cézanne, he eliminated much of the pictorial scaffolding of buildings from his paintings. In what seems to be an attempt to recapture the spontaneity of the early days of Impressionism, he concentrated on foliage, vegetation and trees, using a loose, long, rapid stroke. But his style varied and he tended to overwork his surfaces. In some paintings his brushstroke was short, tight, matted, the foliage rendered as dense rather than light and open. Dissatisfaction with his painting, a searching for new techniques, and perhaps growing personal uncertainties were reflected in his work.

 * *Color plate on page 134.*
 ** *Color plate on page 167.*

Rue de l'Hermitage, Pontoise,
1874. (264) 16⅛ × 12⅝. 41 × 32.
Photo courtesy M. Knoedler & Co., Inc.,
New York. Private collection

11.

The Ordeal of the Seventies

"What hard times these are!"
—*Pissarro to Murer, 1878*

THE FAILURE of the first exhibition of the Impressionists presaged a period of hardship and obscurity just at the time their paintings were most "impressionistic."

In an attempt to resolve their dilemma, Renoir, Monet and Sisley—joined out of principle by the loyal Morisot—auctioned some of their work at the Hotel Drouot. With the critics hostile and the public scornful, they were fortunate to obtain prices ranging from modest to low. Monet averaged 233 francs per painting, much less than he had been receiving; Sisley averaged only 122, Renoir, only 112. "I have had some details about the Monet sale," Piette wrote. "You are wise, Pissarro, to have kept away from these battles which tear one's heart to pieces and punch a hole into one's pocketbook—for the benefit of the auctioneers!"

When the Société's future looked doubtful in the autumn of 1874, Pissarro was urged by Alfred Meyer, one of the artists in the first Impressionist exhibition, to lead a new, larger and more permanent association of artists. "I absolutely need you so that we can be heard and go forward," Meyer wrote him. The few others interested at that point, he added, "cannot discuss it in the same way you can." Pissarro's prestige, political knowledge and persuasiveness were essential to the new association, soon called *L'Union.*

Meyer suggested that the organization have an administrative council of three, a secretary and a treasurer; that it be organized as a cooperative society, as the original group was, with a diversity of artists, so that the authorities would not be "suspicious" of them. "Workingmen call it a syndicate: you call it what you wish, but it's the principle that you feel is necessary," he wrote Pissarro. Meyer pressed him "to take the steps you believe ought to be taken to collect the debris of our former association," and later proposed that the group consist of sixty artists paying annual dues of 60 francs each. Pissarro brought Cézanne, Guillaumin, Béliard and LaTouche into the new organization.

Although the Impressionists had formally dissolved their Société, they still clung to the concept of a group exhibition. In the spring of 1876, they decided to hold a second one, in quarters at the Durand-Ruel gallery on the rue le Peletier. This time there were more paintings, 250, by only eighteen artists, among them some newcomers, including Gustave Caillebotte, a wealthy engineer who had become friendly with Monet and

131

Renoir at Argenteuil. A former student at the Ecole des Beaux-Arts, his straightforward, modest manner won the confidence of the Impressionists.

In the first show, Monet had exhibited twelve paintings, Renoir seven, and Pissarro five. In the second, Pissarro submitted six canvases, a modest number outshone by the brilliance and profusion of eighteen paintings by Monet and fifteen by Renoir. The rich, bright colors of Monet's Argenteuil scenes dominated the show. The aroused Duret sounded an alarm to Pissarro, who had been so involved with helping to organize the exhibition that he must have neglected his own interests.

> Monet, rue le Peletier, has an exhibition overwhelming in number and size of the canvases. He overwhelms everybody except Renoir who occupies an entire panel next to him. You have only 6 canvases there, some of which are not intended to strike and impress the public and the bourgeois.
>
> It seems to me that this exhibition is going to attract much attention and will be decisive for the enemy. You should come here, make a choice of your best canvases—at your collectors's or elsewhere—and like Renoir and Monet arrange a grouping that will make an impression. Everything is a matter of comparison and beyond question of intrinsic value. You occupy too little space.
>
> If you need any of the paintings belonging to me, they are at your disposition. But you mustn't lose time.

Julie forwarded the letter with a peroration of her own scribbled on the back:

> Duré [sic] is giving you good advice. The future depends on it. Do as much as possible. I send you his letter, there is no time to lose.

Since the catalogue lists twelve paintings by Pissarro, including two borrowed from Durand-Ruel and one from Chocquet, he must have responded quickly to their prodding. His canvases included summer, spring and winter landscapes, plus a few genre scenes. Euphorically ignoring Duret's earlier assessment, Pissarro jotted down the prices he hoped to obtain, ranging from 300 to 1,000 francs, one of the rare cases of wishful thinking indulged in by this usually realistic man.

It was a rich exhibition, including Degas's washerwomen, the New Orleans cotton market, some of his dancers; Monet's *Japonnerie* and *La Plage à Ste. Adresse*; some of Renoir's portraits. Pissarro's landscapes included several profoundly skillful studies of snow and fog, but they were too subtle to be eye-catching.

Some critics were generally approving; unfriendly critics at least gave them much more publicity than at the first exhibition. Hostility was preferable to silence, but many of the notices were rabid. In *Le Figaro*, the influential Albert Wolff called them "lunatics . . . a frightening spectacle of human vanity gone astray to the point of madness. . . . Try to make M. Pissarro understand," he wrote, "that trees are not violet, that the sky is not the color of fresh butter, that in no country do we see the things he paints and that no intelligence can accept such aberrations."

This time at least the artists did not lose money. After all expenses were paid, their original contributions were refunded plus a dividend of 3 francs each.

Again Pissarro was taken aback by the critics's onslaught and the general failure of the exhibition, the only bright spot being the sale of Monet's *Japonnerie* for 2,000

**The Pond at Sunset,
Montfoucault,** 1874. (268)
21¼ × 25⅝. 54 × 65.
Private collection,
Switzerland. Photo
courtesy Sotheby Parke
Bernet & Co., London

**The Harvest at
Montfoucault,** 1876. (364)
25½ × 36¼. 65 × 92.
Musée du Louvre
(Jeu de Paume)

Factory near Pontoise, 1873. (215) 18⅛ × 21¼. 46 × 54.
Museum of Fine Arts, Springfield, Mass. (James Philip Gray collection)

francs. Pissarro also found himself torn between loyalties to the original group of Impressionsts and to Alfred Meyer's more formal *L'Union*. When Meyer had first pressed Pissarro to join him in organizing it, *L'Union* seemed like a logical and broader successor to the Impressionists's group, which in 1874 had a very uncertain future. But now the Impressionists were exhibiting again, and he was disturbed by Meyer's attacks on Monet. He poured out his soul-searching to Cézanne, who was now placed in the role of reassuring Pissarro. "If I dared, I should say that your letter bears the marks of sadness," Cézanne replied. "Pictorial business does not go well; I am much afraid that your morale is colored slightly gray by this but I am convinced that it is only a passing thing." Referring to Meyer's proposed show, he added:

> If we should exhibit with Monet [and the Impressionists], then I should hope that the exhibition of our cooperative [i.e., *L'Union*] would be a flop. You will think me a beast, perhaps, but one's own affairs before everything else. Meyer, who has not the elements of success in his hands with the cooperative, seems to me to be . . . looking out for himself. He can tire public opinion and bring about confusion. In the first place, too many successive exhibitions seem to me bad, on the other hand people who may think they are going to see the Impressionists will see nothing but "conservatives." . . . the prestige of the Impressionists being helpful to me I shall exhibit my best work with them, and whatever "neutral" work I have with the others.

When Meyer was finally ready to organize an exhibition in 1877, Pissarro decided, as did Cézanne and Guillaumin, that the *L'Union* group lacked the quality and cohesiveness of the Impressionists, and they withdrew. The *L'Union* exhibition received little attention.

Except for occasional sales to a small group of collectors, Pissarro had no income and little prospect for any. The screws were tightening. The negative reaction to the Paris exhibition, the financial depression, Durand-Ruel's difficulties, all combined to reduce the market; in addition, the Impressionists painted so rapidly and produced so many pictures that the market, extremely limited to begin with, was glutted.

In the fall, Pissarro again found a haven with the faithful, generous Piette at Montfoucault. That autumn his paintings were particularly beautiful, among them one of his greatest, a broadly painted harvest scene in which the amber of the harvest and the green of the country are brilliantly contrasted with the blue Breton sky.*

Willing to dispose of paintings at almost any price, he had to spend valuable time in Paris, chasing desperately after collectors and dealers. He stayed at Rachel's on the rue Paradis Poissonnière or at a small room on the Quai d'Anjou, near Guillaumin and Cézanne, where he kept some of his paintings for display; but soon he could not afford even the small expense of the room.

Since Durand-Ruel had suspended purchases, Pissarro constantly sought other dealers, no matter how limited their potential. Madame LaTouche, whose husband had participated in the first Impressionist exhibition, was now acting as a dealer and managed occasionally to find a buyer. She paid him 50 or 100 francs. A newcomer, Eugène Murer, born Meunier, a boyhood schoolmate of Guillaumin's, became important to Pissarro. A novelist manqué, a poet and painter, he and his half-sister owned a restaurant and pastry shop on the Boulevard Voltaire which became informal

* *Color plate on page 133.*

headquarters and a haven for the Impressionists. His limited help was critical. At times a hard bargainer, Murer was aided by the enticing odors of fresh bread that weakened the resistance of hungry painters; he would give them meals and advance small amounts of cash in exchange for their paintings, thus gradually acquiring a magnificent collection. Within ten years he had accumulated twenty-five Pissarros, twenty-eight Sisleys, ten Monets, sixteen Renoirs, eight Cézannes, twenty-two Guillaumins, and several others. His restaurant became a nineteenth-century Jeu de Paume. Its unique decor unfortunately has not been preserved. According to Murer's memoirs, Renoir decorated the frieze with brilliant garlands of flowers and Pissarro covered the walls with landscapes of Pontoise. Whatever transient guests thought of the art, the lively painting and bright colors must have heightened the ambiance, which was certainly enjoyed by the artists, writers and musicians who gradually developed the habit of dining there on Wednesday nights. The group included Renoir, Sisley, Guillaumin, Vignon, the engravers Guérard and Rodolphe Bresdin, the musician Cabaner, who was an intimate friend of all the Impressionists. Pissarro, Cézanne and Monet joined them when they were in Paris.

A benefactor of a different kind was Julien "Père" Tanguy, a courtly, gentle ex-Communard who returned from exile in 1874 to open an art-supply shop on the rue Clauzel. A passionate Socialist, he did his best to live his philosophy, constantly extending credit to his friends when they could not pay for colors or canvas, taking their unsaleable pictures when they had no money, feeding them when he could. In Pissarro's difficult years from 1874 to 1880, he ran up a bill with Tanguy for 2,413 francs. Pissarro introduced Cézanne and Vignon to him, and Tanguy soon won the trust of Cézanne, whose work he admired the most. Gradually the shop became a small museum, filled with paintings by Cézanne, Pissarro, Renoir, Sisley, Guillaumin, Monet.

Some of Pissarro's letters of this period reveal his desperation to find buyers, and at prices only a fraction of what he had hoped to get just a few years before. In July, when Murer wanted to buy a Breton interior instead of a hillside scene, Pissarro offered both at 50 francs each and reminded him that Madame LaTouche had paid 100 francs for

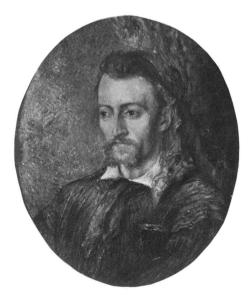

Portrait of Eugène Murer, 1878. (469)
26⅜ × 22⅛. 67 × 56.
Museum of Fine Arts,
Springfield, Mass.,
James Philip Gray collection

The Watering Place at Montfoucault, 1875. (320) 28¾ × 36¼. 73 × 92. The Barber Institute of Fine Arts, University of Birmingham, England

larger canvases. A few months later, his situation was even more urgent: "I sent Petit [the dealer] a little panel for which I count on getting 50 francs," he wrote Murer. "But they've asked me to call again, M. Petit being out for the day. What am I to do? I long for this drop of water like a traveller in the desert. Could you not advance me this amount? They are anxiously waiting for it at Pontoise."

In November, Murer had an inspiration: to hold a lottery for a Pissarro painting. He was confident that among his customers he could dispose of 100 tickets at 20 sous, or one franc each, netting the painter 100 francs—or 400 if they raffled four pictures. Pissarro was enthusiastic. "I am sending you by the messenger four canvases for the lottery. My wife thinks it is a good idea that might well be followed up and she thanks you very much. I will bring you two small canvases to complete the series, if four are not enough. Another idea: don't you think it would be better to put them into cheap frames to make them more presentable? To cover the cost, increase the number of tickets by fifty, if necessary. What do you think?"

Adolphe Tabarant, who had access to Murer's papers, describes the saga of the 20-sou lottery:

> The hundred tickets were easily placed. All the little servant girls of the neighborhood wanted one. One of them happened to draw the lucky number. She rushed up to claim her prize. Murer took her into the shop and there showed her, humbly propped up amid a glorious array of fruit tarts and cream buns, the picture she had won. Disappointed, the little maid made a long face, looked mournfully, now at the queer little painted thing, now at the succulent dainties by which it was surrounded. How she wished she still had her 20 sous.
>
> "If it is all the same to you," she said at last, "I'd rather have a cream bun."
>
> She was given the cream bun and sent away delighted, and Murer, still more delighted, kept the picture.

In the spring of 1877, Pissarro suddenly found himself facing the possibility that his paintings would be seized by creditors. Piette lamented that he could not help his friend because he had no cash at the moment. He added, "Don't lose courage; sacrifice a part of the cargo to save the ship. Some friend you have. I can't give you more precise advice."

He was rescued by Caillebotte. "I learned with pleasure that M. Caillebotte has bought some of your paintings," Piette wrote, "giving you some time to get back on your feet." That timely purchase of three paintings enabled Pissarro to stave off his creditors and prevent a forced sale.

At the height of his predicament, he considered the idea of earning some money by designing ceramic products which could be fired in the ceramic factory in Osny. "I believe that with your skill you should succeed admirably in making decorated pottery," Piette commented on the idea, and later, when Caillebotte's purchase provided momentary relief, "Can your idea of pottery succeed without too high warehousing costs and without suiting the purposes of the manufacturer too much? Because there, too, I believe, producing isn't enough—you have to find collectors. But I don't doubt there is more desire for a vase than for a painting."

Pissarro apparently dropped the grandiose idea of making decorated pottery objects and painted about thirty to forty ceramic tiles, marked either 1877 or 1880 on the few that carry a date.

He painted them in green monochrome on a white porcelain background and probably fired them in the ceramic factory in Osny. Most of them are about six or eight inches square; some are four by eight; others are four inches high and sixteen inches long; some are round, about eight inches in diameter. The designs are based on his paintings, prints or sketchbooks—lyrical landscapes, with shepherdesses, cowherds, apple pickers, cabbage gatherers—familiar motifs beautifully executed. He also painted rockbound seascapes and a series of picture-postcard scenes of Venice, probably copied from Corot's sketches or those of other painters, since he never had visited Italy. Made strictly for commercial sale, the Venetian tiles lack any semblance of "sensation."

The generous Caillebotte, who continued to help the Impressionists, took the initiative in organizing a third Impressionist exhibition. "The exhibition will take place;

Old Woman on Road, 1880.
Oil on tile. 6¼ × 6¼. 15⅞ × 15⅞.
Private collection, New York

it must," he wrote Pissarro in January 1877. Caillebotte advanced the rent money himself when premises were found at 6 rue le Peletier.

Piette, persuaded by Pissarro to join the group for the third exhibition, did so despite his antagonism toward Monet and Renoir, who had not attended his recent one-man show. Their lack of support demonstrated, he felt, that their goals were personal rather than political. He wrote Pissarro:

> The gentlemen of our association have not appeared (except for Cézanne and Guillaumin). If you had been here, I am sure you would have come. Why? Because independent of your friendship, a feeling of solidarity would have prompted you to do so. Since we wish to fight against a common enemy, we should enter into a sincere pact. You are doing this, but neither Renoir nor Monet see anything in the annual association but a means to use the others as rungs of a stepladder.

In stressing "solidarity" and the "fight against a common enemy," Piette was expressing what separated him and Pissarro from the others: political consciousness, crusading spirit, ideological involvement.

The third exhibition was a remarkable event. The hanging committee—Pissarro, Renoir, Monet and Caillebotte—gave Cézanne the most prominent position on the red plush walls, where there were sixteen of his landscapes and still lifes and one of his *Bathers.* There were twenty Renoirs, including his paean to pleasure, *The Moulin de la*

Galette, and his gay mixture of dappled sunlight and shade, *The Swing;* thirty Monets, among them eight of his powerful views of the Gare St. Lazare; Sisley's inspired *Floods at Marly* and sixteen other landscapes; twenty-five Degas pastels, oils, and drawings of his most famous subjects—café concerts, ballet dancers and nudes. Pissarro showed twenty-two landscapes, views of the banks of the Oise and the hills and gardens of Pontoise. To enhance the delicacy and glowing color of his paintings, Pissarro insisted on hanging them in simple white frames, an innovation that marked the break from the tradition of elaborately carved gilt frames that, he felt, overwhelmed the paintings. Durand-Ruel, already concerned with the public's reaction, was unhappy about this additional affront to convention.

"Nowhere, at any time, has such an exhibition been offered to the public," wrote Georges Rivière in *L'Impressioniste,* a small magazine he published during the exhibition. But the public was not at all convinced that these were masterpieces. Rivière defended Cézanne strongly and made perceptive comments on Pissarro, of whom he wrote: "Where can we find more grandeur, more truth and more poetry than in these beautiful landscapes, so calm and so full of that kind of pastoral religiosity which covers the green fields with a melancholy tint. Some landscapes recall certain passages of *Les Misérables.* There is the same epic dignity, the same mystery, the same force, simple in its solemnity."

Cézanne wrote Zola in August, "It appears that profound desolation reigns in the Impressionist camp. Gold is not exactly flowing into their pockets and the pictures are rotting on the spot. We are living in very troubled times." The situation deteriorated sharply.

Monet, frequently besieged by creditors, offered to sell his paintings at bargain-basement prices (five sketches to Murer for 125 francs, four paintings for 200 francs) or begged small loans or advance payments—50 francs from Manet, another 50 from Dr. Gachet. In 1877, he sent desperate letters to Zola and others. With his wife ill and pregnant (Michel Monet was born in March 1878) and creditors hounding him, there is no doubt that Monet's predicament was grave, but it must be viewed in the perspective of his life style. In 1874, despite the loss of Durand-Ruel as a buyer, his income totalled 10,559 francs, and in 1875, 9,765 francs. In 1876, sales of his works or advances against future deliveries brought him 12,313 francs; in 1877, they totalled 15,197—substantial sums. The average income of a Parisian doctor was 9,000 francs, enough to allow him to live comfortably, with a servant. True, an artist had to spend from 500 to 2,000 francs a year for colors and canvases, but Monet tended to live extravagantly when sales were high and to fight off disaster when income dropped. At Argenteuil he had a large establishment, with two servants and a gardener, and had extensive improvements made on the house and grounds. When hard times came, he maneuvered desperately. As Pissarro ironically commented on himself, "What a joke. It is a wonderful business, being a bourgeois without a cent."

Renoir, too, was desperate. At one point he wrote a friend, "I've got to find forty francs before mid-day and so far I've only got three." The crisis might have been exaggerated, but the shortage was real. Murer recalled that in Pissarro's absence one

Wednesday night when the artists met for dinner at his restaurant, Renoir commented wryly on the competition:

> Over the dessert Renoir told us that all day long he had been about from place to place with a picture under his arm trying to sell it. Everywhere he had been bowed out with the words: "You have come too late. Pissarro has just been here. I've taken a picture from him as a matter of common humanity. You know. Poor chap, with all those youngsters." This "poor chap," repeated at every door he knocked at, exasperated Renoir, who was very much put out at not having sold anything.
>
> "What," he cried, with that good-natured ogre's voice of his, and rubbing his nose nervously with his forefinger—a familiar gesture with him—"because I am a bachelor and have no children, am I to die of starvation? I'm in just as tight a corner as Pissarro; yet when they talk of me, no one says "that poor Renoir."

When he faced his easel, Pissarro was usually able to cast aside his troubles, but in 1878 they were too severe to be sloughed off. He was depressed, at times in despair, throughout the year. His faltering confidence is revealed in a letter to Murer acknowledging receipt of 20 francs for a painting:

> I have received the 20 francs you sent me by my boy [Lucien was now 15]. Many thanks. . . . I am still waiting for the thing that shall deliver me out of this hell of inaction. Mlle. Cassatt paid me a visit, also. Desboutin and the Italian man of letters came to see me. The latter is so enthusiastic about this style of painting. He thinks so highly of my art that I am confused and can hardly bring myself to believe what he says. I don't understand how a stranger has a clearer insight than myself.

And then, despite his own woes, he added, "I want to take him to see Guillaumin. I am certain he will like his work a great deal."

It was a year of fear. As he wrote Murer, "Art is a matter of a hungry belly, an empty purse, of poor, luckless devils."

And it was a year of sadness. Piette died suddenly in April, only fifty-two years old—a terrible blow to Pissarro. Piette was not only his most intimate friend and confidant but his most consistent admirer, always generously supporting him. Pissarro knew that in Montfoucault the family always had a refuge. Now they were completely on their own.

The usually indomitable Julie, pregnant again, began to weaken, finally succumbing to depression after years of strain. The shock of the loss of income from Durand-Ruel, just when she finally seemed to have the comfort of security, had been traumatic.

A second catastrophe struck the Pissarros in June. The department store owner Hoschedé, patron of Monet and collector of Impressionist paintings, was forced to sell his collection to pay his creditors. Nine Pissarros were auctioned for a total of 404 francs, one for only 7 francs, another for 10! In a year's time his prices at auction had dropped an average of 100 francs.

The effect was immediate. "For a whole week now I have been rushing about Paris vainly trying to discover the one man needed, the buyer of Impressionist pictures," he wrote Murer. "I am still looking for him. . . . I ran an enthusiast to earth, but the

Hoschedé sale was my undoing. He will be going in for a few inferior things of mine which he will be able to get cheaply at the Hotel Drouot. And here I am once more without a penny."

In 1878, Pissarro spent much time in Paris, constantly making the rounds of dealers and collectors in usually vain efforts to make a sale. Frustrating and demoralizing as these sojourns were, at least they gave Pissarro a chance to see his friends and swap ideas on their mutual problems. They had a new meeting place, the Café de la Nouvelle-Athènes, on the Place Pigalle, and he went there often in 1878, less often later.

Manet and Degas dominated, as they had at the Café Guerbois; Renoir was often there, denouncing the nineteenth century because "there was no one who could make a piece of furniture or a clock that was beautiful and that was not a copy of an old one." Others included Monet when he was in town, and a newcomer, Forain; the critics who were defenders of the Impressionists—Duranty, now "a quiet, elderly man," Duret, Philippe Burty, Georges Rivière, Armand Silvestre and Paul Alexis; Marcellin Desboutin, immortalized in Degas's *The Absinthe Drinkers;* the eccentric musician Cabaner, who had bought a full-size cast of Venus de Milo for his studio, found her too tall, cut off her head and fitted her in snugly.

Among the habitués was the writer George Moore, who has left a vivid description of Pissarro: "No one was kinder than Pissarro. He would always take the trouble to explain to students from the Beaux-Arts why Jules Lefèvre was not a great master of drawing. Pissarro was a wise and appreciative Jew, and he looked like Abraham; his beard was white and his hair was white and he was bald, though at the time he could not have been much more than fifty." If Moore was recalling the period of about 1878-80, then Pissarro's hair had turned white in the seven years since his self-portrait of 1873. To another contemporary observer in the café, Pissarro was "a skillful landscapist, who sees nature as blue, and resembles, with his bald forehead, his spiritual eyes under black eyebrows, Abraham in an opera-bouffe with his long hoary beard." And others greeted him with "Hail to Moses" when he arrived, his prophet's beard streaming in the wind and his portfolios tucked under his arms.

The personal relationships among the Impressionists were sometimes strained during this period of struggle. Deeply disappointed at the lack of public recognition, they were competing for the same buyers, they were uncertain about whether they were on the right course, and they quarreled with increasing heat over the composition of the group. Degas, who often insisted on the inclusion of artist-friends of his whom the others disdained, was particularly difficult. A letter from Piette (undated but probably written during the second exhibition) indicates that Degas had some sort of hostility toward Pissarro that flared up despite their intermittently close working relationship.

> Yesterday . . . I was appproached by Sisley who was talking with Monet and Degas, and I extended my hand which he shook. At the same moment Degas extended his hand to me and mechanically I took his, but that was a reflex gesture, done quickly before I could think and against which I reacted immediately by my coldness. After what has happened between you and this gentleman I regret having even taken his hand because beyond that

you are right, I have found and have said that his phrase was sadly deplorable . . . I think the expression betrayed the thinking of M. Degas.

According to Piette, Degas denied saying whatever offensive statement was attributed to him, but Piette reported that all the rest believed Pissarro's version. Did Degas sneer at Pissarro's painting? Was it an intemperate anti-Semitic remark? Whatever it was, its effect was short-lived.

The year 1878 was a gruesome ordeal for Pissarro. Though the summertime was a poor season for sales, he spent part of it in Paris desperately trying to find buyers. (So much time did he give to the search that the number of paintings he finished dropped from fifty-two in 1877 to thirty-nine in 1878 and thirty-seven in 1879.) He dreaded returning to Pontoise empty-handed. Julie was at her wit's end; creditors were pressing, the landlord was demanding rent, Lucien was ill, she was expecting another child and at forty her pregnancy could not have been easy. Meanwhile, she had to use every possible stratagem to obtain food for the children; her rabbits, pigeons and vegetable garden could not feed them in all seasons.

At Pontoise, Pissarro seemed almost overwhelmed by his problems, striking a rare note of defeat. "It is no longer bearable," he wrote Murer. "Everything I do ends in failure. I had been counting on a considerable sale to the American lady, but [it was] only a small thing, a little canvas for 50 francs. That fell into the pit like a drop of water in a raging fire. When will I get out of this mess and be able to give myself with tranquillity to my work? My studies are made without method, without gaiety, without spirit because of my feeling that I must abandon art and try to do something else—if it is possible to serve a new apprenticeship. Sad!"

While he was in Paris, a note arrived from Julie scribbled on the back of a letter from Duret saying he was unable to buy any paintings at the time. The cow had fallen into the water, she reported. "Two weeks have gone by and you are no richer, no pictures, no work. I don't understand anything. Winter is coming, and you have spent the whole summer in Paris and you told me yourself that everyone you know is away. What are

LEFT. *Man with Hat.* Pen and ink. Ashmolean Museum, Oxford

RIGHT. *Woman with Basket.* Pen and ink. Ashmolean Museum, Oxford

you doing? I am very tired of this life. Lucien is better. . . . I hope that as soon as you have something you will come."

Julie never understood what was involved in Camille's efforts to sell his paintings in Paris, and she always felt she could have been more successful. In her loneliness she envied him the company she thought he must have been enjoying there; but if he did spend some evenings in pleasurable company, he passed his days in bitter, humiliating, usually fruitless pursuit. It was a continuing conflict. "Your mother believes that business deals can be carried off in style," he wrote Lucien later, "but does she think I enjoy running in the rain and mud, from morning to night, without a penny in my pocket, often economizing on bus fares when I am weak with fatigue, counting every penny for lunch and dinner? I assure you all this is most unpleasant—but I want just one thing—I want to find someone who has enough belief in my talent to be willing to help me and mine keep alive."

His pursuit led him round and round in a very small circle. He found a new dealer, Portier, and the Arosa brothers were slowly accumulating his paintings (by 1878, Gustave Arosa had bought three Pissarro paintings, and Achille Arosa had purchased five); but a letter to Murer shows how miniscule was the group he mainly relied on. "Duret came to see me, he seemed very enthusiastic, but nothing sold. M. de Bellio hasn't appeared yet . . . could you do me the service of buying five canvases for 100 francs each, or lend me 500 francs? I wrote to Caillebotte and made him a similar proposition with 1,000 francs. I will try to get this thorn out of my foot and be able to limp along—that's my last hope." Duret-Murer-Caillebotte-de Bellio: the very same collectors upon whose doors Monet, Sisley and Renoir were pounding. Dr. Georges de Bellio, a Roumanian homeopathic physician, had become a loyal collector and friend of the Impressionists during this period. On occasion he made timely purchases of Pissarro's paintings, and also provided free medicine and advice.

Pissarro expressed his despair in a note to Duret: "So you see business is dreadful. Soon I shall be old, my eyesight will be failing, and I shall be no better off than I was twenty years ago." Even so, he knew that no other life was possible for him. He had to paint and he had to live by his painting. The depth of his dedication was revealed in a letter he wrote Murer about the problem of Guillaumin, whose grandparents were insisting that he hold on to his full-time job, which he wanted to abandon so that he could paint. Guillaumin's frustration over having so little time to paint had created an emotional crisis that disturbed his friends.

> Let Guillaumin reflect about the position a little; let him consider that, single, one can get out of any difficulty, one works for oneself. The grandparents have too much influence over him. . . . He would do a hundred times better to send the city job to the devil. Obviously you have to have a bit of determination, you cannot dodge about. . . . What I have suffered you can't imagine and what I am still suffering is terrible, very much more than when young, full of enthusiasm and fervor, convinced as I now am that I am lost and without a future. Nevertheless it seems to me that I would not hesitate, if I had to begin all over again, to follow the same path.

Then, with his characteristic considerateness, he added, "Does it follow that one ought to advise a friend to do the same thing? It depends so much on the character, on

the convictions of each of us." In a note a short while later, he said, "I hope that friend Guillaumin is better and calmer. What an advantage to be single, he doesn't know his strength."

His frank conclusion that he could not have followed any other course, no matter what the cost, was the deep-felt statement of the dedicated artist. But the suffering was not his alone. Physically and emotionally, Julie bore the brunt of their struggles, with none of the pleasures he derived from his painting; the children also paid a penalty—his absences, the tensions from financial stress, all took a toll on their security, despite their parents's love for them.

On November 29, he announced to Murer that Julie had just given birth to another boy, named Ludovic Rodolphe after their late friend Piette. There were now four boys to support. He continued to paint, trying to balance his need to feed his family against his conviction that he must paint according to his own vision.

Julie, backed by Alfred Pissarro, insisted that sixteen-year-old Lucien now share his parents's responsibilities by going to work. Camille much preferred that Lucien's artistic talent be nurtured, but yielded to her constant pressure when Alfred found a job for Lucien in Paris, wrapping packages. To Camille's relief, his son's employer concluded that Lucien's talents did not lie in the business world.

The reactions of Monet, Sisley and Renoir to similar financial pressure provide an interesting contrast in their attitudes toward the principles at stake in the exhibitions. Despite Manet's generous help—in January 1878, he agreed to pay Monet 1,000 francs "against merchandise"—Monet was in constant financial distress from the fall of 1877 throughout 1878. His move from Argenteuil to Vétheuil was delayed until the most pressing creditors were paid, with the help of loans from de Bellio, Caillebotte and his wife. Renoir and Sisley were equally hard-pressed, offering their paintings at bargain prices and trying to scrounge small loans. As the fourth Impressionist exhibition approached, in 1879, Sisley and Renoir dropped out. "I believe we must not isolate ourselves too long," Sisley wrote Duret in March. "We are still far from the moment when we shall be able to do without the prestige attached to official exhibitions. I am, therefore, determined to submit to the Salon. If I am accepted . . . I think I'll be able to do some business."

Renoir also decided to submit to the Salon and vigorously defended his position later in a letter to Durand-Ruel from Algiers:

> There are in Paris hardly 15 art lovers capable of liking a painter unless he is in the Salon. There are 80,000 who would not even buy a "nose" [an inch of canvas] if a painter is not in the Salon. That is why every year I send two portraits, little as that may be. Furthermore, I don't wish to descend into the folly of believing that a thing is bad or good depending on where it is hung. In a word, I don't want to waste my time in having a grudge against the Salon. . . . I believe one must do the best painting possible. That's all. If I were accused of neglecting my art, or of idiotic ambitions, of making sacrifices against my convictions, then I should understand the critics.

Monet, utterly discouraged, told de Bellio, "I am giving up the struggle as well as all hope; I don't have the strength to work any more under these conditions. I hear that my friends prepare a new exhibition this year; I renounce taking part in it, not having done

Kitchen Garden with Trees in Flower, Spring, Pontoise, 1877. (387) 25⅝ × 31⅞. 65 × 81. Musée du
Louvre (Jeu de Paume). Shown at fourth Impressionist exhibition

anything that's worth being shown." Caillebotte refused to accept this defeatism. "If
you could see how youthful Pissarro is!" he wrote Monet, hoping to arouse him from his
lethargy. In the end, he borrowed twenty-nine of Monet's paintings from collectors to
insure his friend's being represented.

The exhibition opened April 10, 1879, at 28 Avenue de l'Opéra. Pissarro exhibited
thirty-eight works, including twelve fans and four pastels. In his effort to achieve some

sales, he included the lower-priced fans and pastels for the first time. Despite the absence of Sisley and Renoir, this exhibition was more successful than the others. More than ten thousand people attended, and each participating artist received 439 francs. Sisley's defection to the Salon did him no good; he was rejected. But Renoir's portrait of Mme. Charpentier and her children was acclaimed. Characteristically, Pissarro did not reproach him for his desertion nor did he envy him. "Renoir has a big success at the Salon," he wrote Murer. "I believe he is launched. So much the better. Poverty is so hard."

The example of Renoir's success strongly influenced Monet. Although, like Pissarro, his opposition to the Salon was based upon deeply felt principle, his debts, his abandonment of any hope to reach buyers through the Impressionist exhibitions, and his despair at the death of his wife in September 1879 overwhelmed him. He joined Sisley and Renoir in abandoning the pledge not to submit to the Salon, and in 1880 sent two paintings to the jury. Of the original group who had participated in all the independent exhibitions, the only ones left were Degas, Rouart and Pissarro.

Degas was openly contemptuous of the "renegades" and constantly attacked them at the Café de la Nouvelle-Athènes. "Do you invite those people to your house?" he asked Caillebotte. At the fifth exhibition, in 1880, he took advantage of the absence of so many of the Impressionists to invite two more of his friends to participate, further confounding those left from the original group who were always irritated by his erratic behavior.

Caillebotte was incensed at Degas's insistence on forcing those whom he considered both minor and non-Impressionist artists into the group, his destructive, if witty,

Path through the Woods, Summer, 1877. (416)
$31\frac{7}{8} \times 25\frac{1}{4}$. 81×64.
Musée du Louvre (Jeu de Paume).
Shown at fourth
Impressionist exhibition

comments on everyone else, and above all, his attacks on the Impressionists who had begun to exhibit at the Salon.

He poured out his wrath to Pissarro in a long letter that indignantly traced Degas's disruptive acts. In the course of his outrage, he pinpointed the unique position Pissarro now held among the Impressionists:

> If there is anyone in the world who has the right not to forgive Renoir, Monet, Sisley, and Cézanne, it is you, because you have experienced the same practical demands as they and you haven't weakened. But you are in truth less complicated and more just than Degas. . . . You know that there is only one reason for all this, the needs of existence. When one needs money, one tries to pull through as one can. Although Degas denies the validity of such fundamental reasons, I consider them essential. . . . The only person, I repeat, in whom I recognize that right is you.

Banks of the Oise near Pontoise, Cloudy Weather, 1878. (434) 21¼ × 25⅝. 54 × 65. Musée du Louvre (Jeu de Paume)

12.

Pissarro and Gauguin–I

"You can ask Pissarro if I'm not gifted. . ."
—*Gauguin to Emile Schuffenecker, 1888*

THE 1879 Impressionist exhibition included a new member, Paul Gauguin, then thirty-one, who had first met Pissarro at the banker Gustave Arosa's home about five years earlier. Gauguin was, at that time, doing well as a stockbroker's agent and was just beginning to draw, his interest in art having been stimulated by the collection of Arosa, his guardian. Pissarro encouraged Gauguin in his drawing, as he would have encouraged anyone, probably thinking of him as a successful young businessman and a potential patron. Gauguin looked up to Pissarro as an experienced mentor, an intelligent and articulate talker, and an artist involved with the most advanced group of painters in Paris.

Gauguin soon began to act as middleman between Pissarro and businessmen who wanted to buy the new art, both for enjoyment and as an investment. He wrote Pissarro (in an undated letter, probably 1874): "An employee of the stock exchange wants to buy two paintings and naturally I am making him take Pissarros. . . . Don't be annoyed at what I say, you know as well as I how difficult the bourgeois are to satisfy, but I would like to have for this young man two paintings with the most stylish and charming subjects possible. He's a fellow who knows nothing at all but has no pretention of knowing anything which is already something."

Through Pissarro, Gauguin met the other Impressionists and began to collect their works. Soon he himself began to paint, on Sundays. Remarkably gifted, he quickly developed a facility for landscape in the style of Corot, whose work he could study in Arosa's collection. In 1876, he submitted a landscape to the Salon and was accepted. His new interest in art was unexpected and distressing to his wife, Mette, who thought she had married not an artist but a man whose chief interest would be in building a secure family life.

Gauguin spent more and more time on his art; he went with an office colleague, Emile Schuffenecker, to draw from the model at the *Académie Colarossi*. And Pissarro, when he came in to Paris from Pontoise, spent evenings with him discussing his drawings and giving him the benefit of his knowledge of oil painting techniques. Gauguin seized on Pissarro's methods, experimented with them, little by little transforming himself from a Sunday painter into a proficient artist, absorbing the master's interest in landscape, in the play of tones under natural light and in integrated

149

Gauguin: *Garden in the Snow,*
1879. Ny Carlsberg
Glyptotek, Copenhagen

compositions. He was ambitious, eager to exhibit his work, and Pissarro and Degas agreed that he could show with them at the 1879 Impressionist exhibition, which opened on April 10. Gauguin must have been invited at the last minute, for he wrote to Pissarro on April 3: "I accept with pleasure the invitation which you and M. Degas have extended to me and naturally, in this case, I will follow all the rules which regulate your organization."

"In this case" referred to his status as a new invitee, careful to be on his best behavior. He showed one piece of sculpture, perhaps considered by the tactful Pissarro as being a potentially less troublesome entry in an exhibition almost exclusively of painting and therefore more acceptable to other members who were often hostile to the admission of new exhibitors. Gauguin was also represented as a collector, three of Pissarro's paintings being listed in the catalogue as belonging to "Monsieur G." With money and interest in buying paintings, he was a valuable addition to the roster.

The year 1879 was an important one for Gauguin as a painter as well as a collector. During his summer holiday, he and Mette and their three children were welcomed by Julie in Pontoise, where he had his first chance to paint side by side with Pissarro over an extended period of time and quicken the pace of his apprenticeship. Pissarro took an interest in the developing ability of this eminently teachable young man, Julie provided hospitality and companionship for Mette, and their children played together while the men were off painting or talking. Pissarro taught him to choose his tones carefully—a way of painting which had already attracted him to Corot. The warmth of Gauguin's feelings toward Pissarro at this time are unmistakably expressed in a pencil

drawing the pupil made of his master, portraying him with an expression of kindliness and infinite patience, a touch of sadness in his eyes. He appears older than his fifty years, an indulgent, fatherly and wise presence.

Later that year, Gauguin painted scenes of snow-covered houses and barns seen through a screen of dark, leafless trees, as in Pissarro's paintings of the same winter. Invited again by Degas and Pissarro, he showed these paintings also at the 1880 exhibition. The invitation incensed Monet, who opposed the intrusion of new artists into the original group and called Gauguin an "untalented amateur," declaring, "I am an Impressionist, but I only rarely see my colleagues, men or women. The 'Petite Eglise' has become a banal 'ecole' which opens its door to the first dauber who shows up."

Unabashed by Monet's disdain, Gauguin exhibited with the Impressionists in the sixth show, in the spring of 1881, and for the first time received critical notice: high praise for a realistic nude from the writer J. K. Huysmans, who had reservations, however, about his landscapes: "Even though these paintings have quality, I don't stop for them. The personality of M. Gauguin still finds it difficult to escape the over-shadowing influence of M. Pissarro, his master."

Huysmans, who had previously criticized the Impressionist style as too crude, the colors as too strong and had spoken of the "indigomania" of the group, was now convinced that Impressionism had come into its own. "One fact is dominant," he wrote, "the blossoming of Impressionist art, which has reached maturity with M. Pissarro." What had happened was that his eyes, like the eyes of others, had become accustomed to the idiosyncracies of the new style. Pissarro said, "For a while he considered us sick. . . . Little by little he has come to take the position that we are

Study for **Woman Washing a Pot,** 1879.
(473) Ashmolean Museum, Oxford.
Shown at fifth Impressionist exhibition

Pissarro's card of admission, fifth Impressionist exhibition

Messieurs Bracquemond, Caillebotte, Degas, Forain, Gauguin, Guillaumin, Lebourg, Levert, Pissaro, Raffaeli, Rouart, Tillot, Eug. Vidal, Vignon et Zandomeneghi, vous prient de leur faire l'honneur de visiter leur

CINQUIÈME EXPOSITION
Ouverte du 1ᵉʳ au 30 Avril 1880
10, RUE DES PYRAMIDES
(A L'ANGLE DE LA RUE SAINT-HONORÉ)
De 10 heures à 6 heures.

La présente Carte servira d'Entrée pour une Personne.

Cézanne: *The Mill at Pontoise,* 1881. Staatliches Museum, East Berlin

cured." In his article "L'Exposition des Indépendants en 1881," Huysmans wrote: "M. Pissarro may now be classed among the number of remarkable and audacious painters we possess. If he can preserve his perceptive, delicate and nimble eye, we shall certainly have in him the most original landscapist of our time."

His praise was not exaggerated. Pissarro made a very impressive showing with twenty-eight pictures, the largest number and the strongest showing by any one artist in the exhibition. Fifteen were gouaches—all figure studies: market scenes and peasants at farm chores, and a charming sketch of two children, probably Georges and Félix. Morisot and Degas submitted a half-dozen works each; the other participants were Cassatt, Gauguin, Guillaumin and Vignon. Monet, Renoir and Sisley did not show at all.

During the summer holidays of 1881, Gauguin again took his family to Pontoise and met Guillaumin and Cézanne, who was there with Hortense and their son. The foursome ranged the area around the Hermitage, painting, sketching and debating methods and approaches. Though Gauguin respected Cézanne's work and bought several of his paintings, he disliked his slovenly dress, scatological language and stubborn dogmatism. He wrote to Pissarro from Paris in the fall of 1881: "Has M. Cézanne found the exact formula yet for a work which everybody would accept? If he finds this recipe for the compression of all his exaggerated sensations in a single, unique procedure, try to make him tell all. Administer one of those mysterious, homeopathic

drugs so he'll talk in his sleep and then come to Paris as soon as possible to let us know about it."

Gauguin's worldliness and elegant irony made Cézanne suspicious; they were never friends. Once, in a minor burst of paranoia, Cézanne complained that Gauguin had tried to steal his "little sensation" from him. Gauguin, an excellent mimic of any style when he wanted to be, did several still lifes which must have acutely annoyed Cézanne. Though Pissarro tried to explain their foibles to each other, their enmity took on such proportions that when they returned to Montmartre, where they both lived, Gauguin's son, Emile, was forbidden to play with Paul, Cézanne's son. The breach was never healed.

During the late seventies and early eighties, Cézanne continued to travel back and forth between Aix, L'Estaque, Paris and Pontoise, where he spent from May to October of 1881 on the Quai du Pothuis, number 31, close to the Hermitage quarter. Zola's country house was only about ten miles away, in Medan, and Cézanne visited him "by road and at the expense of my legs" more than once. Although he was personally close to Pissarro and still painted with him, Cézanne had moved beyond his period of virtual apprenticeship and had become more intent on capturing mass, structure and rhythm in his paintings. *The Mill at Pontoise,* 1881, shows how he had moved through Pissarro's teaching to a new synthesis, assimilating the landscape to his own style. It is built up by interlocking architectural forms with natural forms in a complex, rhythmic mosaic, as Pissarro had done in *La Côte des Boeufs,* for example. The randomness of the reality, a quality usually retained by Pissarro, is in Cézanne's work organized into a classical composition which balances horizontals and verticals, though they are slightly askew, a habit of his which adds tension to his paintings. The black, empty windows of the mill add a sting of mystery to the scene; but Cézanne is primarily interested in visual pattern and spatial rhythm, and less in human activity or emotion.

Becoming more withdrawn and solitary in his habits and spending more of his time in the south, he visited Pontoise for the last time in the summer of 1882. Pressure from his mother and his sister, Marie, finally induced him to marry Hortense in 1885, when their son was fourteen years old. She preferred to live in Paris with the boy; Cézanne remained in Aix with his mother and sister. More and more he turned in on himself. He later said, according to Emile Bernard, "Isolation, that's what I'm good for. At least then nobody gets their hooks into me."

He and Pissarro lost intimate contact with each other in the eighties. They continued to respect each other's work, and met occasionally, but their lives went in separate directions.

Georges Pissarro recorded the camaraderie of The School of Pontoise in a pen drawing he did from the memory of a day in the summer of 1881. He called it *The Impressionist Picnic* and inscribed their names along the bottom: Guillaumin, Pissarro, Gauguin, Cézanne, Madame Cézanne and "le petit Manzana"—himself as a boy of ten. The scene is the side of a hill in the Hermitage quarter (with one of its caves visible) overlooking the valley of the Oise. Guillaumin and Pissarro (in boots and a

broad-brimmed hat) are sitting on the rocks eating bread, Gauguin standing beside them, Cézanne painting at his easel while Hortense fries some eggs over an open fire and the little boy watches. Three easels are set up; one stool and a portfolio are on the ground. The drawing suggests the companionship of the painters, their pleasure in working together and comparing notes on their versions of the same motif, stopping to relax and eat together. The presence of the woman and child adds a familial warmth far from the rigid atmosphere of the Parisian academies. The drawing is a souvenir of the friendships Pissarro enjoyed during the years at Pontoise and also a souvenir of "the Impressionist decade"—the 1870's.

By 1880, France's gradual recovery from the depression of 1873 led to extensive speculation, an atmosphere favorable to investment in art. Durand-Ruel was finally beginning to move his stock, including work of the Impressionists, and a banker friend, Jules Feder, lent him cash to finance expansion. The year wound up with a burst of cheer for Pissarro, when Durand-Ruel paid him a total of 1,750 francs on the last two days of December. The dealer's new flexibility enabled him, for the first time in five years, to renew purchases of the Impressionists's paintings. In 1880, he paid a total of 10,000 francs to Degas, Sisley and Pissarro, whose new affluence continued throughout 1881, when he signed receipts from the gallery for 14,450 francs, some of it prudently spread out in installments. In that year, Durand-Ruel's payments to

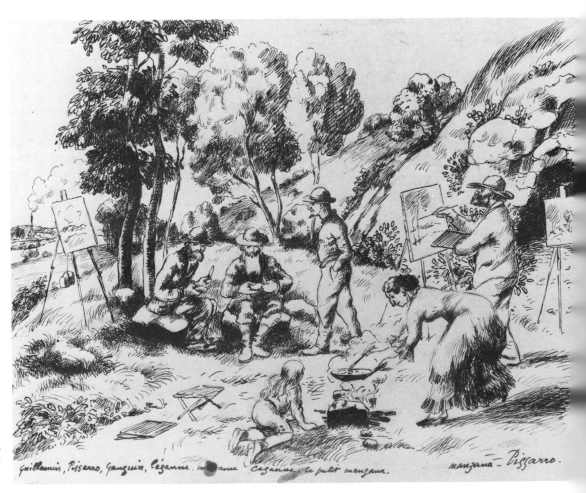

Manzana (Georges Pissarro): *The Impressionist Picnic.* Collection M. Félix Pissarro, Menton

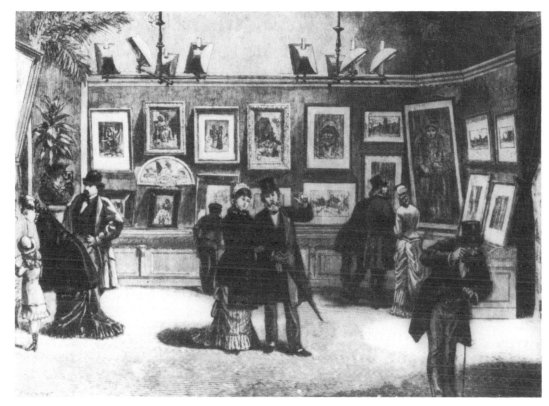

Artist unknown:
***Durand-Ruel's
Gallery,*** 1879.
Lithograph. Photo
Durand-Ruel, Paris

Pissarro, Degas, Sisley, Renoir and Monet totalled 71,000 francs. The Impressionists's severest trial seemed to be over. "I'm not rolling in money, as the romantics say," Pissarro wrote Duret in 1882. "I am enjoying the fruits of a moderate but regular sale. I ask only one thing; that this continue. I dread a return to the past."

At last the beleaguered Julie could walk through the streets of Pontoise without fear of encountering creditors; they could now be paid off gradually. The increased income meant the children could have clothing; a relief from the diet of rabbit and vegetables; even a two-week trip in the summer of 1882 to the Côte d'Or, an escape from the care of children—a rare chance for Julie and Camille to relax together.

Within a week after receiving his first payment, Pissarro wrote excitedly to his new confidante, his niece Esther Isaacson, now in her mid-twenties, "Durand-Ruel, one of the great dealers in Paris, came to see me and has taken a large part of my canvases and watercolors, and proposes to take everything that I do—it means tranquillity for some time, and the means of doing some important works. . . ."

He could now afford to hire models and put more emphasis on the human figure in his paintings. Some years before, when Duret had urged him to do that, Pissarro had said, "I have always thought about painting, as you advise me to do, a biggish picture with subjects; the thing to do is to find a suitable person in the proper character who would be willing to pose. Money is the only way to get over the difficulty and money is

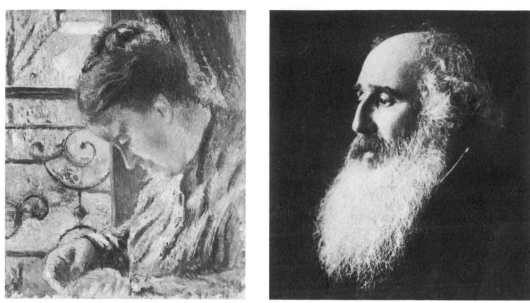

LEFT
*Portrait of Mme.
Pissarro Sewing
near a Window,*
c. 1877. (423)
21⅝ × 18⅛.
55 × 46. Ashmolean
Museum, Oxford

RIGHT
Camille Pissarro,
c. 1880. Photograph
courtesy
John Rewald

unfortunately what I haven't got. . . . But never fear, as soon as I see a chance to carry out a plan, I shall take it."

Pissarro had begun to do some large figure paintings in 1879. Now he could carry out his plan to do more. For several years, beginning in 1881, he did a series of paintings in which the figures, rather than being incidental to the landscape, are significant—most often peasant women engaged in their daily rounds: harvesting, combing wool, guarding sheep or cows, digging, weeding, gathering hay, sorting his favorite cabbages, or simply resting in the fields. One of the most popular paintings from this period is *Young Girl with a Stick**, 1881, in which an adolescent girl, her body in transition between coltish angularity and mature grace, is resting on a grassy bank, dreaming and toying idly with the stick she uses to guard her sheep or cows. Her shadowed face reflects the colors of her hat and the sunstruck foliage around her. The blue of her blouse and skirt fuses with the patches of blue shadow among the grass and leaves; yellow meadow flowers make small, soft explosions of brightness. The forms and textures of her figure and the background are unified by the golden dappled light that suffuses and harmonizes them all. "I shall never do more careful, more finished work," Pissarro said of this painting. The girl is painted tenderly, with a sensitive appreciation of the exact time in her life, just between childhood and womanhood. Had she lived, his daughter Minette would have been about the same age.

Pissarro's pastoral scenes depict labor in the fields truthfully but not fully. His peasants are lifelike in their performance of farm chores, but, with few exceptions, they do not reflect the harshness of their labor. They are not sweaty or dirty or aching with weariness from backbreaking work. The peasant women in the fields are often young, especially when they are the central interest of the canvas. When his figures are small, they seem natural although stiff, sometimes awkward in their movements; when he

* *Color plate on page 168.*

painted them large, as they work in the fields, he sometimes idealized them. Perhaps he saw them through the rosy tint of his philosophy and his appreciation of their way of life. He was more interested in depicting the rhythm of the seasons, the rhythm of their lives, than in portraying them as individuals. None of their faces is memorable, even though he was a good portrait painter.

Many of the paintings from these years, especially those with larger groups of figures, were completed in the studio from life sketches. It was Gauguin who encouraged him in this direction, knowing his feeling of malaise, indecision about his work, groping for a new approach. "I think it's time for you (if, however, it's in your temperament) to do more in the studio," he suggested, "but things ripened in advance from the point of view of composition and subject."

One of these carefully composed paintings, *Shepherd and Washerwomen at Montfoucault*, finished in the studio from sketches made on a trip to Piette's farm, was shown at the seventh Impressionist exhibition, in 1882. It is static and artificial. Two peasant women kneeling beside a stream have turned stiffly in unison to look up at the calm, imposing figure of a shepherd. Caught in the low rays of the setting sun, the figures seem frozen in a timeless tableau, suggestive of the dignity of their traditional tasks. It was doubtless this quality that led the critic Chesneau to compare Pissarro to Millet, a comparison that Pissarro rejected with heat and humor. "They are all throwing Millet at my head," he wrote Duret, "but Millet was biblical! For a Hebrew, there's not much of that in me. It's curious!" It is curious, too, that he would deny the influence so firmly, since some of his paintings that year obviously owe something to the older artist and since he appreciated Millet's drawing. The explanation may be that Pissarro, a convinced atheist, felt that religious beliefs were a dangerous hindrance to social reform, whereas Millet's most popular paintings—*The Angelus*, for example— had obvious religious overtones. Pissarro was outraged at the public's response to it:

LEFT
The Hay Gatherers.
Pencil.
Photo courtesy
M. Knoedler & Co.,
Inc., New York

RIGHT
Poultry Market at Pontoise, 1882.
(576) 3 1⅞ × 25⅝.
81 × 65.
Norton Simon
collection,
Los Angeles

This canvas, one of the painter's poorest, a canvas for which in these times 500,000 francs were refused, has just this moral effect on the vulgarians who crowd around it: they trample one another to see it! This is literally true—and makes one take a sad view of humanity; idiotic sentimentality which recalls the effect Greuze had in the eighteenth century: *The Bible Reading, The Broken Jar*. These people see only the trivial side in art. They do not realize that certain of Millet's drawings are a hundred times better than his paintings which are now dated.

Some observers agreed. Huysmans wrote: "M. Pissarro is entirely rid of any reminders of Millet; he paints his peasants without false grandeur, simply, as he sees them." Degas defined the difference: "Millet? His *Sower* is sowing for Mankind. Pissarro's peasants are working to make a living."

As a beginner, Pissarro had been interested in Millet. His tendency in the early eighties to go back and explore early interests again was shared by other Impressionists. Renoir returned to lush female figures in Oriental costumes; Monet took up seascapes again: as if linked by psychic bonds, the painters looked back into their pasts to find new directions. In 1880, the end of the "Impressionist decade," there was a sense of weariness, a loss of the energy of beginnings, a casting around for something new, old or different to restore vigor and refresh vision.

Pissarro's changing focus resulted in an oil and several gouaches in 1881 and 1882 which contained his first groups of figures with no landscape background—scenes of the marketplace at Pontoise. The faces of his figures are for the most part idealized, his peasant women types rather than individuals, which led Degas to call them "these angels who go to market." But Pissarro was not as interested as his friend in psychological realism. It was the human give-and-take, the primitive economy of the market system, the bartering, the interaction of the figures and personalities which appealed to him as an observer of the small-scale social and economic structure of his town.

Much as he loved the Pontoise countryside, after painting it for almost fifteen years he felt he needed the stimulus of fresh subjects. He was reluctant to take the time to seek a new environment, but the dampness of the area where they lived concerned him for the health of his family. A move was necessary. Toward the end of 1882, he took temporary quarters in Osny, a village several miles to the north of Pontoise, up on a high plain away from the river valley. He continued to work there with Gauguin, Guillaumin and his other friends. The slight change of locale did not cure his discontent with his painting.

His mood of experimentation in the early eighties, his search for new stimuli, new problems, led him to make some changes in his techniques as well as his subjects. He laid the paint on in small, crosshatched strokes of separate hues, one over the other, which built up a dense webbing of color and texture, like flattened, matted grass. Sometimes he gave the same dense, "worked" texture to the flesh and clothing of his figures as he did to the landscape. He was preoccupied with achieving an effect of luminosity in his pictures, and from 1880 he began to work more and more in gouache, tempera and pastel. Pictures done in these media have always been less expensive and easier to sell, which was one of Pissarro's motivations. But his instincts were also

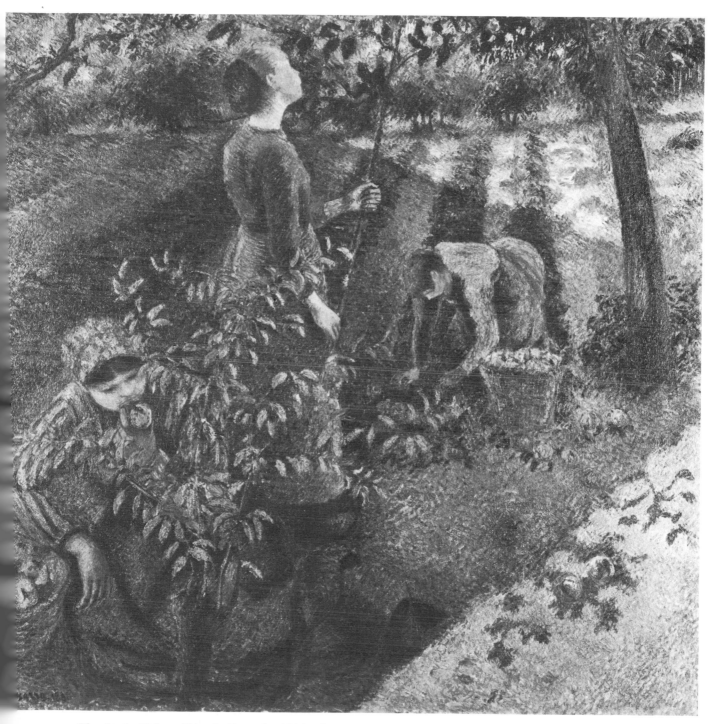

The Apple Pickers ("Apple Eaters"), 1886. (695) 50⅜ × 50⅜. 128 × 128. Photo Akio Nakamura, Kurashiki, Okayama, Japan

pressing him toward greater clarity in the representation of luminous color. In gouache, colored pigments are mixed with opaque white, producing clear, light tints. Tempera has similar qualities and is also fast-drying. Pastel chalks tend toward the light side of the spectrum and Pissarro could lay his strokes one on top of the other without chemically mixing the colors, which occurs when one stroke of wet oil pigment is placed on top of another. He was looking for a way out of his recent tendency to overwork the surface of his canvases with pigment in an effort to achieve light and unity. This technique built up a heavy, three-dimensional surface, so thick that it cast small shadows when the light came from the side. These shadows disturbed Pissarro in his new frame of mind; they caused unforeseen effects and "disorder." He wrote Lucien in 1883: "I am very much disturbed by my unpolished and rough execution. I should like to develop a smoother technique which, while retaining the old fierceness, would be rid of those jarring notes which make it difficult to see my canvases clearly except when the light falls directly on them from the front."

His works in gouache, pastel and tempera helped him to develop a "smoother technique," to divide his colors more distinctly, and to work with clearer and lighter tints of those colors.

In Pissarro's work in the early 1880's, there is another important new tendency, toward decorative flat patterns and curving "arabesques" in the composition. In 1882, he made a study for a large painting called *The Apple-Eaters;* in July 1883, he wrote Lucien: "As for my large canvases, I have two which you know, pictures I meditated on for two years. My *Apple-Eaters* I worked on a good deal; I should like to finish it by April." He finished this painting in 1886 and showed it at the eighth Impressionist exhibition. It was an important work to him; he often mentions it in his letters to his son. It depicts three women in an orchard, one stretching up to pick apples from a tree with sinuous branches, one stooping to the half-filled basket on the ground, the third seated on the ground, dreamily putting an apple to her lips. The rhythm of the curves connecting the three figures is as slow, graceful and deliberate as a pavanne. The viewpoint is high, which eliminates the horizon line and calls attention to the flatness of the pattern made by the grass, paths, trees and the contours of the figures. The composition of this extraordinary painting foretells Gauguin's later style and the aesthetics of the symbolists and the nabis.

These two enthusiasms of Pissarro, for clearer and more luminous colors and for greater emphasis on surface pattern, were alien to the naturalism of the Impressionist approach. His experiments were leading him toward the new style he was to adopt later in the decade.

13.

Pissarro, Degas, Cassatt and Le Jour et la Nuit

"Pissarro is delightful in his enthusiasm and faith." —*Degas to Bracquemond, 1879*

Pissarro's artistic pilgrimage in the late seventies and early eighties plunged him into the challenging, if unremunerative world of printmaking. It was an exhilarating artistic experience and it offered what he always found stimulating—the working companionship of artists he respected, in this case, Edgar Degas and Mary Cassatt.

The challenge was to achieve the "painterly" effect of Impressionism—the play of light, the subleties of shadow, the range of tonal values—by technical means. He had to make a sketch, transfer his "impression" to the plate in his studio, rework the plate to his satisfaction—scraping, burnishing, adding or deleting, crosshatching—retouch the plate with ground, immerse it in acid and pull proofs. The pursuit of technical mastery was a dominant characteristic of Pissarro's printmaking.

He had made his first etching in 1863, greatly influenced by Corot. Occasionally he had executed others, tentative and casual, until 1874, in Pontoise. There he had worked with Dr. Gachet and made several etchings, including the massive and magnificent portrait of Cézanne. In this period, his etchings were done in line, with no effort at tonality in the subleties between white and black. He also experimented with lithography in 1874, producing a dozen images, but did not return to it for twenty years.

The stimulus for his involvement with printmaking at the end of the seventies came from Degas, who had the idea for launching an ambitious project, a monthly journal of prints, *Le Jour et la Nuit,* if sufficient backing could be found, especially from Caillebotte. He invited Pissarro, Mary Cassatt, Félix Bracquemond (the printmaker who exhibited with the Impressionists), Caillebotte, Marcellin Desboutin, and Raffaelli to participate with him, but only Degas, Cassatt, Pissarro and Bracquemond worked on the first issue. Of the original group of Impressionists, Pissarro was the one Degas singled out to collaborate with. It may seem surprising that two such different personalities were drawn into a close working relationship; indeed, a clash would seem inevitable. The bachelor Degas was arrogant, élitist, upper bourgeois, anti-social, politically conservative, his interests focussed on city life and night life. The white-haired family man, Pissarro, was modest, gentle, conciliatory, sociable, of insular Jewish-bourgeois background, politically radical, a painter of the countryside.

Degas scorned *plein-air* painters "who cluttered up the field with their easels" and attacked "paintings by which you can tell the time of day as by a sundial." Pissarro's

reliance on his "sensations" was foreign to Degas, or so he claimed. "No art was ever less spontaneous than mine," Degas said ". . . of inspiration, spontaneity, temperament—temperament is the word—I know nothing."

But at that moment, the two had much in common. There was mutual respect, the core of any working relationship. Degas had been one of the first to buy paintings by Pissarro, who admired him more than any of the Impressionists—"without doubt the greatest artist of the period," he called Degas—and they shared a conviction that solid composition was important. Despite differences about artists to be included, they also shared the tensions of the exhibitions and, more than the others, an unwavering belief that they should be continued. Although they proceeded from different philosophies, they were the most consistent in their opposition to the Salon and the official art circles. Both wanted public recognition but showed an antipathy to seeking it. Self-promotion was alien to both of them. While Pissarro painted and drew peasants at work in the fields, Degas pictured the ballet dancers, seamstresses and laundresses in their jobs in the city. Both drew and painted women at their tasks—often in the awkward and ungraceful positions of everyday activity—although from different emotional and social bases. Degas studied his subjects with detachment, as a scientist would observe them under a microscope. Pissarro felt empathy for his peasant women. Pissarro could never have made Degas's monotypes of prostitutes, drawn without mercy and at times almost pornographically, but he shared Degas's absorption with the female figure and lacked only the money for models.

They admired the same artists. "There have been three great draftsmen in the nineteenth century: Ingres, Delacroix and Daumier," declared Degas, who collected 1,800 lithographs by Daumier and as many done by Ingres as he could afford. He drew inspiration from all three, especially Ingres and Delacroix. Pissarro told Lucien of seeing works by Ingres that were "wonders" and "marvellous" and once sent Lucien ten lithographs by Daumier and one by Delacroix, writing, "I prize them very much . . . fill your mind with the real artistry of these two great masters." Both, concerned with ideas, were more intellectual than the other exhibitors. In fact, politically conservative though Degas was, this complex and contradictory man had enough objectivity about French society to express approval of parts of what Proudhon advocated in *De la Justice*, *Du Principe de l'Art* and *Confessions*, although he satirized Proudhon's verbosity. When Pissarro advocated anarchism, he had an informed as well as a sardonically biting opponent. And Degas, unreconciled to the new industrialization and the changes taking place in French society, could appreciate Pissarro's landscapes of a relatively unchanged rural France.

Degas was a reserved, private man, selective in his contacts and lofty in his critical standards. At that particular time of his life, Pissarro's qualities seemed to meet his needs. It is likely that the perceptive, tolerant Pissarro, who found the Impressionists's quarrels "so human and so sad," sensed that Degas's biting tongue and hostile manner were symptoms of insecurity and feeling of rejection. Degas later confessed to a friend, Evariste de Valernes:

> I was, or seemed to be, surly with everybody. I had a sort of urge to be brutal, due to my unsureness of myself and my bad temper. I felt so ill-made, so ill-equipped, so ineffectual,

Paul Cézanne, 1874. Etching. (D 13) 10⅝ × 8⅜. 27 × 21.4. New York Public Library

Desboutins: *Portrait of Degas,* 1876.
Etching. Photo Durand-Ruel, Paris

and yet it seemed to me that my approach to art was the right one. I nursed a grievance against everyone and against myself. I beg you to forgive me if sometimes because of this confounded art of mine I have wounded your lofty, so wonderfully understanding mind, even perhaps your heart as well."

At about the time Degas wrote that, Pissarro was pointing out to Lucien that Degas was "very fine and sympathetic to people who are in trouble."

Perhaps what bound them most was the fellowship of printmaking, the endless challenges, the constant discovery of new techniques, new variations on ancient methods, the search for perfection. Pissarro wrote Lucien, "I continue to jog along, surrounded by my unfinished paintings and drawings, seeking the rare bird whose plumage is resplendent with all the colors of the rainbow, whose song is musical and pure; perfection, as Degas would say, why not!"

In the pursuit of that perfection, they were like freewheeling jazz musicians in their improvisations, combining simple etched lines with soft-ground etching, adding aquatint, touching up with drypoint. They invented the *manière grise*, or "gray manner," to obtain lightly shaded tints or large tonal areas, simulating the effect of a fine-grained aquatint by rubbing the plate with a pencil-shaped emery stone. They became virtuosi of the copperplate, as uninhibited by conventional methods of printmaking as by the traditions of academic painting.

Pissarro's goal in prints as in painting was to express his "sensation." He was often more concerned with the overall impression than with precise draftsmanship. "Engraved impressions," he called these prints. Sometimes he used aquatint to portray the broad mass of an object rather than to model it. He employed soft-ground uniquely and rolled sandpaper into a stump, using it to get grain effect (confusing the critics, who thought it aquatint). As a printmaker, his goal was to achieve on copper or zinc the tonal effects of an Impressionist painting.

Sometimes, like Degas, he retouched the proofs with pastel or watercolor, making them even more unique, seeking more complex effects. The possibilities were endless: adding aquatint or drypoint strokes or soft-ground to the original etched lines, with variations in the bite of the acid, the paper used, the inking, the pressure of the press. The inking particularly gave him scope for creating painterly prints by using it generously or sparingly, by wiping it precisely or smearing it.

In 1878, Pissarro made only one print; but his output jumped to eleven in 1879, and in 1880 he made six more. On many of them, he worked closely with Degas. It was a therapeutic experience. In 1879, he seems to have shaken off his depression, undoubtedly stimulated by the lure of copper or zinc and needle, and by the cooperative involvement with Degas and Cassatt.

It was the first time he had worked with Mary Cassatt. The aristocratic Pennsylvanian expatriate and the fatherly, transplanted Antillian formed a lifelong friendship. She had appeared in the Salon of 1874 and joined the fourth Impressionist exhibition at the invitation of Degas. She quickly developed a liking and respect for Pissarro, bought some of his paintings and induced her friend Louisine Elder (later Havemeyer) to purchase a Pissarro painting as one of the first in her collection of Impressionist works. In 1881, when Mary Cassatt's brother visited Paris, she brought him Pissarro and Monet paintings to launch him as a collector. When she entertained American friends, she often tried to sell them one of Pissarro's paintings, left with her for that purpose. Cassatt and Pissarro occasionally went to galleries together, where his white beard must have made them seem like father and daughter, although he was only fifteen years older. She respected his judgments, his intellectual curiosity and his vast experience. Later she recommended pupils to him (although he was usually loathe to give formal instruction), for, as she said, "Pissarro could have taught stones to draw correctly." In the dispute over the seventh exhibition, Gauguin urged Pissarro to see Mlle. Cassatt because of his "influence" over her.

Since Degas had an etching press, Pissarro occasionally pulled the proofs himself, sometimes working alongside Degas or Cassatt. Sometimes he sent the plates to Degas or to another artist, Jacque, or to Salmon or Delâtre, professional printers of etchings, for proving. Never happy about entrusting the presswork to others, since inking was so vital in the effects he sought, he longed to have his own press.

Except for the etching made for *Le Jour et la Nuit*, he pulled few proofs, often only one or two, of each state, annotated them for later comparison, and then went to work on the next state. He pulled so few proofs because, like Degas, he had no commercial purpose, keeping them for himself or giving them to a few friends or to his sons. Because of the economics of print collecting, their scarcity now makes them most valuable.

The basic etching procedure is relatively simple. After a plate, preferably copper, is prepared with an acid-proof ground of resin, the etcher draws his design with a needle, penetrating to the copper when he wants a line to print. The plate is then put in an acid bath, which eats away the exposed parts. For variety of strength of line, the plate is taken out of the bath as soon as the bite reaches lines which the artist wants to be faint. These lines are then "stopped out" with a protective varnish; the copperplate is returned to the bath, which bites more deeply into the other lines; they are then varnished, and the process is repeated. When only simple lines like these are used, a single light suffuses the entire proof, and modeling is achieved only by crosshatching.

Degas was not only generous in sharing his equipment and technical knowledge but warm and direct in his comments. On one occasion, he wrote Pissarro:

> I compliment you on your enthusiasm. I hurried to Mlle. Cassatt with your parcel. She congratulates you as I do in this matter.
>
> Here are the proofs: the prevailing blackish or grayish shade comes from the zinc, which is greasy in itself and retains the printer's black. The plate is not smooth enough. . . . [Zinc was inferior to copper as an etching plate, but much cheaper.]
>
> In any case you can see what possibilities there are in the method. You must practice dusting the particles in order, for instance, to obtain a sky of uniform gray, smooth and fine. That is very difficult, if one is to believe Maître Bracquemond. . . .
>
> This is the method. Take a very smooth plate (it is essential, you understand). Degrease it thoroughly with whitening. Previously you will have prepared a solution of resin in very concentrated alcohol. This liquid, poured after the manner of photographers when they pour collodion onto their glass plates (take care, as they do, to drain the plate well by inclining it), this liquid then evaporates and leaves the plate covered with a coating, more or less thick, of small particles of resin. In allowing it to bite, you obtain a network of lines, deeper or less deep, according as to whether you allowed it to bite more or less. To obtain equal hues this is necessary; to get less regular effects you can obtain them with a stump or with your finger or any other pressure on the paper which covers the soft-ground.
>
> Your soft-ground seems to me to be a little too greasy. You have added a little too much grease or tallow.
>
> What did you blacken your ground with to get that bistre tone behind the drawing? It is very pretty.
>
> Try something a little larger with a better plate.

Degas is describing here the preparation of liquid aquatint, essential for Pissarro's purposes since it made possible a richness and variety of tonal color. When the acid penetrates the porous ground of aquatint, it forms hundreds of tiny dots that make a tint, essential for modeling, for shadows, for reflections of light, for tonal relationships, for adding a painterly quality to an etching when combined with other methods. Degas was also learning from Pissarro, as his inquiry about the bistre tone indicates.

In the same letter, he discussed adding a new dimension—color—and the connoisseur of the night club and ballet finds himself enthusiastic about Pissarro's cabbages. "As for color, the next one you send, I'll have a print done in colored ink. I have some other ideas, too, for color plates. Do try to produce something more finished. It would be delightful to see some very careful outlines of cabbages. Remember, we have got to make a start with one or two really fine plates from you. I am going to make a start

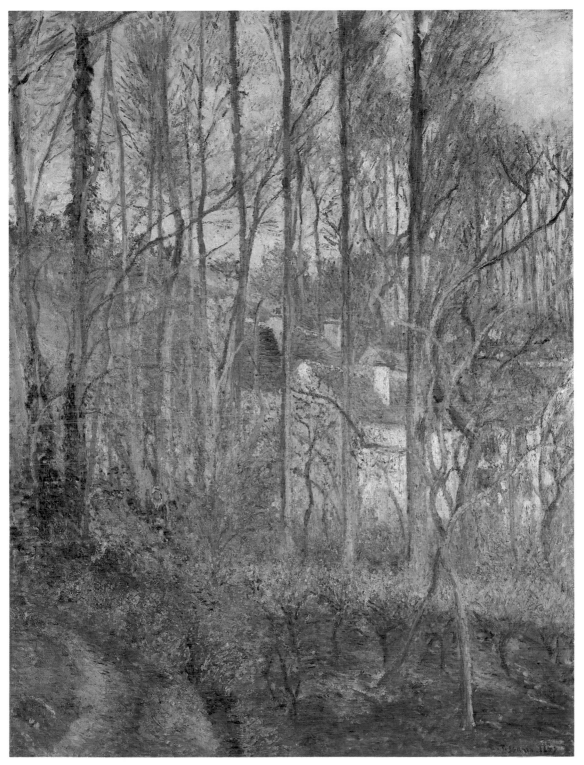

La Côte des Boeufs, 1877. (380) 44⅞ × 34¼. 114 × 87. National Gallery, London

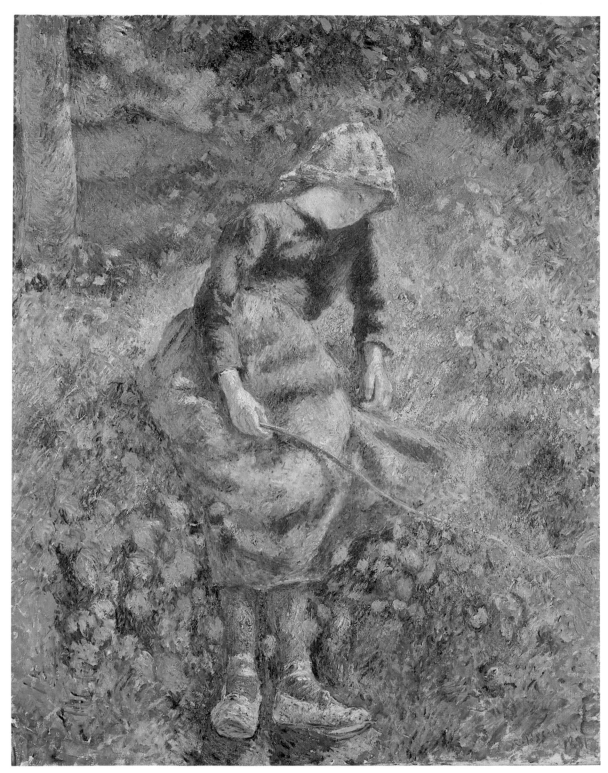

Young Girl with a Stick, 1881. (540) 31⅞ × 25⅝. 81 × 65. Musée du Louvre (Jeu de Paume)

myself one of these very days. . . . No need to compliment you on the artistic quality of your vegetable gardens. . . . Good luck."

Pissarro promptly accommodated him with *The Field of Cabbages*, done completely in soft-ground.

There is a simple explanation of Degas's reference to the "soft-ground" being too "greasy." Soft-ground etching looks as if it were drawn by a pencil, which in a sense it is. When the ground is prepared, tallow is mixed with it. The etcher lays a thin sheet over the ground and draws directly on it with a pencil. Some of the ground sticks to the paper when it is taken away, creating a soft, grainy effect when the acid bites into the plate.

All these methods, plus drypoint, in which the artist scratches his lines directly on the plate with a steel needle, were used by Pissarro, often in combination, as he would sometimes go through state after state until he felt he had exhausted the possibilities. For one print, he made as many as sixteen states, more even than Rembrandt, his ideal as painterly etcher. In some cases, he changed the mood, even the season, as he made new states, adding or dropping figures, shifting the shadows. In a sense, he was creating a "series," as Monet did with his cathedrals and haystacks. To a conventional printmaker, the final state usually, though not always, represented the achievement of his goal. In some instances, this is true of Pissarro; but often his "final" state was simply one of many different approaches to the original motif.

Degas, too, made numerous states, once as many as twenty, but his changes were usually less basic, more often minor, reflections of his striving for perfection. Like Pissarro, he regarded printmaking as a challenge, a pictorial exercise, to be done for pleasure alone. His absorption in the process is reflected in a letter from Marcellin Desboutin, the engraver and witty café companion of the Impressionists: "Degas . . . is no longer a friend, no longer a man, no longer an artist. He is a plate of zinc or of copper blackened with printer's ink and this plate and man are laminated by his press in the gears of which he has completely disappeared!"

Degas tried to shame Bracquemond into active involvement in *Le Jour et la Nuit*. "The aquatint is progressing even without you (who should be teaching us instead of leaving us to our own devices)," he wrote Bracquemond near the end of 1879. "Pissarro has just sent, via the Pontoise carrier, some attempts at soft-ground etchings. . . . Pissarro is delightful in his enthusiasm and faith." And later: "We must talk about the journal. Pissarro and I together made some experiments, of which one by Pissarro is a success. Mlle. Cassatt is in the midst of some at this moment. It is impossible for me, with my living to earn, to devote full time to it."

(In 1878, Degas's sense of honor impelled him to give up most of his money to repay debts incurred by other members of his family. He was no longer affluent, but, unlike Pissarro, he always had a market for his work among wealthy collectors.)

He was enthusiastic about the journal. "Mlle. Cassatt is making some delightful experiments in prints," he wrote Pissarro. "Try to come back soon. I am beginning to tell everyone about the journal. . . . we are going to cover expenses. That's what several print collectors have told me."

As the opening of the fifth Impressionist exhibition neared, where *Le Jour et la Nuit*

was to make its debut, Degas's excitement rose. "It is opening on April 1," he wrote Bracquemond. "The posters will be up tomorrow or Monday. They are in bright red letters on a green ground. There was a big fight with Caillebotte as to whether or not to put names on. I had to give in and let him put them up. When on earth will they stop the headlining?" Degas deplored all personal publicity.

When the exhibition opened, Pissarro, Degas and Cassatt displayed the prints they had prepared for *Le Jour et la Nuit*, Pissarro's colorfully mounted on yellow paper, with purple frames, the colors of sunlight and shadow. Unfortunately, this was the journal's

Woods and Undergrowth at the Hermitage, 1879. Etching and aquatint. (D 16) 8⅝ × 10⅝. 21.9 × 26.9. Bibliothèque Nationale, Par

Effect of Rain, 1879.
Aquatint and
drypoint. (D 24)
6¼ × 8⅜.
15.9 × 21.3. New
York Public Library.

only semblance of an issue; Degas was unable to raise enough funds from Caillebotte or others to finance publication. Since none of the participants had ever previously tried "commercial" printmaking—and had open contempt for it—Degas's failure was not surprising.

Though unappreciated, the prints were brilliant portents of the graphic work yet to come from these three artists, and all three were sufficiently related in technique to reflect their collaboration. In *In the Opera Box, No. 3 (Lady with a Fan)*, Cassatt uses soft-ground and aquatint to achieve a massive sculptural portrait of her sister Lydia holding a fan and posed against the sweep of the balcony in a darkened house, a beautiful study of light and shadow.

Degas chose to present *Mary Cassatt at the Louvre, Musée des Antiques* (etching, aquatint and drypoint), showing Cassatt and her sister Lydia gazing at a husband and wife in an Etruscan sarcophagus. The living and the dead seem to be confronting each other in this witty, subtly toned print, Cassatt drawn from the rear, poised, confident, with the appraising manner of a connoisseur.

The subject selected by Pissarro, the only landscapist among the Impressionist printmakers, was *Woods and Undergrowth at the Hermitage,* in which he masterfully combined soft-ground, drypoint and aquatint to capture the differing ways in which light strikes trees, roofs, undergrowth and a solitary figure. It is a reverse approximation of the 1879 painting of the same name; through dense trees and undergrowth the

Woman Emptying a Wheelbarrow,
1880. Etching and aquatint. (D 31)
12½ × 9. 31.9 × 23. Fourth state.
The Art Institute of Chicago.
DeWolf and Joseph Brooks Fair
collection, 1957

sides and roofs of houses are glimpsed. Pissarro often used this familiar motif of foliage and curving, twisted branches against the solid forms of houses. Again, it is a picture that requires much "seeing"—the viewer has to peer through the tangled underbrush to make out the houses and hills, all drawn in clear perspective. Like the paintings, it demands study. Penetrating through the tree barrier, the viewer becomes aware of horizon and sky, of the sinuous grace of tree trunks and branches, of surface bark peeling in the late fall, of a tonal harmony that bids him to cross the fields into the hills. As in so many of his paintings, the total "envelope" of light unifies the heterogeneous elements.

In the exhibition, Pissarro displayed in one frame four states of the six made of this print, as he did with two other prints. Since there was often an abrupt change in mood and technique between some of the states, the effect was of a series: the first was an eerie abstraction; in the second, forms take shape darkly, modelled by aquatint; by the sixth, light has completely broken through the linear pattern of trees.

Possibly out of disappointment at the failure of *Le Jour et la Nuit*, Degas made no more etchings or lithographs until 1884, but Pissarro kept experimenting on his own. His subjects were varied: landscapes, cabbage fields, effects of rain (the Japanese influence here), sunset, twilight, footpaths in the woods, lonely figures wandering on

Woman Emptying a Wheelbarrow,
1880. Etching and aquatint. (D 31)
12½ × 9. 31.9 × 23. Sixth state.
Sterling and Francine Clark Art
Institute, Williamstown, Mass.

the road—later a recurrent theme in radical art. In many of these and most of his later
prints of farm life, his subjects are women performing menial tasks. He was drawn to
the female figure in the work milieu of rural France, with its isolation and its demand-
ing toil. If there is any ideology, it is a humanistic empathy with his subjects. He does
not find their work debasing, as he later shows industrial labor to be. Not until the
mid-nineties did he make any prints that bordered directly upon the political. The
themes are often similar to those of his paintings, but the prints have, of course, a more
intimate quality, and many of the figures have more fluidity than those in his paintings.
Their relatively small size, however, and prosaic subjects have limited their popularity
mostly to connoisseurs. They lack the immediate impact, for example, of Renoir's
colorful, larger lithographs.

 One of his greatest prints of this period, *Woman Emptying a Wheelbarrow*, went
through eleven states, of which an early one reflects the bleakness of winter, the side of
a barn visible through a bare tree with branches like a witch's arms. By the eleventh
state, the scene has become a sunny summer's day and it is the blooming foliage of the
tree that obscures the barn. (Eight impressions of this print, of varying states, were
found in Degas's atelier after his death.)

 Although his use of aquatint is uneven in his early works, in *The Rondest House at*

the Hermitage he achieves a transparency of tone that has the delicacy of a Japanese wash drawing. Silence pervades the wispy lyrical beauty of this scene. The print is a remarkable tour de force that in the handling of light and shadow approaches an Impressionist painting.

In this print and several others, Pissarro's delicacy of tone achieved an overall painterly effect that elicited praise from Degas, whose relationship with Pissarro was reflected in several monotypes made between 1878 and 1880. Although he ostensibly scorned landscape painters, he executed a number of monotypes of landscapes, either from quick sketches or from memory; in some, he seems to have drawn on Pissarro motifs for inspiration: The winding road ending at the horizon in *La Route* is reminiscent of many of Pissarro's paintings. *Willows* picks up the curving road and the willow trees of Pissarro's print *Twilight with Haystacks,* and *The Climbing Path* has the familiarity of a detail from Pissarro's 1875 painting *The Climbing Path at the Hermitage, Pontoise.* Pissarro probably learned the monotype technique at this time from Degas, although he did not apply it until much later.

Pissarro's unpretentious, often untidy subjects do not have the immediate appeal of Degas's ballet dancers or Renoir's nudes and children. His line is never as sweeping or as strong as Degas's. His faces are often weakly drawn and lack individuality; he seems more concerned with the search for the effects of atmosphere, and in this he succeeds. In his handling of light and shade and reflection, he is the most "impressionist" of the Impressionist printmakers.

The Rondest House at the Hermitage, 1882. Etching and aquatint. (D 35) 6½ × 4⅜. 16.5 × 11.2. Bibliothèque Nationale, Paris

Twilight with Haystacks, 1879. Etching, aquatint and drypoint. (D 23) 4½ × 7. 11.5 × 18. Bibliothèque Nationale, Paris

Long Landscape, 1879. Etching and aquatint. (D 17) 4½ × 15½. 11.3 × 39.4 British Museum, London

14.

First One-Man Show

*"I will calmly tread the path I have taken,
and try to do my best."*
—*Pissarro to Lucien, 1883*

WHEN the time came to begin planning the seventh Impressionist exhibition, to be held in the spring of 1882, Pissarro found himself in the middle of a three-cornered dispute involving Caillebotte, Degas and Gauguin. Caillebotte was refusing to exhibit with Raffaelli, the friend of Degas, ostensibly because he painted in a conservative realist, rather than Impressionist, style, but essentially because Caillebotte had not forgiven Degas for his treatment of Renoir and Monet when they had participated in the Salon of 1880. Degas attempted to smooth over his differences with Caillebotte, insisting, however, on including Raffaelli in the exhibition. The dispute gathered momentum, and Gauguin made a dramatic gesture of resigning in response to Degas's threat to resign, and wrote to Pissarro on December 14, 1881:

> Yesterday Degas told me angrily that he would sooner hand in his resignation than turn away Raffaelli. If I look coolly at your situation, ten years since you undertook the task of these exhibitions, I immediately see that the number of Impressionists has grown, their talent has increased and also their influence. In contrast, on Degas's side and by his doing alone the trend has been worse and worse; every year an Impressionist has left to give way to nobodies and students of the Ecole. In another two years you alone will be left in the midst of these schemers of the worst kind. All your efforts will be for nothing and Durand-Ruel's too. In spite of all my good will I cannot continue to act as buffoon to M. Raffaelli and Company any longer. Please then accept my resignation. . . . I believe that Guillaumin feels the same way. . . .

Faced with the defection of Caillebotte and Gauguin, Pissarro found himself with divided loyalties in a difficult situation. There was no doubt that Gauguin was right; after the departure of Cézanne, Sisley, Renoir, Monet, Caillebotte and now Gauguin and possibly Guillaumin, Pissarro and Berthe Morisot would be the only painters who worked in the Impressionist style in a group taken over by the friends of Degas. He deeply respected Degas as an artist in spite of his prickly personality, but he wanted to hold the Impressionist group together, and Degas was the divisive force. He was troubled and hesitant about making a decision. Gauguin responded to a letter from him on January 18, 1882:

> I received your extraordinary letter this morning; one would say that the fog is influencing your mood at present. You are certainly in a black mood; I thought that you didn't use that color any more. . . . Not much is happening [with the exhibition]; we have an obligation of

176

6,000 francs on our hands [the rent for the exhibition space at 251 rue St. Honoré for three years], complete misunderstanding among the group and nothing resolved. Guillaumin doesn't even know whether to go ahead and order his frames. I will never give up my conviction that for Degas, Raffaelli is a pure pretext for breaking with the group. That man has a perverse spirit which destroys everything.

Gauguin was convinced that the Impressionists could succeed only by joining together and presenting themselves as a movement. Much of his correspondence with Pissarro in 1881–82 expresses his ideas on that subject. "In each epoque a movement takes form and surges ahead. . . ." he wrote. "We are interesting because with talent we form a phalanx of painters convinced of the value of our movement and protesting against the merchandising of art. . . . Yes, grouped together we are interesting. Abroad as well as here they follow the battle eagerly and if they feel that we are united they will cry bravo. . . ."

And again urging that the exhibitions be made up only of those painters who worked in the Impressionist style: "If you put a Cézanne beside a placid, conventional landscape, the Cézanne will look like a joke. If, on the contrary, you are grouped together, the similar nature of the ensemble forms a *principle* which imposes itself [on the viewer]. . . ."

Gauguin shrewdly insisted on the strength to be gained by presenting a united front, showing the public that this new painting was not an isolated phenomenon but an important tendency in nineteenth-century painting. His canny sense of the place of

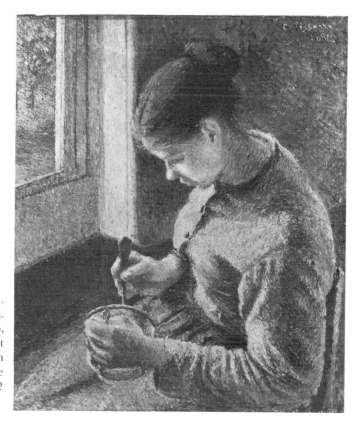

The Café-au-Lait, 1881. (549) 25 × 21½. 65 × 54. The Art Institute of Chicago, Palmer collection. Shown at seventh Impressionist exhibition and first retrospective exhibition, 1892

Impressionism in history focussed his considerable energy on the stalled seventh exhibition. Pissarro must have expressed despair at the prospect of ever carrying through their plans, for on January 25, 1882, Gauguin exhorted: "If you abandon the game, it is finished. . . . See Caillebotte and organize yourself to exhibit *this year* . . . if Caillebotte doesn't want me, I give you full authorization [to go ahead anyway]; the essential thing is that the *Impressionists* exhibit. . . . Do the exhibition with five if you wish; you, Guillaumin, Renoir, Monet and Caillebotte, but do it, you know that your future depends on it. . . ."

It was Durand-Ruel, impatient with the wranglings, who took charge, soothing pride and solving differences. Since he handled their pictures, he had a keen interest in seeing a successful exhibition of their works take place. Monet and Renoir were loathe to refuse him when he pressed them to exhibit. He had done so much for them and their comrades; they did not want to alienate their most important dealer. Even so, Renoir, who was ill with pneumonia in L'Estaque, wrote Durand-Ruel several bad-humored letters. At first, he was willing to show only with Monet, Sisley, Morisot, Degas and Pissarro. Then he refused to show with Gauguin and resented Pissarro's insistence on including him: "Let it be understood that I will not be associated in any way with the Pissarro-Gauguin combination. . . . Please don't take this personally, because it's not you who is doing this exhibition, but M. Gauguin; I continue to be your devoted and faithful artist. I am only looking after our common interest for I estimate that to exhibit there would make my prices fall by 50%."

Included with the same letter was a rough draft of a note that Renoir dictated to his brother from his sick bed:

> . . . To exhibit with Pissarro, Gauguin and Guillaumin is as if I were to exhibit with some sort of socialist group. A little farther and Pissarro will invite the Russian Lavrof [the Russian anarchist, Pierre Lavrof] or some other revolutionary. The public doesn't like what smells of politics and I certainly don't want, at my age, to become a revolutionary. To continue with the Israelite, Pissarro—that's revolution. What's more, these gentlemen know that I took a big step forward as a result of showing at the Salon. It is a matter of not losing what I have gained. They will do anything, even at the price of dropping me once [the show has] failed. I don't want that! I don't want that! Get rid of these people and give me artists like Monet, Sisley, Morisot, etc., and I am with you, for it's not about politics any more, it's about pure art.

It is possible that the note reflected the views of Renoir's brother rather than those of Renoir himself. Pissarro later wrote Monet:

> Do you know, my dear Monet, that the younger brother of Renoir is really insufferable, not that his complete nonsense has any effect on me, but it does cast discredit on his brother in particular and on our group in general. . . . This wretched Renoir has treated me in the worst way; it seems that I am a prime schemer without talent, a mercenary Jew, playing underhanded tricks to supplant you, mon cher, and Renoir. It is so absurd that I pay no attention to it, only the dangerous aspect of it is the dispute he stirs up, the discord he tries to provoke. It has miscarried, my friends knowing what to believe, but it has cast suspicion on Renoir the painter who certainly does not deserve it . . . it seems to me that I have always shown great admiration for his brother. Is it because I am an intruder in the group? . . .

Pissarro in his studio.
Photograph Pissarro family documents

Julie Pissarro, 1883. Pastel.
Private collection, England.
Photo courtesy John Rewald

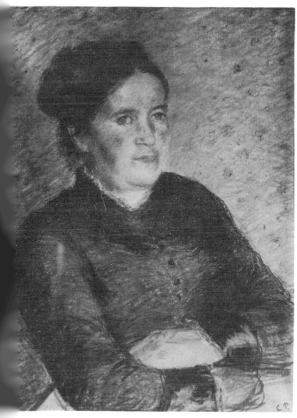

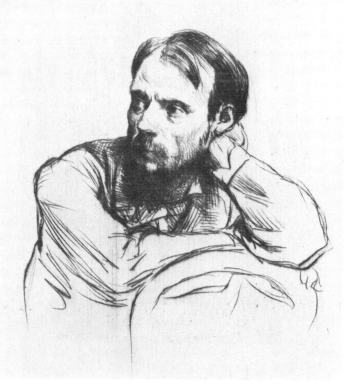

Desboutins: *Renoir.* Etching and drypoint.
Bibliothèque Nationale, Paris

For all his close friendships, he still felt insecure, the outsider, the alien.

Renoir later excused himself for the content of his note, with its hint of anti-Semitism, on the grounds that he had been ill at the time it was written. Although the anti-Semitism may have been his brother's, Renoir's attitude toward the politics of Pissarro, Gauguin and Guillaumin is clearly antagonistic. Gauguin's political stance is not known; he never discussed it in his letters. Renoir's judgment indicates that Gauguin shared at that time the attitudes of his father, Clovis Gauguin, a journalist whose republican sympathies had forced him to leave Paris in 1849, when Louis Napoléon came to power, and of his famous grandmother, Flora Tristan, a militant socialist and fiery revolutionary. In any case, Renoir certainly grouped Pissarro, Gauguin and Guillaumin together as political leftists and feared being tainted in the eyes of the public by associating with them. "It's not about politics any more" implies that the Impressionists did have a political position previously, which Renoir now wished to avoid in favor of "pure art." In the same note, in what seems to be a sarcastic defense of his determination to show at the Salon, he says: "Unfortunately, I have one goal in life and that is to sell my paintings for higher and higher prices."

In spite of all the difficulties, the seventh Impressionist exhibition did in fact open on March 1 at 251 rue St. Honoré. The participants were Renoir (who allowed Durand-Ruel to exhibit the paintings he already owned), Monet, Sisley, Pissarro, Caillebotte, Morisot, Guillaumin, Vignon and Gauguin. Degas did not exhibit, in protest against the exclusion of Raffaelli. This show was more homogeneous than the previous exhibitions; all the participating artists painted in the Impressionist style, and each showed a substantial number of canvases. The effect came closer to demonstrating Gauguin's idea of the importance of Impressionism as a *movement* with a strong central principle. The critical reception was warmer this time, or at least the press was less aggressively hostile. Jules Clarétie mixed his faint praise with condescension and concluded that the ". . . group was composed of people with right ideas and wrong colors. They think well but their vision is faulty. They show the candor of children and the fervor of apostles. I am thinking of the gray-haired ones like M. Pissarro. One might be tempted to admire them, these naive creatures!"

Huysmans, in his review, regretted the absence of Degas and Raffaelli and expressed annoyance at the predominance of landscape. Pissarro, however, showed twenty-five oils, ten gouaches, and one distemper, only nine of which were pure landscape. The balance were scenes of peasants working or resting. He also showed several canvases dominated by large figures seen close up.

Gauguin, now solidly entrenched with Pissarro's faction of the Impressionists and grudgingly accepted by the others, continued to pursue his interests: painting, collecting and finance. He was doing sculpture as well and had evidently interested Pissarro in this medium. In an undated letter, probably written in 1882, he gave Pissarro some technical advice about armatures and commented: "Decidedly, a mania for sculpture is developing. Degas does it—he shows horses in sculpture and you are making cows. . . ." (No sculptures by Pissarro are now known; whether or not he ever actually completed or preserved any of his sculptured cows is uncertain.)

The Paris stock market fell sharply in 1882, and a major bank, l'Union Général,

failed. The prosperity of 1880–82 had collapsed, leaving a wake of bankruptcies, including that of Durand-Ruel's backer, Feder, from whom he had borrowed the money to back the Impressionists. The effect was not felt immediately, for contrary to previously published accounts, Durand-Ruel did continue to make payments to Pissarro and to the others, although at a rate which gradually diminished after 1883. His payments to the Pissarro account totalled about 12,000 francs in 1882, about 14,000 in 1883, about 10,000 in 1884, and about 9,000 in 1885.

With four children and a wife depending on him and with the economy in a depression, Gauguin felt his situation growing more precarious. He wrote to Pissarro, "The love of my art occupies my mind too much for me to be a good employee in business, where one cannot be a dreamer. But on the other hand, I have a large family and a wife who is unable to cope with poverty."

Gauguin's and Pissarro's ideas of poverty were different. Gauguin had a shrewd sense of the value of money and the ways to make it; he had achieved a degree of comfort and had savings and assets. Pissarro lacked financial security from the time of his liaison with Julie. But he was at least accustomed to living in insecurity and coping with the problems of supporting a large family. He then had five children, including the baby, Jeanne (called Cocotte), born in 1881 and named after her dead sister. And he had the help of Julie who was used to making do on a minimum budget and using her wits and hard work to keep the family fed. By comparison, Gauguin and his family lived extravagantly. He had made 35,000 francs in the boom year of 1879, but Mette had never been very good at economizing. He did the best he could at juggling his needs. He continued to work at his office during the week, and on Sundays he visited Pissarro and painted with him.

Pissarro invited him to spend the summer holidays with them again in 1882. At this time, they probably collaborated on their extraordinary double portrait. Each one

Double portrait of Gauguin by Pissarro and Pissarro by Gauguin, c. 1883. Pencil. Musée du Louvre, Cabinet des Dessins

drew the other on the same sheet of paper. (It is impossible to know who made the first drawing.) Gauguin portrayed Pissarro leaning back, puffing on his pipe, calmly evaluating some painting or idea. The pencil lines are soft and rubbed. Pissarro drew Gauguin in heavy, quick strokes of the pencil, accentuating the angles of his face. Gauguin's nose is sharp and bony, his head forward on his neck, his eyes avid. The younger man seems to look intensely over the shoulder of his mentor as if to absorb by sheer will and energy the object of his thought.

Since the 1882 Impressionist exhibition had been mounted only with great difficulty, amidst disagreements and tensions, Durand-Ruel was reluctant to organize another, deciding instead to hold a series of one-man exhibitions, an idea the artists greeted without enthusiasm. One-man shows were a novelty often ignored by the critics, who disdained them as commercial promotions. Nevertheless, in 1883, Durand-Ruel scheduled shows for Boudin, then Monet in March, Renoir in April, Pissarro in May and Sisley in June.

Pissarro had little faith in one-man shows and almost less in his own painting. When Monet's exhibition opened, he wrote pessimistically to Lucien: "Monet's show, which is marvellous, has not made a penny. A poor idea to have one-man shows. The newspapers, knowing that a dealer is behind it, do not breathe a word. . . . It is very discouraging."

On the eve of Renoir's show, he had a dinner reunion with Duret, deBellio, Monet and Renoir. The principal topic of discussion may well have been "Where do we go from here?" for Monet and Renoir were also at crossroads in their painting. "I have difficulty now in doing what I used to do easily," Monet confessed to Durand-Ruel, and Renoir later recalled, "Around 1883 . . . I had gone to the end of Impressionism and I was reaching the conclusion that I didn't know how either to paint or to draw."

Renoir's show only increased Pissarro's anxieties. "Renoir has a superb show," he reported to Lucien, "a great artistic success, of course, for here you can't count on more than that. I shall appear sad, tame and lustreless next to such éclat. Well, I have done my best."

As the deadline neared, his pre-show jitters grew. "I am discontented. I will not exhibit my ink drawings, I shall show only important works. I shall follow the examples of Monet and Renoir, who did not show more than fifty well-chosen canvases which were then well spaced. . . . I am sad enough in my pictures, there is no point in wearying them still more with a lot of little knickknacks, which can have little interest to strangers—my doubts increase as the moment nears."

By accident or by design, his evening opening had been preceded that day by the opening of the Salon. Although they were glassy-eyed from examining the enormous exhibition of officially selected art at the Salon, Pissarro's friends loyally appeared to pay tribute to the white-haired artist of fifty-three. He was bathed in the warmth and affection of those who had shared his struggles for more than a decade.

Seventy canvases were spaciously exhibited through several rooms. In two of the rooms, the paintings had the white frames that Pissarro preferred. The lighting had improved considerably since his Salon days. On tracks suspended from the ceiling were clusters of gas or arc lights, encased in reflectors focussed on the paintings, which

The Harvest, 1882. Distemper. (1358) 26⅜ × 47¼. 67 × 120. Bridgestone Museum of Art, Tokyo.
Photo © Arch. Photo. Paris/S.P.A.D.E.M. Shown at seventh Impressionist exhibition
and at first one man show, 1883

were hung at eye level, between a panel strip on top and wood panelling below, unlike
the Salon system of covering the walls from top to bottom.

Pissarro included in the exhibition some of his paintings from the mid-seventies.
But rather than show primarily canvases that had previously been well-received—
his paintings from the late sixties and early seventies—he chose to exhibit much of
his newer, more problematic work, painted in short, densely interwoven strokes,
market scenes and landscapes such as *The "Chou" at Pontoise.* The inclusion of many
of his paintings from the searching period of the early eighties must have con-
tributed to his feeling of uncertainty about the show.

Feigning indifference, Pissarro reported the opening laconically and briefly in the
middle of a letter to Lucien. There were "many" visitors, he noted, but: "Am I happy?
Gracious, no, my pictures don't get across—I have been paid many compliments, but I
do not compliment myself. Aside from two or three things, the show is weak. Enough
said on this subject."

The usually objective Pissarro was confusing his unease with his current painting, his
apparent need for a new approach, with past accomplishments. His increasing
uncertainty about Impressionism as he had practiced it for a decade prejudiced his
view of his work: "It goes without saying that I received not a few compliments. The
ones I value most came from Degas who said he was happy to see my work becoming
more and more pure. The etcher Bracquemond . . . said—possibly he meant what he
said—that my work shows increasing strength. I will calmly tread the path I have
taken, and try to do my best." And then his uncertainty pours out: "At bottom I have
only a vague sense of its rightness or wrongness."

Although the one-man shows produced no sales, Durand-Ruel was loyally persistent. He sent three each of paintings by Pissarro, Monet, Renoir and Sisley to Boston. "We should try to revolutionize the new world simultaneously with the old," Durand-Ruel proclaimed to the radical Pissarro. But Boston critics and public paid little heed to the show, as Pissarro had expected. "What will it be like in Boston if in Paris they treat us as sick or as crazy?" Pissarro asked.

Durand-Ruel was undeterred in his search for markets. He opened exhibitions of the Impressionists in Rotterdam and Berlin, and for three months staged a large exhibition at Dowdeswell's galleries in London. Critics complained that the paintings were "unfinished." The *Morning Post* called the show "mirth-provoking . . . a source of comic entertainment"—shades of 1874. But at least the art journals were favorable, according to Lucien's report from London.

Six months later, when Lucien suggested a Pissarro show for London, his father, stung by the critical response there, refused. But then, with acute objectivity under a layer of exaggeration, he noted: "Remember that I am of a simple, melancholy temperament, with a rough and unpolished way of looking at things. It is only in the long run that I can please, if there are those who will view me with a little indulgence."

He was not alone in his discouragement. When Monet, isolated at Giverny and disheartened by the drop in sales, wrote him asking for news of Durand-Ruel, Pissarro was sympathetic but not very encouraging. "I also have been overwhelmed by fear of the future and a great sense of discouragement," he replied. "As to giving you news of Durand-Ruel . . . I know that nothing is selling, in London or Paris, my exhibition has had no receipts . . . as for Sisley's show, it is even worse. . . . Can Durand-Ruel continue like this, it is hard to say."

To Lucien he confessed: "After having made so much effort, it's sad not to be sure of tomorrow."

Although by the end of 1883 he had received 14,000 francs from Durand-Ruel, neither he nor the others could be sure of collecting from the dealer when they needed money. Durand-Ruel often had to refuse specific requests for funds. It was this uncertainty—shared by free-lance writers and artists—that strained the nerves of the Impressionists, already sensitized by traumatic memories of the seventies. And the dealer's laments were not reassuring. "You cannot imagine what difficulties I have had for about a month now," he wrote Pissarro.

As fall approached, Pissarro wrote Monet again: "I have been fortunate enough to have had Caillebotte to help me get through the summer. Without his help, sales would not have been enough to save me from ruin." It had been a difficult summer, but he was not actually facing "ruin" at that moment. The statement reflected the underlying unease among the Impressionists. The ground seemed to be shifting under them: prospects were cloudy, their problems manifold.

15.

Pissarro and Gauguin–II

"Gauguin disturbs me very much; . . ."
—*Pissarro to Lucien, 1883*

IN 1883, Lucien, then nineteen, was sent to London to learn English, in the hope that a bilingual ability would qualify him for a good job in France. Julie was anxious for him to enter the commercial world and thus avoid the trials of the artistic career to which he seemed to be heading. From his childhood, he had sketched and painted: he grew up enjoying the kindly attention and encouragement of his father, Piette, Cézanne, Monet and Gauguin. Camille's first portrait of Lucien, at eleven, shows him sketching. Camille seems to have gone along with Julie's fears, to conciliate her and because he was momentarily discouraged in his own work.

"I spoke to you about my oldest son," he wrote Duret in London. "I have decided to send him to England to accustom him to speaking English and to continue his commercial education. Would you have the goodness to look for a place for him, or to give us some letters of introduction?"

Camille was very close to his eldest son, who resembled him in physical appearance and in personality. His portrait of Lucien in 1883 shows a bearded young man emerging from adolescence, self-conscious and somewhat withdrawn. Gentle, intellectual, creative when he gained self-confidence, Lucien shared many of his father's interests and qualities. The father had always been overprotective of his son, who was ill prepared in temperament or training for the business world. Although Pissarro seemed to accept the need for Lucien to earn a living in business, his chief concern was the boy's development as an artist. Unwittingly, he was setting the stage for many internal and family conflicts.

Lucien's departure for London initiated Pissarro's correspondence with his son. Continued whenever the two were separated, the letters to Lucien rank with the writings of Delacroix and Van Gogh in their revelation of a man as painter-writer. Lively, intimate, poetic, very human, humorous and sad, they reveal his passionate concerns—for his family, his friends, his politics, his art. Perhaps art should head the list: his doubts and satisfactions, his absorption, his detailed and inspirational instruction on drawing—all are in the letters. And his uninhibited judgments of his friends reveal much of them and of him.

Lucien went to live with his moody Uncle Phineas Isaacson and his cousins Alice and Esther. Esther, now twenty-five, introduced him to the pleasures of London. Lively, intelligent, and cultured, she took the shy young man to concerts and museums,

introduced him to her friends and tried to give him confidence. The socially backward Lucien needed encouragement. "If you have no doubts I can do something artistically, I have many," he wrote his father. "Mother tells me to kiss Alice for her. I must regret to report I have contented myself with just thanking her. I have never kissed my cousins and wouldn't dare begin."

Lucien found a temporary, non-paying job with a music publisher. Pissarro was sending him 150 francs a month now, we learn from unpublished letters, more than Camille's father had given him at the beginning of his career. Pissarro was interested in his son's artistic growth, ostensibly as a Sunday painter. When he wrote Lucien in January 1883, immediately after the young man's arrival in London, he added a P.S.: "Don't forget to draw." Hardly any letter is without some reference to art, and in March he wrote, ". . . for your enjoyment—and your future, too, who knows?—do not give up drawing, draw often, always from nature, and whenever possible consult the primitives. If you could only be persuaded that no other activity is so intelligent and so agreeable. What would be perfect would be for you to become quite mad about art; Sundays and holidays would then become days of real happiness—you would await them with impatience—this will not come of itself—you have to feel it!"

To bolster the insecure Lucien, who doubted his talent, the none-too-subtle proselytizer added: "Gauguin came to spend last Sunday with us; he made two sketches. He is completely taken with your still life, as well as with the landscapes you began, they were on the right track. Guillaumin also found your works really fine; they are superior to much that is done by many a painter with pretensions. . . ."

In March, he urged Lucien to give up his "job" as it would divert him from drawing and from long-range goals as an artist; but in June, he was more realistic, urging Lucien to "try to find a paying job where you can learn business. Because one doesn't know what can happen with Durand-Ruel, who seems to me very badly off at the moment. I don't receive what is needed for the house. . . ."

Since his income was so unpredictable, Pissarro could no longer keep his studio on the rue des Trois Frères. "I think I will much regret not having one foot in Paris any longer; it was very useful for me since it allowed me to keep up with the art world. But we must do the best we can."

In the fall, in search of stimulation and new motifs, Pissarro decided to spend about two months in Rouen. He wrote to Lucien on October 31 that he had heard from Gauguin, who was also planning to go to Rouen.

> He is going to look me up and study the place's possibilities from the standpoint of art and practicality. He is naive enough to think that since the people in Rouen are very rich, they can easily be induced to buy paintings. . . . Gauguin disturbs me very much; he is so deeply commercial or at least he gives that impression. I haven't the heart to point out to him how false and unproductive this attitude is. True, his needs are great, since his family is used to luxury, but just the same his attitude can only hurt him. Not that I think we shouldn't try to sell our work but I regard it as a waste of time to think only of selling; one forgets art and exaggerates one's own value.

Pissarro also confided to his son that he was not looking forward to telling Gauguin that the prospects for another Impressionist exhibition looked dim for the following

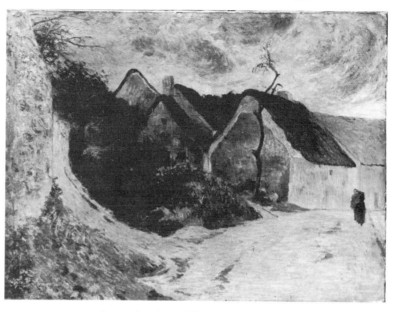

Portrait of Lucien, 1883. Pastel.
(1563) 22½ × 14½. 57 × 37.
Ashmolean Museum, Oxford

Gauguin: *Osny, Chemin Montant*, 1883. Ny Carlsberg
Glyptotek, Copenhagen

year. Gauguin, bent on making his reputation by exhibiting as much as possible, would be sure to cause an uproar. Although, in writing to Lucien, he made a severe judgment on Gauguin's concern with making money (a natural concern for a man with a large family who was considering the risk of switching from business to art at thirty-five), he was loyal to him with potential patrons. He wrote to Eugène Murer on November 2:

> I received a visit from Gauguin who wants to establish himself in Rouen. He is determined to get away from Paris and immerse himself totally in painting; he counts on hard work to win him a place in art. We have covered Rouen looking for a house and the matter should be settled tomorrow. Gauguin counts on isolation to affirm him in his own way and counts on his friends and acquaintances to help him conquer the art collectors. If you could be useful to him around Legrand in particular and his friends in general you would give me pleasure and I would be grateful. Isn't his determination bold? He will succeed!

Pissarro's trip to Rouen buoyed his spirits. He spent two creative months there and discovered a motif that was always to fascinate him and inspire some of his greatest paintings: the industrial harbor of Rouen on the Seine. From his window overlooking the harbor, Pissarro worked on several canvases at once—the effects of fog on the plaza, the sunlight on the river, and the loading of boats on the quays in different kinds of weather. Never idle, he painted the square below from a window in his room when bad weather prevented him from working outdoors, or wandered with his sketchbook through the narrow streets of old Rouen.

Rouen also inspired him to etch a series of prints that express his delight with the ancient city. Collectively, his prints form a panorama of the narrow streets of the old city; the busy squares; the bustling waterfront; the discharge of cargo and hauling of nets; the cranes, masts and smokestacks against the sky; the river and its bridges. One must see the early proofs to appreciate the extraordinarily rich tonality of some of the prints. In his *Rue Damiette, Rouen,* he left a surface of ink, almost like a monotype (probably using sandpaper to vary the depth of the shadows), and achieved a diffused light and overall tonal effect. His 1884 version of the *Place de la République, Rain Effect* is a brilliant achievement, capturing on zinc an effect similar to Impressionist paintings. Instead of broken brushwork, he uses gouges and his *manière grise* to show the tracks in the mud and the reflections on the glistening pavement. Horses struggle to maintain their footing, passers-by rubberneck or press forward in the rain—it is an acutely observed moment of reality. Pissarro must have felt proud of this print, for he displayed it with six others at the eighth Impressionist exhibition, in 1886.

In *Cours-la-Reine,* or *The Banks of the Seine, Rouen,* he reveals his gift for ironic observation. At a busy stretch of the river, silhouetted against the sky are a large willow tree, a smokestack with smoke billowing and the towers of three ancient churches—nature, materialism and spirit existing side by side in rare harmony.

When he finished the paintings on which he had been working simultaneously, he was again assailed by doubts:

> I have just concluded my series of paintings, I look at them constantly. I who made them often find them horrible. I understand them only at rare moments, when I have forgotten all about them, on days when I feel kindly disposed and indulgent to their poor maker. Sometimes I am horribly afraid to turn around canvases which I have piled against the wall: I'm constantly afraid of finding monsters where I believed there were precious gems! . . . Thus it does not astonish me that the critics in London relegate me to the lowest rank. Alas! I fear that they are only too justified.

His natural objectivity reasserts itself:

> However, at times I come across works of mine which are soundly done and really in my style, and at such moments I find great solace. But no more of that. Painting, art in general, enchants me. It is my life. What else matters? When you put all your soul into a work, all that is noble in you, you cannot fail to find a kindred soul who understands you, and you do not need a host of such spirits. Is not that all an artist should wish for?

Much as Rouen restored Pissarro's enthusiasm, he had no illusions about the kind of reception his art would have there. When Murer suggested that he hold an exhibition in his hotel, Pissarro was cynical:

> I don't believe in the possibility of selling pictures at Rouen. You may be sure, my dear friend, that at the sight of my recent studies the collectors would toss rotten apples at me. Remember that in Paris we are still outcasts, beggars. No! it is impossible that an art that upsets so many old conventions should obtain any approval, especially at Rouen, the home of Flaubert, whom they don't dare acknowledge!!! No, the bourgeois are bourgeois, from the tips of their toes to the hair on their heads! Tell Gauguin that after thirty years of painting I am strapped. Let the youngsters remember that.

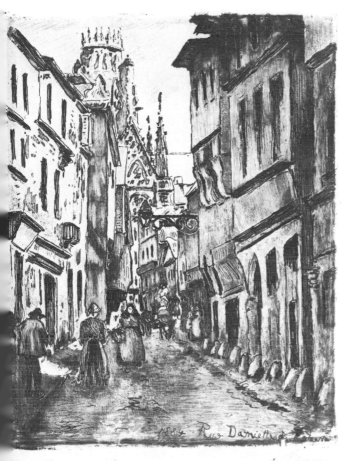

Rue Damiette, Rouen, 1884. Aquatint and drypoint. (D 52) 7⅝ × 5⅞. 19.5 × 14.8. New York Public Library

Place de la République, Rain Effect, 1884. Etching and aquatint. (D 44) 5 × 5. 12.5 × 12.5. New York Public Library

Cours-la-Reine, or **Banks of the Seine, Rouen,** 1884. Etching. (D 49) 4⅞ × 5½. 12.3 × 14. Bibliothèque Nationale, Paris

Back at Osny, he concluded: "Results of my trip: I am glad to be back in my studio; I look at my studies more indulgently; I feel more sure about what is to be done."

Gauguin moved to Rouen early in January 1884, as he had planned, but things did not go well for him; the market for his pictures there was no better than in Paris. The stock market slumped badly in 1884 and pessimism inhibited investment of all kinds, including paintings. Gauguin saw his savings eaten up and his prospects dwindle.

Pissarro continued to help and advise him, but a rift was growing and the differences in their temperaments and philosophies were becoming clearer as Gauguin matured. Pissarro confided to Lucien his disillusion with Gauguin's politics, which evidently supported the imperialist policies of the French government in Indo-China. The

House in the Country, 1883. (596) 28⅝ × 36⅜. 73 × 92. Private collection, Cleveland

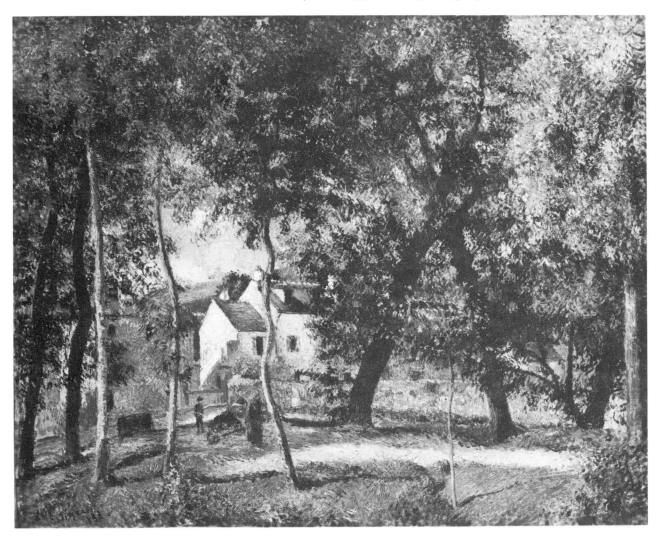

government had sent a military expedition to enforce the treaty which made the area a French protectorate. Its chief, Henri Rivière, had just been killed in Hanoi by anti-French insurgents in a surprise attack. Political opinion in Paris was split. Those who, like Pissarro, were opposed to the government, favored a minimum of French interference in Indo-China and felt that Rivière's death was being used as an excuse to escalate the hostilities, with territorial expansion as the ulterior motive. Pissarro wrote:

> That crazy Gauguin has been praising our foreign minister's policy to the skies. I listened to him for a long time; he slaughtered the opposition for its stupidity and senselessness just as he did during the Tunis incident and on other occasions. I listened quietly. I am always intimidated; I don't know enough about these matters. But at last I begin to realize that my poor friend Gauguin does not always see clearly—he is always on the side of the bastards! He is more naive than I thought. . . .

In August, Gauguin wrote Pissarro that Mette was planning to return to Copenhagen to explain their desperate situation to her parents and ask them to help. He felt defeated and trapped. In a later letter he wrote:

> Today my trip to Denmark was settled. I will probably leave during December. What can I do, I am completely broke and I cannot live like Guillaumin, who has no children. I've taken a job as representative of a French firm, working on commission. I hope that this will earn me our daily bread and still allow me freedom to paint. . . . You promised me a portrait of your children; you would be very kind to send it to me. . . .

Gauguin was very attached to the Pissarro children. He had spent hours carving a walking stick for Georges.

The same letter mentions that he was studying the interpretation of character through handwriting, "with passion." He proceeded to analyze Pissarro's personality through his handwriting, though he acknowledged the difficulty of being objective about a person already known to him. What followed was the first description of Pissarro's personality by a contemporary. It cannot be dismissed as merely a new game; it is revealing, both of Pissarro and of Gauguin, who wrote:

Your handwriting shows:
Simplicity, frankness
Not very diplomatic
Thinker—balanced
More poet than logician
Not open to new ideas
Lively mind—very enthusiastic
Great ambition
Stubbornness and softness mixed
Lazy
Sometimes hard-up and money-hungry
Parsimonious
Sometimes egotistical and a little cold
Does not swerve from the path laid out
Very mistrustful
A little eccentric

Graceful letters. A feeling for art but not aesthetic

The spelling, often of your own invention, reveals a man disposed to ignore one detail in order to concoct another

Finally, a very complex character

Gauguin's description includes some unexpected points in the light of what we know from other witnesses and later commentators, who have been almost universally uncritical of Pissarro, most often describing his praiseworthy qualities. Gauguin's admittedly biased description deserves examination.

"Simplicity, frankness," qualities often attributed to Pissarro, are constantly revealed in his letters to his sons and his friends. But the "not very diplomatic" raises some questions. Pissarro must have possessed a fair amount of diplomacy and tact to act as the intermediary between the various members of the Impressionist group, to get through the maze of the art world in Paris, and to sell his paintings.

Acknowledged for his qualities as a "thinker" and for his "balanced" judgment, he was probably the most intellectual of the Impressionists, the artist most interested in political and social philosophy, most able to understand several points of view about the same question—a mixed blessing; it sometimes made him worry and vacillate and feel anxiety over choices among alternatives that a less thoughtful man would not even have perceived. Monet's passion and conviction about his work, for example, was undisturbed by the kind of self-doubts and uncertainties that "balanced" thinking produced in Pissarro, who tended to be uncertain of his own work, judging it against the tradition of art and the work of his contemporaries. It is possible that the Jewish tradition, in which intellectual pursuits were highly valued, formed this quality of his character.

Gauguin's phrase "more poet than logician" modifies our ideas about Pissarro as a thinker, and indicates why he seemed reluctant, even unable, to explain in any theoretically coherent way what he was doing as an artist. He has been described in various accounts as the "theorist of Impressionism," but there is no written evidence of this. Asked to define anarchist art, he begged off, saying it was impossible to do so. Though he did write a brief description of the theoretical basis of neo-Impressionism for Durand-Ruel in 1886, it was based on the ideas of Seurat, who *was* a theorist. Pissarro liked to talk about art, he enjoyed working in the company of artists, and constantly compared their aims and results. His letters to Lucien and Georges include analyses of drawings and paintings with specific suggestions for improvement, revealing his abilities as a teacher; but there are few indications of theoretical, abstract thought.

"Not open to new ideas"—a curious statement about a pioneer of Impressionism, soon to adopt neo-Impressionism and always open to innovative ideas. One of the criticisms of Pissarro's life work is that he was too open to new ideas, experimenting with too many different approaches to painting. But Gauguin was moving toward commitment to symbolism and could have felt that Pissarro's resistance to it showed a conservative tendency to reject the new. It is true that Pissarro throughout his life followed a single idea about the purpose of his art: the depiction of the real world and his personal, honest sensations in confrontation with it. "Does not swerve from the

path laid out" confirms this trait. Pissarro also "did not swerve" from paths laid out in his life. He was completely committed to Julie, to his marriage, to his family, to his ideals.

His "lively mind" and enthusiasm are traits confirmed by his letters, which show him to be well-informed, intensely interested in his artistic, social and political worlds, a partisan in his attitudes about them.

The reference to "great ambition" was certainly true. The values of hard work, ambition and success had been imbued in him by his mother and father. Success for them meant money as well as any other kind of reward. Alert to the vagaries of the art market, concerned with getting decent prices for his work, willing when necessary to adjust to the demands of buyers, he was also ambitious for his sons, counselling them both on how to sell their work and how to achieve integrity in it.

The "lazy" characterization is most improbable, considering the amount of work he produced and the value he gave to work in his letters. Gauguin, who until this time had worked by day as a businessman while painting evenings and weekends, might have envied Pissarro's freedom to spend full time painting or thinking about painting, and thus considered him "lazy"—a misinterpretation fortified by what Pissarro called his "Creole temperament," the heritage of his tropical upbringing, his tendency to move slowly and ruminate over his work. There were periods when he painted little.

The characterizations "parsimonious" and "sometimes hard-up and money-hungry" reveal a difference between the two men's attitudes toward money: Gauguin was accustomed to living in relative luxury and spending money as he pleased; Pissarro lived frugally and spent as little as possible. Even when he had money, Pissarro's insecurity forestalled his spending it freely. Gauguin had acted as a dealer for Pissarro and had also bought some of his paintings, and one gets the impression that Pissarro often tried to drive a hard bargain.

"Sometimes egotistical and a little cold" probably says more about Gauguin's expectations of Pissarro than about the man himself. Pissarro was cooler and more restrained than Gauguin, certainly as egotistical as an artist must be to keep faith in his own worth, and proud and touchy. But Gauguin expected fatherly warmth and help from him and was disappointed that, immersed in his own troubles and increasingly disenchanted with Gauguin's disingenuousness, Pissarro could not give him all that he needed.

Gauguin notes that Pissarro is "very mistrustful." Pissarro was a wary man in many ways. In letters, he frequently expressed suspicion of dealers and skepticism about the motives of artists and critics. He had misgivings about his own work that often prevented him from moving ahead with confidence in his instincts. That he was a latecomer to the art world of Paris, an outsider, with his Jewish background and tropical upbringing, contributed to his mistrust. Confronted with the sophistication, experience and unscrupulousness of many of his colleagues, he might have felt vulnerable and self-protective. He supported and identified with the underdog in the world of politics and art. He felt comfortable with simple country people who were possibly more easily trusted and not so threatening to him as many of the complicated and unpredictable Parisians. He may have felt this same sense of comfort from Julie, a

country woman whose motives were not veiled by coquettish strategies.

Gauguin finishes his analysis by referring to Pissarro as a "very complex character." His complexities were reflected in the contradictory qualities that Gauguin saw in him: ambition and laziness, stubbornness and softness, a lively and a closed mind, enthusiasm and mistrustfulness. Though this analysis of Pissarro, based on his hand-writing, is incomplete and biased, it is a unique glimpse into his personality.

At the beginning of the summer of 1885, after about six months in Denmark, Gauguin returned to Paris with his son Clovis. He could not bear to leave all his children behind. But he had made the final break with Mette and his family. He visited her once more to bring Clovis back; from then on, he was alone with his talent and his guilt.

It is interesting to speculate about Pissarro's role in Gauguin's decision. Gauguin later wrote to his wife, trying to justify his desertion of his family: "I wanted, in spite of the certainty my conscience gave me, to consult others—men who counted—to know if I was doing my duty. They all agree with me that my business is art, that it is my capital, the future of my children, the honor of the name I have given them. . . ."

Pissarro was certainly among the "men who counted" to Gauguin; his opinion would have weighed heavily. Pissarro strongly believed that artists should devote themselves only to art. His attitude about this is clearly expressed in the letter he wrote about Guillaumin's situation. But for Pissarro it was never a choice between his family and his career. He assumed he would manage both and had no built-in resistance, as Gauguin did, to combining them. Gauguin's conflict was sharply drawn between the bourgeois, family-centered life in which the husband and wife filled complementary roles, both centered around perpetuating the family, and the romantic notion of the free life of self-expression, in which the artist had no responsibilities to anyone but himself and his art. For Gauguin it was either/or. He could not do both; he chose to run away from his wife and family.

Pissarro had no heroic ideas about the Artist versus Society. He wanted to integrate his life and his art. If he ever thought of escape as the answer, he did not act on it. Though he had a family to support, he insisted on making his living only by painting; he did not sacrifice his own needs to satisfy theirs. If he could not make enough money selling paintings to support his family, then other solutions would have to be found: raising rabbits, borrowing money, cutting expenses, etc. He trod his own path and tried to take those he loved along with him. But Gauguin had separated the two parts of his life with so deep a chasm that he could only leap from one side to the other. Having developed a self-image of the tortured, martyred, artist-as-Christ which was as romantic as any Byronic poet's, psychologically Gauguin was in many ways the opposite of Pissarro, whose good sense and moderation precluded such a self-image. Pissarro felt a guiltless kinship and harmony with nature and things natural in his own world. Gauguin relished excesses of joy and pain; he was an agony- and ecstasy-seeker; he wanted to follow his instincts without repression, and to live like a simple savage. He had a highly developed sense of sin and keenly felt its attraction and repulsion. His search for innocence drove him finally to the South Seas, as far away as he could run from his other life. Pissarro, no doubt unwittingly, encouraged Gauguin in the first

step of his flight by urging him to spend all his time painting and damn the consequences. Perhaps he did not foresee a complete split between Gauguin and his family; his own life experience was so different.

Since the house at Osny was too small for his growing family and he could not find a home in Pontoise at a reasonable price, Pissarro began early in 1884 to "scour the country" for a place to live that offered interesting motifs. Meaux: "little character." Versailles: a "false capital, no types that interest me." L'Isle Adam: "long, long streets, sad, sad walls, stupid, stupid bourgeois homes. Can a painter live here? . . . No! I require a spot that has beauty!" Compiègne: "a very level, bourgeois and solemn place." (The only advantage was that the house had a field so large "we shall even be able to play cricket.") Gisors, in Normandy, seemed possible. Three streams wandered through the town; it had winding streets, the ruins of a castle, a fascinating cathedral; above all, it was a market town. Three kilometers away, in the little village of Eragny, on the banks of the Epte River, the family found what they had been seeking: a countryside familiar enough to provide Pissarro with his favorite themes yet different enough to offer fresh stimulation.

Pissarro family, Eragny, 1884. Photograph courtesy John Rewald. From left to right:
Alfred Isaacson, Julie, Camille holding Jeanne; Georges in rear, Félix seated, Rodo on Lucien's knee

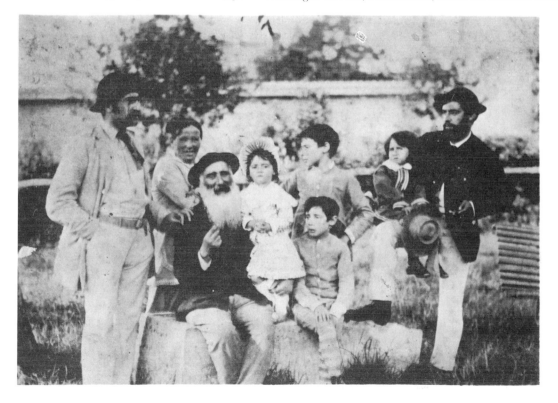

It had two drawbacks: the potential isolation—it was almost two hours from Paris—would be hard on the gregarious Pissarro, and in a small village it would be difficult to escape creditors.

On the main route from Paris to Dieppe, Eragny had a population of three to four hundred and a single street, tree-lined on the approaches to the village. Near the Pissarro house was a steepled church next to a large, ancient Normandy manor house, both quick to catch a painter's eye. Across the street was a stable and farther down was the large Delafolie farm, where the children could ride horseback.

The house, which was to stay in the family until Julie's death, in 1928, was a substantial (forty-five feet square), mansard-roofed, two-storied brick building, and like most of the homes, at right angles to the street. The entrance was thus on the side, opening onto a small garden with acacias and weeping willows. It was spacious enough to accommodate the Pissarros, the five children, the new baby due in August (Julie was forty-six), Lucien and other visitors. With a large barn in the rear that might eventually become a studio, it was one of the largest houses in the village. Beyond was a small stream where the family laundry could be washed.

Its former occupant had been a farmer. Between the house and the barn were a poultry yard and a pigsty, the area framed by a shed, with hen coop, that still stands. Manure piles reached to window level. Obviously, there was work to be done. Within a short time, the area was cleared and trees were planted; a garden was started for Julie, a rabbit hutch installed. Four years later, when Pissarro painted *View from My Window*, the vista was little different from today: apple and pear trees beyond the shed, grazing land, woods and low hills on the horizon. Just beyond the edge of the horizon lay the ancient hamlet of Bazincourt, with traditional beam-and-stucco houses, their huge thatched roofs sloping almost to the ground.

There is no record of what the villagers thought of the arrival of the white-bearded painter from another world. We do know that eventually he was made an honorary member of the fire department and that many of the villagers posed for him. Perhaps they all got used to him and some were proud to have so distinguished a neighbor. In any case, now Pissarro was closer than ever to his models, the peasants. And Julie was closer to the small village environment of her childhood.

16.

Life at Eragny

*"The children are in pretty good health. . . .
All of them draw . . ."*
—Pissarro to Lucien, 1883

As ART and nature dominated Pissarro's life, so did they influence his children as they were growing up in Eragny. Their house was a miniature museum; at their doorstep was the world of nature. The dining room walls were crowded with paintings and drawings by artists whose names were familiar to all, even the youngest. Some they had met, a few they knew intimately, and all they had heard discussed. There were Cézanne's *Self-portrait* and a portrait of his wife, his *Halle des Vins* and others; Monet's *Effect of Snow;* a Delacroix painting; a Degas dancer, Van Gogh's *Autumn Effect;* a Manet watercolor; paintings and drawings by Guillaumin, Cassatt, Sisley, Van Rysselberghe, Seurat, Signac, Luce and other friends.

Second-generation Pissarros were also on display, in other parts of the house. Georges covered the white walls of the hallway with paintings of turkeys, cocks, hens and other birds, while Félix painted on his door a ferocious black-and-white rat.

Behind the garden, at the rear of the house, was an expanse of tall grass to hide in as well as apple trees to climb and to shake for their fruit. Beyond, the Epte wound through a large pasture, enclosed by a fence that invited climbing. On the banks of the Epte were willows, thickets and other enticements for hide-and-seek, for adventure, and for discovery. Pissarro often took long walks in the fields with his family, where he savored the pastoral peace, the quiet broken only by an occasional bark in the distance, answered by the roar of the family Great Dane, "Da." As they strolled through the fields, with Cocotte and Paul-Emile (born in 1884) chasing grasshoppers and then racing to catch up, they stopped to identify the plants, flowers, shrubs, and insects, which Georges in particular hastened to draw in their "studio" on the first floor. To Pissarro's joy and Julie's mixture of pride and regret, all the children displayed a talent for art from their childhood. Pissarro was the proud drawing master of what they called the "School of Eragny," giving free rein to the imagination of the young ones, criticizing the work of the older ones, but trying not to influence them.

Evenings, the family traditionally sat around the kerosene lamp. Julie sewed and Camille corrected the children's work. He once described a typical scene to Lucien:

> The children are in pretty good health. . . . All of them draw, and the drawings always are to be sent to Lucien. I deceive them about this, for otherwise my letters would be enormous and costly. However, there are times when I am tempted to send you their fantastic landscapes, terrible horsemen, frightful massacres, in which warriors continue to battle

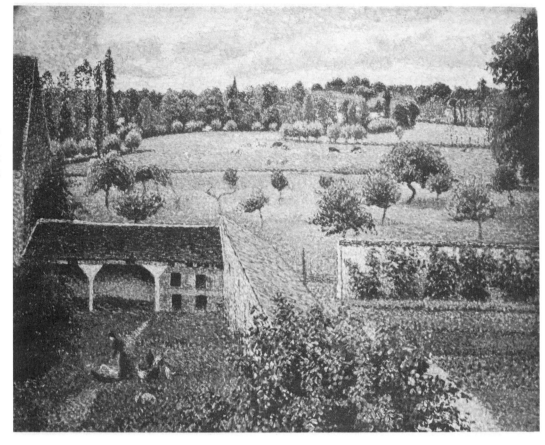

View from My Window, 1886. (721) 25⅝ × 31⅞. 65 × 81. Ashmolean Museum, Oxford. Shown at eighth Impressionist exhibition

even when they have lost their heads; here is bravura pushed to the limit, people running like Hop-o'-my-thumb, here is an incredible Hoffmannesque world of fantasy!

Then, dutifully but without conviction:

I should be happy if these youngsters gave as much attention to their studies as they do to their drawings.

Over the years he watched and reported with delight the development of the children as artists. His letters are full of proud descriptions:

"Titi [then fifteen] works with me every day at the studio, he makes his study quite well, with a very steady hand . . . he hasn't yet understood values, it will come; he loafs, he still likes to play, to run, it's natural for his age," he wrote Georges, who at eighteen was in London for six months in 1889 to study decorative woodcarving at an arts and crafts school. "Rodolphe [eleven] is still the same, grumpy, philosophical, he is busy with his little men, nothing else, he has not taken to serious studies yet; Paul-Emile [five] makes spider legs, which in his imagination become cars, horses, drivers, hens, birds, etc., etc. Cocotte [eight] sews and nurses her doll."

A month later, Pissarro sees progress: "Titi always draws, a little lazy, still loving sports passionately, never mind, he progresses, little by little," he wrote Georges.

"Paul-Emile is beginning to make stupendous compositions; sometimes he passes the entire day in the studio singing, whistling, and painting some extraordinarily comical things. Rodolphe, always calm, scribbles, scribbles on paper, like Cocotte who does the same, but less madly."

Within a year, Cocotte officially joined the School of Eragny. When Pissarro sent some paintings to Signac for an exhibition, they were packed in cardboard on which Georges, who had made a pastel of geese, and little Cocotte had been drawing. The critic Félix Fénéon, in Signac's studio when they were unpacked, seized the drawings. "He thought the geese were mine," the exultant father told Lucien, "and as to the second symbolic drawing by Cocotte, he was enthusiastic about it . . . here's Cocotte launched into symbolism without knowing it—what's Gauguin going to think of this unexpected competitor . . . !"

Cocotte obviously was the recipient of a father's special feeling for a daughter. Later, when she strutted around proudly in a new dress that had a bustle in the rear, he drew an affectionate sketch of her for Esther Isaacson and noted: "She passes her hand all wide open with fingers spread out over her dress and she says it is soft!!— what would she say if she could see herself from the rear!!!"

Once, as a special gift, Pissarro sent Esther Isaacson a collection of the children's drawings for her, Alice and Georges. For Georges, Rodo sent an illustrated tale, Titi a drawing of a horse, and Lucien an illustrated almanac. Rodolphe and Titi teamed up to illustrate a collection of fables for Esther. Camille sent Alice a gouache, and Lucien painted a fan for her and made a pen-and-ink drawing for Esther Bensusan, a friend of Esther Isaacson's who had visited them. The School of Eragny was busy!

The children were noisy and sometimes quarrelsome. The older boys teased the younger ones, and they teased the gentle Cocotte. There were times when Pissarro longed for quiet so that he could concentrate on his work. "One after another the children took sick," he wrote Lucien. "They have all practically recovered, and the usual racket is beginning again." And when Julie returned from a visit to Paris with Paul-Emile and Cocotte: "Guingasse [Paul-Emile] and Cocotte quickly renewed their

Letter with drawings by Camille. Private collection, New York

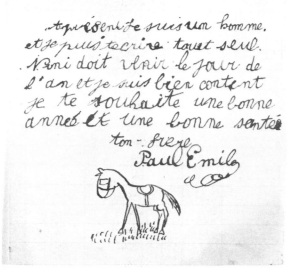

Paul-Emile Pissarro, c. 1895. Lithograph. (D 146)
3¾ × 4½. 9.5 × 11.5. New York Public Library

Letter from Paul-Emile. Ashmolean Museum, Oxford

Félix. Photograph Pissarro family documents

Ludovic-Rodolphe. Crayon. Ashmolean Museum,
Oxford

The Artist's Children,
Cocotte and Bébé,
c. 1886. 16¼ × 12¾.
41¼ × 32¼. Collection of
Mr. and Mrs. Paul Mellon

antics. We can hear them squealing in the garden. Everything was really too peaceful here."

The older boys had exasperating periods of laziness, lack of interest and stubborn resistance to authority, brought on, perhaps, by their father's tendency to be overindulgent and their mother's to be too strict. Pissarro complained to Lucien:

Maximilien Luce: *La Famille*
Pissarro. Musée Maximilien Luce,
Mantes. Photo Robert Chanoine

Neither Titi nor Georges has done much work here. They think mostly of blowing false notes on a hunting horn and bicycling through the country and other such pranks that hardly advance their knowledge of values and colors.

Georges is very changeable and easily becomes discouraged. . . . At such moments, no efforts! His excuse is that he is waiting for sensations, the old theory of inspiration. I have not yet been able to convince him that inspiration, or rather sensation, has to be enticed by regular work every day.

There were times, too, during the late eighties, when the tensions caused by financial stress must have cast a pall over the house and affected the children. In 1887, especially, when there was little money, at times none, the family's happy inventiveness must have been stifled. "Wind, rain and not a penny . . . very sad this year," Camille reported to Lucien in the summer of 1887.

Eragny provided few distractions. There was a small village store where the family could buy sweets, an annual fair that boasted two carnival booths but no merry-go-round. However, as Camille remarked, "So few things are necessary." There were the fields and streams to play in, and horses to ride, but at night the village was deserted.

The neighboring town of Gisors was livelier. On market days, Mondays, Julie went to buy and possibly to barter, often bringing Paul-Emile and Cocotte, and occasionally Camille joined them to sketch the busy market square. He delighted in the treasures of this ancient capital of the Vexin, eastern gateway of Normandy—especially the twelfth-century chateau and the church with its mixture of Medieval and Renaissance styles. In 1885, when shy Lucien was unable to persuade Esther Isaacson to visit them, Camille wrote him a letter that sounded like a travel brochure:

You, who are an artist, ought to be able to make Esther understand that Gisors has art treasures that should delight a tourist with taste; tell her about the diversified style of the church, about the wooden doors of Jean Goujon, about the stairways, the genealogical tree, the *French frescoes* (rare), and the basin, which I almost omitted from my list. This basin is a whole world!—and then there are the park, the carvings on the town hall, the museum with its extraordinary stuffed birds; in short, you should unroll the list of attractions, and get her to decide to stay here as long as possible.

Gisors had its pitfalls, too. Georges and Titi were attacked one night by a gang of drunken gymnasts, "egged on by a lad from Eragny," who stole Georges's pistol. Only a stranger's intervention saved them from being beaten to death. "It was not their fault—this time," Pissarro commented of his rambunctious sons. ". . . such things are always happening to the two boys. But there is no preventing boys from fighting." That Georges was armed and that an Eragny youth was the instigator of the attack naturally raises questions about their acceptance in Eragny. At the height of the anarchist scare, Pissarro remarked that he distrusted some of the people in Eragny. Undoubtedly some of the villagers harbored a parochial suspicion of people who were "different."

For the most part they had to entertain themselves. Dinnertime brought them all together around the oval table, where Camille often fascinated them with stories of the exotic Caribbean, perhaps bored them with discourses on painting, and teased and joked. Georges was the family clown, Titi the family mimic and satirist, often mocking the gestures of the villagers. "Titi and Georges are disguising themselves and acting

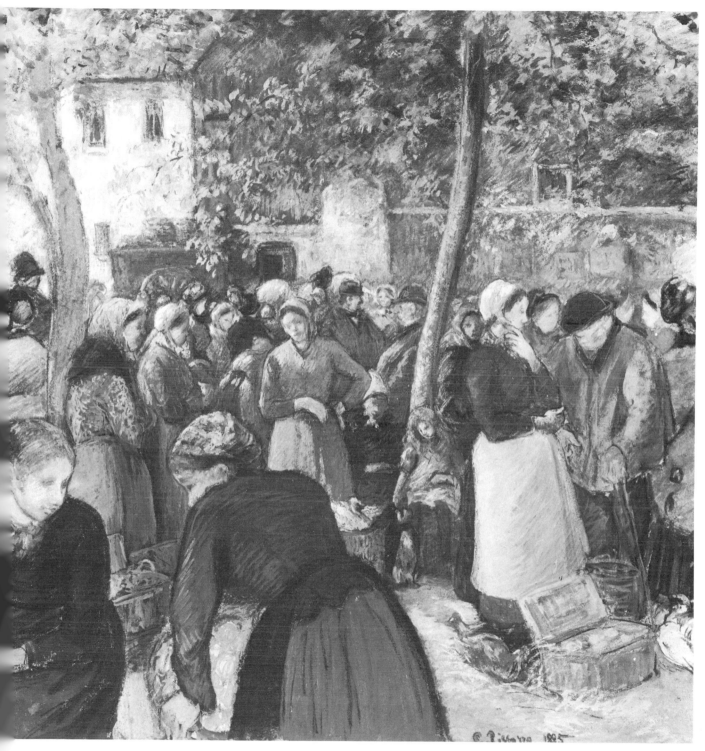

The Poultry Market at Gisors, 1885. Distemper. (1400) 31⅞ × 31⅞. 81 × 81. Museum of Fine Arts, Boston. Bequest of John T. Spaulding

Pissarro house
at Eragny.
Photograph

like devils and your father is laughing like a fool, he is worse than the children," Julie wrote Lucien. "Little one [Paul-Emile] is in the process of learning the alphabet and counting. 7617620340, etc., and tells me, 'You see, maman, I know how to count very well but I don't know how to put the numbers in order.—I'll count and you put the numbers in the right order!' It's very funny."

All the sons used school exercise books as sketchbooks, the covers lavishly decorated with the animals of Eragny. Sometimes they drew local scenes, but more often they engaged in biting caricature, especially Georges. Sharp observers of the domestic scene, they irreverently drew Julie attacking Camille, Camille stepping back from his easel and falling over a cliff, Camille and Lucien trying to persuade a bashful local girl to pose in the nude.

The satirical sense of fun that ran through the family materialized in an extraordinary collaboration called the *Guignol.* The whole family contributed drawings and prose satirizing themselves, the villagers, their uncles, aunts, cousins. No one was immune. The drawings were made on a coarse, hay-colored paper and each issue was unique. At the end of the year Georges bound the issues in satin or calico decorated with a cock of brilliant plumage. All participated in the 1889 series, including five-year-old Paul-Emile, who won admittance to the School of Eragny with a drawing *A Horse in the Snow.*

Their father was often the butt of the children's humor. He was always uneasy about the Great Dane. One day when he was painting in the garden, the Dane suddenly came bounding toward him. Frightened, Camille leaped to his feet, brush in hand, and the dog raced right past him—in pursuit of a rabbit. Rodo promptly created an embroidered version of the scene for the *Guignol,* in a comic-strip series of drawings of

Village of Eragny, 1889.
Watercolor. 10¼ × 7¼.
Photo courtesy
M. Knoedler & Co.,
Inc., New York

a frightened Pissarro being pursued by a wild dog, holding onto his palette as he ran, scattering the colors, while his gleeful sons watched him flee.

On one occasion in Paris, Pissarro and sons encountered Mary Cassatt, who took them for a ride in her car. When the Pissarros returned to Eragny, Paul-Emile announced how much they enjoyed a ride with "a beautiful lady." Julie's response, when she learned who it was, indicated a hint of jealousy, which did not go unobserved by the sons. In the next issue of the *Guignol,* the children teased Julie with a drawing by Guignoleur Titi of Camille, the timid lover, tearing the petals of a daisy, with the caption, "Passionately . . . madly . . ."

Camille relished this cooperative endeavor, a welcome escape from his cares. When Esther Isaacson visited them in the late summer of 1889, he reported to Georges:

> We will not send the *Guignol* until Esther leaves, there are still a few things to finish. . . .
> Tell the grumpy subscribers that we make them wait so we can do better, that the
> subscribers are not the masters and must wait patiently while the grrrreat ones who do
> them the honor of working for them patiently improve their work!!!! (Rather long, that
> sentence.)

It was an isolated life, with almost no one near by to provide companionship for Pissarro, except for Hyacinthe Pozier, a landscape artist. Occasional visitors were a major event for the whole family. Paul-Emile recalled that when Monet visited, "he seemed like a god to the boys, but he was smiling and affectionate with his young admirers." Mirbeau, Signac, Mary Cassatt and other critics and artists came from time to time, but there were periods when Pissarro had little contact with the art world. The winters were particularly difficult, especially when credit and food supplies were low.

Camille read as much as his eyes permitted. His interest in political affairs led him to the anarchist journals and the daily press, plus the works of Kropotkin, Grave and Reclus. Among his friends were many authors, and he read their books: Zola's novels, Mirbeau's *Calvary* and *Diary of a Chambermaid,* Huysmans's novel *A Rebours,* and criticism. The poetry of Baudelaire, Verlaine and Paul Adam, the letters and novels of Flaubert—Camille devoured them all. He found Zola's novels "a bit too photographic" and did not completely approve of Verlaine, or of Baudelaire's *Les Fleurs du Mal.* Nevertheless, he recognized "their superiority as works of art." If a work was innovative in style or form or content, he was interested, and ready to support it.

When sickness struck in so large a family, it often spread and immobilized almost all of them. The "physician" was Camille, a devout believer in the homeopathic medicine that his friends Drs. Gachet and de Bellio practiced. Pissarro's manual and prescription guide was a large tome by Dr. Louis Simon, a homeopathic doctor whom Pissarro often consulted in Paris. Many of the medicines Simon recommended are still used today: ipecac for diarrhea, *nux vomica* and belladonna for stomach pain, for example. Pissarro's dedication to homeopathy reflected his conviction that this form of medicine, with its herbal remedies and distrust of surgery, was nature's way of healing the body.

Like a mother hen, he would cluck nervously when any of his children fell sick, then consult the Simon book and prescribe the appropriate remedies from the box of medications he always kept full. When he judged the illness to be serious, he called on Dr. de Bellio for consultation. When his sons were in London, he constantly concerned himself with their health and did not hesitate to diagnose and prescribe dosages by mail. "Take 8 globules [of *nux vomica*] in 120 grams of water for 8 days," he prescribed for Lucien's stomach pains, and then, like any conscientious physician, "and write me the result." When Georges mentioned having a persistent cough, Camille sent Esther, whom he had asked to keep a protective eye on his eighteen-year-old son, a box of medications and referred her to page 472 (coughs) and page 122 (chills) of her copy of Simon's book for the proper dosages of *nux vomica* and *nux muschata.* "And above all, have Georges take his dosages regularly, one shouldn't take a cough lightly."

But when surgery seemed to be required, Dr. Pissarro was in a dilemma. When Georges's appendix became inflamed, Pissarro learned that the only physician available—who was not a homeopath—had only one approach: to operate. "But the homeopaths, what do they do? I am very perplexed," Pissarro anguished to Lucien. The book did not offer a remedy, and he was opposed to surgery. He faced the inevitable and permitted the operation, but Georges became seriously ill after it, and Pissarro's distrust of surgery lingered.

Julie was equally concerned with the health of her sons when they were away, but she seems to have practiced a form of preventive medicine—by sending them baskets of pears, apples, walnuts and other products of her orchard. She scolded her sons even into adulthood, grumbled and complained about them, but rushed to them if they became ill. During the eighties, life for Julie at Eragny was gruelling. There were five children to be clothed, fed—and disciplined. On the weekly wash day, Julie tore into the laundry with the aid of a laundress who received as much drubbing from her as the soiled clothes and sheets did. While Julie attacked the laundry as an enemy to be conquered, and everyone near by felt her cyclonic dudgeon, the boys at a safe distance

made caricatures of the whole scene. There was little money in the house, a large garden to be cultivated, never-ending work even with a maid's help—when they could get a maid—and constant worries. Julie was so accustomed to unrelenting struggle that she tended to drive herself ceaselessly and to neglect her health. Her approach to undisciplined adolescents was a brusque, sometimes harsh impatience; but they understood that much of Julie's dour and scolding manner was on the surface.

In a letter to Lucien, when he was working in Paris, she complained of his not writing after sending her his soiled linen so she could wash it: "I find time to mend and to launder your things and you, you don't even take the trouble to say thank you." Then she scolded him for eating at his aunt's home—the Estrucs's—for "they can't afford it, etc., etc.," and suddenly, "I feel lonesome not to see you work in your studio in the evenings." And Lucien signed one of his letters, ". . . your son who loves you and who knows that you are good in spite of your tough façade."

Julie was generous with beggars who came to her door, wept at the funerals of villagers and often displayed sympathy for those who, like her, were of humble origin. When a servant girl of friends arrived at her door, barefoot and in rags, she clothed and fed her. When Julie found that the girl had been sexually abused and had been thrown out "like a poor dog" without pay, her indignation exploded. She was particularly outraged because the young woman's employer had once been a household servant: "I don't understand how some people who have been domestics like you and me and many others are not more sympathetic to others."

She shared Pissarro's high moral principles, but she was much firmer than he in demanding that the children live up to them. He advised them, reproached them, complained in private to Lucien about their lapses, but Julie attacked head-on any misbehavior. When Titi had relations with a young woman and might have been the father of her child, Julie demanded that he face up to the problem. "Always remember, my poor Titi, that a man ought always to do his duty and have nothing dishonest to reproach himself for. Don't laugh at a girl who gave herself to you. Do what you should and don't be a coward. When Georges left I gave him 100 francs to send this girl and you kept them. You have robbed your mother, and what is worse, you have stolen the child's bread. I am always lecturing you. Try to be honest."

The harshness Julie displayed at times reflected the harshness of her own life. Her toughness and discipline in the periods when the Pissarros were practically penniless kept the family afloat. As she wrote Titi, "If sometimes I have been severe, it was in your own interest."

She worked alongside any helpers in the orchard and vegetable garden, which she always complained was too big for her to handle. The flower garden was her chief, if not only, relaxation. She enjoyed making graceful arrangements of roses, peonies, iris and poppies. She was proud of her large house, gracious to visitors and liked to play the role of "lady of the house." In the nineties, as financial pressures eased and the boys grew up and began to leave, the lessened burdens gave Julie more leisure to enjoy the home in which she took so much pride.

To Camille, however, the house sometimes seemed like Julie's "Eragny Castle." He would have preferred to be closer to Paris. The village was beautiful in the spring ("The country is magnificent, the apple trees are heavy with blossoms, the field is superb

with green") and in the fall, but in the summer, although he worked constantly, the heat was unbearable at times, and the winters were hard, much as he liked to paint his "snow effects." "I fear above all the bad days of winter, the frightful overcast days of December, the snow, the thaw, the gloom," he confessed to Lucien.

And the children, as they grew older, gradually left. Camille wrote Lucien in a melancholy mood:

> I really want to go to Paris and see what is happening there. . . . Is it anxiety about money, the fact that the coming winter already makes itself felt, weariness with the same old motifs, or my lack of data for the paintings I am doing in the studio? It is partly due to all these things, but what hurts me most is seeing the whole family break up, little by little. Cocotte is gone, soon it will be Rodo! Can you see us two old people, alone in this great house all winter?

His fear never materialized. Cocotte returned to Eragny after boarding school in Paris and Paul-Emile wanted only to remain at Eragny and work with his father. In the summers of the late nineties, the old white-bearded patriarch and his devoted young son painted together in the fields around the house. Pissarro had a "rolling studio" built by a local carpenter, a two-wheeled cart mounted with a large box containing easels, brushes, pigments and canvases. Paul-Emile pushed it along until his father found a view that appealed to him and then the two set up their easels. The boy treasured these precious days and later recalled that when Pissarro was painting the sky, he "seemed to be in a trance," and Paul-Emile realized that he should not break the silence with a word until his father had laid down his brushes.

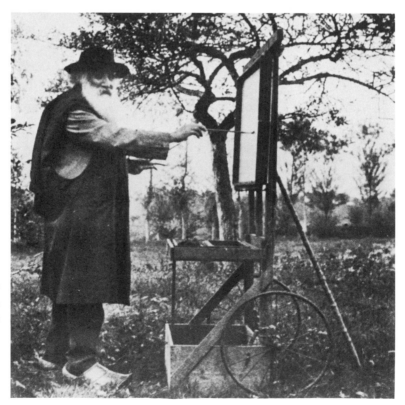

Pissarro and his "Rolling Studio,"
Eragny. Photograph Pissarro
family documents

17.

Pissarro, Seurat, Signac and Neo-Impressionism

"I do not believe, my dear Lucien, that to be understood I will have to wait again as long as I did when I made my debut."
—Pissarro, 1886

PISSARRO'S preoccupation with pattern and his experiments with color in the late seventies and early eighties had much in common with the experiments being made at the same time by Georges Seurat, whom he did not meet until 1885.

His first personal contact with the new color theories "in the air" came in 1883 through Lucien, back from England for a summer visit. One day Lucien brought home a nineteen-year-old artist he had met sketching in Pontoise, Louis Hayet, whom Camille later described as "very dreamy and very practical." Hayet was a self-taught artist, and as he travelled in the Normandie and Paris region, he had been systematically applying Chevreul's color theories since 1881. His experiments seem to have paralleled those of Seurat in the same period.

Two years later, Guillaumin introduced Pissarro to Paul Signac, whom he had met painting on the banks of the Seine. Signac, exactly the same age as Lucien, was talented, extroverted, energetic and enthusiastic. The son of well-to-do shopkeepers in Paris, he was painting landscapes in clear, pure colors, using an Impressionist brushstroke. He and Pissarro were attracted to each other immediately. In October 1885, he introduced Pissarro to Seurat, whom Signac had met the previous year at the exhibition of the new Society of Independent Artists, where Seurat had shown his monumental canvas *Une Baignade*. The critic Roger Marx had commented there that Seurat had applied "without awkwardness and even with much accuracy, the method of multicolored strokes dear to Camille Pissarro." Since they had already been so linked in the press, Seurat and Pissarro were undoubtedly curious to meet each other.

Seurat was twenty-nine years younger than Pissarro, grave, self-contained, logical and regular in his habits. (Degas called him "the Notary.") His physical appearance matched his personality: He was extremely tall, well-built, controlled in his movements; he dressed in perfectly cut dark clothing and appeared at evening events with an elegant silk top hat, cape and gold-handled cane. The son of a wealthy property owner, Seurat was single, had a regular allowance and no money worries. Despite their differences in temperament and situation (Pissarro was never as friendly with the cool and solitary Seurat as he was with the ebullient Signac), the two had a great deal to talk about. They compared notes on their experiences as pupils of Henri Lehmann. Pissarro had studied briefly with him in the late fifties, and Seurat had recently spent four years as his student at the Ecole des Beaux-Arts.

Landscape at Osny,
c. 1884. (629)
18 × 21⅝. 46 × 55.
Columbus Museum
of Art, Ohio:
Howald Fund purchase.

Of course, they talked about color and the new scientific researches into its nature and effect. Seurat had read the new French translation of Ogden Rood's *Modern Chromatics* in 1881 and was experimenting with Rood's findings. Rood summarized the latest theories of color, gave clear explanation of the differences between color as pure light and color as painter's pigment, and described his experiments using both daylight (white light) and candle or gaslight. Directing light through transparent colored glass or gelatin sheets, Rood observed the effect on white surfaces and on colored surfaces. He confirmed, in light, the "law of simultaneous color contrast" which had been worked out by Chevreul for pigment.

The basis of Chevreul's law is a physiological fact about the eye. If one looks for a minute or so at a square of intense red and then at a white wall, one will see a "ghost" afterimage—a square of greenish hue, green being the complementary (or most highly contrasting) color to red in pigment. The same phenomenon occurs with the other complementary colors of pigment: blue/orange, yellow/violet, etc. If a stroke of pure red is placed next to a stroke of pure green in a painting, both the red and the green will appear more brilliant, since the green afterimage the eye produces from the red makes the green appear greener and the red afterimage produced by the green intensifies the sensation of the red. The relationship between the two colors produces an effect (in interaction with the eye of the viewer) which does not exist if the two colors are separated and looked at singly. These complex interactions of color were an endless

source of fascination to painters with the preoccupations of Pissarro and the Impressionists.

Seurat had been experimenting with the discoveries of Rood to find the ways in which they could be applied to painting. Rood was most interested in color as pure light, and he isolated the complementary colors of light, which are somewhat different from those of pigment. The complementary of green light, for example, is purple light, while the complementary of green pigment is red pigment. The complementary of orange light is greenish-blue (cyan blue); the complementary of orange pigment is a pure, primary blue.

Seurat concluded that in order to achieve the effect of colored light in a painting, the complementaries of light rather than pigment should be used. He also wanted to use pure colors and to avoid the chemical mixing of two different hues, either on the palette or by putting one wet stroke over another on the canvas. He mixed only white with pure hues to produce clear tints of pure colors, and he applied his paint to the canvas in small, separate touches, or "points."

When he and Pissarro met, Seurat was working on *Sunday Afternoon on the Island of the Grande Jatte*, the monumental demonstration of his ideas and method. Before beginning his painting, Seurat had analyzed the colors and the tones and the interactions between them in various studies. He decided, for example, what propor-

Marketplace in Pontoise, 1886. Pen and ink. The Metropolitan Museum of Art, Robert Lehman collection, 1975

tion of purple should appear on a black dog standing on the green grass in a shaded area (purple being the complementary, or "contrasting afterimage," of green in light). Once Seurat had decided on the proportions, had chosen his pure colors and tints and had laid his basic drawing on the canvas, he could proceed almost automatically to execute his plans with small dots of pigment. He could paint at night in his studio by gaslight, for example, since his decisions had been made in advance and could not be affected by the changed appearance of color under artificial light. "I paint my method," said Seurat, "that's all there is to it."

Pissarro was immediately won over to Seurat's ideas and techniques and began with great enthusiasm to try them out for himself. It may seem strange that the fifty-five-year-old master should be so willing to adopt the ideas of a man twenty-nine years younger than he and with far less experience, but Seurat provided him with a codification of the innovative ideas about division of colors with which Pissarro had instinctively been working during the previous several years.

Pissarro encountered Seurat's ideas at the right time psychologically. Since the late seventies, he had been searching for a better balance between his subjective sensations and the recording of the objective landscape. He had tried some paintings in what seems, for him, an expressionistic mode. He recoiled from this tendency and described one of these works as a "romantic extravagance" with a "passionate style of execution" which he wanted to change. Pissarro was looking for a way out of emotionalism, which he saw as damaging to his work. "To make art it is necessary to master one's passions entirely," he had written to Murer in 1878. "Romanticism in life is not compatible with art."

The mechanical brushwork of Seurat's method deliberately suppressed the personality of the artist and made the "individualism" valued by the Impressionists less important. It offered a cool, rational, objective way of going about the work of painting. It had the additional advantage of being "scientific" at a time when anarchists like Pissarro believed in the promise of science to pierce the secrets of nature and to give everyone the intellectual and material benefit of this knowledge.

Pissarro set to work and in January or February of 1886 displayed in a dealer's window a small landscape executed with "dots," the first such picture ever exhibited (Seurat had not yet shown his pointillist work). When Signac saw the painting, he grew enthusiastic over the new style and enlisted his talent and fighting spirit in its cause.

Pissarro's early landscapes in the neo-Impressionist style—for example, *Peasant's House, Eragny*—are not very different from his previous landscapes in motif, spatial construction and composition. He applied paint in small, squarish dabs all over the canvas, leaving unpainted areas between the touches of pigment. These "breathing spaces" between the spots of color open up the surface of the canvas and give a feeling of light and air to the image. Signac was always more influenced by this particular, sensitive "touch" of Pissarro's pointillism than he was by Seurat's more tightly controlled "dots."

Pissarro, eager to get the novel style before the public, had already begun to agitate for another exhibition of the Impressionist group which would include Seurat, Signac and Lucien Pissarro. He did succeed in convincing Durand-Ruel to accept paintings by

Seurat and Signac for an exhibition of Impressionist works held in Madison Square Garden, New York, in April. This show, including works by Manet, Renoir, Pissarro, Monet and Degas, aroused lively interest; Americans were more receptive to the new style of painting than the tradition-bound French public had been. The exhibition was extended for a month and moved to the National Academy of Design.

One of those who found the show particularly interesting was José Martí, the Cuban revolutionary and poet, who wrote at length about it in *La Nación*, from his own politically radical point of view. Martí felt that the paintings in the exhibition showed:

> . . . with fraternal tenderness and with brutal sovereign anger, the wretchedness in which the meek and lowly live. Those are the starving ballet dancers! Those are the sensuous gluttons! Those are the drunken laborers! Those are the dried-up peasant mothers! Those are the perverted sons of the wretched! Those are the women of pleasure! And they are impudent, bloated, hateful and brutal! These unfinished and sincere sheets of color do not give forth the subtle but venomous perfume which so pleasantly scents so many fine books and elegant paintings where crimes of the senses and the spirit are portrayed with a seductive talent!!

Martí's reaction to the subject matter of the Impressionists, colored by his own political orientation, contrasted with the later opinion that the Impressionists were concerned simply with portraying the pleasures of middle-class French society.

Martí's interpretation of Impressionist painting also contrasted with contemporary opinions. Most of the other criticism was limited to comments on the style, much of it in praise of its novelty and boldness, although some very critical. The *New York Herald* critic thought Pissarro had a good eye for color. Seurat's *Une Baignade* was praised, somewhat inaccurately, as revealing the "uncompromising strength of the Impressionist school."

Americans accepted Seurat and Signac to some extent; it was more difficult for Pissarro to convince the Impressionist group to accept them. Degas was against it, as Pissarro reported to Lucien: "I told Degas that Seurat's painting *La Grande Jatte* was very interesting. 'I would have noticed that myself,' he said, 'except that it is so big.' Well, if Degas sees nothing in it so much for him. That simply means that there is something precious that escapes him. We shall see."

The Impressionist group abhorred the rigidity of Seurat's method. What he and Pissarro saw as a scientific approach, a way to understand and depict the newly discovered laws of colored light, most of the Impressionists scorned as an encumbrance to expression and sensation. Pissarro rose to the challenge of the fight. He dubbed his old colleagues "romantic" Impressionists in contrast to the "scientific" Impressionists of his new group.

> Yesterday I had a violent run-in with M. Eugène Manet [Morisot's husband, who was helping to finance the exhibition] on the subject of Seurat and Signac. . . . I explained to M. Manet, who probably didn't understand a thing I said, that Seurat had something new to contribute which these gentlemen, despite their talent, are unable to appreciate— that I am personally convinced of the progressive character of his art and certain that in time it will yield extraordinary results. Besides, I am not concerned with the appreciation

of artists, no matter who. I do not accept the snobbish judgments of "romantic Impressionists" to whose interest it is to combat new tendencies. I accept the challenge, that's all!

Manet and Degas eventually accepted Seurat, Signac and Lucien Pissarro, and the exhibition finally opened on May 15 without Monet, Renoir, Sisley and Caillebotte. The group included Mary Cassatt, Degas, Forain, Gauguin, Guillaumin, Berthe Morisot, Odilon Redon and Vignon. It was in fact the last joint exhibition of the Impressionist group and the first public appearance of the neo-Impressionists. The works of Camille and Lucien Pissarro, Seurat and Signac were shown in a separate room dominated by Seurat's immense *Sunday Afternoon on the Island of the Grande Jatte,* which was ten feet wide and almost seven feet high. The public and the critics focussed on these strange new paintings using what one called the "fly-speck" technique. *The Grand Jatte* caused the sort of stimulating scandal that was the lifeblood of the avant-garde, guaranteeing at least the notoriety, if not the success, of the new group.

George Moore recounted how the young art students jeered at Seurat's and Pissarro's paintings, exaggerating their boisterous laughter "in the hope of giving as much pain as possible." Signac recalled that on the opening day of the exhibition, the well-known painter Alfred Stevens shuttled between the exhibition and the near-by Café Tortoni, recruiting batches of boulevardiers and taking them to look at Seurat's canvas "to show how far his friend, Degas, had fallen" in agreeing to exhibit with such horrors.

What added to the general air of mockery and confusion was that the public could not distinguish among the works of Seurat, Signac and the two Pissarros. George Moore confessed his bewilderment:

> The pictures were hung low, so I went down on my knees and examined the dotting in the pictures signed Seurat, and the dotting in those that were signed Pissarro. After a strict examination I was able to detect some differences, and I began to recognize the well-known touch of Pissarro even through this most wild and wonderful transformation. Owing to a long and intimate acquaintance with Pissarro and his work, I could distinguish between him and Seurat, but to the ordinary visitor their pictures were identical.

A more sympathetic response came from the symbolist writer Paul Adam:

> As much by the uncompromising application of scientific coloring as by the alien qualities of innovators, Messrs. C. Pissarro, Signac and Seurat mark most manifestly the definitive tendency of Impressionist art . . . this exhibition initiates a new art, eminently remarkable by the scientific bases of its processes, by the return to primitive forms and by the philosophical concern for rendering pure apperception.

One critic, Félix Fénéon, became a wholehearted advocate of the new painting. The brilliant twenty-five-year-old Fénéon worked as a clerk in the War Ministry and in the evenings he edited the *Revue Indépendante,* a small but influential literary magazine he had founded in 1884, in which he published Mallarmé, Huysmans and other symbolists. Fénéon contributed art reviews to the anarchist press that were written with precision and lucidity, and without pedantry. After the 1886 exhibition, he

Spring Sunlight in the Meadow at Eragny, 1887. (709) 21¼ × 26. 54 × 66. Musée du Louvre (Jeu de Paume)

became friendly with Seurat, Signac and Pissarro. Tall and imposing, top-hatted and dandyish like Seurat and Signac, with a pointed Mephistophelean beard, Fénéon was sardonic and skeptical, and also a loyal, devoted and highly principled friend. Pissarro was charmed by his wit and intelligence, his perceptive understanding of the neo-Impressionists, and his "laughter at the expense of the bourgeoisie."

Fénéon published articles attempting to define the aims and techniques of the school he dubbed "neo-Impressionist," a term he probably got from the artists themselves. Signac later explained the name:

> If these painters, better designated by the term *chromo-luminarists*, adopted the name *neo-Impressionists*, it was not in order to curry favor [the Impressionists had still not won their own battle] but to pay homage to the efforts of their predecessors and to emphasize that while procedures varied, the ends were the same: *light* and *color*. It is in this sense that the term *neo-Impressionist* should be understood, for the technique employed by these painters is utterly unlike that of the Impressionists.

Fénéon confirmed the widening breach between the neos and the Impressionists. "As for the new recruits to Impressionism," he said, "they will take the path of the analyst Camille Pissarro and not that of Claude Monet." Exhibiting together again would be impossible; the neos had to search for new opportunities to show their work.

An exhibition was held in August by the Society of Independent Artists. (Camille Pissarro did not take part in any exhibitions of the Independents during the 1880's; he gave up his niche to his son, Lucien.) In November, Pissarro was invited to show his paintings in Nantes and used his influence to get Seurat and Signac accepted. Early in 1887, the neos were invited to exhibit in Brussels with Les Vingt, a group of twenty independent Belgian artists, mostly about Lucien's age. The group included Jan Toorop, Henry van de Velde and Théo van Rysselberghe, who became a close friend of Pissarro. Seurat's *La Grande Jatte* created a stir in Brussels, as it had in Paris; his enormous painting overshadowed the more modest work of Camille and Lucien and became a rallying point around which sympathetic writers like Emile Verhaeren, Gustave Kahn and Octave Maus centered their partisanship for neo-Impressionism.

Signac travelled to Brussels to attend the exhibition and wrote back to Pissarro:

> I left the Exhibition of the *XX* exhausted. An enormous crowd, a dreadful mob—very bourgeois and anti-artist. In sum, a great success for us: Seurat's canvas was invisible, impossible to approach, there was such a huge crowd. . . . Your paintings do very well; unfortunately their small number and size isolate them. They disappear a little, lost among the large canvases around them. . . . Pointillism intrigues people and forces them to think that there is something behind it.

Pissarro was invigorated by the company of the young neo-Impressionists and the atmosphere of revolution in the group; it recalled the fight of the Impressionists to find a place in the public eye. He could share his political convictions with several of them at a period when French politics was marked by the escalation of anarchist action and by agitation for social change among working-class groups and intellectuals alike. Maximilien Luce, twenty-eight, son of a shipping clerk and with only primary school education, as a youth had witnessed atrocities committed against the Communards and

Peasants' House at Eragny, 1887. (710) 23½ × 28¾. 59 × 72. Art Gallery of New South Wales, Sydney

The Hay Gatherer, 1884. (651) 28¾ × 23⅝. 73 × 60. Photo courtesy Christie's, London

had been a radical ever since. Stocky, russet-bearded, with snub nose and bulging forehead, always wearing a battered hat and blue worker's trousers, Luce was the most "proletarian" and radical of the painters, the most prolific contributor to the anarchist press and the closest to Pissarro, who was charmed by his directness and convictions. Signac, the most intellectual of the young group, became the theorist of the role of art in anarchy as well as the analyst of pointillism. In varying degrees of commitment, Angrand, van Rysselberghe and, later, Henri-Edmond Cross shared Pissarro's anarchist philosophy. Although there is no written record of Seurat's anarchism, his discussions with Fénéon indicated that his friends's beliefs reflected his. Significantly, Pissarro developed his closest friendships with Luce and Signac, the most radical political thinkers among the group, and their friendship continued long after he had abandoned neo-Impressionism.

In the eighties, the neo-Impressionists's approach to content at times reflected prevalent anarchist theory. Peter Kropotkin advocated in his publication, *Le Révolté*, what Proudhon had advocated before him: to reveal the truth to the public, to represent reality, thus inevitably to criticize the social order. Although the neo-Impressionists never consistently attempted to follow Kropotkin's dictum, at times they portrayed the industrial suburbs and other aspects of contemporary life never seen at the Salon. Seurat made many drawings of the poor people of Paris, and in his *Une Baignade*, the bathers are of the working class of Asnières, an industrial section of Paris, with factory chimneys in the background. Signac painted *Gas Tanks at Clichy* and other industrial subjects, as did Luce, Lucien and Angrand.

As Signac later expressed it:

> By their new technique, the very opposite of the hallowed rules, they reveal the vanity of the traditional methods; by their vivid studies of the sordid workers's flats of Saint-Ouen or of Montrouge, by representing the massive body and the curious ruddy color of a digger near a pile of sand, of a blacksmith in the incandescence of a forge, or better yet, by the synthetic representation of the pleasures of the decadent: balls, chahut, circuses, as did the painter Seurat, who had such a keen feeling for the degradation of our epoch of transition; they bear witness to the great social action in which workers and capital are engaged.

Pissarro dined with the Independents now instead of with the Impressionists and went often with Seurat, Signac, Dubois-Pillet, Luce and others to the Café de la Nouvelle-Athènes. He described to Lucien the animosities among the artists there:

> The hostility of the romantic Impressionists is more and more marked. They meet regularly, Degas himself comes to the café. Gauguin has become intimate with Degas once more and goes to see him all the time—isn't this seesaw of interests strange? . . . I was naive, I defended him [Gauguin] to the limit and I argued against everybody. It is all so human and so sad. They are angry with us, and will not pardon me for being sincere enough to want to be faithful to my deepest convictions.

On another night at the Nouvelle-Athènes:

> . . . we saw Guillaumin, Gauguin, Zandomeneghi. Guillaumin refused to shake hands with Signac, so did Gauguin; . . . it appears that the cause was a misunderstanding in Signac's studio. Nevertheless, Gauguin left abruptly without saying good-bye to me or to

Signac. Guillaumin came over to shake hands and asked whether I was going to dine with the Impressionists on Thursday. Much surprised, I answered that this was the first time I had heard of the dinner. You can be sure that I won't spend thirteen to fifteen francs for dinner; I have three francs in my pocket. Besides, we no longer understand each other. It seems that the old group will close ranks; as for me, I insist on the right to go my own way. So much the worse for the narrow-minded! . . . Our role is very simple: we must stand alone! We have the stuff to be strong.

Pissarro met with much opposition from his old friends. ("Zandomeneghi looks at me with compassion and seems even mournful. It is very curious. . . ." "Durand says that Monet pities me because of the course I have taken. So! . . . Perhaps he does now . . . but wait.") He was surprised by their attitude, but tolerant: "Who the devil told him [Raffaelli] that I was angry with the old group? It seems to me that they, not I, are the ones who are offended, and all because I have the cheek to have an idea which they don't share. These authorities on art are obstinate and stubborn, but they are men of genius!"

As the gap between them widened and Pissarro's new style aroused hostility among both collectors and dealers, his tolerance turned to jealousy and suspicion, and his enthusiasm for his friends's paintings was temporarily replaced by contempt: He called Monet "sloppy and completely incoherent"; Gauguin "a maker of odds and ends"; Renoir "unintelligible . . . incoherent"; Sisley "commonplace, false, disordered."

His isolation and financial difficulties inevitably affected his judgment. A paranoid vein runs through some of his comments to Lucien in the first half of 1887: "I am sure Monet and Renoir worked against me with Petit," he wrote, but his common sense impelled him to add, "perhaps I am exaggerating." "I met Sisley; as ever, and like the others, he is secretive." "My canvases were scattered to give them less importance." "They will try anything again and again—particularly Gauguin—to steal our place."

This was aberrant behavior for a man who was normally judicious in his judgments, loyal to his friends, enthusiastic about their work. He was paying an emotional as well as financial penalty for his single-minded, almost fanatical dedication to the neo-Impressionist principles. The streak of paranoia that burst out so crudely in 1887, when he was penniless and desperate, reappeared from time to time in mild form.

Of the Impressionist group, Gauguin was the harshest critic of Pissarro's switch to pointillism. He commented to Emile Bernard: "You see what's happened to Pissarro as a result of always wanting to be on top of the latest trend. He's lost any kind of personality and his work lacks unity. He always followed the current movements from Courbet and Millet up to these young chemists who pile up little dots." Gauguin had no use for neo-Impressionism; he was intent on finding his own path, one that diverged from observation of nature and toward the symbolization of human experience.

Pissarro was offended by what he regarded as Gauguin's mercantile streak, his cold ambition, his competitiveness, his pretensions to leadership of a school; and he was hurt by Gauguin's rejection of neo-Impressionism, which implied his rejection of Pissarro. The two became antagonistic. Pissarro criticized Gauguin's "sharp practice" to Lucien; Gauguin wrote to Bernard, "Hang Pissarro. When I am in Tahiti, I can say to hell with Pissarro and his gang."

The division was based on more than personal disappointment with each other and disagreement over style. Pissarro felt that Gauguin had betrayed an earlier commitment to realism in art as a statement of political position. He blasted Gauguin's painting *Jacob Wrestling with the Angel* to Lucien:

> . . . I do not criticize Gauguin for having painted a rose background nor do I object to the two struggling fighters and the Breton peasants in the foreground, what I dislike is that he stole these elements from the Japanese, the Byzantine painters and others. I criticize him for not applying his synthesis to our modern philosophy which is absolutely social, anti-authoritarian and anti-mystical. That's where the problem becomes serious. This is a step backward; Gauguin is not a seer, he is a schemer who has sensed that the bourgeoisie are moving to the right, recoiling before the great idea of solidarity which sprouts among the people—an instinctive idea, but fruitful, the only idea that is permissible! The symbolists also take this line. What do you think? They must be fought like the plague!

And bitterly reporting the increasing acceptance of Gauguin's work, Pissarro states:

> It is a sign of the times, my dear son. The bourgeoisie, frightened, astonished by the immense clamor of the disinherited, by the insistent demands of the people, feels that it is necessary to restore to the *people* their superstitious beliefs. Hence the bustling of religious symbolism, religious socialists, idealist art, occultism, Buddhism, etc., etc. Gauguin has sensed the tendency. For some time now I have been expecting the approach of this furious foe of the poor, of the workers—may this religious movement be only a death rattle, the last one. The Impressionists have the true position, they stand for a robust art based on sensation, and that is an honest stand.

He was infuriated by Gauguin's religious subjects, blinded to the fact that they were Gauguin's real preoccupations and not the result of a coldly commercial streak. But Pissarro's habit of kindness was strong. Only a few months before, he had written to

Manzana (Georges Pissarro): *Gauguin.*
Crayon. Private collection

Octave Mirbeau, the playwright, novelist and critic, to help the destitute Gauguin raise money to go to Tahiti. Although Pissarro resented Gauguin's "shamelessness," he had written: "I asked our friend Monet for your address to find out whether you knew about Gauguin's potteries. They are rather strange in a manner simultaneously exotic, barbaric and wild, and have great style. Since you have a taste for artistic things, even strange ones, you ought to go and see them if you haven't already. There are a fair number of pieces with his friend M. Schuffenecker... you will also be able to see his painting there."

Pissarro still had hopes that Gauguin would eventually change his approach to art, for he wrote Lucien in March 1891: "Gauguin is leaving for Tahiti. . . . He will come through. We who were so close to him know that he has great vitality and is inured to the difficulties of life, and can take a new tack if need be!"

Gauguin left for Tahiti in 1891 and spent most of the rest of his life in the South Seas. When he returned to Paris in 1893 for an exhibition of his Tahitian work, young Georges Pissarro made a caricature of him in his imposing astrakhan hat and cape, looking like some gigantic and sumptuous gypsy.

Pissarro and Gauguin rarely saw each other again and were never reconciled. Each probably felt rejected by the other, a painful stand-off in a father-son relationship. Their pain accounted for the bitterness of their antagonism. Gauguin may have had the unrealistic expectation that if he followed Pissarro's advice and devoted himself to art, his kind and paternal friend would somehow help him make a living. He was disappointed in this; Pissarro had enough trouble helping himself and his family. And Pissarro was deeply hurt when his gifted pupil and protégé turned away from all his teachings and broke publicly with him and the Impressionists.

But while he lost the friendship and admiration of Gauguin, he had support from his new young colleagues, especially Signac, who spent the summer of 1886 painting with Lucien in Petit Andelys and corresponded with Camille about their work and ambition. Signac thanked Pissarro for his efforts to have him admitted to the show in Nantes: "It is so good and so rare to find support among the masters that one reveres."

Signac saw himself as a warrior in a glorious fight for a new art, and the smell of battle in Nantes exhilarated him: "There will be a fight. So much the better, we will hoist our flag to the top of every barricade and fire. Every shot counts in this troop. . . ."

"Are you working a lot?" he inquired in another letter. "Have you found a practical way to divide the colors? I am smearing paint around, wasting time, working a lot without any results. But I think I have made progress."

In the fall, he and Seurat visited Pissarro in Eragny, and Signac took a lesson from Lucien in the art of etching. Seurat, not entirely pleased that he had acquired followers, complained of being "imitated too much" and feared that if too many painters adopted the pointillist technique, his own invention of it would be forgotten. Pissarro was aware of this as early as the fall of 1886, when he wrote a brief description of his new artistic doctrines for Durand-Ruel, who was preparing a brochure to accompany the exhibition in New York. He advised the dealer:

> If your son puts out a publication on this subject, I want it well understood that it is M.
> Seurat, an artist of great worth, who was the first to have the idea and to apply the scientific

theory after having studied it profoundly. Like my other colleagues, Signac and Dubois-Pillet, I only followed the example given by Seurat.

Pissarro went on to describe the theory of neo-Impressionism:

To seek out a modern synthesis by scientific methods based on the theory of colors discovered by M. Chevreul, and after the experiments of Maxwell and the measurements of O. N. Rood.

To substitute the optical mixture for the mixture of pigments. Said in another way, the splitting up of tones and their constituent elements, because the optical mixture produces more intense luminosities than the mixture of pigments.

As to the execution, we regard it as completely unimportant; art has nothing to do with that according to us. The only originality consists in the character of the drawing and the particular way of seeing of each artist.

Pissarro and Seurat were seeing each other almost every day at the beginning of 1887, talking over their paintings and buoying each other's spirits. Though Pissarro was confident that neo-Impressionism would succeed, Durand-Ruel did not like his pointillist style and his clients were just as resistant to it. In 1886, the dealer paid Pissarro only 3,400 francs. By the beginning of 1887, the expenses of maintaining a large house and a family of eight had drained all of Pissarro's resources. He found himself penniless again; his loyalty to the new style he believed in was costing him dearly. His letters reveal desperation:

I am here in Paris without a cent; I am hard put to find a solution. Even if I wanted to leave I wouldn't be able to do so without borrowing. . . .

I wasn't able to write you, for I had to conserve my last few cents. . . .

Tell your mother that I am enormously concerned about the rent, etc. And that I am splitting my head to find a way out. Today I am going to track down Heymann. Who will get me out of this?

Durand-Ruel has not answered my letter. Strange. I wanted him to buy everything in my studio, except my pastels and drawings. . . . If I could, even at a sacrifice, get a few thousand francs, I would be able to work tranquilly for a while. And I would be willing to sell everything except the ones belonging to your mother and the ones hanging up in the dining room. Among these there are several canvases that would appeal to those who like my former style. Perhaps Murer could be persuaded? Or perhaps he knows someone who would be interested? Ask him.

Pissarro was driven to sell one of his most precious possessions:

At the moment the only thing left for me to do is to sell my Degas pastel. It will be painful to let it go, but it can't be helped. What do you think? If I could get from five to eight hundred francs it would certainly lighten our burden.

The more I think of it, the more mortified I feel about parting with the Degas and the more convinced I am that I must sell it. It is painful to do so; it means losing one of our purest joys. . . . Signac says it is worth at least a thousand francs. Arrange somehow to *get it to me undamaged*; I am going to see Portier about it.

Monet, meanwhile, was selling well, and although Pissarro usually admired and defended the talent of his old friend, he somewhat righteously questioned his motives:

"Monet plays his salesman's game and it serves him, but it is not in my character or in my interest to do likewise. Above all it would be in contradiction to my conception of art."

To Julie, who was concerned about the rent and about the children and the maid, who were ill, and wanted her husband home with her in Eragny to help, Pissarro wrote, "Don't be afraid, I'm making every effort and I love you all too much not to do the impossible, but I repeat—I cannot force circumstances to change."

Pissarro returned to Eragny only to find more troubles. He wrote to Lucien, now in Paris:

> Here we are again in a hopeless mess. . . . Your mother has—so she told me—nothing left. And you know how she is in such a situation. Here is the rock which must be raised again and again, without end. . . .
>
> This epoch is certainly full of stupidities; I have a reputation gained by many years of effort; I have drudged, despite your mother's constant remarks to the contrary, I have done the work of four to attain a true and proper renown, the kind won in a fair fight. Bah! It is as if I had been singing to myself all the time.

Brickyard at Eragny, 1888. (724) 23⅝ × 28¾. 60 × 73. The J. Paul Getty Museum, Malibu, California

It was not entirely his new technique which was responsible for his straits. The world-wide economic crisis which had begun in 1883 had not ended.

Nevertheless, his strict adherence to the "dot" was wavering. The first sign was his impatience with the time it took to finish a painting using this technique. He had written to Durand-Ruel in November 1886: "I am working hard, but what a long time it takes. It's unbelievable, but I spend three or four times more time to finish a canvas or a gouache. I am desperate about it." In December, he wrote to Lucien, "I have been yoked to this painting for the exhibit in Brussels for fifteen days."

The fact is that his experiments with the actual "dot" lasted a relatively short time—less than a year. He soon returned to a stroke, a very small, curved touch. But he clung firmly to the principles of divided color, and allowed one stroke to dry before laying another over it, to avoid chemical mixing of the pigments.

In September 1887, Signac wrote him asking why Durand was not taking any paintings from Pissarro since he could no longer be reproached for the "terrible dot." "In this regard I think that you were perfectly right to adapt your former method of execution to your new canvases. . . ."

Pissarro's money worries and his growing dissatisfaction with his dealer forced him to turn to Durand-Ruel's arch rival, Georges Petit, who had been showing the work of advanced painters at his luxurious galleries, the "International Exhibition," since 1882. Monet and Renoir had already placed their paintings with him, but Pissarro had remained loyal to Durand-Ruel. Now he found Petit's exhibition space more attractive, even though he objected to the commercialism of the operation. Monet, sympathetic to his situation, although the two were at odds over their directions in art, wrote to Pissarro in March 1887 to explain:

> . . . at the last meeting of the Committee of the International Exhibition, we voted your admission . . . to prove to you that in spite of the divisions between us for the past year, divisions which were not made by us, we have not forgotten our duty. Although Renoir and I know your point of view and your repugnance for this exhibition, we believed we should have voted for your admission even though we didn't know how you would take it—it's up to you now, dear friend, to decide what to do. We have done what we should. Answer as soon as possible to Giverny.

Pissarro decided to show at Petit's. As he wrote to Lucien: "I am very glad I decided in favor of exhibiting; it was an experience I needed. Who knows, I may never again be able to show with the old group of Impressionists, and I have every reason to be satisfied."

Taking part in the exhibition was good for Pissarro. His new paintings were seen by great numbers of the public and the entire art world. He received the usual adverse criticism, but also some appreciation from sympathetic writers like Jules Desclozeau: "Camille Pissarro has painted a field bathed in sunlight, whose forms, colors and reflections are admirably synthesized. It is more *field* than any field we have ever seen."

18.

Pissarro's Anarchism

*". . . if it is utopian, in every way it is a
beautiful dream."*
—Pissarro to Mirbeau, 1892

"I FIRMLY believe that something of our ideas, born as they are of the anarchist philosophy, passes into our works, which are thus antipathetic to the current trend," Pissarro declared to Lucien in April 1891.

What was this anarchist philosophy? What were his "ideas" and how did they relate to his art? to his life?

To understand Pissarro, one must understand the philosophy that attracted so many intellectuals in the closing years of the nineteenth century. By the mid-eighties, Pissarro was no longer virtually alone as an advocate of anarchism when the talk was political at the cafés. The elder statesman among the newly converted writers and artists, he was the respected "veteran" of the anarchist movement. He was not a profound or original thinker about anarchism, but he was the first artist to have a consistent and lifelong devotion to anarchism, a tradition of radical thought that influenced the neo-Impressionist movement, the nabis, the cubists and a large number of artists until World War I.

When Pissarro tried to proselytize for anarchism in the seventies, there was no cohesive or influential anarchist activity and only a sporadically published press. But after the anarchists formed their own International, in 1881, the movement began to gain acceptance and it erupted explosively on the French scene during the nineties. It was never large in numbers, but it reached some workers through anarchist clubs and had a broad influence among intellectual circles in Paris. Most of the leading symbolist poets and novelists—Gustave Kahn, Paul Adam, Emile Verhaeren, Laurent Tailhade, Bernard Lazare, Stephen Mallarmé—were drawn to anarchism, as were Pissarro's critic friends Georges Lecomte, Mirbeau, Fénéon, Alexandre and Geffroy. "The poets descend from the Ivory Tower," Lazare wrote.

The utopia of anarchism fascinated many artists and writers at that time. Artists who painted in a nonacademic, unconventional style and writers who departed from the norm were still rejected by French bourgeois society, and the avant-garde identified with other rejects. Protective of their independence, many artists were attracted to anarchism's stress on the rejection of authority and the exaltation of the individual. Theorists emphasized that under anarchism the artist would be free to express his own concept of the beautiful.

Many symbolist poets were drawn to anarchism's humanitarianism out of genuine

226

sympathy for the poor and the unemployed. To some, anarchism had a fascinating
mystique: It was daring, it was a new experience, it seemed to imply a dramatic
sweeping away of a corrupt society by the "cleansing" process of terrorism. Their
participation was more romantic impulse than cerebral conviction.

The need for radical change was obvious to any sensitive observer: French society
was full of inequities. Parisians with a conscience were always confronted with the
plight of the unemployed, of the countless prostitutes, of the discarded elderly and the
weak, of the thousands who died of hunger every year. France lagged behind England
and Germany in social legislation, and when its prosperity collapsed in 1882, the nation
entered into a depression that lasted, with little relief, until the end of the century. Bad
harvests and Phylloxera disease in the wine country increased the ranks of the
unemployed as landless and jobless farm labor flocked to the cities.

The new industrialism was exploitative and dehumanizing, but French industry was
actually undeveloped; as late as 1896, two out of three workers were agricultural.
Hence, talk of workers seizing power by revolution was pure illusion. Nonetheless,
there were violent upheavals and repressions on a small scale throughout the eighties,
culminating on May 1, 1891, when troops killed ten demonstrators agitating for an
eight-hour working day in the mining town of Fourmies. Like other radicals and many
liberals, Pissarro was outraged. "You have read in the newspapers the shocking
massacre at Fourmies in the North!" he wrote Lucien. "It is truly unheard of that
soldiers should allow themselves to be led into the most cowardly and most infamous
acts by the bourgeois! . . . there's the effect of the brutalization of the barracks." And
prophetically: "Every year the first of May will be a day of agitation which little by little
will take on momentous proportions."

Except for sporadic outbursts of violence, anarchist revolutionary action in the
eighties was mostly verbal. Fiery anarchist songs were sung in the cabarets and

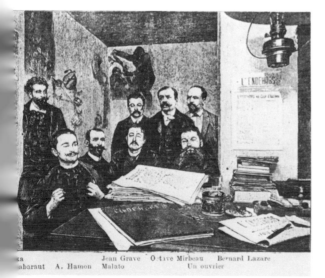

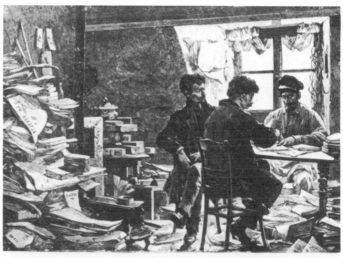

Artist unknown:
Anarchist Leaders. Engraving from Dubois,
Le Péril Anarchiste. Bibliothèque Nationale, Paris

Artist unknown:
Editorial offices of La Révolte. Engraving from Dubois,
Le Péril Anarchiste. Bibliothèque Nationale, Paris

peddled in the streets. Revolutionary pamphlets were passed from hand to hand. One anarchist newspaper, Emile Pouget's *Le Père Peinard*, founded in 1889, was written entirely in workers's racy slang, pungent and brutal, and illustrated by many of France's leading caricaturists and artists. It poured out calls for direct action, including theft if one was hungry, and assassination of unjust judges. Pissarro was among its readers, but he was philosophically closer to Jean Grave, who edited *La Révolte*, an anarchist publication, which endeavored to spread the word through education. Grave, a former shoemaker, was a mild yet firm man, and though he had little formal education, he wrote clearly and soberly, popularizing complicated ideas. His office, in the garret of a house on the rue Mouffetard, was the intellectual center of anarchism. Unlike Pouget, Grave argued that any theft was corrupting and contrary to anarchist ethics. He devoted space to the arts and literature, publishing original poetry, essays and excerpts from novels by contemporary and classical writers. Pissarro was among the many intellectuals who subscribed to *La Révolte:* Luce and Signac, predictably, and also Anatole France, Huysmans, Mirbeau, Daudet, Mallarmé, Lecomte and Rouget de Lisle. Pissarro had a lifelong cordial relationship with Grave.

The leading anarchist philosopher in the eighties and nineties was Peter Kropotkin, a Russian nobleman who had moved to France in the late seventies. He had been imprisoned in 1883 after violence in Lyon (with which he had no connection). When Prince Kropotkin was released, in 1886, he went to England, where he continued to write pamphlets, articles and books that helped form the philosophical and theoretical basis of anarchism. Pissarro read them carefully and urged his sons and friends to read them.

Kropotkin succinctly expressed the anarchist philosophy in 1887: "Anarchy, the No-Government system of socialism," he called it:

> In common with all socialists, the anarchists hold that the private ownership of land, capital and machinery has had its time; that it is condemned to disappear; and that all requisites for production must and will become the common property of society, and be managed in common by the producers of wealth.

But whereas the socialists and communists envisaged a planned society and the communists called for a dictatorship of the proletariat, Kropotkin stressed the "No-Government" concept:

> The ideal of the political organization of society is a condition of things where the functions of government are reduced to a minimum, and the individual recovers his full liberty of initiative and action for satisfying, by means of free groups and federation—freely constituted—all the infinitely varied needs of the human being . . . the ultimate aim of society is the reduction of the functions of government to *nil.*

Anarchism was opposed to all authoritative institutions that curbed man's freedom—the state (especially), the church, private property, even, some anarchists believed, the family.

Federated free groups were the key to Kropotkin's vision of society on regional lines. He called for a "return to a state of affairs where corn is grown, and manufactured goods fabricated, *for the use of those very people who grow and produce them. . . .* Each

region will become its own producer and its own consumer of manufactured goods."

Jean Grave spelled out more principles of anarchism in his book *Moribund Society and Anarchy*, which led to his imprisonment because the chapter on "Militarism" incensed the authorities. He attacked the courts, patriotism, militarism and colonization. He regarded as meaningless such social reforms as an income tax, a shorter work week, and minimum wages, for they were palliatives that in the long run would entrap the exploited still further. "There are no inferior races," Grave wrote, in contrast to Proudhon, who considered blacks—and women—"inferior." And, like Kropotkin, he repudiated Proudhon's nationalism and his defense of private property for the small producer. Grave and Kropotkin had a more magnanimous view of a cooperative society.

Grave stressed that, while all should have enough to eat, ". . . we also contend that each should be able to develop himself according to his faculties, and to procure those intellectual gratifications which the needs of his brain create." This surely must have appealed to Pissarro.

In his *Paroles d'un Révolté*, Kropotkin called particularly on artists to harness their talents to the cause of revolution.

> You poets, painters, sculptors, musicians, if you have understood your true mission and the interests of art itself, come then, put your pen, brush, burin in the service of the revolution. The arts have a mission to accomplish for the achievement of the future society. . . . Depict for us in your vivid style or in your fervent paintings the titanic struggle of the people against their oppressors; inflame young hearts with the beautiful breath of revolution which inspired our anarchism. Tell the wife how beautiful is the action of her husband if he gives his life to the great cause of social emancipation. Show the people the ugliness of contemporary life and make us touch with the finger the cause of this ugliness. Tell us what a rational life would have been if it had not collided at each step with the ineptitudes and ignominies of the present social order.
>
> The struggle for truth, for justice, for equality, in the bosom of the people—what will you find more beautiful in life?

Later, in *The Conquest of Bread*, Kropotkin seemed to place limitations on the artist's role:

> The best canvases of modern artists are those that represent nature, villages, valleys, the sea with its dangers, the mountain with its splendors. But how can the painter express the poetry of work in the fields if he has only contemplated it, imagined it, if he has never delighted in it himself?

Pissarro, somewhat closer to peasant life than Kropotkin living in exile in London, balked at his concept of the artist-as-peasant in a letter to Mirbeau:

> I have just read Kropotkin's book. A propos of art, there would be many things to find fault with. Kropotkin believes that one must live as a peasant in order to understand them. It seems to me that one must be wrapped up in his subject to render it well, but is it necessary to be a peasant? Let us be artists first and we will have the ability to feel everything, even a landscape, without being a peasant.

In 1894, the social psychologist Augustin Hamon published *Psychologie de l'anar-*

chiste, based on a questionnaire he had sent to many leading anarchists. His generalized synthesis fits Camille Pissarro almost exactly:

> An anarchist type could be described as follows: a man subject to the spirit of rebellion in any form (spirit of opposition, self-analysis, criticism, or innovation), possessing a great longing for freedom, either an egotist or an individualist, with deep curiosity and thirst for knowledge. To these characteristics must be added a deep love for others, an acute sensibility, a vivid sense of justice, a logical mind with strong combative instincts.

All these factors propelled Pissarro to become an anarchist—philosophic rather than activist—but sufficient to draw the government's attention to him.

When a letter from Lucien took as long as five days to reach him at Osny, he was suspicious. "Unquestionably it was opened by the postal authorities, for the envelope is smudged. One has only to read such and such a newspaper to be suspected, and put on the index," but then he notes that Lucien's last letter had arrived on time and adds ironically—and naively: "I suppose the postal authorities are reassured about our intentions and see that they were on the wrong track."

Pissarro was right in conjecturing that the authorities kept a surveillance on radicals. A later departmental police dossier lists the subscribers in the province of Eure, where Eragny is situated, to the two anarchist newspapers, *Le Père Peinard* and *La Révolte*. Pissarro's name appears on both lists. The police report refers to him as "the well-known Impressionist painter" and comments, "His political opinions are not known in Gisors or in the areas." He was discreet enough not to proselytize in a small village. (Pissarro's friend Octave Mirbeau was also listed as a reader of *Le Père Peinard*. In 1892, when Pissarro complained to his son Georges that Mirbeau's local postal authorities occasionally destroyed letters Pissarro had addressed to him, he was both amused and annoyed: "If we were plotting an evil deed, we would not be such idiots as to mention it in the mail.")

What were the major elements in Pissarro's political thinking? The clues are in his letters and in an extraordinary primer on society he prepared for his nieces. These writings reveal a man with a passionate hatred of injustice and of the society in which he lived, a deep sympathy for those whom he regarded as the victims of that society, and an anarchist's typically vague dream of a world he believed would eventually materialize out of the destructive chaos that surrounded him.

In 1883, Pissarro pragmatically hoped that the Republic would survive. He had little faith in it, but preferred it to a church-monarchy-army restoration. In February, when the republicans in the Chamber were engaged in a parliamentary struggle with the right-wing forces, he wrote Lucien, "The political situation is so bad that we have to be prepared for the worst eventualities. The future is not rosy. In any case one hardly has leisure for painting when one feels the nation fighting to safeguard the republican government which it cost so much blood to establish." But when Lucien asked his opinion of Clemenceau, he was skeptical: "It is naive to rely on any man in the Chamber. . . . Clemenceau is radical, but nevertheless no socialist. . . . Don't trust even his radicalism. . . . If you read the article 'Revision' in the copy of *Le Proletaire* which I am sending you, you will see what we think of him and of all the celebrated republicans who promised so much but, don't worry, they give little."

He took the orthodox anarchist position that the republican, parliamentary form of

government was only a cynical manipulation of the exploited poor, who had no genuine representation. He probably derived some of his ideas from Kropotkin, to whom representative government was a "sad comedy" and "class rule." Pissarro's views emerge from his and Lucien's efforts to educate Esther Isaacson politically. He had such respect and affection for his bright and open-minded niece that he was always trying to liberate her from her "bourgeois" attitudes. When Esther regretted the outcome of the elections in England, Pissarro's reply was caustic:

> It matters little to people who work hard and are dying of hunger. You should know then, ma petite Esther, that the best way of being free is not to delegate any of your powers. . . . England is at the same degree of cretinism as we are except that because of their idiotic and Protestant educational system, they are blinded by an appearance of false values, false morals, false liberties. France, or at least the Latin race, is more free of this rubbish and will be more apt to follow a new way.

When Esther's reply indicated her faith in universal suffrage, including votes for women and the poor, as the key to reform, Pissarro, the disciple of Kropotkin, pounced on what he regarded as her naïveté:

> Universal suffrage, the instrument of domination of the capitalist bourgeoisie, let me tell you, has been judged once and for all by the progressive forces—its time is past! . . . It serves only the big shots effectively! . . . You can easily imagine the absurdity of having everybody's interests represented by one gentleman, even if he were a splendid man. Let me suppose that I, a painter, should nominate the right honorable ——. I beg you to tell me how he could serve me? Will he ever understand, as a professor, the necessity to level those Bastilles of art, the Ecole des Beaux-Arts, the academies, the coalition of dealers, fat capitalists who make reputations, no, don't you agree?. . . Universal suffrage has served as a means of the bourgeoisie to dominate the economic situation. Therefore, it must disappear; within ten or twenty years, perhaps sooner, this will be the general outcry as well as for the expropriation of capital. . . .

Pissarro's attempt to proselytize Esther Isaacson culminated in his only visual frontal assault upon Parisian society. He expressed his deep contempt for it—and his strong compassion for its victims—in a remarkable series of pen-and-ink drawings that he made for Esther and her sister Alice. "Turpitudes Sociales," he called them. Intended only for a private audience, they are savage and ironic, sentimental and tough. Some draw upon Daumier, Hogarth and Cruikshank. The passion that Pissarro repressed in his painting as inappropriate is poured out here. Some of the drawings are crude, but they show the artist's lifelong fascination with problems of light. He uses the light of a street lamp, a skylight or a candle to create dramatic shadows and sharpen the violence of his subjects. In the night scenes, the dark shadows are baleful, the light stark. In nearly all, the entire surface is covered with quick, tiny pen strokes, a substitute for the aquatint of his etchings.

He depicts the anguish of the poor, the homeless and the hungry, but he only hints at prostitution, an institution frequently deplored in the anarchist press as typical of a "rotten society." As he wrote Esther and Alice, he did not want to offend their delicacy "in view of your education and sex" and hence had selected only the more "respectable" of the depravities of the bourgeoisie.

The "book" (it was finally published as a book, *Turpitudes Sociales*, in 1972) begins

Capital, 1889.
Pen and ink

on a note of hope. On the title page an old philosopher with a scythe and an hourglass—Time—sits high on a hill and ironically contemplates a sleeping Paris, where smoke pours from chimneys. The Eiffel Tower—ugly symbol of what Pissarro sarcastically calls "beau moderne"—"tries to hide" a rising sun with "ANARCHIE" curved around the rays—a symbol the anarchists often employed to depict the dawning of the new era.

In the series, there are twenty-eight drawings of the exploited and the exploiters, the captions often taken directly from Jean Grave's *La Révolte.* The theme is set in the opening drawing: A statue of a banker, hugging a bag of "capital" to his breast, towers above a crowd of howling, emaciated poor. "The war of the weak against the strong," says the caption. In his letter to Esther and Alice accompanying the drawings, Pissarro describes this first one: "The statue is the golden calf, the God Capital. In a word it represents the divinity of the day in a portrait of a Bischoffheim, of an Oppenheim, of a Rothschild, of a Gould, whatever. It is without distinction, vulgar and ugly." Jewish names? Pissarro? No coincidence, for in the third drawing, outside the Bourse ("Dante's Hell," he calls it), many of the bankers are drawn with exaggeratedly big noses, as are the small-scale speculators, both men and women, in the following drawing. It is true that an anti-Semitic streak runs through some of the anarchist and radical literature of the nineteenth century and the big nose was a convention of radical imagery, but it is surprising coming from Pissarro until one reads later, in a letter to Lucien: "The masses . . . dislike the Jewish bankers, and rightly, but they have a

UPPER LEFT. ***The Temple of the Golden Calf***, 1889. Pen and ink. UPPER RIGHT. ***The St.-Honoré Prison***, 1889. Pen and ink. LOWER LEFT. ***Little Bread***, 1889. Pen and ink. LOWER RIGHT. ***Uprising***, 1889. Pen and ink. All of these drawings and that on the opposite page are from *Turpitudes Sociales*, published in facsimile by Editions d'Art Albert Skira, Geneva

weakness for the Catholic bankers, which is idiotic." Pissarro did not really discrimi-
nate. His hostility toward bankers and speculators was essentially a class attitude, that
of the radical, artistic Jew toward the wealthy Jews of finance and those involved in the
stock market rather than in constructive endeavor. It was expressed in a private
message for his Jewish nieces and not intended for publication. His attitude reflected
that of his friend Jean Grave, who wrote in *Moribund Society and Anarchy,* "Is it not
the Grand International Swindling Association of Jewish and Christian bankers which
owns our railways, holds the key of our arsenal, and has the monopoly of our supplies?"
Pissarro hated all bankers, Jewish and Christian.

In another drawing, he switches to religion, to the elaborate "Burial of a Cardinal
who has taken the vow of poverty." ("Hypocrite!" Pissarro hurls at him.) It is a
magnificent composition, with the curve of crowds dramatically following the curve of
the procession—both played against the horizontal line of a river, with smoke
symbolically pouring from factories on the far bank. The drawing is a copy of a
watercolor Pissarro made of a funeral procession at Rouen in 1883.

In a factory scene—he calls it a prison—the patron has "the air and face of Louis
Philippe," and two workmen are dead or dying from exhaustion. "The poor are subject
to slavery, chained to perpetual pauperism," reads the quotation from *La Révolte.* A
striking drawing of seamstresses shows them jammed together at tables in a Paris
version of a sweatshop, the dark figures dramatically silhouetted by the spray of light
from overhead lamp shades. "The Prison St. Honoré—it is advanced, like a 'pension,'
very paternal! . . . do you think these working women are lucky?" Pissarro asks.

In other mordant images, a wretch hangs himself, an old man sprawls in the street
awaiting death, women sleep three in a bed in an airless room and a woman leaps to her
death from a bridge (in a copy of a Cruikshank etching). There is a parade of life's
cruelties and ironies: a struggling musician, a failed artist, a homeless child being
sentenced as a vagabond. In "Les Strugleforlifeurs," Pissarro coins a word combining
English and French to describe the robbery of a bourgeois by three bandits who use
force to "make him restore what he has stolen by force." He has no illusions about some
of the wretched poor—they get drunk and beat their wives. He also attacks the
bourgeois marriage of convenience with a Hogarthian scene of a groom eagerly saying,
"I do" to a bride who is ugly but has a large dowry.

One drawing, of a starving household, is much cruder than the others, deliberately
so, it turns out. "This rough sketch is the first idea of a drawing I wanted to do over
again. I have preferred to put it in as it is; its tragic brutality, its churlish execution, is
more telling than a polished drawing."

In the final scene, the workers are fighting on the barricades against the government
troops. A child, woman and old man, symbolic of the weak who suffer first, lie dead at
their feet. "The poor are going to hurl themselves on the rich," reads the final caption
from *La Révolte.*

The sentiments may be the naïve, stock phrases of orthodox anarchism, but they are
expressed with a fierce passion that springs from conviction. Most of the drawings are
vigorous and forceful, as passionate as the themes, and the composition is always
superb. The contrasts of light and shade are dramatic, the blacks ominous. Pissarro is

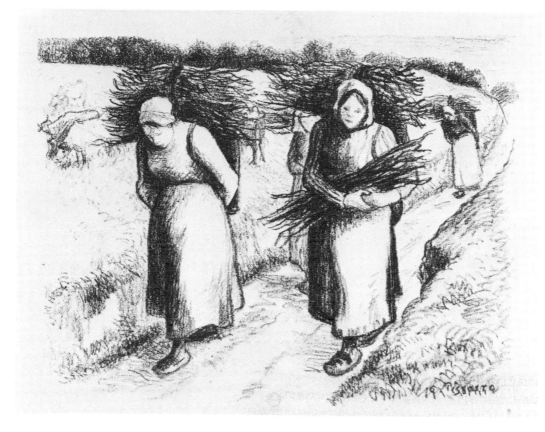

Women Carrying Fagots, 1896.
Lithograph.
(D 153) 9 × 11¾.
22⅞ × 29⅞.
Bibliothèque
Nationale, Paris

strongest when he deals with suffering and weakest when he portrays symbols, such as those of capitalist bankers and their minions. This is not surprising: he was more at home caring than attacking.

His hatred for the exploitation and degradation caused by industrialism bursts out here. Although both peasants and hired farm help worked long, backbreaking hours, Pissarro rarely showed them exhausted or debased—perhaps because, from an anarchist point of view, the peasant retained his dignity as an individual, most precious of all possessions, and being close to the earth, he represented what could become the ideal existence.

Anti-imperialism was a fundamental part of radical thinking in an age of rampant colonialism. When the British were facing revolts in Egypt, Pissarro exulted to Lucien: "As for the troubles the British are having in Egypt, they deserve it! At last *right triumphs over might.* What will the bourgeoisie say to that!" When the English were fighting the natives of the Transvaal area of Africa, he observed: ". . . if by force of money and effort they succeed in subjugating the peasants, what a future for the civilized world . . . oh, the bourgeois!"

His hatred of imperialism, a recurrent theme in his letters, lasted all his life. Even at seventy-two, his capacity for indignation was undiminished. In one letter, he roared at Lucien's wife, Esther: "And the coronation, the great, great Victory of the English, the

Boers completely routed, etc., etc!!! What cheek, eh? These shopkeepers!! The *New York Herald* is stinking with jingoism, it's comic and heartbreaking."

Pissarro's contempt for capitalism was all-encompassing. According to his young friend, the critic Georges Lecomte, when Pissarro read in the textbook of Paul-Emile or Cocotte a reference to "legitimate profits," he strode over to the village teacher and demanded, "I would like very much to know what is a legitimate profit." The concept of "profit" offended what Lecomte called "his humanitarian outlook, his generous and simplistic view of the world"; but his intellectual honesty made him question his own efforts to sell his paintings and earn a living in a capitalist world. "A really true article in *La Révolte* demonstrates clearly that we are all only a pack of crooks," he wrote Mirbeau. "Indeed, isn't a crook one who sells a painting to a friend or admirer, all the more so when he is not satisfied with his work and is totally incapable of putting a value on it? . . . damn! You will answer that we are forced to howl with the wolves or die of hunger. That's true—but that doesn't take away the value of the argument. All crooks!"

Like all radical artists and writers living in a society antipathetic to their ideals, Pissarro was in constant conflict between his beliefs and his need to support a family. "It is disgusting to be part of such a degenerate business," he wrote Lucien. The only way out, he felt, was to "make works of art full of sensation, wholly uncommercial, satisfactory to both artist and collector." This would have been a neat solution to his problems if he could have achieved it, but the built-in contradiction was the major reason for his economic stress until the nineties.

Although he lived as a bourgeois and admitted it, he felt he did not earn his living as a bourgeois did. Rather, he was a "proletarian without overalls." "One can hardly conceive of a bourgeois without unearned increment," he wrote Lucien. "All those who work with their hands or brains, who create, become proletarians when they depend upon middlemen—proletarians with or without overalls." Perhaps he summed it up best when, toward the end of his life, he told Lucien: "Money is an empty thing; let us earn some since we have to, but without departing from our roles!"

Pissarro was passionately opposed to the Catholic Church, which anarchists regarded as a bulwark of reaction. Sometimes his principles placed him in a disconcerting predicament. When Julie's niece, Nini Estruc, a frequent visitor at Eragny and a model for his sketches, was to be married, her fiancé insisted on a church wedding to placate his customers. Pissarro, who had agreed to participate in the ceremony, was vexed. "I am very embarrassed, this is very painful to me," he wrote Lucien. "I may flatly decline to escort the bride . . . it would go against all truth." Since Nini continued to visit and occasionally pose for him, he probably sacrificed his principles on the altar of family harmony.

Many of Pissarro's prints of women farm workers in their daily rounds express his philosophy only in the broadest sense; they are engaged in hard physical labor, but for the most part there is no hint of social criticism. He implies that the farm worker's toil is superior to that of the factory worker or seamstress, as he showed in *Turpitudes Sociales*. But in *Women Carrying Fagots*, which was also published in Jean Grave's *Les Temps Nouveaux* (successor, in 1896, to *La Révolte*), and its companion lithograph, *Peasant Women Carrying Fagots*, the women trudge along wearily, bent over by the

weight of their burdens. There is no idyllic element in these prints; the women are performing arduous labor.

In the mid-nineties, Pissarro also made an etching and four lithographs on a favorite radical theme of protest: unemployed migrants, made jobless by the decline in agriculture, who wandered through the French villages, sometimes with families, begging for food. One, *The Homeless*, 1896, was also reproduced in *Les Temps Nouveaux*. These homeless wanderers, like the unemployed in the cities, were the most effective propaganda the anarchists had—living condemnations of capitalism. In most of these lithographs, Pissarro tugs at the emotions. The children are poignant waifs; a beggar leans on a cane for support; another bitter wanderer, one-legged, is trailed by his two children. Surprisingly, Pissarro pulled only his usual small quantity of proofs of all these prints, foregoing the opportunity to reach a wider audience. Perhaps he was content with the reproduction by *Les Temps Nouveaux* of three of his prints. He also made a pen drawing, *The Stevedores*, 1893, drawn on the docks at Rouen, for *La Plume*, and a color lithograph, *The Plowman*, 1898, used as a frontispiece for a *Les Temps Nouveaux* booklet by Kropotkin.

After Pissarro sent his drawing of stevedores to *La Plume*, he wrote Mirbeau, "I made a drawing representing some bearers of coal on the bridge at Rouen. Fortunately I had done this motif during my stay there, otherwise I would have been forced to send him a tree trunk, which wouldn't have done the job. I wonder what a man of letters means by 'anarchist'? Something alien, it seems to me. Is there an anarchist art? What? . . . decidedly they don't understand! All the arts are anarchist! When it is beautiful and good! That's what I think of it."

"Anarchist" when it is "beautiful and good." His concept was not far from that propounded by Signac in the pages of *La Révolte* in 1891, repudiating direct social advocacy in art and declaring that innovations in technique and esthetics challenged bourgeois standards and were more revolutionary than mere propaganda art. Signac pointed out that the novels of Zola and Flaubert, while written for purely literary ends, spread "the revolutionary cause."

> It would be an error, in which the most well-intentioned revolutionaries often fail, to demand a systematically precise socialist tendency in works of art, because this tendency will be found even stronger and more eloquent among pure esthetes, revolutionaries by temperament, who, departing from the beaten path, paint what they see, how they feel, and unconsciously give, very often, a vigorous blow of the pick to the old worm-eaten social edifice, which is cracking and falling apart in the same way that an old cathedral is secularized.

Jean Grave and other writers in *La Révolte* and *Les Temps Nouveaux* attacked Signac as well as those who advocated an outright art for art's sake position, urging artists to create paintings that would contribute to social change, while granting that art should also be inherently beautiful and not always bear a "message." Lucien challenged this position in a letter that probably reflected his father's views: "The distinction you make between art for art's sake and art with a social tendency doesn't exist. Every production which is truly a work of art is social (whether or not the creator wishes it), because he who has produced it makes his fellow men share the most passionate and purest

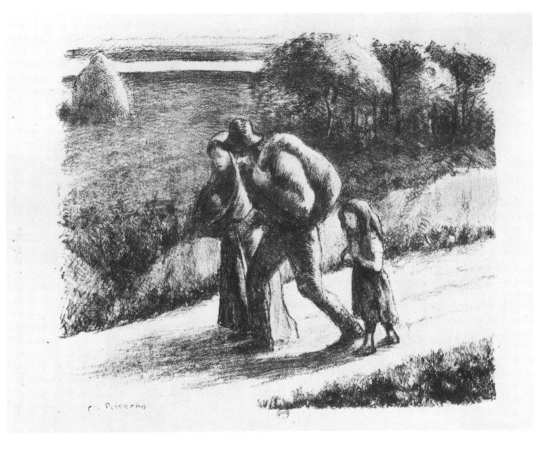

The Homeless,
1896.
Lithograph.
(D 154) 9⅞ × 11⅞.
25 × 30⅛.
Bibliothèque
Nationale, Paris

emotions which he has felt before the sights of nature. . . . This work of pure beauty will enlarge the aesthetic conception of other people." Or, as Pissarro once expressed it to Lucien, there will be "a better time when man, having achieved another mode of life, will understand the beautiful differently."

The anarchist painters were agitated over this issue, usually coming to Lucien and Camille's comfortable conclusion that a truly beautiful work of art in itself was a challenge to corrupt bourgeois taste.

Pissarro was convinced that his "anarchist" art would have to wait a generation to be appreciated. ". . . only another generation, free from all religious, mystical, unclear conceptions, a generation which would again turn in the direction of the most modern ideas, could have the qualities necessary to achieve my approach." But his optimism convinced him that the dawn of anarchism was not far off. He was confident that "The future . . . will bring the abolition of capital and property." When anarchist agitation was at its height, in 1892, Pissarro noted, "It is easy to see that a real revolution is about to break out—it threatens on every side—ideas don't stop!" Four years later, he was still confident: "Reaction is trying to take over but it is too late, people no longer believe in the authority of God, religion, government, etc."

What did Pissarro have in mind when he said that his work contained "something" of

his anarchist ideas? Certainly there was no overt attack on capitalist society, no obvious advocacy of anarchism. But there were elements in Pissarro's art that reflected his philosophy. Most fundamental was his disregard for bourgeois standards of "beauty," official art values in painting, from the seventies on. He consistently painted without regard for academic aesthetics, thus in a sense defying the state. Many non-anarchist painters also shared his approach, but his work had several other aspects that set him apart. His peasants represented a way of life exalted by the anarchists. Although Kropotkin argued that the machine should be harnessed for the benefit of mankind, Pissarro, like so many anarchist intellectuals, was repelled by the exploitation of the industrial worker. His utopian vision of peaceful villages and fields, a rural life in which the only stress is that of hard but clean work outdoors, is in implied contrast to the horrors of factory labor. There is no hint of the heavy hand of authoritarian government in the life of these peasants. Pissarro often showed peasant men and women engaged in harmonious cooperative endeavor, as in harvesting or gathering fruit. When they are at the marketplace, there seems to be a healthy interchange, with no whiff of the Bourse.

It is not the "ugly reality" that Kropotkin urged artists to portray, it is not the art with blunt social message that Grave advocated, nor is it simply "beauty" as an example to enlighten the masses. There are the "passion and pure emotion" before the sights of nature that Lucien called for. At the heart of these paintings is his wish to picture a world that was passing and needed preserving in the ideal society of the future. His vision is of men and women perfectly integrated into their natural environment.

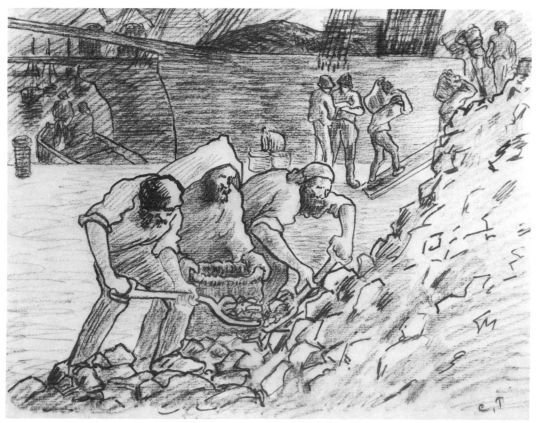

The Stevedores.
Pen and crayon.
Collection Mount
Holyoke College
Art Museum,
South Hadley,
Mass.

Pissarro's vision of himself as an artist integrated into his social environment was described by Mirbeau in a sensitive article:

> Not only does M. Pissarro paint, but he knows why he paints and what he paints. He applies his reason to it as a technician and as a philosopher. . . . He doesn't believe that a painter should be a superterrestrial being, outside and above humanity. He firmly believes that the painter is in the world in the same way as the poet, the farmer, the doctor, the chemist, the worker who shapes and forges iron. The painter, for him, does not at all accomplish an esoteric or luxury task. He contributes, as does everyone who makes something useful, beautiful, to the general harmony of the universe.

Even though Pissarro was philosophically opposed to the effects of industrialization, from the sixties on he painted factories as an integral part of the countryside or the waterfront. No matter how he deplored what went on inside them, he found the buildings visually interesting. They were part of the new reality of the French landscape and he accepted them as such. He delighted in the vertical thrust of the chimneys, the smoke elongated by the wind against blue sky, the softness of smoke against rigid forms. The movement of wind-swept smoke saves several of his paintings from being static.

Just as he recoiled from direct agitation in his painting, so did he shun becoming an activist; however, in 1889, he joined a discussion group, Le Club de l'Art Social, which met weekly for a year to discuss the social uses of art. It included writers such as Ajalbert, Cladel and Adolphe Tabarant, who was to become Pissarro's biographer; militants such as Louise Michel and Jean Grave; and others who were less radical but critical of French society, such as Rodin, who hoped, vainly, to build a huge Tower of Labor, perhaps to counterbalance the Eiffel Tower.

Pissarro's anarchism was consistent. The radical youth who loses his fervor for change in middle or old age is a familiar figure. Many artists who were anarchists in the eighties and nineties drifted away from radicalism when they became successful. Pissarro, however, maintained his revolutionary ardor to the end and never wavered in his financial and moral support of the radical cause.

Among his papers is a receipt from *Cri du Peuple*, a socialist newspaper that veered toward anarchism, for 5 francs "from citizen Pissarro." It is dated January 23, 1888, a time when his finances were at their lowest. Four years later, the Spanish anarchist artist Charles Malato, a friend of Pissarro from the fifties, wrote that Luce had sent him the total sum derived from a sale of one of Pissarro's paintings. "The money will be distributed as you intend and only two or three close friends will know from whom it comes." Pissarro also sent Fénéon 40 francs for the children of arrested anarchists and later sent Grave 50 francs. There was a considerable number of contributions over the years, and undoubtedly many of which there is no record. Most were relatively small sums, though important when his own reserves were limited; but as his finances improved, so did his contributions. Twice he paid the debts to the printer of *La Révolte* and *Les Temps Nouveaux,* making possible the continuation of publication, Grave recalled. Both contributions were considerable, more than 1,000 francs.

Julie was not happy about these gifts to a cause which she probably felt contributed to their troubles. A letter from Pissarro to Lucien in 1896, when he helped the

imprisoned Pouget, gives insight into Pissarro's motivation beyond the obvious humanitarianism and devotion to the cause: "I am sending you a letter from Pouget, who is in prison, and on the back you will read your mother's harsh words for me because I am moved by Pouget's misfortune. However, I am only returning to another what Caillebotte did for us when we were in trouble and glad we were to have his help. I don't understand her reproaches."

Julie's objections never seemed to have restrained him. When Grave was imprisoned for a month in 1891 for copyright violation, Pissarro urged Mirbeau to take up his defense in the journals for which he wrote; and in 1900, he sent Grave a check "for the refugees"—probably radicals from Italy, where a counterreaction was driving them into exile.

He found it difficult to describe in writing the relationship between the artist and anarchy.

> Luce wants to know whether you would collaborate with me [he wrote Lucien] in outlining the anarchist conception of the role artists could play and the manner in which they could organize in an anarchist society, indicating how artists could work with absolute freedom once rid of the terrible restraints of Messieurs capitalist collector-speculators and dealers. How the idea of art would be further developed, the love of beauty and purity of sensation, etc. etc. . . . I am afraid that I will be unable to set down on paper the ideas that come to us so often—it is so difficult to formulate an idea.

When Berrichon, editor of an anarchist publication, asked Pissarro to write an article on "anarchist art," again he declined. "I am absolutely incapable in spite of my desire to do you a service." Instead, he appealed to Mirbeau to write the article in his place, insisting that when he took up pen or pencil, "I am an idiot." Obviously no "idiot" as a writer, perhaps he hesitated because he could not expand on his vague sentiments that "all arts are anarchist when they are beautiful and good," and "Proudhon says in *La Justice* that love of earth is linked with revolution, and consequently with the artistic ideal."

Pissarro could not express his thoughts on "anarchist art" because his anarchism was more emotional than intellectual. At no time did he carefully analyze its elements and form a coherent philosophy. His conception of the anarchist world of the future was conveniently amorphous, though strongly felt.

But the vagueness of his vision did not prevent him from dreaming a dream. As he wrote Mirbeau after Kropotkin's *The Conquest of Bread* was published, "One must admit that if it is utopian, in every way it is a beautiful dream, and as we often have had examples of beautiful dreams become realities, nothing prevents us from believing that it will be possible one day, unless man fails and returns to complete barbarism."

19.

Pissarro and the Brothers van Gogh

"What Pissarro says is true, you must boldly exaggerate the effects of either harmony or discord which colors produce."
—Vincent to Théo van Gogh

WHEN Pissarro showed his paintings for the first time at Georges Petit's International Exhibition in 1887, one of the visitors was Théo van Gogh, the director of the Boussod and Valadon Gallery on the Boulevard Montmartre, and brother of Vincent. Théo was enthusiastic about the art of the Impressionists and persuaded his gallery to buy their work. He was impressed with Pissarro's paintings and invited him to exhibit at Boussod and Valadon, a welcome alternative to dependence on Durand-Ruel. Théo also introduced his brother to Pissarro. Vincent was eager to learn about the new painting, and Pissarro took time to explain his theories and techniques. The thirty-three-year-old Vincent, whose paintings had been dark and almost without color, changed his palette completely during his stay in Paris. He even experimented with the neo-Impressionist "dot" in several paintings of 1887, but his temperament was too passionate to adhere to a strict divisionist system.

Vincent shared Pissarro's antipathy to bourgeois values and his concern for the protection of artists as well as workers from the pressures of a capitalist economy. He wrote to Gauguin:

> After you left Paris, my brother and I stayed together for a while—a time which will forever remain unforgettable to me! The discussions covered a wide field—with Guillaumin, with the Pissarros, father and son, with Seurat, whom I did not meet until soon before leaving. . . . Often these discussions had to do with problems that are so very near to my brother's heart and mine, that is, the measures to be taken to safeguard their means of production (paints and canvases, etc.) and to safeguard, in their direct interest, their share in the price which pictures bring a long time after they leave the artist's possession.

Vincent also valued Pissarro's advice and wrote Théo several letters about it:

> You will receive another big pen drawing which I'd very much like Pissarro to see if he comes on Sunday.
>
> I am greatly pleased that Pissarro thought something of *The Young Girl*. Has he said anything about *The Sower?*
>
> What Pissarro says is true, you must boldly exaggerate the effects of either harmony or discord which colors produce. It is the same in drawing. Accurate drawing, accurate color, is perhaps not the essential thing to aim at because the reflection of reality in a mirror, if it could be caught, color and all, would not be a picture at all but no more than a photograph.

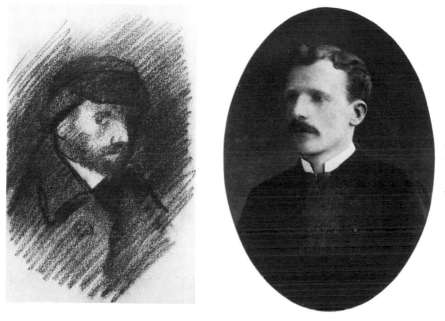

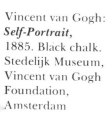

Vincent van Gogh:
Self-Portrait,
1885. Black chalk.
Stedelijk Museum,
Vincent van Gogh
Foundation,
Amsterdam

Théo van Gogh.
Photograph
Rijksmuseum Vincent
van Gogh, Amsterdam

Vincent responded, as had Cézanne and Gauguin, to Pissarro's fatherly warmth and steadiness. Although his own future was insecure, Pissarro apparently communicated a feeling of stability to Vincent.

In 1887, Pissarro received only 439 francs from Durand-Ruel. His income was augmented by some payments from Théo van Gogh and Georges Petit, but it did not reach 4,000 francs. It was a year of extreme uncertainty, in which the strain on Julie and the family was severe. Alfred Pissarro tried to help by finding a job for Lucien, but his effort only intensified the family's stresses. Camille angered Julie by advising Lucien not to accept the position, for it had a string attached. "This position was offered to you only on one condition, that you would accept it without any *arrière pensée* of returning to illustrating or painting," Camille wrote Lucien. "Your uncle has expressly told me that he would incur the reproaches of these businessmen if at the end of a year or two you would quit the job. That would be very injurious to him." Camille also angered Alfred, who felt rebuffed when he tried to help. Occasionally the brothers had had convivial evenings together; but their philosophical differences were insoluble, and sporadic antagonism was inevitable. Camille's determination that he and his sons pursue artistic careers at whatever costs was resented by the more practical Alfred, who probably wished he could afford the "luxury" of an artist's life. On his part, Camille resented what he regarded as his brother's insensitivity.

Pissarro's responsibilities—maintaining integrity as an artist and filling the physical needs of his family—seemed in the late eighties to be in direct conflict, but his letters show that he was then better able to keep his balance than during his emotional crisis of the late seventies. More aware of the shape of his life and goals, he was willing to change his compass readings but not his destination. He had developed a calm and ironic objectivity about his place as family man, artist and worker in the social scheme.

One of his difficulties was Durand-Ruel's refusal to take paintings from him, although Pissarro was moving away from Seurat's method. And time was a factor. In July, he wrote to Lucien: "My painting *The Cleft* is hardly advancing even though I work on it every day. It is really taking much too long. . . . Perhaps I will be compelled to return to my old style? That would be very embarrassing! We shall see. Anyway, I will have learned to be more precise."

Though he could admit to his son, with humor, the possibility of giving up neo-Impressionism, Pissarro defended his position vigorously against others. Visiting the Murers for lunch one day several months later, he bumped into Renoir.

> A tremendous discussion of the dot! At one point Murer said to me: "But you know perfectly well that the dot is impossible!" Nettled, I replied that he no doubt took me for a hypocrite. Renoir added: "You have abandoned the dot, but you won't admit you were wrong."
>
> I said, "My dear fellow, I am not that senile. Besides, you, Murer, know nothing about it; and as for you, Renoir, you follow your caprice. But I know where I am going!"
>
> Then there was much abuse of our young friends: Seurat discovered nothing, he takes himself for a genius, etc. You can be sure that I didn't let these remarks pass unchallenged. . . .

The drop in income was hard on Julie, particularly after a few years of prosperity. She borrowed money, bought food and medicine on credit and exhausted herself to keep the household running. At forty-nine, she was no longer young. At her insistence, a job in Paris had finally been found for Lucien, with Degas's help, in a firm that printed color lithographs. Although Julie tried to find a job for Georges, he was still at home.

Her despair deepened. "You say to 'wait, wait,' " she wrote Camille in Paris. "For thirty years you've been saying the same thing. I am old, ill, always with the same trouble and misery—it will finish me."

Their debts mounted rapidly. Julie's frustration impelled her to take over the task of selling her husband's paintings; she probably figured she could do no worse than he. In August 1887, Camille wrote to Lucien:

> I can't give you any further details about how your mother expects to succeed better than I; she doesn't know herself, I suppose. I have a vague idea she is counting on Murer, but I'm afraid she's deluding herself. . . . Well, she left me yesterday with Cocotte for Pontoise to go from there to the Murers! Next, she intends, I think, to go to Paris. . . . I couldn't discuss the matter with your mother and dissuade her; it would only have resulted in quarrels which simply irritate us and keep us from solving the problem. This is the state we are in: darkness, doubt, quarrels. With all that, one must produce works that will stand up to those of one's contemporaries. One must create art, without which all is lost. So, my dear Lucien, I stiffen myself against the storm and try not to founder. Your mother accuses me of egoism, indifference and nonchalance. I make heroic efforts to preserve my calm so as not to lose the fruit of so much thought and labor.

Julie's expedition was fruitless. She returned to Eragny with one hope: a proposition for Murer to arrange a sort of fake auction at which Pissarro would offer his own stock of paintings as some "so-called private collection." Pissarro rejected the idea. He judged that such an auction "would be a complete disaster, unless Murer were prepared to

bid, and if necessary to buy 3,000 or 4,000 francs' worth of paintings, which I am certain he is not." Otherwise, his paintings would be sold at humiliatingly low prices.

Julie was pushed to the edge of despair by her failure, by Camille's rejection of the one possibility she had turned up and by her inability to understand the strategies of the art world. The depth of her anguish was revealed in a letter to Lucien:

> Your poor father is really an innocent; he doesn't understand the difficulties of living. He knows that I owe 3,000 francs and he sends me 300, and tells me to wait! Always the same joke. I don't mind waiting, but meanwhile one must eat. I have no money and nobody will give me credit. I paid off a little of the debts here and there, but it is so little that they don't want to give me any more credit. What are we to do? We are eight at home to be fed every day. When dinner time comes, I cannot say to them "wait"—this stupid word your father repeats and repeats. I have used up anything I had put aside. I am at the end of my tether and, what is worse, have no courage left. I had decided to send the three boys to Paris and then to take the two little ones for a walk by the river. You can imagine the rest. Everyone

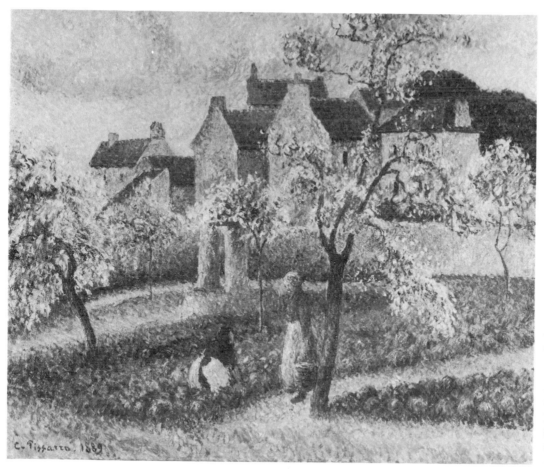

Plum Trees in Flower, 1889. (728) 18⅛ × 21⅝. 46 × 55. Photo courtesy Christie's, London. Shown at first retrospective, 1892

would have thought it an accident. But when I was ready to go, I lacked the courage. Why am I such a coward at the last moment? My poor son, I feared to cause you all grief, and I was afraid of your remorse. Your dear father wrote me a letter which is a masterpiece of selfishness. The poor dear man says that he has reached the top of his profession and doesn't want to prejudice his reputation by having an auction sale or by pawning his pictures. Not to prejudice his reputation! Poor dear, what repentance for him if he should lose his wife and his two little ones! To uphold his reputation! I think he doesn't know what he is saying. My poor Lucien, I am terribly unhappy. Good-bye. Shall I see you again, alas?

Julie's despair was aggravated by Camille's reasonableness; to her, his lack of emotion meant that he was not taking the situation seriously. Lucien acted as peacemaker, trying to explain his father to his mother:

It's curious that you are unhappy that Papa is not worried. On the contrary, I admire him. If by bad luck, he was a man who allowed himself to be overcome by discouragement, what would become of us? A discouraged man is incapable of working and above all of working well. To make good painting, it's necessary to have complete serenity of spirit, which happily, he has. It's already unfortunate that you are so anxious. If both of you despair, everything will be lost, while with coolness and perseverance, we can still get out of this. Reflect, my poor mother, and try to be a little reasonable. From what I've been able to see, things are getting better and the latest canvases that Papa has sent out have had much success.

As to the auction that Murer proposed, it's clear that it's he who wishes to profit by such a sale.

In spite of Pissarro's apparent serenity and his efforts to overcome anxieties about money, his work did not go well in 1887. The number of paintings he did dropped to about ten, from eighteen the previous year and thirty-three in 1885. Although Camille did more gouaches in 1887 than in the two previous years, Lucien later pointed out that his father had destroyed quite a few paintings during 1887 out of dissatisfaction with them.

The neo-Impressionist venture was also marred by the eruption of a quarrel over who had originated the method. Signac blamed the misunderstanding on "ill-informed critics." For example, an article had appeared in *Le Matin* referring to Seurat as "a new pupil of Pissarro." Seurat resented such an interpretation; he became suspicious of his colleagues and protective of his position as the originator of neo-Impressionism. "If too many artists take up this technique it will lose its originality and will have no more value," he wrote Signac. "It is my right to think that and to say it . . . because I painted in this way only to find a style for myself."

Understanding Seurat's jealousy of his method and obsession with secrecy, Pissarro kept out of the quarrel as best he could. After seeing the frame of *Les Poseuses*, which Seurat had painted with a pattern of dots, Pissarro had written to Signac with some irony: "It's indispensable. We'll have to do the same. . . . The picture is not at all the same picture if it has white all around it. I shall try it myself—but of course I will only exhibit the result after Seurat has made it known that he thought of it first."

Nevertheless, Pissarro was aware that as an artist established long before Seurat appeared and as the oldest of the neo-Impressionists, he must seem the chief threat in

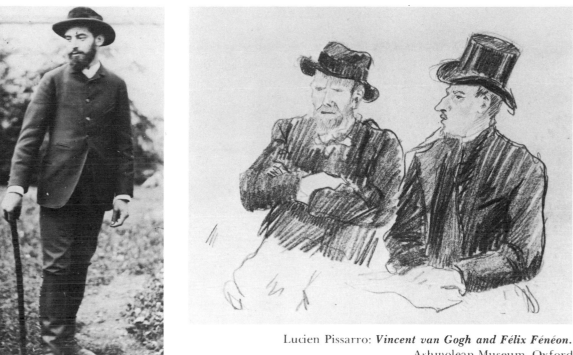

Lucien Pissarro: *Vincent van Gogh and Félix Fénéon.*
Ashmolean Museum, Oxford

Lucien Pissarro. Photograph Pissarro family documents

Seurat's mind. His response was to take up a parallel but independent path. He wrote to Signac:

> It's disquieting. For the future of our Impressionist art we must absolutely stay outside the school of Seurat. (You probably saw this coming, by the way.) Seurat is a graduate of the Ecole des Beaux-Arts and he's absolutely steeped in it. So look out! That way lies danger. This is not a question of technique or science, but of a tradition that must be kept intact. Science belongs to everyone and you must use it as you want to, but hold tight to the gift you have, that of feeling as a free and independent artist. Leave Seurat to work out his problems.

Pissarro was giving advice to himself as well. By the fall of 1888, he was becoming more disenchanted with his modified neo-Impressionist technique, writing to Lucien:

> I think continually of some way of painting without the dot. . . . I hope to achieve this but I have not been able to solve the problem of dividing the pure tone without harshness. . . . How can one combine the purity and simplicity of the dot with the fullness, suppleness, liberty, spontaneity and freshness of sensation postulated by our Impressionist art? This is the question which preoccupies me, for the dot is meager, lacking in body, diaphanous, more monotonous than simple, even in the Seurats—especially in the Seurats.

"Dividing the pure tone without harshness" was the goal Pissarro had set for himself; inevitably, it led away from neo-Impressionism. He was trying to reconcile pointillist

methods with his own natural tendencies, and the two were inherently at odds. His instincts as a colorist had always led him to juxtapose close tones and analogous hues to create subtle effects and delicate harmonies, but the neo-Impressionist technique is based on the vibrant note produced by juxtaposing two strongly contrasting or complementary colors. Signac later described the way in which Pissarro deviated from the neo-Impressionist norm: ". . . [Pissarro] strives to diminish the distance between two tints by introducing into each one of them intermediate elements which he calls 'passage.' But the neo-Impressionist technique is based precisely on strong contrast, for which he feels no need, and on the violent purity of tints, which hurts his eye."

Pissarro's struggle to align neo-Impressionism with his own nature took its toll. He produced relatively few paintings in 1888 and 1889, although he searched constantly for a synthesis. Félix Fénéon asked him for information on his theory of "passages" for an article he was preparing, but Pissarro was not confident enough of his direction to articulate it clearly. He reported to Lucien:

> . . . I will write him what seems to me to be the truth of the matter, that I am at this moment looking for some substitute for the dot. So far I have not found what I want. The actual execution does not seem to me to be rapid enough and does not follow sensation with enough inevitability. But it would be best not to speak of this. The fact is I would be hard put to express my meaning clearly, although I am completely aware of what I lack.

He confided to his favorite niece, Esther, that he was very discouraged, that business was disastrous and that "this stupid *Exposition Universelle*" (for which the Eiffel Tower was constructed) was making things even harder. His mood was so low that he felt the blackest suspicions:

> . . . a matter of race, probably. Until now, no Jew has made art here, or rather no Jew has searched to make a disinterested and truly *felt* art. I believe that this could be one of the causes of my bad luck—I am too serious to please the masses and I don't partake enough of the exotic tradition to be appreciated by the dilettantes.

This is the first time Pissarro attributed his lack of success to possible discrimination. Even so, honesty compelled him to qualify it, from a "probable" cause to "one" of the causes. Although anti-Semitism was widespread in France, there is no evidence that Pissarro suffered from it personally. In his despair, he flailed about for any excuse.

His melancholy was deepened by other events: Rachel was dying, Alfred had become ill, and one of Camille's eyes was severely inflamed. In April, Lucien wrote Julie that Grandmother "is always very fussy; I believe the poor old lady doesn't have a long time." By May, when Camille had written Esther, Rachel's condition had worsened. She died on May 30, at ninety-four.

Pissarro felt the loss deeply. The emotional tie was unbroken, his dependence on her deeply ingrained. She was strong, neurotic, demanding, but supportive. For years he had stayed at her apartment on his trips to Paris and had brought his children to visit her. Just as Monet had painted his Camille on her deathbed, so Pissarro felt impelled to etch Rachel near the end, as she lay sleeping, her face and hand lit by the rays of a candle. A stillness pervades the image. Huge curtains alongside the bed seem ready to envelop the dying figure. It is a Rembrandt-like portrait of an old woman exhausted

Grandmother, Effect of Light, 1889. Etching. (D 80) 6¾ × 10. 17⅛ × 25½. Bibliothèque Nationale, Paris

by life's struggles. Rachel is close to leaving "this world where there are very few pleasures for very many sorrows," as she had described it to Camille when his daughter Adèle had died twenty years before.

Pissarro's estrangement from his brother was intensified by a dispute over possible inheritance from Rachel's estate. Camille felt that his father's losses incurred in his investment in Alfred's business in Argentina and St. Thomas in the fifties should be deducted. He was acting more to protect his children and the Isaacson children than himself. Nonetheless, he felt genuine concern during Alfred's illness and was deeply grieved when Alfred died on April 20, 1890. He was now the only survivor of the generation that had left St. Thomas in the fifties. (The inheritance dispute, it turned out, was academic, for Rachel's estate consisted of little more than income from the house in St. Thomas, greatly diminished in value as the island's commercial activity decreased. Eventually, Pissarro arranged amicably with Alfred's son, Frédéric, to sell the house and share the proceeds with the Isaacson children.)

In 1887, Lucien had reported to Julie that his father had gone to a physician for treatment of an inflamed tear gland, that it was not serious, only rest was needed. But with the passage of time, the inflammation increased. In April 1889, Camille was back at the oculist's. He described to Esther the diagnosis of the eye condition that troubled him for the rest of his life:

> After having skillfully probed the lachrymal canal, he told me there was a growth of bone that was obstructing the canal's passage; generally one forces the passage, but he told me that is absolutely dangerous, the consequences are disastrous. It is better to find another way and here is what he advised me: To take a homeopathic medicine (Aurum) in order to reconstitute the covering of the bone which is bare, and let the tissues restore themselves;

it will take at least six months. But precautions must be taken—avoid wind, dust, wash the eye with boric acid immediately. All that is hardly easy for a painter who has to face the elements.

Periodically the inflammation flared up. Pissarro met this painter's nightmare with courage. "I shall have to keep my eye bandaged for another eight days," he wrote Lucien two years later, after one of his trips to the doctor. "I shall try to work with one eye; Degas does it and gets good results; he has only one good eye!"

When his eye was inflamed, he had to give up working outdoors, and eventually had to do most of his painting from behind a protective window or in the studio.

In the late eighties, he came to depend more and more on Théo van Gogh to sell his paintings and advise him on business. In February 1890, Théo organized a major exhibition of Pissarro's works: twenty-six recent oils, temperas and gouaches, including figure paintings in his modified neo-Impressionist style. Most of the pictures were lent by new collectors of Pissarro: Clemenceau, Gallimard, Dupuis, Bougle and others. The reception was positive, but Pissarro himself was, as usual, skeptical of praise. He wrote to Georges, three days after the opening: "My exhibition is very successful to judge by the number of visitors—but no sales, no serious offers. The amateurs are close-fisted, as always. Many compliments, but that's not enough to prove their sincerity to me."

In the next several weeks, however, five out of the eight available pictures were sold, netting Pissarro 3,650 francs after the gallery's commission had been deducted. With additional payments of 3,800 francs for sales Théo made during the year, his income from Boussod and Valadon in 1890 totalled almost 7,500 francs, somewhat easing the tensions in the household.

The preface to the catalogue, by Gustave Geffroy, was a sensitive appreciation of Pissarro's special qualities as a painter, persuasive and gracefully written. It was also an acknowledgment of his integrity as an artist:

> The 26 works exhibited by M. Camille Pissarro sum up his researches of recent years, a new evolution of his artistic talent. . . . He was the accepted landscapist of the Normandy fields, tranquil kitchen gardens adjoining village houses, the sincere observer of the comings and goings of the countryside; his exact perception of light, his soft and clear evocations of the look of the earth and the sky were admired. Then he stopped taking the path he had walked with a regular step, a constant speed. When the hour of success came, the time when men customarily have won their place and content themselves with being exploiters of a genre, purveyors of success, repeating to the point of boredom a formula, a style and a subject, Pissarro, the honest and obstinate worker, decided to halt and set out by a new route. . . . There is no more honorable effort or one which better merits praise. There is no spectacle which teaches us more than that of such a painter, accepted by the critics and by the amateurs and who yet tries to do something more.

Geffroy went on to describe some of the individual works in the exhibition and concluded:

> With this artist in love with living light, with the heavy heat of afternoon and whom the critics of yesterday sometimes treated as excessive and fanatical about it, there is a delicacy which knows the charm of rustic life and which expresses it in a language of nuances. Proofs

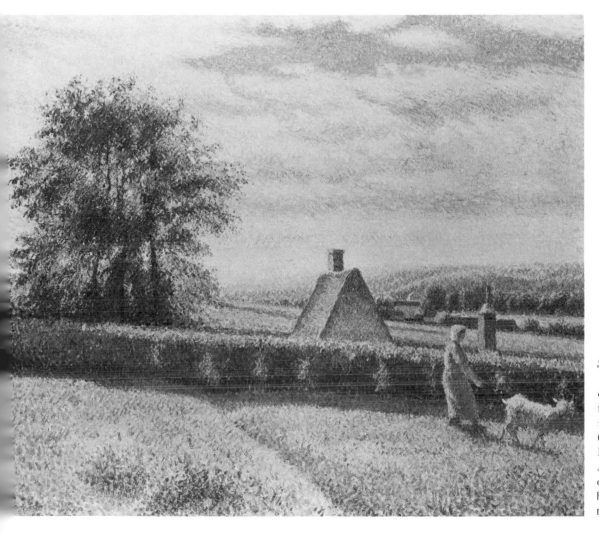

Spring Pasture, 1889. (Not in catalogue raisonné.) 23⅝ × 27⅝. 60 × 70. Museum of Fine Arts, Boston; deposited on loan by the Trustees of the White Fund

abound among these 26 works: this rosy haymaker, so slender and with such high style who nevertheless remains real, this other haymaker seen from the back, with a young and supple body, these conversations at the end of the field, this young peasant at her toilette, and these gouaches, in the shape of fans, where the light still brightens and softens the calm fields, the airy skies, the pure horizons.

The exhibition closed on March 15, and Théo reported to Vincent: "The exhibition of Pissarro's work is over; a lot of people came to see it and five pieces were sold. For the moment it is all that we could hope for."

Pissarro became personally closer to Théo van Gogh than he ever had to Durand-Ruel. The bond with Théo was Vincent, who was then in St. Remy, near Arles. In 1889, Théo had written to Vincent about Pissarro's recent eye trouble and the death of Rachel. Vincent responded:

So old Pissarro is cruelly smitten by these two misfortunes at once. As soon as I read that, I

thought of asking him if there would be any way of staying with him. If you will pay the same as here, he will find it worth his while, for I do not need much except work. Ask him in an offhand way and if he does not wish it, I could go to Vignon's. It's queer that already two or three times before this I had the idea of going to Pissarro's; this time, after your telling me about his recent misfortunes, I don't hesitate to ask him.

Théo approved of Vincent's plan and asked Pissarro, who duly reported the conversation to Julie:

> Van Gogh asked me if it would be convenient to take his brother in with us next spring. His doctors have said that he is cured but that his madness could return although in shorter and less severe fits. I told van Gogh that it was not possible for us, that you had a great deal of difficulty with the children but that I would see if we could find a place where he could be tranquil and could work—that's not easy.

Pissarro did not, however, reply to van Gogh's question quite so directly as he claimed. He must have told Théo that he would ask Julie and let him know, softening his refusal and making it seem to be Julie's decision and not his own. Théo wrote Vincent: "I spoke to Pissarro and discussed the question. I don't think he has any great authority in his own house, where his wife wears the pants. After a few days he told me it was not possible for you to stay with them but that he knows somebody at Auvers who is a doctor. You can possibly stay with him. Pissarro will look him up and ask."

It has often been reported that it was Julie who refused Vincent because she was afraid for the children, but it was in fact Pissarro who decided. "Somebody at Auvers who is a doctor" was, of course, Gachet. Pissarro did succeed in getting Dr. Gachet's promise to look after Vincent, who duly arrived in May 1890 and stayed at a little pension in the village, about a half mile from Gachet's house.

Once he was settled, Vincent wrote Théo: "I have seen Dr. Gachet, who gives me the impression of being rather eccentric, but his experiences as a doctor must keep him balanced enough to combat the nervous trouble from which he certainly seems to be suffering—at least as seriously as I."

Gachet did what he could for Vincent, or perhaps they did what they could for each other, and Vincent went out into the wheat fields around Auvers to paint. A little later that month, he finished a painting of the summer fields under a coldly brilliant sun and then fired a bullet into his chest. He died two days later in his little room at the inn, leaving Théo half insane with grief.

Théo's health deteriorated rapidly after his brother's death. He became ill and unstable, and in a moment of exasperation resigned from Boussod and Valadon. Camille wrote to Lucien that autumn: ". . . he handed his resignation to the B's and suddenly went mad. He wanted to rent the Tambourin [a bar where Vincent had exhibited] to form an association of painters. Then he became violent and this man who loved his wife and son so deeply tried to kill them. In short, they had to take him to the clinic of Dr. Blanche."

Théo died in January 1891, and was buried beside Vincent in the little cemetery of Auvers. Pissarro mourned his death philosophically: "Poor lad, he is safe from pain now. It was sad to see him, once so active and intelligent, out of his wits!"

The exhibition of Pissarro's paintings which Théo had mounted in 1890 seemed to mark the completion of the artist's journey through neo-Impressionism. Soon after came the tragic news that the movement had lost its leader. On March 30, 1891, Camille wrote to Lucien:

> Terrible news to report: Seurat died after a very brief illness. I heard the cruel news only this morning. He had been in bed for three days with a disturbance of the throat. Improperly treated, the illness developed with ruinous speed. It is my impression that the malady was the very one de Bellio told me about some time ago: diphtheria. The funeral takes place tomorrow. You can imagine the grief of all those who followed him . . . it is a great loss for art.

Another letter soon followed:

> Yesterday I went to Seurat's funeral. I saw Signac who was deeply moved by this great misfortune. I believe you are right, pointillism is finished, but I think it will have consequences which later on will be of the utmost importance to art. Seurat really added something.

In the years that followed, Pissarro rejected neo-Impressionism as passionately as he had once embraced it. He criticized an exhibition of Théo van Rysselberghe's paintings as being spoiled

> . . . by the pernicious practice of systematic employment of the dot. . . . Théo is very gifted; I am afraid he will persist for some time to come in this terrible and cold manner of execution which has value only if one looks at works exclusively from the point of view of conscientiousness and stubborn toil.

Peasant Girl Seated. Black crayon. Fogg Museum of Art, Cambridge, Mass., Paul J. Sachs collection

After commenting on the paintings of Signac and Henri Cross:

> . . . I am so sick of this sort of thing that all my pictures done in my period of systematic divisionism, and even those I painted while making every effort to free myself from the method, disgust me.

Of Angrand, he writes:

> Oh, what theories . . . boring and exasperating! I couldn't keep from telling him that it was simply idiotic, that their science was humbug, that the truth was that they were not artists, that they had killed their instincts for the sake of a false science, that Seurat, who did indeed have talent and instinct, had destroyed his spontaneity with his cold and dull theory, that Monet achieved more luminosity than they did and that his pictures are much less rotten and boring!

In spite of his violent disavowal of "systematic divisionism," Pissarro had gained a great deal from his experience with it. To the spontaneous recording of his "sensation" in the face of nature, he had added precision. The long, rigid discipline so strengthened him that technique was no longer a problem. Released from his laborious analysis of color, his brush was freed to transcribe his sensations and impressions swiftly and accurately.

He had also absorbed the abstract qualities of neo-Impressionism: the non-naturalistic colors, the flattened spaces, the emphasis on surface pattern. He had achieved a clarified organization of space, a firmness in composition, a more refined combination of colors and a more precise, delicate brushstroke. He benefitted from all the experience in his search for a synthesis between a realized impression of nature and a unified painting.

Why did Pissarro, normally so balanced and objective, swing so wildly from passionate disciple to passionate apostate? Was it regret for four precious years "wasted" as he was approaching sixty? Was it guilt over his family's suffering? Was it the resentment of one who had gambled and lost? Did he feel that his "sensation" had been endangered? That his instinctive response to nature had almost been lost in the complexities of technique?

The violence of his reversal may have been the reaction to finding himself at the edge of an abyss in his art. But he had grown as well, through his willingness to commit himself to experiment. As he wrote to his niece Esther in 1890:

> I began to understand my sensations and to know what it was I wanted when I was about 40 years old—but vaguely. When I was 50 years old, in 1880, I formulated the idea of unity but without being able to depict it. At 60, I am beginning to see the possibility of doing that.

20.

Success, Birth and Tragedy

"Your moment has come!"
—Bernheim to Pissarro, 1891

IN PARIS in the 1890s, Pissarro was a familiar figure. When he strolled through the streets with his sons and friends on his visits from Eragny, he covered his ailing eye with a narrow bandage of black silk which contrasted with his olive complexion and his full, snowy beard. He usually wore a soft black felt hat, a black Inverness cape brought from England and a silk neckerchief of a light color. Georges Lecomte said Pissarro was "noticeable, obviously a personage, because of his air of nobility, his elegance and simplicity. A small man, he leaned on his cane or walked slowly with an air of majesty."

Of his five sons, it was Lucien who was most frequently with him, and often Georges, until both left for England; afterward, it was Félix, Rodolphe or Paul-Emile. They ate in a restaurant in Montmartre or at the English tavern on the rue Amsterdam described by Huysmans in his novel *A Rebours*. Lecomte sometimes went with them to dinner or to the Café de la Nouvelle-Athènes. He recalled: "Often, when the conversation was a bit long, I saw the eyes of the younger boys blink and half close, these children whom Camille Pissarro brought with him, one after the other, so that they could discover the beauties and the miseries of Paris and its strange inhabitants."

Thadée Natanson, publisher of *La Revue Blanche*, met Pissarro in the nineties and has left a vivid description of his "soft and sparkling eyes," deep-set, brilliant, with a slightly oriental look, his "musical and persuasive voice, beautifully measured, modulated and melodious." Natanson remembers him as being like a young man, ardent, passionate, affectionate with his friends, without anger or hate although sometimes "severe out of love of justice." He was full of the "patriotism of Impressionism" and all his life a vigorous proselytizer for the movement. Natanson continues: "He did not look merely like a patriarch but like 'le bon Dieu' himself, with his resolutely arched nose. His hands were very fine and long and on them this 'bon Dieu' had warts which humanized him. What humanized him even more was a certain mischievousness in his smile."

Pissarro's eye grew worse in 1891, and troubled him for the rest of his life. No sooner would one abscess form, break and heal than another would develop. Each time it necessitated wearing a bandage constantly for eight to ten days and working with one eye if at all. He tried various treatments; in April, he reported that his homeopathic physician, Parenteau, was injecting oil with silver nitrate into the tear duct to provoke an inflammation and accelerate the process of healing. The treatment seemed to work, but then in May: ". . . a new abscess broke out and I was forced to suspend all my work.

255

I leave tomorrow for Paris. I will go to see Parenteau who will probably operate on my eye. I was penniless and didn't know how I could leave here; as a last resort I wrote to Monet who promptly sent me 1,000 francs. . . ."

Monet was affectionate and responded immediately whenever he was asked for help. In February, when Camille asked for a loan, Monet's reply showed the depth of their friendship: ". . . don't stand on ceremony. If we have had little annoyances or disagreements about the groupings or the school, it was idiotic, in short we are too old friends not to help each other if the occasion arises. . . ." Monet also gave him the addresses of several collectors.

In July, the eye infection flared up again and Camille observed: "Just when I least expected it, just when I was fully at work, this cursed eye trouble came back. I was working in our field in superb weather, there came a sudden wind—or maybe it was a puff of dust—and in two days an abscess had formed and broken. Once again I must spend two wearisome weeks in Paris. I didn't deserve this—I expected to be able to work until autumn at least."

Nonetheless, in July he was able to repay the 1,000 francs he had borrowed from Monet, who assured him "there was no urgency to repay me so quickly. I fervently wish that the operation will have a good result and you can return to work. . . . I hope that fortune will bring you a little of the luck that favors me."

If Pissarro was frightened by the threat of losing his precious vision, he kept it to himself. By autumn, he was working normally again and wrote to Lucien, "My work is going well. I drudge away at my four canvases with ecstasy."

In spite of Pissarro's concern with his eye, the year 1891 brought some new satisfactions. In April, he and Mary Cassatt showed their prints together at Durand-Ruel's, where the Society of French Painter-Engravers was holding an exhibition at the same time. The Society had refused to include the work of Pissarro and Cassatt on the grounds that they were both foreigners—a decision that was surprising, since Pissarro had exhibited with them in 1889 and 1890. In fact, the display of prints in 1890 had brought his first recognition by the French government. Two prints were selected by the Superintendent of Fine Arts, Burty, for purchase at 40 francs each: *Meadow and Windmill at Osny* and *View of Pontoise*. Absent from Paris at the time, Pissarro wrote Burty that his price was 50 francs, not 40, and he understood that Burty had taken three prints, not two. Just then Burty died and the Minister of Fine Arts insisted that the records authorized the purchase of only two at 40 francs each. Distrustful and resentful, Pissarro demanded the return of his prints. A year later, he had had no response. "There you are," he wrote Mirbeau. "You understand why I don't want to have anything to do with these people, with this X who sets my prices by the force of bayonets." Nevertheless, he was proud that his work was considered purchasable by the Ministry of Fine Arts. There is no record that the dispute was ever resolved.

Delighted that his prints and Cassatt's were being shown in competition with those of the Society, he gloated to Lucien, "We open Saturday, the same day as the patriots . . . who, *entre nous,* are going to be furious when they discover right next to their exhibition a show of rare and exquisite works."

He was enthusiastic about Cassatt's colored etchings, so prized today. Her tones, he wrote, were "even, subtle, delicate, without stains on the seams: adorable blues, fresh

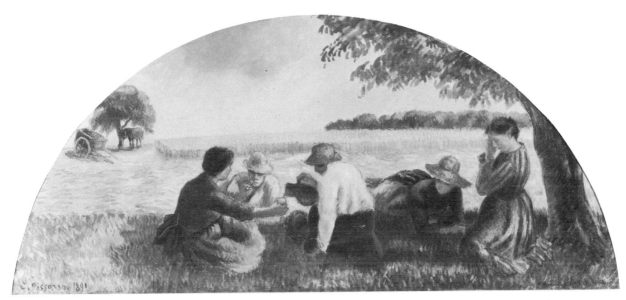

Meal in the Fields, 1890. Fan. Photo Sotheby Parke Bernet & Co., London. Private collection

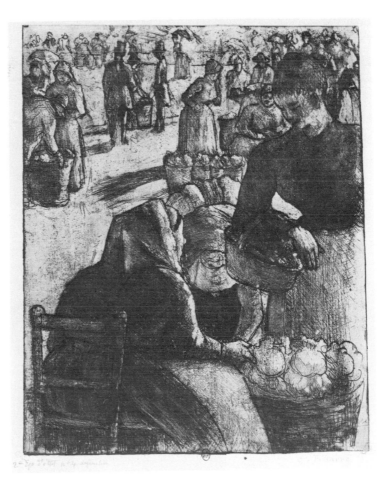

Vegetable Market, Pontoise,
1891. Etching (D 97)
10 × 7⅞. 25½ × 20.
Bibliothèque Nationale, Paris

rose, etc. . . . The result is admirable, as beautiful as Japanese work. And it's done with printer's ink!"

Ever since they had worked with Degas, they had been friends, often conferring on methods for outwitting Durand-Ruel by finding other outlets or dealers for their work. Mary Cassatt had valuable connections in the United States. Her brother was a high official of the Pennsylvania Railroad, and on her recommendation her friends, the Havemeyers of New York and later the Stillmans and the Whittemores, bought paintings of the Impressionist school. Her friend Sara Hallowell acted as an "agent" for the Impressionists with American collectors such as the Potter Palmers of Chicago, who acquired works by Sisley, Monet and Pissarro through her.

She and Camille knew that the artists dependent on Durand-Ruel found that he offered them progressively less money. The painters who had alternatives could of course force him to compete for their work. "I would go along with her if she left Durand," Pissarro reported. "She will use all the influence she has to push our paintings and engravings in New York as she wants to upset Durand. . . . I believe Mlle. Cassatt is beginning to understand my recent work; never before was she so enthusiastic as this last time."

Their joint exhibition at Durand-Ruel's included his recent prints of market scenes as well as watercolors, gouaches and painted fans. Although Degas complimented Pissarro, particularly on the style of his figures, and was charmed by Cassatt's prints, the public did not respond.

Pissarro eventually got his own press, and though he kept searching for new methods and effects, he still did not consider himself a professional printmaker. "I only regard it as a pastime," he told Lucien. "I suppose you will have difficulty in making people understand that I am not an engraver, that these are simply graven impressions." "Amateur" he was, in one sense: In 1888, he had given Portier, the dealer, a set of all his prints in payment for a debt of 100 francs. Portier sold them to the collector S. P. Avery of New York, who demanded a pen-and-ink self-portrait of Pissarro to complete the transaction. This Pissarro did for an additional 50 francs. Thus, the New York Public Library, beneficiary of Avery's collection, acquired all of Pissarro's prints up to that date, including many rare states, for all of which he received only 150 francs. But he was thrilled that by 1891, Avery, Keppel and Kennedy—"the three biggest dealers" in America, as he characterized them, not quite accurately—had taken some of his prints, and yet in France he still had little audience. He wrote Esther Isaacson in 1892: "My prices are ridiculously low, but no one understands my prints."

Despite his growing reputation, Pissarro was finding it difficult to recover the audience he had lost during his neo-Impressionist period. He felt he was back at zero and commented: "I am leaving Paris without having made the most modest sale . . . one would say that people feel that I am no longer good for anything . . . that's the way it is, and the more I try the more humiliated I am. So I shall leave for Eragny, since I don't want to stay here without a penny. There are moments when I ask myself whether I really have talent. . . . In fact I often doubt it. What does my work lack, or what does it have too much of?"

Pissarro's disappointment was sharpened by the tremendous success of Monet, who at that point could not paint enough pictures to meet the demand. Everything the latter

did, according to Pissarro, went to America at prices of "four, five and six thousand francs." What people wanted more than anything else were his *Haystacks in the Setting Sun.*

Pissarro was amazed by all this and by the news that Monet was going to have a one-man show at Durand-Ruel's and exhibit nothing but *Haystacks*—that was what the collectors wanted. "I don't understand how Monet can submit to this demand that he repeat himself," Pissarro wrote, "such is the terrible consequence of being successful!"

He reported to Lucien soon after Monet's show opened:

> . . . every painting has already been sold for from 3,000 to 4,000 francs each! If I could only sell one-fourth that many paintings I would be only too happy to help Alice and Esther in my turn, but no, it has been decreed that I am not to have the satisfaction of making those near me happy, even your mother, who certainly deserves some rest from care. It breaks my heart!

Though envious, Pissarro described his friend's exhibition objectively:

> I went with one eye bandaged and had only the other to see Monet's marvellous *Haystacks in the Setting Sun.* They seemed to me to be very luminous and very masterful, that was evident. But for us to develop, we ought to see deeper. I asked myself, what do they lack? Something very difficult to define clearly. Certainly, in rightness and harmony they leave nothing to be desired; it would rather be in the unity of execution that I could find something to be improved or rather, I would prefer a calmer, less fleeting mode of vision in certain parts. . . . just the same, this is the work of a very great artist.

Durand-Ruel told Camille that one reason for Monet's success was that he had not "shocked the collectors," as Pissarro had, with an unpopular style. Pissarro was dissatisfied with the dealer's explanation and decided that it would be best for him to find other markets. He dealt with Maurice Joyant, who had replaced Théo van Gogh at Boussod and Valadon; with Portier; with the Bernheim Jeune gallery; and with private collectors. He realized that Impressionist painting was now reaching a wide market, and his new paintings, brighter in color but basically Impressionist in style, were attractive. By October, Pissarro was able to report to Lucien that though he was not counting on Durand-Ruel, he expected to make 10,000 or 12,000 francs that year. His earlier mood of discouragement was dispelled by his success and hopes for the future. Now he was able to support Lucien and Georges in London. Julie, in a mood of extravagance, spent a month in Paris, seeing the sights with the two youngest children and shopping for clothes for all of them. In December, Pissarro and Julie attended a performance of Maeterlinck's *Les Aveugles* in Paris with Mirbeau and his wife, and Camille wrote to Lucien: "You should see her [Julie], she is astonishing. You would not recognize her with her black velvet coat, stylish hat and opera glasses . . . it's nothing short of a transformation! And with all that she had two great straw market baskets with her when she came to Montmartre! If she knew what I am writing about her she would be angry. . . . Finally, I believe our troubles are coming to an end and then you won't have to worry."

His sense that his star was rising was accurate. At the intermission of *Les Aveugles*, the artist Carrière came to shake hands with him and said: "I come to inform you that you have had a great deal of success in New York and that you are going to receive

offers. I think I ought to let you know so that you won't be taken by surprise."

Events accelerated rapidly. Joyant asked to come to Eragny to purchase paintings. Bernheim displayed four of Pissarro's pictures in his window: the large, vigorous and spacious paintings of the *Seasons* that he had done for his patron, Arosa, in 1872. Impressionism had been so completely accepted that Pissarro's earlier landscape style looked like the work of an old master. Dealers and collectors felt that Pissarro had been undervalued and that now was the time to buy his work. Bernheim advised him: "At the first auction including some of your paintings you will find five or six dealers ready to bid at high prices, and if you want I will organize a show for you. Your moment has come!"

Pissarro was ready to seize the moment and planned his strategy quickly. He had talked to Lucien and Georges about holding an exhibition in Paris jointly with them, but now everything was changed:

> You must understand that I am on the point of a definitive success. This is understood by everyone interested in my work. It goes without saying if I have a show I must exhibit *alone* and under first-class conditions. I have been invited to show in three places: Durand's, Boussod and Valadon's and Bernheim Jeune's. Most likely I will decide for Durand. . . . I must make my way. I must get through while the favorable moment lasts.

He decided on Durand-Ruel. The exhibition, scheduled to open January 23, 1892, and run until February 20, was to be the first extensive retrospective—to include fifty paintings done between 1870 and 1892 and twenty-one gouaches from 1880 to 1890. Time was short. On January 10, he wrote to Lucien:

> I have only ten days in which to finish from five to six canvases begun from the window and my figure paintings. If my eye does not betray me, I will be ready. As soon as I see Durand senior, I will write you to come, there will be so much to do and I would like to work until the last minute. And then I'll have to select paintings of different periods and go hunting for them or asking collectors. Let us hope that something will come of this and that we won't be disappointed this time.

Lucien came from London to help. They chose eleven paintings from the seventies, twenty-four from the eighties, eight done in 1891 and the five completed during the first few weeks of 1892. Ten of the works belonged to Julie. (See illustration Chapter 19, page 245.)

The work of choosing, borrowing from owners when necessary, packing, transporting, framing and hanging was done. The exhibition opened on schedule. There were paintings of Louveciennes, London and its suburbs, Montfoucault, Pontoise, Osny, Rouen and Eragny. The scenes of houses, gardens, rivers, snow-covered roads and roofs, ponds, hillsides, trees, churches and markets ranged from the harmonies and subtle reflections of the Louveciennes paintings of 1870, through the silvery gray and brown luminosity of the early Pontoise convases, the brighter blues and reds, and the stronger geometries, of the mid-seventies to the dense surfaces and divided colors of the early eighties. There were few paintings from the neo-Impressionist period: none from 1886 or 1887 and only three from 1888 and 1889. Figure painting was well represented and those of 1891 and 1892 showed Pissarro's synthesis of Impressionism,

divisionism and the abstract, decorative characteristics of the symbolists and the fledgling nabis.

Georges Lecomte's preface to the catalogue was of course laudatory, but also included the astute observation that Pissarro had passed through the stages of an evolution of painting to which two generations of artists and many schools had contributed, and that the story of his researches constituted a history of Impressionism—researches that "seemed to preface the art of tomorrow." Lecomte emphasized the vanguard quality of the work, linking it with the recent decorative and ornamental tendencies, and noting that for a "long time" Pissarro had not worked exclusively from nature; he had made studies in watercolor or pastel from life and then carefully worked out the composition in his studio. Superfluous details were pruned away; the "essential aspects contributing to the decorative ensemble of the work" were what remained. "This is the way in which M. Camille Pissarro has achieved these syntheses of colors and lines of the most beautiful ornamental effect. Such is, at the present time, the last phase of the development of his art. And, isn't it in this direction that the growth of Impressionism tends?"

Julie, in Eragny with the children, did not attend the opening, but Lucien reported to her from Paris that the exhibition was very successful and that many had come, partly because of an enthusiastic article in *Le Figaro* by Octave Mirbeau. Mirbeau, who had been championing Pissarro's work for years, was the author of *Calvary*, *Sebastien Roch* and other novels assailing provinciality and ultrapatriotism. Anti-militarist and anti-clerical, sympathetic to France's disinherited and to anarchism, he wrote the introduction to Jean Grave's *Moribund Society and Anarchy*. A supporter of Cézanne, van Gogh, Gauguin and Renoir, he not only frequently published favorable comment on Pissarro's paintings, but also tried to help his sons in their careers.

Mirbeau praised the retrospective form of the exhibition, a coherent grouping that revealed the thought of Pissarro, his passions, transformations and progressive mastery of materials. Mirbeau recalled the adversity, the indifference, the attacks, to which Pissarro had always turned "a peaceable face and a superior spirit." He noted Pissarro's part in the "revolution of the art of seeing" which Impressionism had brought, that "envelopment of forms in light, that plastic expression of light on the objects that it bathes, and in the spaces that it fills . . ." which Pissarro and Monet had completely realized. He stated that "no one contests the considerable influence that he exercises on contemporary painting."

> But critics love anecdotes; they are only moved by sentimental vulgarities. There are none of these in the work of M. Pissarro. . . . The eye of the artist, like the mind of the thinker, discovers the larger aspects of things, their wholeness and unity. Even when he paints figures in scenes of rustic life, man is always seen in perspective in the vast, terrestrial harmony, like a human plant. To describe the drama of the earth and to move our hearts, M. Pissarro does not need violent gestures, complicated arabesques and sinister branches against livid skies. A hillside in silhouette under a sky with a wandering cloud is enough. An orchard, with its apple trees in rows, its brick houses in the background and some women under the trees, bending and gathering the apples which have fallen to the ground, and a whole life is evoked, a dream rises up, soars, and such a simple thing, so familiar to

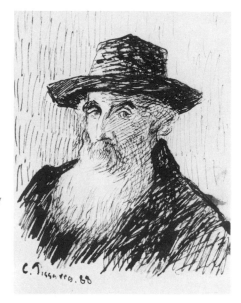

Self-Portrait, 1888. Pen and ink. New York Public Library

our eyes, transforms itself into an ideal vision, amplified and raised to a great decorative poetry.

And I know of nothing as beautiful or as touching as to see M. Camille Pissarro, so young under his white beard, full of all the enthusiams of his youth, and far away from the clamor of the art world, the cliques, the juries, the hideous jealousies, pursuing with the ardor of old his life work, which is one of the most beautiful, one of the most important of our time.

Lucien had some business advice for his mother soon after the exhibit opened:

When you come to Paris, expect to be courted by those who want to get money out of you. Your paintings have had much success and are doing very well. You must hold fast and completely refuse to sell for from here on you can get double for them. It's the time to become shrewd, otherwise we will be cheated. In other words, my dear mother, the day will shortly come when you can rest easy and you can buy yourself a beautiful dress—that wouldn't be too much, would it? You have been patient a long time.

When the show closed, Durand-Ruel bought all the unsold canvases. In 1889, Pissarro had received only 300 francs from him; in 1890, only 164; in 1891, 1,932. But in 1892, his payments from Durand-Ruel leaped to 23,042 francs and Julie had her beautiful new dress. Camille wrote to Mirbeau: "I consider that the rank which has

Henry Bataille: *Octave Mirbeau.*
Lithograph.
Bibliothéque Nationale, Paris.

come to me late in life is a reward for hard and passionate work. I feel like an old military man who, having risen through the ranks to become a captain, retires and tells stories of his campaigns."

Although the long-hoped-for success had finally come to him, at sixty-two, Pissarro did not, could not, retire. Toward the end of May, he finished supervising the start of renovations on his studio at Eragny and set off on a long visit to London and Kew. Just before he left, another crisis faced the family. The owner of the house they had been renting in Eragny suddenly found it necessary to sell; they had to choose between buying it themselves or moving. Camille was disturbed at the prospect of borrowing money just as they were beginning to climb out of debt.

Julie, however, was determined to have the house. The family had lived in it for eight years, she had watched the gardens and the orchards flourish and she knew the townspeople. She must surely have thought that it was time for a little security. While Camille was in England, she plunged ahead. The house would cost 31,000 francs; a down payment of 20,000 was required. She went to see Monet, with whom she had always maintained a warm friendship, and asked if he could lend her 15,000 francs. She told him it was possible to borrow the money from Durand-Ruel, but that would give the dealer too much control; it was better to borrow from friends. Monet immediately agreed. Pissarro, presented with a *fait accompli* and respectful of Julie's efforts, agreed to cooperate. Julie wrote to Monet and to Camille, keeping them informed, as she said, of all the "conferences it's necessary to have with these notaries, these lawyers, the whole litany of fraud." She needed to have the house to give her security and pride. Lucien understood and wrote: "Hey! You are going to be proud if you are the owner and you will hold your head high again, talking about *your* house. . . . Monet has been truly wonderful; one sees that success makes people better! I hope that now you will be more relaxed, that you won't tire yourself out and that you won't scold me too much."

By the end of the summer, the Pissarros owned the house in Eragny, described by Julie as a "fine, bourgeois residence."

Camille went to England for three reasons. First, he invited Maximilien Luce, whose wife had just left him, to come with him to get out of Paris and his deep depression. Second, Pissarro intended to make the most of the English spring for new paintings. He found Kew Gardens delightful. "It's a dream," he wrote Mirbeau. "What trees, what lawns, what pretty, imperceptible undulations of the land!" And after telling Mirbeau about his decision to buy the house, he added, "Who knows, perhaps Kew will be the magic wand which will make the treasures spout and satiate the ferocious notary and proprietor." He completed twelve gay and colorful canvases of the gardens at Kew during late spring and summer.

The third and chief reason was to help Lucien in his courtship of Esther Bensusan, who had accepted him although her father, Jacob Bensusan, was opposed to the match. Lucien appealed to his father, in whom he had faith as a mediator. The romance had begun in 1889, when the girl and her family made a visit to Paris. A friend of Lucien's cousin Esther Isaacson, Esther B. (as she was called to distinguish her from her friend) was a student at the Crystal Palace Art School in London. She had grown up in a cultured middle-class family of Spanish-Jewish descent, had attended concerts with

her music-loving father and was acquainted with the latest artistic and intellectual trends. Intelligent, independent, imaginative and completely disorganized, Esther B. had a tendency to lose her possessions three times over in any given day. It was a family joke. But her bubbling energy and good will always dissipated their exasperation.

Lucien invited her to spend a day at Eragny, where she made an impression, not only on him but on his family as well. After her visit, they collaborated on a charmingly illustrated collection of French songs, entitled in English: "Old French Songs from Eragny's Artists to Miss E. Bensusan." After her return to London, she and Lucien

Title Page of
Old French Songs, by
the Pissarro children.
Ashmolean Museum,
Oxford

corresponded and gradually their letters grew intimate. Lucien wrote about his atheism and his ideas on anarchism, a subject which was beginning to have appeal in England's intellectual circles—even genteel ones. At this point, Jacob Bensusan, who exercised the right of reading his daughter's mail, became alarmed at her interest in these "abhorrent" ideas. He sent a letter to Lucien, asking him not to write about such things: "Esther unfortunately (according to my ideas) has interested herself too much in socialism, with which I have not the slightest sympathy. It is a dangerous subject."

When Lucien started to teach drawing in London in November 1890, Esther joined his class without telling her father. Jacob Bensusan was furious when he discovered it, fearing that his daughter was becoming involved with an impecunious, socialist/anarchist—and, above all, atheist—artist. A feather merchant, Jacob was the very model of a Victorian gentleman: cultured, upright, respectable and conservative. He was also very orthodox. The battle between father and daughter reached such a state that they did not speak to each other, communicating in the same house by letter. Jacob wrote forbidding Esther to attend Lucien's class. Her diary for the last day of 1890 read: "No hope of anything. End of the most wretched year of my life."

Lucien was discouraged, too; he had few pupils and they paid little. "I do not know what to do. I am so discouraged," he wrote his father. "I must earn some money if I am to stay here." Camille was upset at what he regarded as a weak surrender to doubt, and fearful of the effect on Julie, who had not been enthusiastic about Lucien's stay in England, he wrote:

I'm really astonished by your expression of discouragement. For you to write this way means many scenes at home. After I wrote you just to warn you, you had to put your foot in it! If you are already discouraged, you will not accomplish anything in London. You must understand once and for all that one must be sure of success to the very end, for without that there is no hope! It's the same in everything, in business as in art. He who doubts is lost beforehand! How many times have I told you that where there's a will there's a way, but nothing comes of itself. You've hardly been gone a month, damn it, and it takes a little time to arrange one's affairs. You have good opportunities, you ought to succeed, *besides it is absolutely necessary that you do so!* . . . Your mother can't keep her grip. She is constantly discouraged, and if you continue to take the tone you have, you can imagine what the effect can be! So hold fast!

Lucien held fast, hoping for pupils, doing engravings and planning drawings for *The Dial*—a forthcoming publication to be edited by his friends Charles Ricketts and Charles Shannon. Bensusan's opposition only pushed the couple closer together. They began to meet in the traditional lovers's trysting place, the British Museum.

Pissarro cautioned Lucien: "Be very prudent with the Bensusans. I wouldn't like to see this poor Esther B. mistreated, so pay attention! As to that old imbecile of a Jacob . . . get it into your head that he has always been that way. I've known him for 30 years and he has always been stupid and spiteful. . . ."

The affair came to a head in the spring of 1892, when Esther confronted her father with her wish to marry Lucien. He was outraged. "The day we are married, he declares he will go abroad and leave everybody," she wrote Lucien. It was not only Lucien's socialism that was the obstacle, it was his atheism. Jacob insisted that the marriage take place in a synagogue, that Lucien embrace Judaism—which he refused to do, with Esther's support—that any children be raised as Jews, and that any sons be circumcized. The couple responded that after exposure to all religions, the children could make their own decision. As for circumcision, Lucien simply said he needed to be convinced of its medical value. Bensusan then made what he considered a clever stroke, proposing that if Lucien would agree to his terms, and also agree not to see Esther for six months to allow time for consideration, he would settle a comfortable sum of money on her. Lucien was insulted: "Money could never have any weight on my decision in this matter"; and he finally appealed to his father.

Camille replied: "All right. I know you love Esther B. Well, no other solution left than to ask the father. I am quite ready to do what is necessary to help. I will come to London as soon as I can, when I think it is the right moment. I hope that we will succeed. Your mother accepts your decision. We like Esther B. What more? I will do all that is possible to help you."

Camille met with Bensusan in London that summer, but the orthodox Jew and the Jewish atheist could find no common ground. Bensusan swore he would banish his daughter if she married. So, with Camille's support and with the hope that time would soften Jacob's heart, Lucien and Esther proceeded with plans for a civil wedding. On August 11, 1892, Lucien was married, as his father had been, in an English Register office. The witnesses were Camille, Lucien's friends Ricketts and Shannon, and Bensusan's clerk, Prescott (to assure that the wedding actually occurred). The couple left on their honeymoon: a walking tour of Rouen. After exploring the countryside

there, the newlyweds hiked to Eragny, where they spent the first year of their marriage under the protection of the Pissarros. Bensusan was soon reconciled. Esther visited her family in September and wrote to Lucien: "Papa is very affectionate. He seemed very strained and uncomfortable at first but it has all worn off. I stayed in my room last night while they all had prayers and everyone took it as a matter of course and were quite nice as usual when I came down to tea."

In this one year—1892—a major exhibition had brought Pissarro success at last, his oldest son had married and he and Julie had become property owners. But a not-so-welcome event took place involving Esther Isaacson and his son Georges, who had been studying art in England since the early summer of 1891. Georges had met the Isaacson sisters during his first visit in England; when he returned with Lucien in 1891, the two boys often passed pleasant hours with Esther B. and their cousin Esther I. (who was thirty-four and had never married). Esther I. and her older sister, Alice, lived with their father, Phineas, in what must have been a cold atmosphere, given his severe temperament. Esther was intelligent and warm, with an artistic bent, and felt alive with these young people—Georges, then twenty, and Esther B., then twenty-one— who shared her interest in art. Camille had asked Esther I. to keep an eye on Georges: "Observe this boy, who knows nothing, who is a savage, but who is very curious about his sensations. The great difficulty will be to teach him while at the same time leaving him absolutely free. If you want to convince him, make him feel it, you will never get anywhere through reasoning. . . ."

Shy Esther and the mercurial Georges formed an intense friendship. This headstrong boy stirred her romantic imagination, so long unexpressed, and he adored her; she was his dream of the dark, powerful princess in a fairy tale—"Princess Maleine," he called her. He described her to his father after she had come back from a summer vacation, "burned brown by the sun, with her eyes and teeth flashing white." Their friendship ignited into love, and in December 1892, they were secretly married.

Georges Pissarro:
Self-Portrait, 1891.
Collection M. Félix Pissarro, Menton

Her father, on learning that his thirty-five-year-old daughter had married her penniless twenty-one-year-old cousin, apparently disowned her. Esther wrote to Camille in late December with the news; his reaction to her letter shows him at his warmest and wisest:

> My dear Esther,
>
> I received your letter a few moments ago. I have only one thing to say to both of you—be happy! I do not know what Julie will say; in any case she cannot say that you are not worthy to be our daughter. Besides, it is only a half-surprise.
>
> I ask only one thing from both of you, union and harmony with my other children, especially Lucien. I shall tell Julie this afternoon, she is coming to fetch me to go to Dr. Léon Simon.
>
> Did you receive the thousand francs sent by Durand-Ruel? Tell me that and what is still due from Lucien—you must need it.
>
> I kiss you both,
>
> > Your affectionate father,
> > Camille Pissarro

Julie was shocked and distressed by the news, as Camille wrote to Mirbeau:

> . . . the mother is devastated by this unsuitable union. As for me, being unable to remedy an accomplished fact, I wish them happiness . . . my niece's only defect is in being a little disproportionate in age with her young, very young, husband. She is intelligent and devoted, but we cannot help thinking of the future with fear—given the impressionable character of this boy. Well, it's love—and that is a matter which cannot be discussed. . . .

Although his attitude was philosophical, Camille was concerned. Esther was his special favorite; he loved and respected her. Knowing how much they needed it, Camille gave his support to the couple and wrote to Esther:

> My dear daughter and niece.
>
> . . . as I wrote you both, my principle is to respect this feeling—which has to be absolutely personal from the moment you are in the order of nature. If you had asked my advice, I would have told you what I thought. Since you said nothing I can only follow your judgment and pray that the future will not bring disillusion, which would be terrible. . . . I accept what I could not prevent and as I said, I pray that you will not regret this marriage.
>
> > Your father who loves you.

Esther bore a healthy son, Tommy, in August. Then, weakened and ill, she died in early September. Georges was paralyzed by his loss. Julie wrote to Mirbeau: "He is in desperate distress. Fortunately, his little son, who is the picture of his mother, is alive. Poor Georges, he loved his wife so much that if he didn't have the child I think he would let himself starve to death. The infant gives him a little courage, but he is so afraid that some harm will come to him that he won't be parted from him."

Georges was persuaded to let Alice take charge of his son, and Camille wrote to her offering to do what he could for "Maître Tommy." By mid-September, Camille acknowledged an encouraging report from Lucien: "I'm glad to hear that Georges is working again. That is the best way to combat grief."

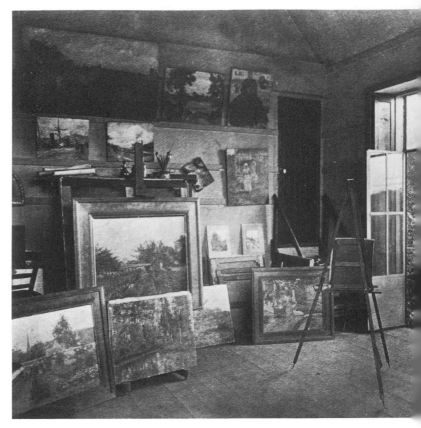

Pissarro's studio, Eragny, exterior.
Photograph Claude Bonin-Pissarro

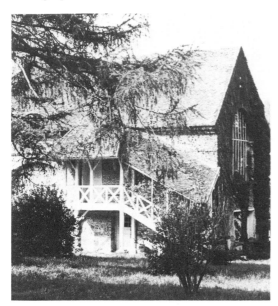

Pissarro's studio,
Eragny, interior.
Photograph courtes
John Rewald

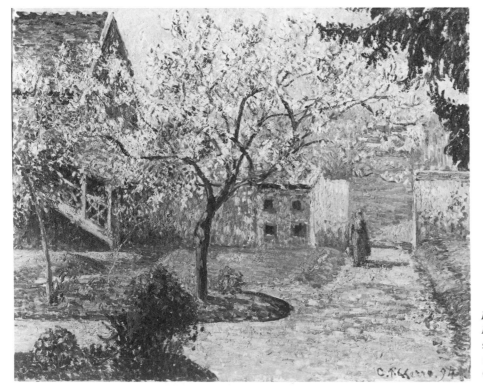

***Flowering Plum Trees,
Eragny*** (with Pissarro's
studio), 1894 (877)
24 × 28¾. 61 × 73.
Ordrupgaard, Copenhagen

21.

Political Exile

"What an epoch! What terrible events are in store . . ." —*Pissarro to Lucien, 1884*

THE TRAGEDY of Esther's death overshadowed the birth of the first grandchild. The family recovered very slowly. In October, Lucien's wife, Esther, gave birth to a daughter, whom they called Orovida after one of her aunts. Life pursued its course.

Camille's studio at Eragny was nearing completion, but typically he worried about becoming a "studio" artist:

> The studio is splendid, but I often say to myself: what is the good of a studio? Once I painted no matter where; in all seasons, in the worst heat, on rainy days, in the most frightful cold, I found it possible to work with enthusiasm. . . . Will I be able to work in these new surroundings? Surely my painting will be affected; my art is going to put on gloves, I will become official, deuce take it! This is a serious moment, I shall have to watch myself and try not to fall!

A windfall came at the end of the year. Durand-Ruel's son, Joseph, came to the studio at Eragny in December and bought 28,600 francs' worth of paintings. "We are at last on the way to solving our problem," Camille exulted. As a result he would be able to make the final payment of 7,000 francs for the house, to return 4,000 francs to Monet and to pay for the work done on his studio.

In 1894, Pissarro set up an etching press in his studio and made the astonishing total of fifty-seven etchings and lithographs as well as an unknown number of monotypes in

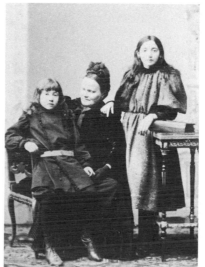

Julie Pissarro, with Cocotte and Paul-Emile.
Photograph courtesy Henri Bonin

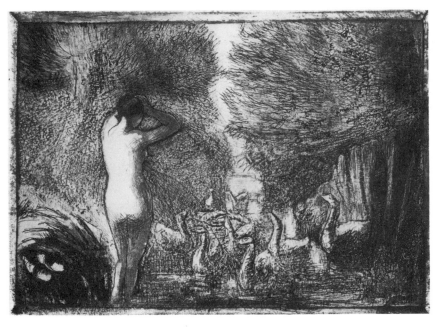

Goose Girl Bathing,
1895. Etching. (D 115)
5 × 7. 12¾ × 17¾.
British Museum

the short period from 1894 through 1896. His return to lithography after a lapse of twenty years was almost by chance. Through Toulouse-Lautrec, he met the publisher of a print journal for whom he did a lithograph on stone (but soon found that he was more comfortable working on a zinc plate). Once started on lithography, he felt impelled to meet the challenge of this medium.

Surprisingly, more than one-fourth of the etchings and lithographs are nudes. Apparently Pissarro had finally located a model or possibly two in Eragny who would pose in the nude, and Julie no longer objected. He did not always draw from life, however, for at times he complained of the lack of a model.

The first etchings on his new press were two studies of plump bathers in a sylvan pool, with no attempt to modify the fleshy figures. "Peasant women—in hearty nakedness!" Pissarro called them. "I am afraid they will offend the delicate, but I think it's what I do best." He also etched some goose girls, slender and adolescent, without a hint of sensuality. But in another etching of a nude goose girl, seen from the rear, a strong light shapes the full sensual curve of her back and buttocks. This plate went through sixteen states before his searching mind was satisfied. He also made several paintings of nudes and was enthusiastic about the results even though he encountered difficulties along the way: his models, unprofessional and not accustomed to remaining motionless, sometimes left in the middle of a pose, and he had to cast around for new ones.

His advice to Georges about nudes was: "There are nudes and nudes, you understand. One falls so easily into an 'academy,' this nude in the style of the Ecole des Beaux-Arts which one never gets rid of once one has acquired the habit. It's like a disease! You must draw the nude as you draw chickens, ducks and geese!"

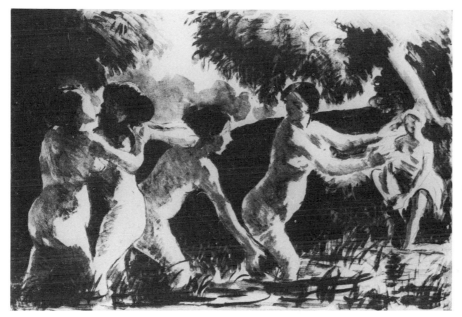

Bathers Wrestling,
c. 1896. Lithograph.
(D 160) 7 × 10⅜.
17¾ × 26¼.
National Gallery of Art,
Washington, D.C.,
Rosenwald collection

Pissarro's first efforts at lithography were tentative, as if he were somewhat uncertain about both the technique and the approach to the nude. There is no emphasis on the flesh; the bodies are veiled in a modest gray tone. But then he begins to experiment with more contrast, and in his second version of *Bathers Wrestling,* unhindered light plays on their bodies, their sexuality is released and suddenly his efforts are brilliantly successful. In this print, four nudes play in a reed-filled pond while a fifth undresses on the bank. The solid blacks of the bank enhance the sensuous light accentuating thighs, stomachs and breasts. It is a dynamic scene, flowing with movement. He seems to have enjoyed showing his peasant women in playful abandon, for in 1895, he produced another series of bathers. In false disparagement, Pissarro called these bather motifs "amusing," but he was particularly pleased when Théo van Rysselberghe said that his nudes "were completely outside the formula of the schools and had an outdoor and real peasant quality."

In this fruitful period, Pissarro did another series of prints of the streets and waterfront of Rouen, and made etchings and lithographs of beggars and wanderers as well as farm workers cutting and gathering hay, resting, chatting. His late lithographs are not as consistent as his etchings: some are sketchy and muddy, and many lack the subtleties of light and shading that so distinguish the etchings of the early eighties. He experimented with color etchings, including a beautifully harmonious idyll, *Peasants Gathering Grass,* a Greek frieze in delicate colors, fused so successfully on the plates that some viewers wondered whether the proofs had been retouched with gouache.

His curiosity also impelled him to experiment with monotypes. The technique, which he probably learned from Degas when they had worked together fifteen years earlier, involved painting with ink or oil on a plate, then rubbing paper onto it or

running it through a press, producing a unique result. The subjects are mostly his familiar themes. Ludovic Rodo has indicated that Pissarro made many monotypes, but only about thirty have been located.

Pissarro was ambivalent about his prints. For years, he regarded himself as an amateur and was indifferent to sales; but by 1895, he was wishing that more collectors would take an interest. "What a pity there is no demand for my prints," Pissarro wrote Lucien in April. "I find this work as interesting as painting, which everybody does, and there are so few who achieve something in engraving." But a year later, when Vollard had a successful exhibition of some of his prints and wanted him to pull additional proofs, Pissarro seemed reluctant to lose his amateur standing. "I replied that I would only sell my prints when I had a whole group of them, and that furthermore I made engravings just for my own amusement and that I didn't care to sell them."

When Boussod and Valadon exhibited thirty-five of his prints in 1892, he had set prices from 20 to 100 francs (six of them were 100 francs), with an average price of 50 francs. By 1898, when Pissarro exhibited fifty-eight prints at Hessele's in Paris, the average had risen to 65 francs; sixteen were priced at 100 to 150 francs. He did not sell many, and in some cases they went for half of what he had hoped for, but he resolved not to let any of his work go for too little. During the decade he gradually increased the price for *Woods and Undergrowth at the Hermitage* from 40 francs to 190. (In 1974, a rare state of it was auctioned for $7,750.) When Vollard offered him only 500 francs for 100 copies of a specially commissioned print, Pissarro indignantly refused. A few months later, he was pleased when a dealer bought single proofs of two prints for 75 to 100 francs each; he was even more pleased two years later when another dealer wanted for display in the major cities of Germany two proofs of every print he had made.

Pissarro's attitude toward his prints evolved from that of modesty to pride. In 1900, he gave one proof of eighty-two of his prints to the Luxembourg Museum, the official depository. By then, he was no longer loathe to sell his prints. When Bernheim Jeune wanted to open a print gallery with portfolios of proofs from twelve plates, Pissarro wrote Lucien to find out what business arrangement Whistler had made for similar use of his plates, but he died before the exhibition could be completed.

By the time of his death, Pissarro had executed almost two hundred prints, nearly three times the output of any other Impressionist, yet they were largely ignored until twenty years after he died. Like his paintings, his prints are uneven, but many combine technical mastery with his unique vision. Only recently have critics become aware of his major contribution to printmaking. Many key prints were republished posthumously in relatively large editions that lost the subtleties of the original impressions. Comparing an early proof pulled by Pissarro, or under his direction, with one of the posthumous restrikes of the early twenties makes the work seem like that of two different printmakers. In an early proof of one of his great prints of 1879, *Twilight with Haystacks* (see page 175), the shadows are extraordinarily deep, the trees softly outlined in the twilight, the highlights created by the setting sun in contrast to the long shadows—a subtle, beautiful evocation of day's end. In the later reprint, only Pissarro's striking composition remains. The subtlety and richness of his inking are gone. Where he had wiped the plate only in certain areas, leaving some ink to heighten contrasts,

now a dead evenness robs the plate of its tone. As he said to Lucien, "Inking is an art in itself that completes the etched line." And there is another difference: Pissarro's earlier proofs varied as he experimented with the application of the ink and the color of the paper. Each one is truly an "original." The later proofs are all "identical."

Monthly "Impressionist" dinners at the Café Riche were a high spot of those years. First begun around 1883 and including Duret, de Bellio, Monet and Renoir, the dinners were interrupted during the late eighties and then reorganized by Caillebotte, who probably paid the expenses, in the early nineties.

On Thursday evenings at seven, Pissarro, Monet, Sisley, Renoir, Caillebotte, de Bellio, Duret, Mirbeau, Durand-Ruel and sometimes Stephane Mallarmé gathered to talk. Pissarro occasionally brought one of his sons; in February 1893, he told Lucien that Titi (then nineteen) had come with him to the Café Riche dinner the night before and had been very bored with the "old gang." The dinners, contrary to Titi's opinion, were lively exchanges of ideas and gossip. Gustave Geffroy, who came occasionally with Monet, described the artists, released from their work, as being in high spirits. Discussions about literature, politics and philosophy as well as art were carried on, sometimes at the tops of their voices, above all in arguments between Renoir and Caillebotte. Renoir, high-strung and sarcastic, seemed to take a mischievous pleasure in goading the judicious Caillebotte, whose face would turn from red to purple when his opinions were mocked. The story goes that Renoir invested in an encyclopedia to look up subjects he could introduce into the conversation and "stump Caillebotte." Sisley was reserved and well-mannered, but Mirbeau threw himself headlong into the arguments, speaking vehemently in thunderous tones. Pissarro, in his "crystalline voice," made subtle comments. He and Monet were the artists most interested in literature, both of them with fine, sure taste. Geffroy remembered a real "tournament" one evening over the works of Victor Hugo, in which everyone passionately stated a case for or against the great romantic. Mallarmé, who often took notes on the conversations, had a special politesse; he could discourse elegantly on all sorts of subjects, chiseling paradoxes with classic grace. At the end of the dinner, the group, reconciled, usually sauntered out to install themselves at some sidewalk café and watch Paris go by.

A new dealer had appeared on the Paris scene—Ambroise Vollard—whom Pissarro soon met and praised: "I believe this little dealer is the one we have been seeking. . . . He is very enthusiastic and knows his job. He is already beginning to attract the attention of certain collectors who like to poke about."

Vollard had an eye for quality and was attracted to the work of the Impressionists. Born on the island of La Réunion, he was an unconventional figure, tall and swarthy (Renoir said he looked like an Othello), and he dressed nattily in clothes made by the best tailors. He was energetic and witty, a great storyteller and a keen judge of the psychology of his clients. If he felt a different title would help make a sale, he changed the name of a painting on the spot. There is a story that a gentleman came into his shop to inquire about a painting of a sleek, powerful bull standing in a field of spring flowers. "What is the painting called?" the customer inquired. "*Virility*," replied Vollard,

whereupon the man's face fell. The dealer corrected himself immediately; the painting was actually titled "*April*," he said. The customer then purchased it and happily took it home with him, knowing that he could now show it to his wife and daughters without fear of being laughed at. Vollard lived in the cellar under his shop on the rue Lafitte and entertained there at sumptuous dinners, Creole style, amidst his fine furniture and first editions. His one great weakness was his snobbery, which, Renoir said, helped him to understand his customers better.

Pissarro placed some of his pictures and Lucien's with Vollard, and also acted as a historic matchmaker, showing him the Cézannes he owned and pointing out their strength and innovative form. Vollard became so enthusiastic that he presented the first one-man show of Cézanne's work, in the fall of 1895. It was the beginning of Cézanne's rise; the reactions, as usual, were strong and mixed. *Le Journal des Artistes* called his paintings "atrocities in oil." But Pissarro's admiration for his friend's work was strengthened. He wrote Lucien:

> . . . In Cézanne's show . . . there were exquisite things, still lifes of irreproachable perfection, others *much worked on* and yet unfinished, of even greater beauty, landscapes, nudes and heads that are unfinished but yet grandiose and so *painted*, so supple. . . . Why? Sensation is there! . . . As Renoir said so well, these pictures have some quality like the paintings at Pompeii, so crude and so admirable! Nothing of the Académie Julien! Degas and Monet have bought some marvellous Cézannes, I exchanged a poor sketch of Louveciennes for a beautiful small canvas of bathers and one of his self-portraits.

Pissarro's judgment was strikingly accurate. He had reproached Joris Huysmans in 1883, upon publication of his book on modern art, for not giving Cézanne the importance due him. When Huysmans asserted that Cézanne was an "eye case" and that his work was "not likely to live," Pissarro claimed that he was "one of the most astounding and curious temperaments of our time who had had a very great influence on modern art."

In the spring of 1894, the old battle between the "academy" and the Impressionists flared up again. Caillebotte died in March. ("He is one we can really mourn," Pissarro wrote. "He was good and generous and a painter of talent to boot.") His collection of art was left to the state, including drawings by Millet and paintings by Manet, Monet, Renoir, Pissarro, Degas, Sisley and Cézanne. His will stipulated that the state must accept the entire collection and that it be hung in the Luxembourg Museum (not in any provincial museums outside Paris) and eventually in the Louvre. The officials balked at his conditions, but they could hardly refuse such a gift completely. The *Journal des Artistes* opened its pages to the debate in April and solicited opinions. Tempers ran high. Gérôme made a ringing statement which showed how closely public morals were still associated with art in France: "We are in a century of decadence and imbecility. . . . The whole level of society is declining visibly. [This legacy] includes the painting of M. Manet, does it not? And of M. Pissarro and others? I repeat, for the State to accept filth like this would mean a tremendous withering of morality. . . . Anarchists! And fools! People joke about it and say, 'It's not important—wait.' But no! It's the end of the Nation, of France!"

*Apple Trees
and Haymakers,* 1895.
(915) 23½ × 28¾.
60 × 73.
Private collection

Gérôme and some other professors at the Beaux-Arts threatened to resign if the Caillebotte bequest was accepted, saying that they "could no longer teach an art of which the paintings admitted to the Luxembourg violated all the laws."

After the negotiations had gone on for about a year, a compromise was reached. Twenty-seven paintings were retained by the heirs and thirty-eight entered the Luxembourg, among them seven by Pissarro, two by Cézanne, seven by Degas, eight by Monet, six by Sisley, two by Manet and six by Renoir. In the process of negotiation, the state had arranged for an expert evaluation of the paintings. Each of Manet's paintings was valued at 6,500 francs; Monet's at 5,750; Renoir's at 5,000; Pissarro's at 1,857; Sisley's at 1,333; Cézanne's at 750; and Degas's pastels at 4,070. An annex was built at the Luxembourg to house the collection, and the opening took place in 1897. Even then, eighteen members of the Institute signed a letter of protest.

Pissarro gleefully sent Lucien the press clippings on the controversy. His triumphant conclusion was: "The truth is they are angry and we are right. At least, so I am convinced. But you may be sure that all this will do us a lot of good. This protest has been a sensation and things won't stop there."

In the spring, he wrote Lucien again: "I shall have to work constantly, I have only a few more years to live and I must not waste my time while I can still see clearly and feel nature intensely, if I am to conclude my life fittingly."

At the invitation of Théo van Rysselberghe and his wife and at the suggestion of Georges Lecomte, Pissarro decided to go to Belgium. "I talked with Lecomte who told

me that Bruges, an extraordinary city near Brussels, would be a gold mine for landscapists because it is an old town which has remained unspoiled by any modernism, and above all it is gray and sad," he wrote Georges. With an advance from Durand-Ruel of 3,000 francs and accompanied by Julie and Titi, he left for Brussels on June 25. His departure could not have been more timely; on the night before he left, President Carnot of France was stabbed to death by an Italian anarchist. ". . . an event which cannot fail to complicate things in France," Pissarro hastened to write Lucien on arrival. "How will all this turn out? The poor painter will certainly not be unaffected." The assassination placed every anarchist in France in jeopardy. It led to passage of a law that forbade anarchist propaganda and gave the police broad powers to arrest suspected anarchists and hold them without charges. Luce was caught in the dragnet, but Pissarro was glad to learn that his friends Mirbeau, Paul Adam and Bernard Lazare had escaped across the frontier.

The stabbing of Carnot culminated several violent acts by anarchists in the nineties that led to countermeasures by the government. From March 1892 to June 1894, eleven explosions and a stabbing killed ten people. Extreme sentences against anarchist terrorists drew more bombings in retaliation. In 1893, Auguste Vaillant, unemployed and driven to desperation by the distress of his mistress and daughter, bombed a Chamber of Deputies which seemed to him indifferent to the plight of the homeless and the starving. Several deputies were wounded, but no one died; nonetheless, he was executed after President Carnot had refused to grant a petition for pardon circulated by one of the wounded deputies. Vengeance followed swiftly. A week after the execution, Emile Henry threw a bomb into the Gare St. Lazare, wounding nineteen, killing one. Paris was in panic. People ran frantically from any suspicious-looking parcel or object. Pissarro was horrified by the events: "What an epoch! What terrible events are in store, and what frightful misery!"

The actual number of anarchists was small. By the end of 1894, after the violence and counterreaction, it was estimated that the ranks included about 1,000 active militants, about 4,500 subscribers to the anarchist press and perhaps 100,000 who would vote for anarchists if they were to be candidates.

Although some anarchists saluted the violence—Laurent Tailhade had hailed Vaillant's "beautiful gesture" and Fénéon was probably implicated in Emile Henry's act—the random slaughter of innocents shocked most anarchist spokesmen who had hitherto been silent or evasive about condemning the acts. Mirbeau wrote: "The worst enemy of anarchy could have acted no better than this Emile Henry. . . . Every party has its criminals and its fools, because every party has its men."

Pissarro's attitude may be deduced from views he expressed to Lucien when Irish terrorists exploded bombs in London in 1884: "You are right to regard this terrorism as futile and base, but what political party is not base? . . . I agree that the Irish terrorists are fanatical Catholics and won't be able to get anywhere, but this does not mean that the English are without their own brand of secular iniquity! In all this I see two things: the egotism and waywardness of man!"

After ten days, Julie returned to France, and Camille, Titi and Théo van Rysselberghe went to Bruges and the near-by coastal village of Knocke. The beauty of the

country captivated Camille. He began work on several oils, but the events in France were disturbing him. Fénéon, who had been indicted as an accomplice of Emile Henry, was one of the "Thirty" placed on trial after the Carnot assassination. They included Luce, Pouget, Grave and Paul Reclus, brother of the distinguished French geographer and leading anarchist theorist Elisée Reclus. Pissarro poured out his fears to Lucien:

> I am afraid that I shall be forced to remain abroad for some time. Since the last law passed by the French Chamber, it is absolutely impossible for anybody to feel safe. Consider that a concierge is permitted to open your letters, that a mere denunciation can land you across the frontier or in prison and that you are powerless to defend yourself! . . . Since I don't trust certain persons in Eragny who dislike us, I shall remain abroad.
>
> I have not yet said a word of this to your mother; I'll wait to know how things are going, it's certain your mother won't be of my opinion. Although there won't be a shadow of evidence that I have in any way committed any unlawful act whatsoever. . . . As the saying goes, if they accuse you of having stolen the Bell Tower of Notre Dame, pack your trunks—and flee!!

Pissarro added that if he couldn't sell any paintings (his exile made that difficult), "black misery" lay ahead. "I am very tormented and perplexed." In August, he was still hesitating to return to Eragny: "Remember that I am tied to anarchism by my friendship with Grave, Fénéon, Luce, etc. They must know it; if the Englishman [their neighbor next-door at Eragny] or any concierge whatever denounced me, that would be enough for me to be expelled or even thrown in jail."

He was not alone in his exile. Titi was with him, and Rodo, now sixteen, joined them. They usually spent evenings at the van Rysselberghes's with Elisée Reclus; Bernard Lazare, the symbolist poet and anarchist; and occasionally Emile Verhaeren, the Belgian anarchist poet. The counterterrorism, the Trial of the Thirty, the destructive nature of terrorism which the anarchist leaders had not really faced up to before, the need for a more positive anarchist program—these were the pressing topics.

Pissarro's room at Knocke was like a field headquarters, with dispatches being rushed off to all branches of his army: advice to Lucien and Georges, homeopathic prescriptions for Julie, money to all, grandfatherly suggestions about his grandchildren, reassurances to Georges when Tommy was sick that all children have vitality, etc. He kept a professional eye on the two sons with him. To Georges he reported: "[Rodo] works a good deal and is making rapid progress; if he continues like this, he will do good things. His drawings are very curious and very personal and of a great perception. . . . Titi is doing a portrait of a young lady of the hotel, it goes well. . . ."

By September, Pissarro had finished four large paintings of the windmills, churches and dunes at Knocke; but there was a worrisome silence from Durand-Ruel, and Pissarro still hesitated to leave. "Could I return to France safely?" he speculated to Lucien. "I don't know at all. I notice that a number of militant figures have left. It seems to me that I, who am absolutely of no importance and participate in no actions of any kind, should have nothing to fear; but as you point out, there is always a threat of some sort." Although his friends on trial had all been acquitted, the atmosphere in France was still very hostile to anarchists.

He finally returned to Eragny in October; the political situation had eased and he had run out of money. His political philosophy (and his temperament) inclined him against any "bourgeois" investments or savings, and he found himself without resources once more, though he had earned large sums in the two previous years. So he was again vulnerable to Durand-Ruel's pressures on him to lower the prices of his paintings. He finally had to capitulate. He reported to Lucien:

Between the two of us (don't breathe a word at home of what follows), I am not displeased to end this struggle; the situation was becoming untenable. In addition to absolute lack of funds and concern for your brothers in Belgium, I had to put up with incessant arguments at home. You yourself were the cause, innocently, of course, of heated squabbles about the inability of all of you to earn money. In your letter to your mother you took her side, agreeing that it would have been better to have learned a trade. . . . Would you have been better off? Your mother says yes.

Self-portrait, c. 1900. Etching. (D 90) 7¼ × 7. 18.5 × 17.7.
Bibliothèque d'Art et d'Archéologie, Paris

22.

Pissarro and Sons, Painters

*"What an admirable family . . . in his old
age, still young and revered, surrounded by
fine sons, all artists, all different!"*
—*Octave Mirbeau, 1897*

IN 1895, Pissarro made a rough pen-and-crayon drawing entitled *The Family of the Artist*. He is nodding in an armchair and dreaming. Swirling around him in his dream are sketches of Julie sewing; Paul-Emile painting at one easel and Cocotte drawing at another, with Lucien standing by, overseeing. Georges is at an etcher's bench; Lucien, Félix and Rodo, portfolios under their arms, dart here and there in search of "amateurs." A family of artists—the dream of Pissarro that came true. All five of his sons became artists—a phenomenon matched only by the Peale family in America.

Given Pissarro's nature—born teacher, discoverer of talent, passionate believer in the nurturing of individual skills, a deeply involved (sometimes overinvolved) parent—it was inevitable that he would encourage his children to be artists if they had talent, which, he was quick to see, they had. They could thus escape the "system" he despised. They could thus avoid being exploited or exploiters. And he undoubtedly wanted his sons to be extensions of himself, not much different from the banker or butcher who wants to see his sons follow in his footsteps.

In 1890, when Georges was nineteen and Félix sixteen, he expressed his ideas about this to Lucien:

> Your mother made me take Titi [Félix] with me so that I could find a job for him. I took him along but I brought him back to Eragny. She accuses me more than ever of having raised you to do nothing; as always I let the storm pass. For after all, what is the point of putting a boy, Titi or Georges, in a factory where he will be exploited and either acquire no skill or if he does learn something learn it badly? . . . That would be idiotic. Wouldn't it be better to have them wait for some good opportunity, and in the meantime, have them work with me? But these false notions prevent me from getting them to work to good effect.

As Gustave Kahn pointed out when the works of sons and father were exhibited together, "In [Pissarro's] house and garden at Eragny, they thought only of art. All the little children were provided with sketchbooks because the first step was to know how to draw. With age they earned like officer's stripes the watercolor box and the tubes of paint. They always had near them, in their father, a counsellor, the most authoritative. He was benevolent but demanding, paternal but sharp. . . ."

In discussing with Georges the possibility that Félix might be trained in marquetry and cabinetmaking, their father saw this craft as a possible family undertaking. "Lucien and I are studying the possibility of a combined production by each one according to his

279

The Family of the Artist, 1895. Pen and sepia ink. Collection Mrs. Lester R. Bachner

aptitudes. Lucien, you, Titi, Rodolphe would find his place in these works. What would you think of a piece of furniture which would be made by all of you, the painting by Lucien, the sculpture by you, and the others whatever they could do some day. This furniture would be made by the brothers Pissarro! . . . like the brothers Le Nain who made such beautiful pictures in their time."

Pissarro was intoxicated by the vision of his sons working together to create beautiful and useful objects which would bring the experience of art into people's daily lives. The pursuit of the dream was not without its price: storm and stress between Camille and Julie, financial sacrifices that at times deprived them of the ease they might have had in later years, disappointment in the sporadic progress of the boys. From the time of adolescence, Pissarro had followed his goal single-mindedly; but some of his sons, growing up in the shadow of a renowned father, and doubtful of matching his reputation, sometimes lost confidence.

During Camille's long absences when he was painting in other areas or trying to sell his work in Paris, Julie was left with the responsibilities of parenthood. Camille, back at home, tended to overcompensate by spoiling them. Julie disapproved of her sons's artistic careers. Always a realist, she knew the long struggle ahead. She did not want them to suffer, and she realized that she and Camille would spend their old age supporting grown-up sons if they became artists. This conflict between Julie and Camille lasted a dozen years, from Lucien's first trip to London until the mid-nineties, when Julie finally, reluctantly, seemed to accept the inevitable.

"Your mother is upset . . . : She claims I encourage you to concern yourself with art, whereas you should think of earning a livelihood," Camille remarked to Lucien as early as 1884.

Julie was actually not so narrow-minded as Camille indicated but yearned for at least some practical application for her sons's art. She wrote Lucien:

Try . . . to be introduced to a newspaper so that, if you are able to draw some sketches here, they will take them at the newspaper as it is absolutely necessary that you earn a living. We are still very tight financially, business is very bad; please don't waste your time trying to be an artist, it is stupid, be a businessman and leave art to those who have money in the bank. Look at poor Monet, how in spite of his great talent he had to fight to sustain himself, and Courbet and so many others. In short, my poor son, do what you think but above all, have courage, try to establish the proper connections over there so that if you do some interesting pictures here you can send them over there.

And she added:

All the children are around the table drawing and they make your portrait. I assure you that you have a funny face.

When Georges's confidence was shaken by Julie's fears, Camille wrote:

It is natural indeed that your mother worries about your future, it is so fragile; for her everything finds its solution in success, but she does not see what kind of difficulties one must go through, she does not realize either that means are never the same and that the only thing to do is to let the young man follow his sensations as much as possible. If the stuff of a talented man is within him, just as does the bee he will know how to find the juice of the flowers on which he will live.

During difficult times, Julie's insecurity became more intense and her fears—for her children, for herself and Camille—erupted into harangues. Her husband tended to tiptoe around her, waiting for her irritation to subside, and quietly continued to teach his sons. He had faith in their potential as artists. His greatest fear was that they might be handicapped by their connection with him, suffer from the critics and collectors who were hostile to him, and above all, tend to imitate him instead of following their own styles.

He took steps to overcome these handicaps. Eventually, Lucien, Georges and Félix were all working in England, away from his influence, despite the cost, for "in France I am a hindrance to all of you." Whenever their work tended to resemble his, he induced all except Lucien to use *noms des artistes*, to protect them from identification with him. Georges signed his paintings "Manzana," Félix's signature was "Jean Roch," Ludovic Rodolphe's was "Ludovic Rodo" and Paul-Emile signed his early work "Paulémile." Lucien used his mother's maiden name, Vellay, for a brief time, but he was too much under his father's wing to take this leap to independence. In 1895, when dealers were developing some interest in the work of his sons, Pissarro was convinced that "their pseudonyms have made it possible for them to be judged fairly."

"Let us speak of art, my boys," he wrote Lucien, Georges and Félix when they were in England in the fall of 1893. "I look at your engravings from time to time and the more carefully I look the more I become convinced that you are real men! . . . I expect Titi to do something big and well-studied, based on nature. Georges's engraving shows progress in the observation of nature. Lucien's has quiet purity. . . ." Then his constructive criticism:

> I do remember the engraving you [Lucien] had in the *Dial*, but I never said that I disliked it. I simply remarked that it would have been better if the figure had been more clearly articulated against the background. This is just a question of the eye, mine in particular, nothing more than that, and it does not imply that your engraving is not admirable from other points of view. Even among masters like Degas, I sometimes discover *manquements de values;* to point these out is not to judge the substance of the work any more than to note a misspelling is to condemn a book.

Pissarro at his writing desk.
Photograph Pissarro
family documents

Lucien Pissarro:
Félix at Easel.
Pencil and crayon.
Ashmolean Museum,
Oxford

But scorn my judgments! I have such a longing for you all to be great that I cannot hide my opinions from you. Accept only those that are in accord with your sentiments and mode of understanding. Although we have substantially the same ideas, these are modified in you by youth and a milieu strange to me; and I am thankful for that; what I fear most is for you to resemble me too much. Be bold, then, and to work!

One of his principles was that youthful talents should be nurtured from the earliest moments, that formal training start as soon as feasible. He wanted Félix to begin serious study at fifteen, for, "if he delays, it will be very bad for him to begin later, it's fatal. He won't be master of his craft and he won't know how to turn it to account." When Félix did begin formal training and soon found his drawing lessons "boring," Camille observed to Georges, "Nothing should be boring. The apple goes to him who knows how to make good use of his youth."

"Draw, draw, draw," he preached to Lucien. "It is only by drawing often, drawing everything, drawing incessantly, that one fine day you discover to your surprise that you have rendered something in its true character." And, "You must *harness* yourself to drawing." "Draw everything, anything. When you have trained yourself to see a tree truly, you know how to look at the human figure."

"Don't strive for skillful line, strive for simplicity, for the essential lines which give

Camille, Rodo, Lucien
and Félix, Belgium, 1894.
Photograph courtesy John Rewald

the physiognomy," he warned Lucien. "Rather incline toward caricature than toward prettiness," Camille cautioned Georges, remembering his own experience at the *Académie Suisse* thirty years before. "Beware of your ease of execution, try not to follow the clever skillful classmates, look at nature, and don't do for the moment what you see. Later you will extract the synthesis of it." Also to Georges, who was particularly fascinated by animals and plants: "When you find a plant to your liking, draw the lines from the plant and with a square cutout or a paper frame, look how the lines appear within this frame. This will give you unexpected shapes, this is done for composition. Degas has often salvaged a picture this way. Finally, observe nature strongly. . . . Go through your sketchbooks, stroll through the parks, watch through the windows the moon, the clouds, the people."

To Lucien: "Curiously enough, the observations you make from memory will have far more power and be much more original than those you owe to direct contact with nature. The drawing will have art—it will be your own."

Until well into the nineties, Pissarro was distressed by the immature behavior of Georges and Félix and their inability to concentrate. He confided his irritation to Lucien in 1891: "You will see how they have progressed. If only these two imbeciles would not be so ill-behaved and mischievous . . . they are full of such childish stupidities. They don't stop squabbling like little kids with the younger children." (Georges was twenty and Félix seventeen.) He was thrilled when they did good work ("Georges has done some extraordinary things"), but three years later he was still exasperated: "What irrationality when one speaks to them. It's as if they had been brought up by bourgeois, yet they have been taught the same principles as you have." There is no evidence that he made much effort to discipline the boys. Usually they got what they wanted.

Georges was his parents's special source of anxiety. He had great promise, but he was the most independent of the sons, in revolt against his parents, stubborn, unpredictably ill-humored and lacking the concern the others felt for each other. Esther's death robbed Georges of a stabilizing influence and his first chance for happiness; it had left him embittered. As late as 1898, when Georges was almost twenty-seven, Julie complained to her husband: "He tells me that I am nothing here, that I am only your mistress, he treats me like a maid." She urged Pissarro to tell him "once and for all" that he would supply him and Tommy only with the essentials; beyond that he must earn his own way.

As the years went by, Pissarro tempered his disappointment at his sons's erratic devotion to art; but as late as 1895, he wrote Lucien: "Have you seen the kids? . . . I hope they are going to work and not passing the time loafing. I would certainly like them to begin to help me a little. If business continues bad it will surely be necessary." His wistful hope that his sons might help him for a change was understandable. In the last half of 1894, Pissarro received only 4,000 francs from Durand-Ruel, and only 16,000 throughout 1895. Although he had other sources, he relied on Durand-Ruel for his principal income. Yet he was giving Lucien 300 francs a month, Alice 300 to 500 for support of Tommy, Georges and Félix 200 each—about 12,000 to 15,000 francs a year. Obviously in a mediocre year this huge drain kept Pissarro at the easel. "You ought to try to place some drawings, no matter where, to sustain me a little," he wrote Georges.

Pissarro tried to find practical application of his sons's skills so that they could earn their living while their art developed. He wrote Lucien:

> Georges and Titi should have addressed themselves to doing a little work in industrial art. I pointed out to them that skill of this kind would enable them to earn their livelihood and make them travel around in order to place their works. It would also be a satisfaction to their mother. Unhappily, exhortation and advice are dead letters, the boys depend too much on me. This is bad from two points of view: the practical and the artistic. If you want to succeed some day, you should turn to the movement seeking to relate art to industry and create an Impressionist style in this field. There is still time!

When it became apparent that there was little audience for his neo-Impressionist paintings, Lucien did illustrations, caricatures (surprisingly strong and individual) and wood engravings for *La Vie Moderne*, *La Vogue* and other magazines. In 1889, he sold the dealer Goupil twenty-five proofs of a woodcut he made from one of Camille's drawings, and proudly sent Julie 100 of the 125 francs he received. London seemed to offer more opportunity than Paris, especially after some engravings he made for *Revue Illustrée* were denounced by many readers for their "coarseness."

Lucien's return to London in 1890 was also prompted by his father's determination to have his sons avoid military service. In the early nineties, the anarchists were agitating against military service, because they felt the soldiers were pawns for imperialist forays or for suppression at home. Pissarro consulted lawyers to confirm that his sons were Danish citizens; but he felt more secure to have them away in England when they were of draft age.

Camille encouraged Lucien in his first engraving efforts in England, which were published by Lucien's friends Ricketts and Shannon at their Vale Press: "You are right,

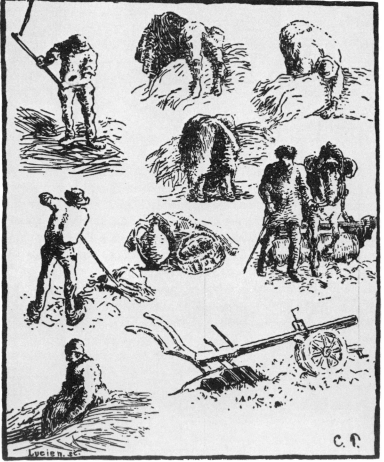

Le Labour, for *Les Traveaux des Champs,* 1888. Drawing by Camille, woodcut by Lucien. British Museum

Les Traveaux des Champs, c. 1890. Drawing by Camille, woodcut by Lucien. British Museum

I believe, to stick to engraving, you are making great progress, and your drawing is more and more wonderful. You really have your own note, and that is tremendous." "Your own note"—Camille's highest praise—and in 1892: "Your engravings are accepted everywhere, that is certain; you have the beginnings of a fame that is not based on mine: that is the point. . . ."

The time seemed ripe for father and son to complete a collaboration they had planned for years—a portfolio on peasants at work in the fields, *Les Travaux des Champs*, with drawings by Camille cut into wood by Lucien. Théo van Gogh had published one of the drawings but had not been able to interest any publisher in Paris in the series. Ricketts and Shannon published a portfolio of six of the woodcuts, in an edition of twenty-five. Camille continued the drawings from time to time—engraved and published as *La Charrue d'Erable* by Lucien after his father's death—but he was eager for Lucien to establish his own reputation.

By 1895, Lucien had started his own press, the Eragny Press, to create books he designed, illustrated and printed with Esther's increasingly capable help. Their first book, appropriately enough for the parents of a baby girl, was an illustrated fairy tale, *The Queen of the Fishes*. Now he proposed that his father make a series of drawings of the tale of Daphnis and Chloe, which he would cut into wood. The project was dropped when they could not find a publisher with adequate distribution. Lucien went on by himself to design, illustrate and print by hand, with Esther's help, several beautiful books in small editions. Pissarro was pleased with his son's development, although Lucien could not yet make a living. He paid for Lucien's press, and offered to pay the costs when his son decided, in 1902, to design his own type face. By 1900, Lucien was also well-known in Europe as an illustrator and had the satisfaction of being asked to make engravings for the *Revue Illustrée*, which had rejected his work in previous years.

For all his sons Pissarro acted as agent, marketing director and sales manager. Wherever they may have been, headquarters was where he was. "It's necessary to prepare the terrain in advance," he told Georges of a plan to sell some drawings. In 1895, his efforts succeeded when Père Martin bought two of Georges's and Félix's paintings.

The same year, Pissarro had at last a stimulus for Georges and Félix to devote themselves to applied arts and an outlet for anything they created. In the William Morris tradition, Henry van de Velde, a Belgian architect of anarchist inclination, a former neo-Impressionist and one of the founders of art nouveau, had been advocating the application of fine arts to household objects. Naturally, these ideas appealed to Pissarro. Samuel Bing, a dealer who was inspired by the work of Louis Tiffany in New York and by trends in England and Germany to make utilitarian objects beautiful, decided to open a huge gallery. He had a building at 22 rue de Provence redesigned and daringly lit by electricity. He called it "L'Art Nouveau" and invited hundreds of artists to exhibit paintings, prints, drawings, sculpture and also furniture, glassware, stained glass, pottery, ceramics, ironware, jewelry and illustrated books.

Pissarro immediately wrote Georges and Félix in England, urging them to prepare some work for the exhibition. They decided to collaborate on elaborate boxes that

would combine Georges's decorative talents and Félix's skill in drawing animals. Camille was to be their official representative in dealing with Bing. Bulletins flew to London: reactions to Georges's ideas; suggestions (principally that they stick to what they knew best), such as "I think it would be very beautiful to work with a peacock, plants, such subjects; if Félix, who likes horses and has such great skills for making them, finds motifs for them, he must study them again and follow nature." Pissarro found a carpenter to make frames for the boxes, and, as always, financed his two sons. Georges also made an elaborate cashbox, decorated with a golden peacock with rubies for eyes.

Lucien sent his book, *The Queen of the Fishes,* and Camille exhibited three paintings: scenes from Eragny, Knocke and Pontoise. In the 1894 exhibition of the Independents, Lucien, Georges and Félix had all appeared; now, for the first time, they were joined by their father.

Camille found a place for Georges's and Félix's five boxes in an enclosed glass case in a small room decorated by van de Velde. They were a *succès d'estime.* Van de Velde thought them "superb"; Mirbeau, Maurice Denis and Arsène Alexandre praised them. "Your boxes are successful, all those who have seen them have been enchanted," Camille wrote Georges, warning him, however, not to count on immediate sales. A remark of van de Velde's gave Pissarro an exciting idea. "He said to me that it would be very chic if at some time you could do something together—he has made some beautiful pieces of furniture, wallpaper painted very simply and beautifully, some wainscotting, some splendid coppers." Most of the other artists seemed uninspired to Pissarro, but the few who did appeal to him seemed to offer the possibility of a movement. Maybe a new generation of brave pioneers was in the making! With memories of the Impressionist group in mind, he wrote Georges: "There is a nucleus composed of Charpentier, van de Velde, Rodin, you two, and Denis who will make their way if they could hold themselves together as a group. That's how the Impressionists maneuvered."

Pissarro's dreams of all his older sons being part of a gallant new band of pathbreakers never materialized. They were never to collaborate as closely as they did on the *Guignol.* Only Georges maintained his interest in the decorative aspects of the applied arts. He began to design tapestries, rugs and furniture, as his father had suggested. In 1901, he exhibited a number of paintings at Durand-Ruel and in 1903, at Bernheim Jeune. Camille was pleased that Duret and others judged them excellent and "found that you do not resemble me, that you have freed yourself from my style," and reported that Bernheim wanted to buy one of the paintings for 200 francs.

By 1900, Rodo had joined the ranks of Pissarro and sons, painters. In August, he made the artistic pilgrimage to London to work under Lucien's tutelage, and returned in November to take a studio with Georges in Montmartre, where they became close friends of Picabia, at that time an Impressionist. Introspective and skeptical, Rodo was inclined to go his own way, and within a year Camille was urging him to stick it out with Georges.

Pissarro felt that Cocotte, too, had a talent to be developed, gently. In 1895, he visited his fourteen-year-old daughter at her boarding school in Paris ("Cocotte is

enchanted. I bought her some pretty evening slippers and some white gloves."). He "took her to the Louvre and to the Centenary of Lithography at the Trocadero Museum, etc., etc. Thus I try, little by little, to open her eyes, and without seeming to be aiming at this. At the zoo I called her attention to some beautiful motifs for tapestries, etc.," he related to Esther. "But I beg you, if either one of you write to me, be careful what you say about Cocotte so as to avoid misunderstandings. . . . Each time Mother goes to see her she tells me that Cocotte is so sad, that she wept when they parted . . . perhaps she did. But with me it is the contrary, the last time she was most happy, and so was I. But of course if the mother cries, the girl weeps with her."

The next year: "I believe that I am going to remove her from there and take her in hand, I am going to have her draw seriously, interest her in the things of nature, etc. She seems to be delighted with the idea and if truly she could become interested in it, it would be a new world for her."

But Julie wanted someone to help her at home, and Cocotte returned to the isolation of Eragny after she finished school. What talents Cocotte had remained undeveloped as she followed the conventional path toward marriage and motherhood. Her years with her mother were difficult and her memories of them always painful. Camille had withstood his wife's opposition to his sons's careers, but seems to have weakened about his daughter's future.

Pissarro never separated art from ethics when advising his sons. "Above all, always conduct yourself courteously and without ill humor," he wrote Georges. "Be very

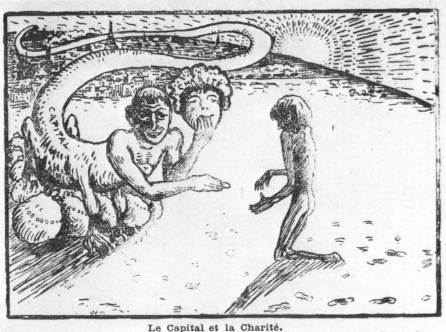

Le Capital et la Charité.

(Père Peinard.)

Capital and Charity.
Drawing by one of the Pissarro sons for *Père Peinard.* From Dubois, *Le Péril Anarchiste.* Bibliothèque Nationale, Paris

polite with people whether they be rich or poor, even more so with the poor, for they are unfortunate." And, reacting to Georges's skill at satire: "What you tell me of these things, of people, seems to me very comical; strictly between us, it's necessary to make absolutely sure that you don't wound sensitive people, aren't we ourselves comical? And if sometimes it's amusing to note what is going on around you, you must use it with discretion and not prolong the joke. . . . I only say this to you to put you on guard against yourself."

He was pleased that the children grew up sharing his anarchist philosophy. From childhood they had heard their father expound his theories, and had read their father's anarchist newspapers. The younger boys were exposed to visitors who more often than not reflected their father's views. Luce was a favorite of theirs. "Luce has introduced us to an *anarchist* at *Gisors!*" Georges wrote excitedly to Lucien in 1891. "This sacré Luce knows everyone!!"

Pissarro encouraged his sons to contribute protest drawings to the anarchist press. "One shouldn't neglect Grave, who is very kind and whom we love," he wrote Lucien. "Therefore, do a strike in London or a procession of the sects which are so numerous in London, an allegory of the misery of money, the wounded of life, etc., etc. Think also of the parable of the blind of Brueghel."

In 1891, when Georges was only twenty, he made two drawings for Père Peinard. Lucien did drawings for *Les Temps Nouveaux* and for the special issue of *La Plume* on anarchism, for which Pissarro contributed his stevedore drawing; and in 1901, with Luce and van Rysselberghe, Lucien illustrated a children's book written by Grave.

When *The Anarchist Peril*, a book by F. Dubois, was published in Paris, in 1894, it contained twelve illustrations by Lucien, Georges, Félix and the sixteen-year-old Rodo. Perhaps Pissarro's proudest moment came in 1899. From time to time, Grave held a "tombola," or lottery, for the benefit of his publication, with artists contributing drawings or paintings. In *Les Temps Nouveaux* of April 15 and 22 of that year, paintings by Camille, Lucien, Georges and Rodolphe Pissarro were announced. Pissarro and sons, anarchist artists. The following year, Camille contributed a drawing and Georges and Rodo gave paintings for the tombola.

In 1897, Mirbeau wrote a somewhat idealized tribute to this unique family of artists:

> What an admirable family that reminds me of the heroic periods of art; in his old age, still young and revered, surrounded by fine sons, all artists, all different! Each one follows his own nature. The father doesn't impose on any of them his theories, his doctrines, his way of seeing and feeling. He lets them develop themselves according to the sense of their vision and of their individual intelligence. He cultivates in them the flower of their individuality. Lucien, a delicate and luminous landscape painter of exquisite sensibility, but not content with expressing himself on canvas alone. Settled for some years in England, he has tried every medium. Wood engraver, etcher, decorator of books, in everything he does he reveals a delightful and discreet taste, charming composition. Georges . . . by temperament and intense imagination leans toward the broader aspects of decoration, seduced by the mystery of form which he tries to capture on canvas, wood, copper. But protected from the symbolist excess by a great love and a great understanding of nature, he dreams of giving furniture a new style.

He wrote of Félix's versatility—painting, watercolor, wood engraving, metal sculpture, drypoint—and "active imagination, originality, love of 'grander visions,' delicate taste."

In 1898, when Lucien's daughter, Orovida, was five, Pissarro exulted: "The deuce! here is still another potential artist. . . . Kidi [Orovida] shows skill in drawing, it was written that she would. Her drawings are already full of sentiment, elegance, waywardness." A third generation of artists was on the way. Pissarro's pride in his family of artists brightened the last years of his life. "It's a beautiful and happy thing that these children have this love of art," he confided to Mirbeau. "Our epoch is so sad that one can at least feel oneself live in a dream of beauty."

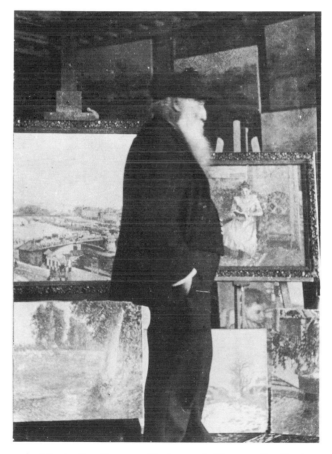

Pissarro in his studio, Eragny. Photograph Pissarro family documents

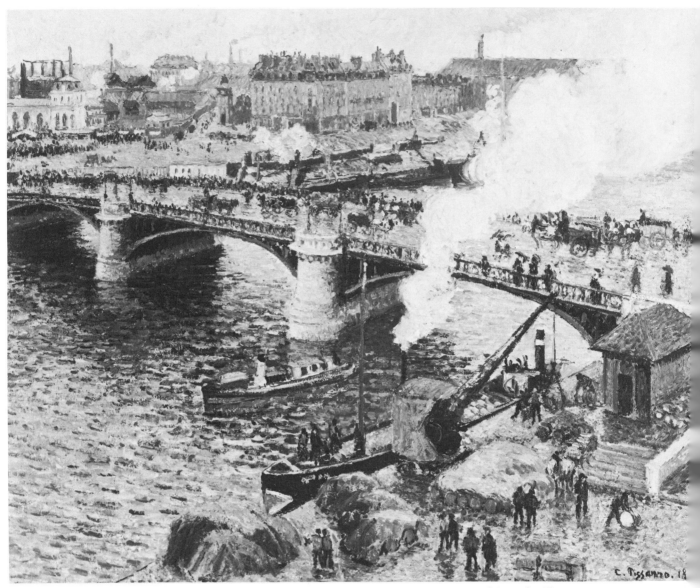

The Boieldieu Bridge, Rouen, Misty Weather, 1896. (948) 29 × 36. 73 × 92. Art Gallery of Ontario, Toronto;
gift of Reuben Wells Leonard Estate

23.

Old Age and
New Challenges

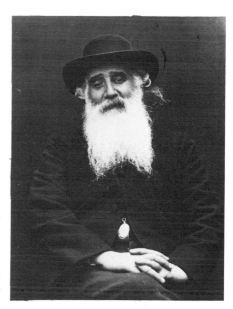

". . . it's terribly difficult, it's almost like trying to catch a bird in flight . . . carriages, buses, people among big trees, large buildings that must be rendered vertically—it's tough! But what can I say, I must do it just the same!" —Pissarro to Georges, 1897

Pissarro, c. 1895.
Photograph Durand-Ruel, Paris

IN JANUARY of 1896, Pissarro returned to Rouen. He had felt isolated in Eragny, was anxious about money, and needed a change from painting the local motifs. By January, he had set up his easel at the Hotel de Paris in a room with a view of the harbor. Although he wrote to Lucien, "When one is old it is so hard just to maintain oneself that it is already something to be able to go one's own modest way," by February he already had eight paintings going at once.

He was particularly pleased with one: a view of the bridge near the Place de la Bourse with crowds of people coming and going, smoke from the boats, quays with cranes, workers in the foreground, all "in gray colors glistening in the rain." In several pictures he worked on effects of fog and sun, of mist, rain and gray weather; but what interested him most in these scenes was their animation, the movement of traffic, pedestrians, workers, boats, the bustle of men and machines*—a new challenge that gave him "fits of hope." At the end of February, he wrote Lucien in a state of enthusiasm about a new subject:

> I think I shall stay here until the end of March, for I found a really unusual motif looking out of one of the hotel rooms facing north. (It's ice cold and has no fireplace.) Just imagine it: the whole of old Rouen seen from above the roofs, with the Cathedral, St.-Ouen's church and the fantastic roofs and really amazing turrets of the city. Can you picture a canvas about 36 × 28 completely filled with old, gray, worm-eaten roofs? It is extraordinary!

He was elated with this painting; it pleased him to see the cathedral "firm, gray and clear against a uniform sky in wet weather." As soon as he finished the painting, he packed up and left for Paris and Eragny, to prepare for an exhibition at Durand-Ruel, opening on April 15. In spite of his enthusiasm for *Roofs of Old Rouen* ("I don't understand how I was able to get this completely gray picture to hold together!"), he was reluctant to exhibit it for fear of its being compared unfavorably with Monet's

* *Color plate on page 299.*

293

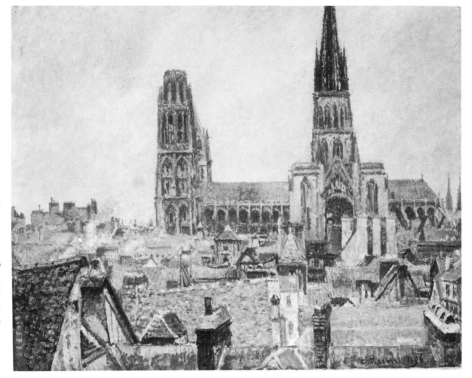

*The Roofs of Old
Rouen,* 1896.
(973) 28½ × 36.
73 × 92.
The Toledo
Museum of Art;
gift of Edward
Drummond
Libbey

paintings of the Cathedral of Rouen. But Arsène Alexandre convinced him to show it. "What the hell," Pissarro wrote, "it is so different from Monet that I don't believe friends will think I'm malicious in showing it. The truth is that Cézanne is the only one likely to find fault, and I don't care. Each of us does what he can." He showed thirty-five paintings in all: a dozen of Rouen, some scenes of Knocke, Eragny and Bazincourt, and one *Bathers*.

The Rouen paintings marked a major change in his art. Their subject matter was completely different from his tranquil rural scenes. They captured a variety of movements organized into a unified composition. And he liberated himself from neo-Impressionist techniques with these paintings by eliminating the "intermediate whites" from his palette and thinning out with turpentine the mineral oil medium with which he mixed his pigments. His hues were therefore purer and more transparent.

The critics saw the novel aspect of these paintings. An article in *Le Temps* of April 18, 1896, noted that he was unexpectedly showing himself to be interested in the tumult of cities and in the movement of crowds. "In his views of the Seine at Rouen, there are bridges full of wagons, buses, and pedestrians, all pell-mell. He infallibly catches the right sense of movement."

Gustave Geoffroy, not entirely satisfied with the Rouen scenes, thought they showed some hesitation and inability to dominate the forms. But he said, on the other hand, "It doesn't displease one to find some 'gaucherie' in the experiments of a great artist. One

makes an excursion with him, one admires the largeness of the world, the agitation of human existence, tumultuous in the great boulevards, then one returns, a little worn out, into the delicious garden. One takes up the old life, one admires the gold of evening, one hears the voices of silence."

The Rouen paintings proved so successful with Durand-Ruel's clientele that the dealer financed another trip for him in September. This time he could afford to live in the more expensive Grand Hotel d'Angleterre, in the same room Monet had occupied, with a fine view. Soon he was working on ten paintings at once, the harbor and bridges shining under different weather conditions and lights. "It is as beautiful as Venice!" he wrote enthusiastically, ". . . there are marvels everywhere I look. . . ."

This visit seemed to generate a new fervor. He exulted to Georges: "I'm working myself to death . . . From my hotel window I can see the boats going by plumed with smoke—black, yellow, white, pink, the ships loaded with lumber docking at the quays. . . . I have on my left the bridge that I painted last winter, but from the opposite side, with the quays and houses of the other bank, a mélange of houses and gray roofs."

Many of these paintings show workers on the docks. In *Turpitudes Sociales*, he had portrayed factory labor as harsh and degrading, but the labor on the docks carries no hint of social criticism. Perhaps he regarded outdoor work as less oppressive; certainly the scene was exciting.

Pissarro kept up a correspondence with Lucien from Rouen. Of concern to him then was the "neo-Catholic revival" in art and literature. Huysmans, among other intellectuals, was sympathetic to Catholicism, and Pissarro was adamantly opposed to this "reactionary turn of the upper bourgeoisie, fearful of the rising anarchist philosophy." He shot off sharp criticisms of what he called the "Symbolist-Catholic-Primitives" and praised Mirbeau for articles attacking the new mystical-religious aesthetic, agreeing with him that artists like Maurice Denis distorted nature, drew badly and did not dispose of values properly. As he had done all his life, Pissarro explained his point of view with energy and clarity: "Beware of the pretty, of sentimentality," he wrote Lucien, "depend on vital sensation like the Gothics, return to nature, healthy and beautiful!" Bracquemond had once said about Pissarro, "This is not a man, but a bowsprit!" This quality came out clearly in Pissarro's letters to Lucien about the new intellectual movement he detested so vigorously: "Damn it, neo-Catholicism may be in style for a bit, but since real belief is necessary for it to succeed, the chances are that it won't get very far. Everybody can't be as sick as Huysmans is, his talent notwithstanding. . . . No, I hope the movement will not succeed. . . . In any case it must be fought against!"

When he left Rouen, on November 12, he had completed fifteen paintings. He felt that what he had done was "bolder" than his previous paintings there, although his humility kept him from being entirely satisfied. ". . . perhaps I am deceiving myself, for the motifs are fleeting—they don't last more than one, two, three days. . . . But at least I painted what I saw and felt. . . ."

Excited by the new possibilities he had found in the movement and life of the city, he began in earnest to paint the streets of Paris during the winter of 1896–97 from a hotel window facing onto the busy Place du Havre, near the railroad station of Saint-Lazare.

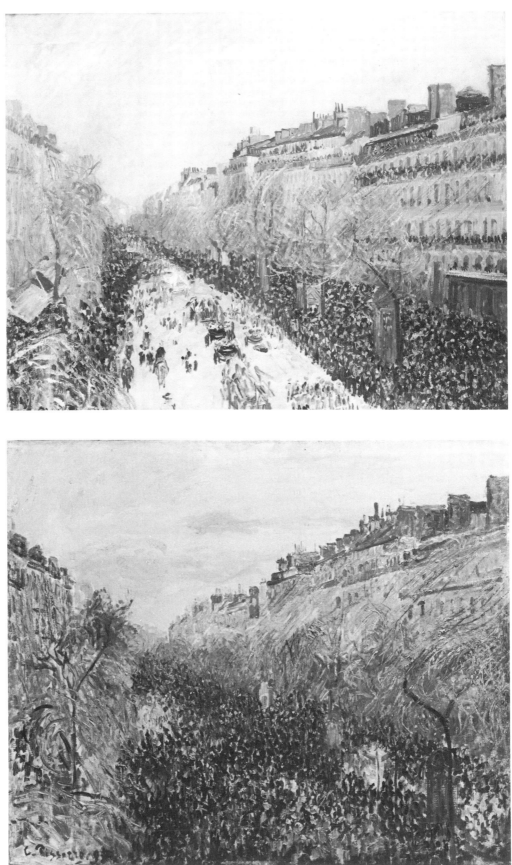

Mid-Lent Celebration on the Boulevards, 1897. (996) 25½ × 32. 65 × 81. Fogg Art Museum, Cambridge, Mass. Bequest of Maurice Wertheim

Mardi Gras, Sunset, Boulevard Montmartre, 1897. (997) 21¼ × 25½. 54 × 65. Kunstmuseum Winterthur, Zurich. Photo by Swiss Institute for Art Research

When he had exhausted this motif, he moved to a room at the Hotel de Russie, at the corner of the rue Drouot, with a view of the broad, busy Boulevard Montmartre and the Boulevard des Italiens. There he painted an astonishing series of the Boulevard Montmartre. Just below him, the pre-Lent Carnival parade of the Boeuf-Gras passed down the Boulevard. He stretched ten canvases in anticipation of the event, and on the day of the parade Julie and the whole family came to watch from his window. Painting rapidly, he captured the glint of the sun on the floats, the parade decorations, and the tumultuous crowds. As the marchers grew closer and finally passed beneath his window, the paintings became more full of movement and more freely and rapidly brushed in large, rhythmic strokes. With intense concentration on his sensations, Pissarro suggested the excitement and the agitation of the crowd, the deafening noise of the parade, in an image that anticipates the German expressionist school. He also painted an extraordinary view of the Boulevard Montmartre at night*. Its stores and cafés are glowing; reflected in the wet streets are the lights of the lampposts dotting away into the distance of a deep-blue night sky that catches a hundred hues from the brilliance of the scene below.

In the spring, Pissarro had bad news from London. Lucien, his precious son, his confidant and hope, had been struck with a mysterious malady that partially paralyzed him. Camille was at Eragny, painting the apple trees in their brief full blossom, when the message came; he hurried to England to be with Lucien, though he could do little to help him. Esther nursed her husband tenderly, feeding him, massaging his limbs day after day, wheeling him through Bedford Park in a bath-chair.

When Lucien was strong enough for the trip, he and Esther and Orovida returned to Eragny with Camille for the summer, where he gradually recovered (although he was never the same; for the rest of his life, the fingers of his left hand were numb).

* *Color plate on page 300.*

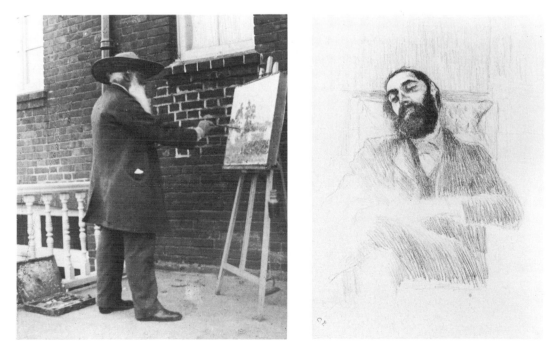

LEFT
Pissarro painting at Bedford Park, London, 1897. Photograph courtesy John Bensusan-Butt

RIGHT
Lucien Convalescing, 1897. Crayon. British Museum.

In October, just before Lucien returned to London, more bad news came. Georges wrote that Félix was seriously ill there. He had been sick intermittently for a year or so; now the disease was diagnosed as tuberculosis in the advanced stage, his doctor warning that he might not survive another crisis. Camille was exhausted, psychologically drained by his anxiety during Lucien's illness, and physically tired, too. Unable to go through another emotional crisis with Félix, his letters show a strange detachment from the reality of his younger son's impending death. He sent him some light reading, arranged to have him cared for in a private sanatorium, worried about the quality of the food there, but did not often write to him directly. He sent brief notes at the bottom of his letters to Georges, or more often asked Georges to show his letter to Félix since he "did not have the time to write to him." On November 11, Georges must have written to say that Félix was feeling better, because Camille responded cheerfully: "I am delighted to know that Félix is completely better. I hope that the bad weather here doesn't keep up forever; it's beautifully sunny this morning."

He seems to have been trying not to let his fear and sorrow take hold of him; to maintain tranquility and objectivity in the face of this terrible event. He finally wrote to Félix on November 16; it was a stiff, controlled letter full of inconsequential news, which skirted the subject of Félix's illness and only hinted at his own turmoil and indecision:

> Georges tells me that you have begun to draw; that will be a good distraction if it doesn't tire you too much. When you have some lithographic paper, we can pull some proofs for you here. I haven't yet found a place to put myself to work. . . . I thought about going back to Rouen or even of going some place near you, if Durand wants to pay for a hotel on the Thames for me; that would be a good thing to do. All of this is going around in my head, we will see what the best thing to do is. . . . I hope that the weather is not too bad in London . . . my eye is doing well, everything is fine at home. . . . I am rushing to get this letter off in time for the mail. . . .

On November 18, Georges wrote that Titi had suffered another crisis and there was no more hope; it was just a matter of waiting for him to die. Camille shrank from going to London, to his son's deathbed. He talked with Julie about what they should do and reported to Georges that she had said, "If you go to London, what's to be done about work and about earning money?" And one of them had to stay in Eragny with Rodo and Paul-Emile. Camille was pressed with work, with business affairs, he said; he wanted to find an apartment in Paris; he was afraid of complications with his eye. In the end, Julie went to London and Camille stayed in Eragny, taking care of the children and forcing himself to work.

He may have accepted the fact that Titi would die, knew that he could do nothing to prevent it and that his presence at his son's death was ultimately unnecessary. His best course was to preserve calm, continue working and stand ready to help Julie and the children through their sorrow and pain. He wrote to Georges:

> It is inevitable; we must take courage vigorously and not let ourselves be disheartened. If I came to join you it would be to relieve you a little or to do something for my poor Titi, but what can I do? What disturbs me most of all is your mother. If she falls ill, what would we do? . . . Kiss your mother for us and tell her that all goes well. Don't let her tire herself; you should ask the doctor for medication to soothe her a little.

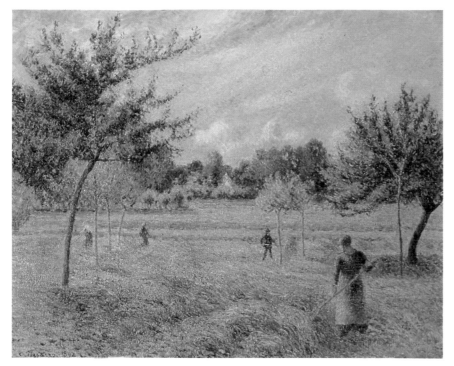

Haying Time at Eragny, 1892. (789)
23⅝ × 28¾. 60 × 73. Art Institute
of Chicago

The Great Bridge, Rouen, 1896.
(956) 28¾ × 36¼. 73 × 92. Museum
of Art, Carnegie Institute,
Pittsburgh

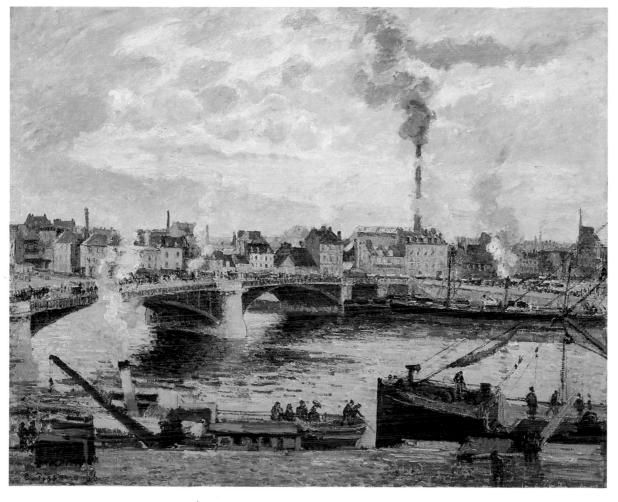

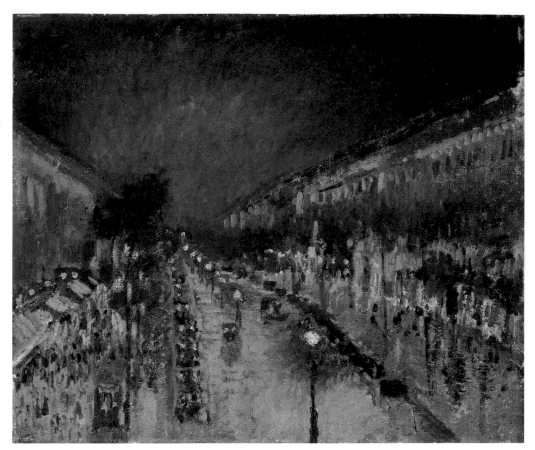

Boulevard Montmartre,
Night Effect, 1897. (994)
21¼ × 25⅝. 54 × 65.
National Gallery, London

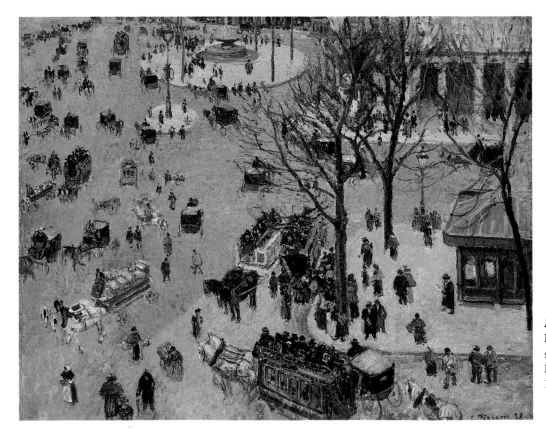

Place du Théâtre Français,
1898. (1031)
28¾ × 36¼. 73 × 92.
Los Angeles County
Museum of Art

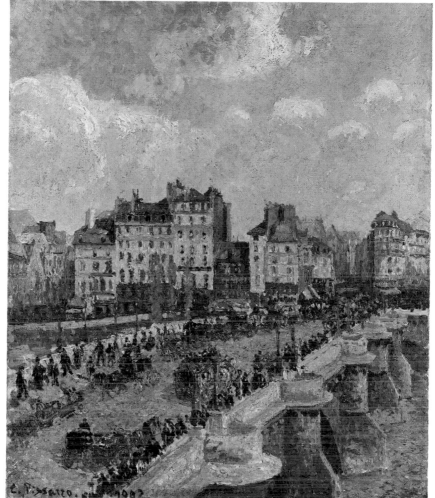

The Pont-Neuf Bridge, Second Series, 1902. (1211) 21⅝ × 18⅛. 55 × 46. Museum of Fine Arts, Budapest

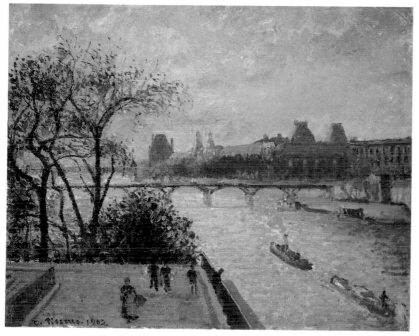

View of the Louvre from Across the Seine, 1902. (not in catalogue raisonné) 22 × 26⅛. 56 × 66. E. B. Crocker Art Gallery, Sacramento

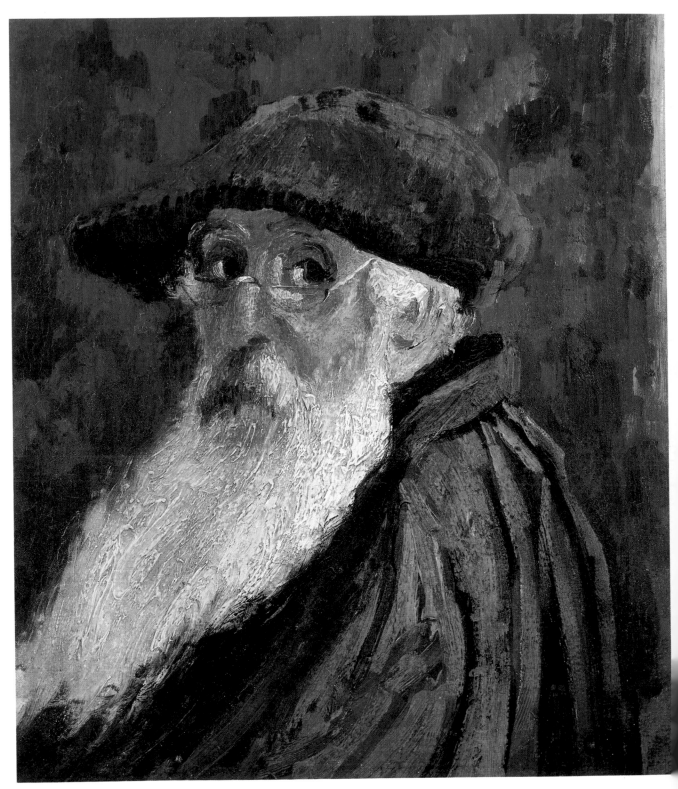

Self-Portrait, c. 1900. (1114) 13¾ × 12⅝. 35 × 32. Private collection, Lausanne

"If she falls ill, what would we do?" Despite Julie's gruff, blunt manner, he always realized how much they all depended upon her.

Félix died in London on November 25, with Julie and Georges at his bedside. The family had not told Lucien about the seriousness of Félix's illness, in an effort to protect him from stress while he was still weak. Esther broke the news to him gently a few weeks later, and Camille wrote:

> We were afraid to inform you and didn't know how to hide grief from you, but in such fatal circumstances we have to be resigned and think of those around us. To give way to discouragement would be dangerous and we must surmount what we could not prevent. In our misfortune, I saw how well Georges rose to the occasion. He showed great strength of character, for he kept your mother from making herself ill. Well, my dear Lucien, let us work, that will dress our wounds. I wish you strength; I want you to wrap yourself up in art. Even that will not keep us from remembering that fine, gentle, subtle and delicate artist and from loving him always.

The death of Félix and Lucien's illness broke the barrier between Julie and Georges. When Georges fell dangerously ill in December of 1899, she rushed to his bedside and helped nurse him back to health.

Camille returned to work with determination. He had found a room in the Grand Hotel du Louvre, 172 rue de Rivoli, with two large windows looking out on the Avenue de l'Opéra and the corner of the Place du Théatre Français. He was eager to begin painting. He left Eragny in early January for Paris, although he was worried about Julie, who was "weeping for our poor Titi night and day." His stoicism struck her as lack of feeling, but he was determined not to surrender to his grief and become unable to work.

The sorrow he was trying to sublimate seemed to sharpen his sensations. His views of the Place du Théatre Français* and the grand boulevards are among his most sensitive paintings, the streets full of people and traffic—"silvery, luminous, and vital . . . and completely modern." They show in particular the great marketplace of Paris, an area of elegant shops and cultural display, the heart of the consumer society: the squares and avenues full of carriages and horse-drawn buses; strollers, shoppers and shopworkers, singly, in twos and in clusters. A particular kind of urban sociability is portrayed; there is companionship among the small groups of people but an impression of general anonymity in the crisscrossing mass of crowds and vehicles. Pissarro made no attempt to give his composition a central point; the scenes are often cut off on all sides by the borders of the paintings; we are mindful of seeing only a section, or a moment, of a larger world in constant change. Our eyes travel outward and press toward the edges of the painting before circling back into the swirl of movement. In several of the paintings, there is no horizon line; the surface of the street appears to parallel the surface of the painting, flattening the space so that we are aware of the abstract pattern formed by the patches of color and tone which represent crowds and buildings. These cityscapes are differently structured from his more conventional compositions, which focus on a central feature. His compositional innovations pre-figure Kandinsky's and Mondrian's abstractions with open edges and floating shapes.

In the cityscapes, his eye was that of a social observer, too. The lively, unfocussed

* *Color plate on page 300.*

compositions communicate the unpredictable interactions of city life, the lack of a sense of one center, erratic passings of strangers, the accidental meetings of anonymous vehicles—very different from his sense of rural scenes as timeless and cyclical.

The news on the streets of Paris, as Pissarro was painting them, was the Dreyfus case. In November 1897, he wrote Lucien:

> I am sending you a batch of newspapers that will bring you up to date on the Dreyfus case, which is so agitating public opinion. You will realize that the man may well be innocent; at any rate, there are honorable people in high positions who assert that he is innocent. The new brochure of Bernard Lazare, which has just appeared, proves that the document that the General gave the press is a forgery. Lazare's contention is supported by twelve scientists of different nationalities. Isn't it dreadful?

Lazare was one of the few who had become convinced that a court-martial had wrongfully convicted Captain Alfred Dreyfus for passing military secrets to German intelligence. Dreyfus had been sentenced to Devil's Island, as much a victim of pre-judgment as of superficial evidence. Dreyfus was an unpopular officer of cold personality and irritating ambition, and he was Jewish—not from one of the Parisian or Bordeaux families that had long since been assimilated, but from an Alsatian family that had emigrated to France after the cession of Alsace to Germany. To a military hierarchy that was for the most part royalist, Catholic, conservative and anti-Semitic, Dreyfus's "guilt" was self-evident. At the trial, held *in camera*, the military court violated basic legal procedures.

Evidence gradually began to accumulate that implicated another officer and established Dreyfus's innocence. By the end of 1897, the Dreyfus family and other advocates had convinced a small but articulate group that an injustice had been done. The guilt or innocence of Dreyfus became lost in the larger issues of "patriotism," "national honor," "order." If the demands of the "revisionists"—advocates of a retrial—were met, the majority felt that the stability of the army was threatened. The still-vocal royalists, clericals, nationalists of every political hue, allied themselves with the military. Many leaders of the Catholic Church, which had been fighting a gradually losing battle against the anti-clerical trend, now saw a chance to counterattack. The vast majority, including peasants and city workers, were loyal to the army.

Anti-Semitic forces, led by Edouard Drumont's newspaper, *La Libre Parole*, seized upon Dreyfus's Jewish background to lash their followers into a frenzy of anti-Semitic outbursts and riots in many parts of the country, including demands that Jews be deported. Many Jews sought safety in neutral anonymity, and some of the middle and upper classes were even hostile to Dreyfus. Only groups of liberal or radical intellectuals braved retaliation and came out publicly for him. When the "Affaire" first broke in the press, most anarchists were either indifferent or hostile to Dreyfus. As an officer, and wealthy, he was not one with whom they could sympathize. They were embittered by the public indifference when they had been persecuted, and a streak of anti-Semitism also stained the record of some anarchists and other radicals in the nineteenth century. The socialist writer Tabarant was impelled to publish a pamphlet warning socialists against listening to Drumont's "cries of cannibalism." Declaring that "socialism cannot be anti-Semitic," Tabarant denounced as imposters those who

expressed anti-Semitic opinions yet claimed to be socialists. However, voices of reason like Tabarant's were in the minority in radical ranks until the broad implications of the Dreyfus case became clear.

As events built up, Pissarro's involvement deepened. As a Jew, he felt menaced by the passions that surfaced during the tumult over the affair. His sense of justice was outraged. He believed in Dreyfus's innocence; his antennae indicated that the forces of the Right—all the groups he despised as anti-social—were aligned behind the anti-Dreyfusards; he was distressed by the violence of superpatriotic mobs and anti-Semitic ruffians. At one point, he even felt threatened with deportation.

When the obviously guilty officer, Major Esterhazy, was acquitted by a military court, Emile Zola poured out at white heat an article with the inflammatory title,

Boulevard des Italiens, Morning, Sunlight, 1897. (1,000) 28⅞ × 36¼. 73 × 92. National Gallery of Art, Washington, D. C. Chester Dale collection

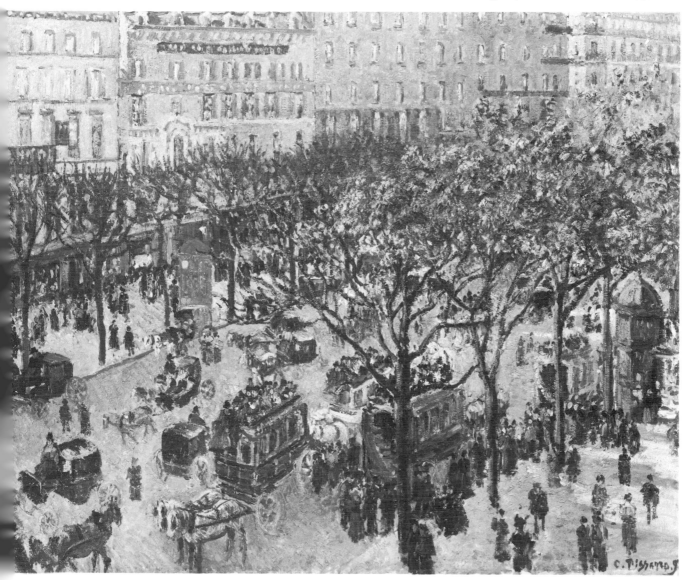

"J'ACCUSE," for Clemenceau's *L'Aurore* of January 13, 1898, arraigning the War Office and leading military figures for their conduct during both trials. His article catalyzed French passions. Anti-Jewish riots broke out in the provinces; even Protestants began to feel insecure.

Like all the Impressionists, Pissarro had been estranged from Zola because of his critical attitude toward Impressionism in the nineties, but his courageous statement prompted an immediate letter of support: "Accept the expression of my admiration for your great courage and the nobility of your character. Your old comrade."

Although he tended to oversimplify the make-up of the forces opposed to a new trial, Pissarro grasped some of the implications of the case: "It is becoming clear now that what we are threatened with is a clerical dictatorship," he wrote Lucien, "a union of the generals with the sprayers of holy water." And then some wishful thinking from a man who wanted only to be left alone to paint: "Will it succeed? I think not. . . . Indignation against the General Staff seems to be growing in the provinces, the socialists are active, it is possible the clouds will lift." Actually, anti-Semitic riots were more ferocious in the provinces than in Paris. "I hope it will not interfere with my work, for I am in fine fettle," he added, and from his window concentrated on painting his vistas of the boulevards of Paris.

But many of the Left now aligned with the Dreyfusards, and some played a leading role in the struggle. Before the belated swing of the radicals in Dreyfus's favor, Julie acutely summed up the attitude of many rank-and-file anarchists. "I was right," she wrote Pissarro, "they are against Zola, it's Pouget [editor of the anarchist *Père Peinard*] who has changed his view. They are furious at him, they say that Zola defends Dreyfus because he is rich, that if he were poor, he wouldn't say a word."

When Zola was indicted for slandering the judges in the Esterhazy trial, Pissarro wrote Lucien, "Naturally everything has come to a stop. . . . I don't think Zola will be acquitted; it would be extraordinary that twelve jurors should see clearly in this matter." Zola was indeed convicted, and Pissarro hastened to write him: "I am among those who believe that you are rendering a proud service to France, your great cry of an honest man has rectified her moral sense, she will be proud one day to have borne you."

His increasing involvement drew a rebuke from Julie. "Doubtless the affaire Zola takes all your time, so you can't write me," she berated him. "That interests you much more than your family."

By the fall of 1898, the case against Dreyfus was collapsing, but anti-Semitic groups continued to prowl through the streets of Paris. Pissarro had a narrow escape but took it in stride. To Lucien he reported: "Yesterday, at about five o'clock, while on my way to Durand-Ruel, I found myself in the middle of a gang of young scamps seconded by ruffians. They shouted: 'Death to the Jews! Down with Zola!' I calmly passed through them and reached the rue Lafitte . . . they had not even taken me for a Jew."

Throughout 1898, his lingering fears were mixed with faith in the victory of reason. "There is a danger, however . . . the bourgeoisie fears like fire the social revolution," he wrote Lucien on January 22, 1899. "It [the bourgeoisie] could still commit the lunacy of throwing itself into the arms of the priesthood; however, it distrusts the

priesthood and people have had enough of militarism, since everyone had to be a soldier. We shall see!"

The Dreyfus affair pitted friend against friend, neighbor against neighbor, and, inevitably, Impressionist against Impressionist. Monet, like Pissarro, quickly came to Zola's support, and courageously signed a public petition on his behalf. (Pissarro and pro-Dreyfus Mary Cassatt, non-citizens, could take no public position.) Radical artist friends— Luce, Signac and Vallotton—and friends among the critics—Duret, Ajalbert, Geffroy and Mirbeau—also supported Dreyfus, as did the symbolist writers and critics Fénéon, Gustave Kahn, Adam and Tailhade.

But Guillaumin, Cézanne, Renoir, Degas and their fellow participant in some of the Impressionist exhibitions, Forain, found themselves in strange alliance with their despised opponent Gérôme on the side of the army. Forain, who had only recently sketched Pissarro's portrait, cofounded and illustrated a violently anti-Semitic magazine. Pissarro wrote Georges:

> Guillaumin thinks that Zola is a humbug and ambitious. He said this in front of Casburne and the employees of Durand-Ruel, all except one of whom shared his opinion. He said that if they had shot Dreyfus after his trial, they wouldn't have had all this mess stirred up by people who furnish no proof. But I replied that they don't have to furnish evidence, these people only have to depend on the evidence which condemned the accused and this evidence is false. Therefore, Zola is right.

Of all those who had participated in the Impressionist exhibitions, Degas became the most irrationally anti-Dreyfus. During the nineties, he had maintained a certain amount of cordial though infrequent contact with Pissarro. As late as January 1898, they met at an exhibition Degas had arranged at Vollard's for a young protégé of his. "Degas was telling me he's a real talent," Pissarro wrote Georges on January 4, 1898, urging him to visit the show.

Degas never spoke to Pissarro again.

Just at this time, when the Dreyfus case was tearing France apart and latent fears and prejudices were surfacing, Degas's misanthropy found outlet in savage anti-Semitism. He blamed the Jews for all of France's troubles. At breakfast he had his maid read aloud to him the more lurid passages of Drumont's wildly anti-Semitic newspaper.

On January 20, Ajalbert brought Degas's extremism into the open. Invoking the spirit of Voltaire, Chateaubriand, Lamartine and Hugo, all of whom had spoken out against tyranny, he assailed the literary and artistic figures who, although pro-Dreyfus, would not speak out publicly. He said he preferred the forthright antagonism of Degas: "When a model in his studio expressed doubt of Dreyfus's guilt, Degas screamed at her, 'You are Jewish . . . you are Jewish. . . .' 'But I am a Protestant. . . .' 'Never mind . . . get dressed and get out!' That is what a pretty girl of Montmartre tells about the old master. That is what I call conviction. I like that! Poor Degas. How stupid intelligent people can become, out of anti-Semitism."

Whatever illusions about Degas Pissarro may have wistfully clung to were dissipated by Ajalbert's article. The next day he sent a copy to Lucien, referring to Degas as *the ferocious anti-Semite.*"

A sad finale to their friendship was noted in Paul Signac's diary of February 11, 1898.

"[Pissarro] tells me that since the anti-Semitic incidents, Degas and Renoir shun him and no longer greet him. What can be taking place in the minds of such intelligent men that leads them to become so stupid?"

Pissarro did not let his feelings affect his judgment of Degas as an artist. Two days after calling him a "ferocious anti-Semite," he declared to Lucien, after seeing an album of his drawings, ". . . what a real master Degas is; his drawings are more beautiful than Ingres's, and, damn it, he is modern!" And two weeks after Pissarro revealed his snub to Signac, he praised Degas's originality: "[Degas] constantly pushes ahead, finding expressiveness in everything around us."

Ambroise Vollard recalled that when Degas and other guests were looking at a painting by Cézanne, Degas remarked, "What nobility there is in it! What a change from Pissarro!"

"Come, Degas, don't be unfair," exclaimed one of his old friends. "You forget that you yourself led me up to Pissarro's *Peasants Planting Cabbages* at Durand-Ruel's and you thought it very good."

"Yes, but that was before the Dreyfus affair," said Degas, laughing at his own outburst.

Thadée Natanson, publisher of *La Revue Blanche*, indicated that Degas's turning on Pissarro was not without penalty. "Intimates of Degas have asserted that, afterward, when he had to pronounce the name of the friend whom he had cherished, it was never without a tremble in his voice."

On Pissarro's death, Degas expressed his regrets to Lucien and gave illness as the excuse for not attending the funeral:

> I was in bed Sunday, dear sir, and I could not go to take the last trip with your poor father. For a long time we did not see each other, but what memories I have of our old comradeship. Tell your family that I sadly shake their hand.

But to his friend Henri Rouart, who had written him about Pissarro's death, Degas gave a different excuse—that he had not learned of the funeral in time—and bared his feelings more intimately:

> All the same, whatever trouble and difficulty I have in writing, I don't want to leave you without an answer, my dear old friend. So he has died, the poor old wandering Jew. He will walk no more, and if one had been warned, one would certainly have walked a little behind him. What has he been thinking since the nasty affair, what did he think of the embarrassment one felt, in spite of oneself, in his company? Did he ever say a word to you? What went on inside that old Israelite head of his? Did he think only of going back to the times when we were pretty nearly unaware of his terrible race? We shall speak of it once more, when I shall see you again.
> Wednesday I went to La Queue and I told them of a strange dream that I had just two days after learning of his death at Tasset's. Just imagine that I met him with a little *more hair* on his head and that, as if I were awake, I had the presence of mind to stop myself just as I was going to say to him: "Why, X——, I thought you were dead." So one keeps one's memory in a dream.

Obviously, Degas was stirred by his former friend's death—and probably was too

embarrassed to attend the funeral, despite his rationalization of being "pretty nearly unaware" of Pissarro's Jewish background. The heritage of "old Moses" in the Café Guerbois was no secret.

Despite the painful emotions of the Dreyfus affair, Pissarro had an active and productive year in 1898; he completed forty-seven oils. His energy, interests and influence seemed to be expanding. After finding him busy at his easel, Signac remarked: "When you compare the old age of this artist, all activity and work, with the senile and dull decay of the old rentiers or retired people, we see what importance art has for us."

In early summer, Camille and Julie took a trip to the village where she was born, Grancey-sur-Ource, in the Burgundy country south of Paris, and visited Dijon and Lyon. In the late summer and fall, Pissarro painted in Rouen; Julie joined him at the end of October, and they made an eight-day excursion to Amsterdam. "The paintings by Hals and the *View of Delft* by Vermeer are masterpieces akin to the work of the Impressionists," he wrote. He set up Georges and Rodo in a studio in Montmartre. In December, he and Julie took an apartment in Paris, at 204 rue de Rivoli, facing the Tuileries, with "a superb view of the park, the Louvre to the left, in the background the houses on the quays behind the trees, to the right the Dome des Invalides, the steeples of Ste. Clotilde behind the solid mass of chestnut trees. It is very beautiful. I shall paint a fine series."

His work was now being exhibited widely. He reported to Lucien in December that he had work in a show in Pittsburgh (at the Carnegie Institute) although he had refused an invitation to serve on the jury, out of principle, and that an exhibition of his paintings was about to open in Moscow. In November, Durand-Ruel showed his work among Impressionist paintings in Berlin and Munich.

The only child left at home was Paul-Emile, who attended the college at Gisors. At fifteen, he idolized his father and wanted only to become a painter like him. Julie did her best to persuade him to stay in the college and learn a trade and earn some money, but the charm of his father's life as an artist was too strong. He left school. When Julie confronted the boy with practical realities: "What are you going to do? You have to think of earning a living!" Camille gently defended his son: "Let him be. He will decide. Let him find his way; it will come by itself."

During the winter of 1898–99, Pissarro painted a series of views of the Tuileries from his hotel window in all weather: misty mornings, sunny afternoons and gray, wet, shining twilights. His exhibition of some twenty paintings at Bernheim Jeune in the spring attracted some favorable although mild comment in the pages of *La Revue Blanche*, where the critic compared him with the more flamboyant Monet, "perpetually the ravished slave of his first impression." Pissarro was called a "reflective visionary."

The following year, Pissarro moved to another apartment in Paris, at 28 Place Dauphine, on the Ile Saint-Louis. From the windows he had a splendid view of the Pont-Neuf* with its busy traffic. To the west, he could see the Louvre down the river. His lifelong effort to capture the elusive quality of light under different conditions was never more successful than in some of these panoramas of the Tuileries, the Louvre

* *Color plate on page 301.*

and the Seine*. He made seventy-one oil paintings of these scenes, slightly altering the perspective and rearranging the pictorial elements as well as observing the changes in the weather. The quantity of the paintings he completed in the last years sometimes works against their quality; they can be merely workmanlike rather than inspired.

Pissarro completed forty-eight oils in 1900, fifty in 1901, fifty-two in 1902. He worked with love and enthusiasm, sometimes under pressure of the knowledge that he had to keep producing because his art was the only source of income for his family. He was still the main support for all of his children and for his two grandchildren, Tommy and Orovida.

His work was interrupted in 1899 when Georges became very ill. Julie nursed him at Eragny until he recovered, but he had had an operation and during a long period of recuperation Julie and Camille had visited him almost daily at the hospital. Although Pissarro was still disturbed by what he considered his son's "chimerical" nature, Georges's illness helped bring them closer together, the reconciliation aided by Georges's settling down to serious work. Twice they painted together. Camille's letters to his son became less querulous, more man-to-man and artist-to-artist; and when Georges remarried, he named his daughter Camille. (She was born a week before the wedding, to Pissarro's distress.)

The major event of 1900 in Paris was the Great Centennial Exposition, a celebration Pissarro termed a "monstrosity" because of its commercialism. The city had been turned into a make-believe world of papier-mâché, plaster, wood and cardboard architecture, exuberant with minarets, spires, domes and towers. Fifty million visitors poured into Paris to celebrate the beginning of the twentieth century.

The Impressionists had a special room in the international exhibition of art at the newly built Grand Palais. Durand-Ruel had chosen the works—of Monet, Sisley, Degas, Renoir and Pissarro—from among those he owned or borrowed. Pissarro had some objections to the commercial atmosphere, but once the exhibition opened, he was pleased to see that it was well done and attracting large numbers of people. Impressionism aroused few hostile reactions now; it was generally accepted by the public, but the old academician and perennial enemy, Gérôme, still objected. On the day of the official inauguration of the exhibition in April, Gérôme, as a member of the Institute, conducted President Loubet around the "Palace of Painting." As they approached the doorway of the Impressionist room, he rushed forward, dramatically barring the entrance and crying, "Go no farther, Monsieur le Président, France is dishonored here!" But his attitude was now archaic. Cézanne's paintings were bringing 5,000 to 6,000 francs; Monet's from 6,000 to 10,000; Sisley's between 6,000 and 10,000 (he had died destitute just a year and a half earlier). Pissarro reported that some of his own pictures, dating from 1874 to 1880, were bringing from 5,000 to 8,500 francs.

In honor of the Exposition, two young artists, Albert Marquet and Henri Matisse, had decorated the Grand Palais with a frieze. Matisse, as a novice trying to find his own way, had sought out Pissarro several years before, visiting him in his hotel room on the rue de Rivoli and watching him paint his gardens of the Tuileries. Matisse later recalled the conversations he had with Pissarro about Impressionism:

"What is an Impressionist?" he asked.

* Color plate on page 301.

"An Impressionist is a painter who never makes the same painting twice," Pissarro responded.

"Who is an example?"

"Sisley. Cézanne is not an Impressionist. He's a classicist—whether he painted bathers, Mont Sainte-Victoire or other landscapes, they are always the same picture. He painted the same picture all his life." (Matisse interpreted this remark to mean that a Cézanne painting represented moments in the artist's sensations and that a Sisley represented a moment of nature.)

Pissarro does not mention Matisse in any of his letters. It is impossible to know whether Pissarro recognized in this young artist who had come to him for advice the genius that made Matisse one of the greatest artists of the twentieth century. It is evident that Matisse recognized Pissarro as a master.

In the summer of 1900, Pissarro spent some time painting at Berneval, a "pretty little watering place an hour's drive from Dieppe." At times he was joined by the English painter Walter Sickert, who later recalled the experience of trying "to recast my painting entirely and to observe color in the shadows." But Pissarro's age was beginning to take its toll; at one point, he became so ill that he could not paint for several weeks. That winter he continued his series of views of the Pont Neuf and the Seine from his apartment in the Place Dauphine.

Dieppe had appealed to him, and the following summer he returned there to paint the church, the market and the harbor. He and the family were enjoying prosperity now: From 1896 to 1901, Pissarro had received a minimum of 32,000 francs a year from Durand-Ruel; in 1900, he had reached a peak income of 44,000 francs.

But at seventy, his prosperity did not dim his burning social conscience and his fierce anti-imperialism. When England ruthlessly fought the Boers, his capacity for indigna tion was still strong. "Unless I am mistaken," he wrote Lucien, "England plays a very dangerous game, whether she wins or loses; at Transvaal [South Africa] she will have played a very bad role which will cost her dearly, both morally and materially. It's a great misfortune for civilization, above all coming from a people who set an example with so many high qualities. Oh, the fools, or rather the wretches!"

He told Lucien that Julie, Cocotte, Rodo and Paul had moved into a large "chalet" at Berneval for the summer, with a pony and carriage at their disposal and room for Julie to invite all her friends and relatives to stay. Occasionally, they visited Camille in Dieppe; in August, he wrote that Alice and Tommy were having a wonderful time there at the annual fair. He was delighted to see his grandson in such high spirits, even though the noise of the merry-go-round and the street organs "playing Gounod at top speed" kept him awake. Georges visited also with his wife and daughter. It was a joy to Pissarro to have his family around him, and he spared no expense to arrange it.

In 1901, his prices were boosted when one of his paintings brought the highest price at the Feydau sale: 10,000 francs. But as fast as he made money, he distributed much of it among his children and grandchildren, a habit that often caused friction with Julie. In 1901, Lucien and Esther wanted to buy a house and asked Camille to lend them 20,000 francs for the down payment. Julie objected to such a large loan and wrote Lucien that his father was "agonizing" over the decision: He really wanted to give Lucien the

Camille, Julie and
grandson Tommy,
c. 1900. Photograph
Pissarro family documents

money but knew that he should not, since his account books showed that his eldest son had already received 40,000 francs from him over the years. She stressed that if Lucien received 60,000 francs from his father, then the other four children would have to receive the same amount or jealousies would develop. She urged him to be more self-reliant and to give up the idea of buying his "shanty." To Camille she argued, in an age of dowries, that "it's Esther's mother who ought to buy this house for them, why must it be you?" She suggested that Lucien's mother-in-law borrow the money through Pissarro's notary, André Teissier, but in the end it was Camille who arranged to borrow the money from Teissier. Lucien and Esther had their house and Julie was furious with both her husband and his notary. But even in his open-hearted generosity, especially toward his eldest son, he often urged Lucien not to be so dependent on him. In 1902, he wrote, ". . . it will be necessary to diminish your allowance this year. You should now be able to lighten my burden a little with your own work."

Actually, Pissarro was not as improvident as he might have been, thanks to Teissier, who had been advising him since the purchase of the Eragny house in 1892. He had become an intimate of the family, a friend of the children, and eventually handled all of Camille's financial affairs. After Teissier convinced him to begin setting aside money for Julie and the children after his death, "and for a dowry for Cocotte," in 1899 Pissarro started investing substantial sums in railroad bonds. The anarchist became a capitalist, *malgré lui*.

In the late spring of 1902, Pissarro visited Georges at Moret, painted a dozen oils there, then returned to Dieppe in the summer to paint another series of views of the harbor, smaller and less industrialized than Rouen. When winter came, he returned to the Place Dauphine and then moved to a hotel on the Quai Voltaire. He had a tremendous burst of creativity in 1903, completing fifty-seven oils and gouaches by the end of September, when his health began to fail.

Irritated by the refusal of Durand-Ruel and Bernheim to pay the prices he wanted for his pictures, he was also distressed by the auctioneers's estimates, set as low as 1,000 francs instead of the much higher prices they had brought a short time before. Encouraged by a substantial sale to a new dealer, F. Gérard, who bought the Dieppe series, Pissarro took the risk of refusing to sell Durand-Ruel any more of his work, hoping to force him to raise his prices. He sent a terse note to the dealer: "I do not accept the prices you offered me in your letter of the 16th," he wrote. "I deeply regret this. Votre tout devoué." And he wrote to another dealer: "I have cut the cable that tied me, thinking it was time to be free." Durand-Ruel stood firm, and Pissarro received no money from him in 1903.

Feeling hard-pressed, impelled to work furiously, though he longed to return to Eragny and "paint some trees," he journeyed to Le Havre with Julie and stayed at the famous Hotel Saint Simeon, where painters had stayed since 1830. Boudin, Corot, Daubigny, Monet and Jongkind had all taken rooms there and painted the harbor. Pissarro complained that "nothing remained of those glorious days" and that the place was now "horribly painted and polished up with rectilinear gravel paths." He felt compelled, he told Lucien, to paint a series that he thought would please his collectors, and completed seventeen paintings of the Le Havre jetty and harbor before leaving in

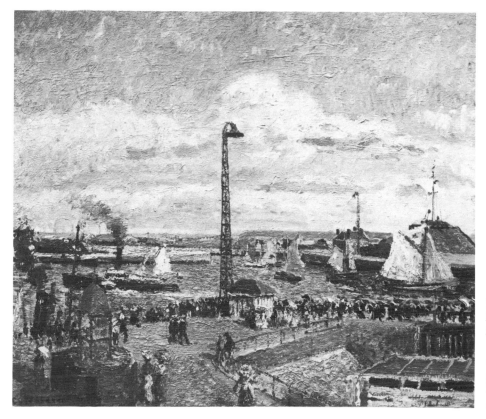

The Pilot's Cove at Le Havre, High Tide, Sunny Afternoon, 1903. (1310) 21¼ × 25½. 54 × 65. Musée des Beaux-Arts, Le Havre

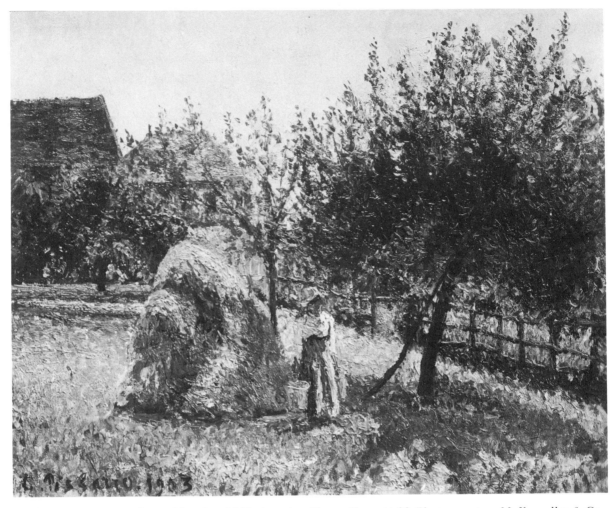

Apple Trees at Eragny, Sunny Morning, 1903. (1275) 21½ × 25⅞. 55 × 66. Photo courtesy M. Knoedler & Co., Inc., New York.

late September, despite his low spirits, his uneasiness about money and the feeling that he was painting only to satisfy his buyers. The paintings, full of fresh breezes, scudding clouds and billowing sails, show an experienced hand, sure and skillful. The compositions are masterfully constructed, utilizing the walls of the jetty to form firm trapezoidal foregrounds which anchor and contain the movement and complexity of the busy scene. They are somewhat conventional paintings. Conscious of the taste of his middle-class collectors in subject and style, Pissarro mustered all his skill, but he was not as enthusiastic about these paintings as he was about his scenes of the Paris streets, rendered more roughly and boldly, or the views of fields around his house at Eragny, so familiar that he could explore changes of season and atmosphere as if they were the changing expressions on the face of a dear friend.

24.

To the Louvre

CASUALLY dropped into the middle of a paragraph in a previously unpublished part of a letter to Lucien of August 29, 1903, is a surprising sentence: "I have been fortunate enough to sell to the Louvre Museum two of my canvases of size 15."

The assumption that Pissarro never received official recognition in his lifetime is therefore mistaken. The Caillebotte bequest of course had brought some of his paintings to the Luxembourg, although they were accepted reluctantly. And the purchase, hardly momentous, of two of his etchings by the Minister of Fine Arts in 1890 indicated at least some official acknowledgement of his stature. But the sale of two paintings directly to the Louvre was a more significant event.

"C'est curieux," as Pissarro might have said, that he was so offhand about this sale. He had once urged that the Louvre be burned to the ground; is it possible that he was embarrassed by the acceptance of his paintings there now? Was he reluctant to admit to recognition from a government and an establishment whose values he had attacked?

All his life, he had been eager for success. Yet he also feared it, for he knew how much he needed to search for an elusive goal. A perfectionist, he was always setting himself challenges. Just as he believed that utopia, "the beautiful dream," might be possible "one day," so was he always seeking a utopia in his art.

Part of his dream was to live to see his sons become artists; now a new generation of talented Pissarros was coming up. He wrote Lucien: "Tell Kidi [Orovida, now ten] that I still haven't had the time to draw her horses, damn! I must draw them from nature; here I have only boats." He had become increasingly involved in the child's budding talent. And later: "I have just received the drawings of Kidi. The large horse is quite remarkable. Rosa Bonheur watch out! She has a feeling for form. I shall write her directly."

By September, his recurrent anxieties were assailing him once again. At small exhibitions in Berlin, Macon, Dieppe and Beauvais, none of his paintings had been sold. His insecurity emerged once more in a letter to Lucien of September 22: "I am waiting for other collectors, but I am hardly besieged by demands! I see that we are far from being understood—quite far—even by our friends."

They were his last written words to Lucien, a sad comment from one whose paintings had just been bought by the Louvre, and doubtless prompted by his break with Durand-Ruel, which had been more costly than he had anticipated. He was also

revealing his habitual tendency to mistrust good fortune. Moreover, he had just recovered, at seventy-three, from an illness which had left him shaken and concerned about the future.

In mid-October, still recuperating, Pissarro caught cold during his move to a new apartment at 1 Boulevard Morland, where he had planned to paint the Seine at Pont d'Austerlitz. Weakened by the previous illness, his condition rapidly grew worse. For three weeks he lay unconscious, with Julie at his bedside day and night. An abscess had developed in his prostate, and blood poisoning had set in. "Dr. Cartier thinks the abscess should be opened as soon as possible, otherwise infection will spread," Lucien wrote Esther. But the homeopath, Dr. Léon Simon, true to his and Pissarro's principles, objected. Although a believer in homeopathy himself, Lucien was disgusted. "In spite of father's condition, *he* (Léon Simon) *has never* even raised the blanket to see the condition of his patient. What a fool!"

Surgery was finally attempted, but the delay was fatal. Pissarro died on November 13, a victim of his convictions. The burial took place on a sunny Sunday afternoon at Père Lachaise cemetery—"a solemn city of winding streets, and of miniature marble temples and mansions of the dead gleaming white from out of a wilderness of foliage and fresh flowers." He was buried in the family plot, next to his father, mother and grandfather. As he would surely have wished, there was no display, no ceremony, no pomp. No one from the Ministry of Fine Arts came, nor would he have wanted anyone. In his death as in his life, there was no pretension.

About fifty of his friends and associates joined Julie and the children on his final journey—Monet, Renoir, Henri Rouart and Raffaelli of the early group of Impressionist exhibitors; the critics Mirbeau, Lecomte, Duret, Fénéon and Mellario; his dealers Joseph Durand-Ruel, Georges and Gaston Bernheim and Ambroise Vollard; his collectors, including the singer J. B. Faure, faithful for thirty years, and Georges Viau. Other fellow artists joined the cortège—Henri Matisse, Théo van Rysselberghe, Emile Bernard, Rodolphe Bresdin, Henri van de Velde and the radical caricaturists Hermann-Paul and Delannoy.

Of the tributes in the press, perhaps Pissarro would have been least uncomfortable with the conclusion to a long eulogy by Frantz Jourdain in *Les Temps Nouveaux:* "He defended the truth, not only in art, but in society."

25.

Retrospect

Renoir once sarcastically referred to Pissarro as "a man who tried everything, even petit point." This superficial judgment of him as an imitator, too easily influenced, has often been repeated. But in fact he formed part of the original impulse toward both Impressionism and neo-Impressionism: his willingness to "try everything" is part of his strength and his contribution.

His career spanned the second half of the nineteenth century, a period bracketed by Courbet's realism and the Fauvism of the turn of the century. He had painted tirelessly, almost daily; his volume of work was prodigious. When Ludovic Rodo compiled a *catalogue raisonné* in 1939, he listed 1,316 oil paintings, 190 gouaches and distempers, 102 pastels and 55 fans. Including those destroyed during the Franco-Prussian War, Pissarro's paintings during his lifetime number more than 2,000 (not including drawings, watercolors and prints). One consequence of the quantity of his work is unevenness. Sometimes the intense response to nature that he depended on did not come and his sensations were not keen enough to transform his modest subject into art. At times he seems to have reacted emotionally and spontaneously to the point of relaxing his technical control. When his paintings are successful, he had found the right balance between willed pictorial construction and empathy with nature, giving his best pictures their intimate serenity.

In the course of his half-century of painting, Pissarro made many stylistic and substantive changes. Intellectually curious and politically radical, he was by nature a seeker, rarely satisfied. The Pissarro of the sixties, the seventies, the eighties and the nineties—each is a "different" Pissarro. In every period of his evolution there are images that fit imperfectly into the pattern of his development. He painted monumental, static groupings of laboring peasants, finished in the studio over many months in the early nineties, during the same period in which he was painting rapid, spontaneous landscapes. His stylistic development followed a winding path full of digressions, but it reveals the steady progress of a great colorist and luminist. A self-portrait of 1898* shows the boldness of his color and his mastery of its use in creating form. Did the young Matisse learn from that blue eyebrow under the blue cap, from the streak of pale vermillion down the side of the eye socket and nose which echoes the brilliant background color? It is a lesson from an old master of color to a young Fauve.

* *Color plate on page 302.*

The variety and quantity of his work, the wide dispersal of his paintings, with many of the greatest in small museums and private collections, make a comprehensive judgment of his art and his contribution difficult. Even the Jeu de Paume has little of his late work, which many consider his best. The work of Monet or Renoir, comparatively consistent, is easier to grasp. Monet developed in what seems to be, at least in hindsight, a straight line. He was relatively free of the intellectual doubts which often hindered Pissarro, a fact which gives Monet's art clarity and drama but makes him seem less complicated as a human being.

Pissarro was committed to the idea of change, of never repeating himself, which kept him alert with the effort to see and respond freshly. Unlike Monet and Renoir, who in their later years often did paint "the same picture over and over again"— beautiful though the water lilies of Monet and the women of Renoir are—Pissarro refused to devote himself to a single subject. Through his last years he painted harbors, cities, markets and churches as well as the trees and rustic scenes that came close to a lifelong obsession. He resisted focussing on the "style" of Impressionism as an end in itself as Monet sometimes did with his "brilliant brushstroke" in ways which were not fully appreciated until the decade of the abstract expressionists. Pissarro shaped style into a tool for portraying the content of the ordinary visible world, which set him apart from the burgeoning impulses toward abstraction among vanguard artists at the beginning of the twentieth century. Influenced by the abstract qualities of Gothic sculpture and Japanese prints, he nevertheless absorbed them into his effort to achieve perfection of composition and harmony of tone in his vision of nature. All paintings are of course creations of the mind, abstractions to a greater or lesser degree, but Pissarro among the Impressionists felt most deeply his responsibility to picture nature realistically as a moral imperative.

Impressionism often has been described as a naturalistic art, springing from the artist's impulse to record his spontaneous reactions. Pissarro's work, varied and complex, shows the inadequacy of this description. He valued his emotional responses and also believed in the necessity of pictorial structure. Although one does not necessarily deny the other, he sometimes saw them as conflicting. He explored neo-Impressionism because of its cerebral nature, as an antidote to too much emotionalism. He criticized Monet and Renoir as "romantic" Impressionists because he felt that they followed their sensations without imposing the discipline demanded by intellectual standards. The contemporary artist he most consistently admired was Degas, that strong-willed artist who insisted on the value of technique, composition and reworking, and was contemptuous of the landscape painters who gave themselves up to their spontaneous responses to nature. Like Degas, he enjoyed etching, a medium that demands forethought, invention and attention to the vocabulary of art. Pissarro never fully resolved his conflict, alternating between the two poles rather than finding a personal synthesis, as Cézanne did. He always appreciated Cézanne and understood his early conflict thoroughly, a conflict which the nineteenth century with its antagonisms among romantics, classicists and realists thoroughly defined and brought into the consciousness of artists.

Because of the directness of his approach, the "unschooled" aspect of his drawing

and his rustic subject matter, Pissarro is often dubbed the most "naïve" and "unsophisticated" of the Impressionists. He was actually, as his letters reveal, a man of great sophistication about art, abreast of the latest movements and always with firm opinions about them, based on personal observation. Although he is quoted as having said that the Louvre should be burned, he of course knew and loved much of the art of the past. He advised Lucien to look at Holbein, French Gothic sculpture and illustration, at Rembrandt and Turner. In his later years, he seemed more willing to admit his ties to the past; as he told Lucien in 1903 during the dispute with Dewhurst over the influences on Impressionism: "David, Ingres, Delacroix, Courbet, Corot. . . . We have today a general concept inherited from our great modern painters, hence we have a tradition of modern art and I am for following this tradition while we inflect it in terms of our individual points of view." That he is called "unsophisticated" is a testament to his will to be so, his desire to rid himself of the encumbrances of intellect and his knowledge of the past.

Pissarro's serenity, his refusal to dramatize and his ability to be "at home" with nature are marks of his personality as a painter. He had a sympathetic insight not only into nature but into the people he painted, and this constitutes the spiritual contribution of his work. A characteristic of Impressionism was the tendency to reject hierarchies of subject matter and the moral values attached to them (one reason the group was so hated by painters like Gérôme). A human being was neither more nor less interesting in visual terms than a tree near by. Both were made up of patches of evanescent color and tone. But Pissarro was concerned with more than the visual aesthetics; he was basically a humanist. He was interested in people, in their most elemental emotions and in portraying commonly recognizable feelings; in his own nature there was no cruelty or rudeness. *Young Girl with a Stick* (one of his favorite paintings) shows his acute sensitivity to an adolescent girl's exact place in the time of her life. It is a beautifully painted harmony of color and tone, and also an insight into the human condition: a statement of a moral ideal as well as an aesthetic one.

Pissarro's anarchist philosophy was often reflected in the unmistakable kinship with humanity which shines in his art. Among the Impressionists, he was the observer of people at work. His politics and his aesthetics converge in his paintings of peasants in the fields. To him, they represented the anarchist ideal, working cooperatively, free of the harsh effects of industrialization, governed only by nature's needs and cycles.

An evangelist for the principles of Impressionism, he refused to become part of the official Paris art world and worked to create an alternate system of exhibitions organized by the artists themselves. He acted as a bellwether, Braquemond's "bowsprit," willing to experiment and risk change. As a leader and teacher, he made an indispensable contribution.

Those qualities as a teacher were acknowledged by Gauguin and by Cézanne, who repeated the lessons Pissarro had taught him all his life. In 1905, Cézanne wrote to Emile Bernard:

The Louvre is the book in which we learn to read. We must not be satisfied, however, with

retaining the beautiful formulas of our illustrious predecessors. Let us go forth to study beautiful nature, let us try to free our minds from them, let us strive to express ourselves according to our personal temperaments. Time and reflection, moreover, modify our vision little by little and at last comprehension comes to us . . . study modifies our vision to such a degree that the anarchist theories of the humble and colossal Pissarro are found to be justified.

Cézanne learned from Pissarro to study nature, to reject formulas of the past and to express his own temperament—the "anarchist theories," as they applied to art, which the older master exemplified. As Cézanne grew older, according to his statement, he understood more profoundly the truth of Pissarro's ideas of thirty years before. As an old man, long after the years at Pontoise, when his genius had achieved a measure of recognition, Cézanne acknowledged his debt. In 1906, his last year, he eulogized his comrades of former years: "Monet and Pissarro were the two great masters, the only ones." In the catalogue of his exhibition in Aix in that last year, he humbly described himself as "Paul Cézanne, pupil of Pissarro."

Gauguin, looking back over his experience, wrote in his notebook near the end of his life:

If the whole of Pissarro's work is examined, we find there, in spite of fluctuations, not only a strong artistic will, never belied, but also an essentially intuitive, pure-bred art. However far one may be from the hayrick or the hillock, in a Pissarro one is able to go out, walk around it, look at it. . . . He looked at everybody, they say! Why not? Everybody looked at him, too, but denied it. He was one of my masters and I do not deny him.

In addition to his significance as a teacher and leader, Pissarro contributed more to the formation of Impressionist techniques and attitudes than he has usually been credited with. He was working closely with Monet in the 1860's and with both Renoir and Monet during the years in which the style took on its recognizable characteristics. Impressionism is not only a style but a way of conceptualizing the world, and Pissarro's concerns were those of the school—light, atmosphere, movement and time. His interest in the passage of time dates from his earliest drawings in Venezuela of people passing each other on the road—the coincidental contact of human beings in the kind of fleeting event which is unique and yet often repeated in a lifetime. To Monet, capturing the passage of time was a maddening challenge—it meant arresting the constantly changing weather, atmosphere and light of the landscape. In the Impressionists's conception of the world—a field of forces in constant motion—no objects pre-existed the condition of movement; they dissolved in the flux of their constantly changing visual appearance. The light, shadow, color and tone were the objects of an Impressionist painting. Monet implied this when he expressed the wish that he had been blind all his life until he suddenly could see and paint what he saw without knowing what it was—a knowledge which would interfere with his simply perceiving a pattern of patches of light, dark and color. Pissarro, though immersed in these ideas, was more interested than any other Impressionist in the passage of time as it affected the lives and feelings of ordinary people. His attitude again alternates between the two poles of a philosophical dichotomy: permanence and flux. Rather than choosing one at

the expense of the other, he clarifies the concepts themselves through his work, like a philosopher-poet. In his paintings of carriages and people passing each other at twilight on a rainy road in Louveciennes (1870), he evokes the puzzling melancholy of the recognition of a distinct moment of time. That moment shimmers for an instant and is gone each time we look at the painting, which paradoxically continues to exist. In his scene of a cluster of houses on a hillside near Pontoise, with the villagers going about their daily rounds, time seems to stand still, giving us a comforting resting place in its usually headlong flight. In the cityscapes and busy Le Havre seascapes, time is rushing by with a sense of urban and industrial urgency. In many of his paintings of peasants working in the fields around Eragny, he suggests the cyclical nature of the seasons and their labor; time revolves in the great circles of the agricultural calendars so beloved by the French Gothic illustrators and by Brueghel. In Pissarro's large figure paintings of the late eighties and nineties, his planters and harvesters, sometimes monumental and static, become symbols of the permanence of this basic human activity in an otherwise changing world.

It is often perceived that Pissarro was consistently interested in firmly structured composition, in itself a visual statement of permanence. His perspectives imply a single, fixed viewpoint; if the world of nature is in flux, the one who views it is stable. Monet, by contrast, in many of his last paintings, dissolves the viewer into the scene; there are few reference points that relate to space on a human scale or gravity as a human experience. But Pissarro constantly reasserts the fact of humankind interacting with the natural world both in his subjects and in his insistence on a logically constructed space seen from a still point.

Pissarro lived during a period when old conventions were disintegrating and new ways of painting and thinking about painting and the world were rapidly emerging. He constantly experimented with these new alternatives; his courage and vision helped to change old assumptions about what was acceptable as art. But once the new way of painting was recognized, Pissarro was not interested in pushing the style itself to its limits, as were Monet and Signac. He took from his experiences only what would further his goals. He remained committed to representing the ambiance of light and color in which he lived and to recreating for the recognition and pleasure of us all the delights and secrets of our human environment.

Epilogue

IN HIS WILL, Pissarro left half of his paintings to Julie, the other half to be divided between Julie and the children in equal shares. To be fair to the younger children, he deducted payments he had made over the years to Lucien, Georges, and Rodo. (In April 1902, when his will was drawn, these sums totaled 52,100, 23,794, and 7,462 francs respectively.)

The estate included 350 of his paintings and fifty of his pastels. He also left nineteen paintings and five watercolors by Cézanne; van Gogh's portrait of Père Tanguy and another van Gogh painting; Manet's *L'Enterrement* and two other paintings, and some pen sketches; Monet's *Effet de Neige;* pastels by Degas, Renoir and Cassatt; and paintings by Morisot, Jongkind, Piette, Guillaumin, Luce, Sisley, Millet and Valadon.

Originally the heirs were to divide the paintings by drawing lots, but Pissarro anticipated the dangers in this. Knowing that hostilities incurred in the "partage" of inheritances had lasted for generations in many a French family, he skirted potential disputes with a codicil that provided for Durand-Ruel and Bernheim to assess the paintings and make the division.

The family assembled for the division at Eragny in June of 1904. Since the children all needed money, they were eager for an immediate auction, but Monet convinced them to await a rise in Pissarro's prices, offered to lend them money, and became an unofficial guardian of Paul-Émile.

For the rest of her life, Julie clung to many of the paintings Camille had given her. She and the children jointly disposed of some of the other artists's work, including some Cézannes. Cassatt attempted to obtain good prices for the Manets and the Degas, but as she was unsuccessful, the family kept the paintings. In 1905, Julie sold a Monet for 5,000 francs and gave the proceeds to Lucien, warning him not to tell the others. Camille would have been amused. From time to time, she permitted groups of her husband's paintings to be sold. In 1906, the family sold fourteen paintings to Bernheim Jeune for 120,000 francs and auctioned 131 watercolors, drawings, and prints, and nine paintings at the Hotel Drouot.

Julie remained in the Eragny house, finding some consolation in her garden, her paintings and her memories. She was "at home" on Thursday afternoons. She

visited her children occasionally, and they her, but her constant criticisms and domineering ways did not make for easy relationships. Cocotte stayed with her mother, reluctantly and unhappily, until her marriage to Alexandre Bonin in 1908. After her daughter left, Julie lived alone until her death, surrounded by paintings and drawings that stirred memories of her life with Camille—paintings of Montmartre in 1863, La Varenne-Saint Hilaire in 1865, a portrait of Minette, Cézanne's sketches of Pissarro and Piette's portrait of Pissarro at his easel, Camille's portraits of Félix and Cocotte, Piette's house at Montfoucault and the road at Louveciennes, landscapes of Pontoise and Osny, the gardens and hillsides of l'Hermitage, views of Bazincourt, and springtime, fall and winter at Eragny.

When Julie heard that even some of Camille's friends now considered his paintings "old-fashioned," she complained vigorously to Lucien. His reply was reassuring: "Don't worry about father, *he will never be forgotten*. Like Corot or Millet, when he does arrive, it will be for good. Father is, among all the Impressionists, the man who represents the nineteenth century most significantly. His philosophy, which you know so well, can be perceived in his art. . . . So don't worry, dear mother, his day will come. It will be a day of glory, I assure you."

After Julie's death, on May 16, 1926, at eighty-seven, her collection of paintings and prints was sold by the children. Monet's prediction that Pissarro's prices would rise proved accurate. A pastel of Julie and the two children at rue des Trois Frères was sold for 22,500 francs, a pastel of Félix for 14,500, a pencil drawing of Cézanne for 6,200, an etching, *Peasant Woman Putting on her Kerchief*, retouched with pastel, for 6,000 francs.

The anarchist tradition in the family did not last long after Pissarro's death. The sons's decline of interest paralleled—or perhaps preceded—the decline of French anarchism itself. The last records of their anarchist activity are in 1906 and 1908, when Georges gave Jean Grave drawings for *Les Temps Nouveaux*, and in 1910, when Rodo made drawings for Grave's paper on beriberi disease.

Lucien continued to illustrate and design books for his Eragny Press, winning the Grand Prix at Milan in 1906; but by World War I, he had to close the Press, although he continued to make wood engravings. From 1914, he concentrated on his paintings, in England or in Provence, in the area of Avignon, most of them sunny landscapes with a delicate, high-keyed palette. Forty-two of his paintings were exhibited at the Galerie Marcel Bernheim in 1924. Although his color differed from his father's and his neo-Impressionist influence lingered much longer, Camille's influence was noticeable. The landscapes, peaceful, lyrical, intimate, were rarely original. His paintings are in museums throughout England and France, but as James Laver has remarked, Lucien was "an Impressionist born a little late." In 1950, the Arts Council staged a retrospective of his Eragny Press books, and in 1963, the Council marked the centenary of his birth with a large exhibition of his paintings. A retrospective was held in London in 1977. He died in 1944, at the age of eighty-one.

Georges, who continued to sign his paintings "Manzana," eventually developed a style very different from his father's: ornamental and decorative, derived from Oriental influences. He used Biblical themes and legends such as *A Thousand and One Nights* as a context for sinuous nudes and brilliantly colored birds. He made tapestries whose gold and silver threads heightened the luxurious coloration. His glassware and furniture also reflected an Oriental taste, but his landscapes were too reminiscent of his father's work. In 1907, Vollard exhibited Manzana's decorative works; Octave Mirbeau wrote the preface for the catalogue. From 1912, Georges had frequent one-man shows, and in 1973, a large exhibition of his work was held at the Galerie Dario Boccaro in Paris. He died in 1961, at ninety.

Ludovic Rodo painted Norman landscapes, as all the sons did, but found his milieu in Montmartre music halls, which he painted for thirty years. Analytical, probing, self-critical, he abandoned painting—possibly his father's shadow loomed

Pissarro Centenary Exhibition, l'Orangerie, Paris, 1930. Photograph © Arch. Phot. Paris/S.P.A.D.E.M.

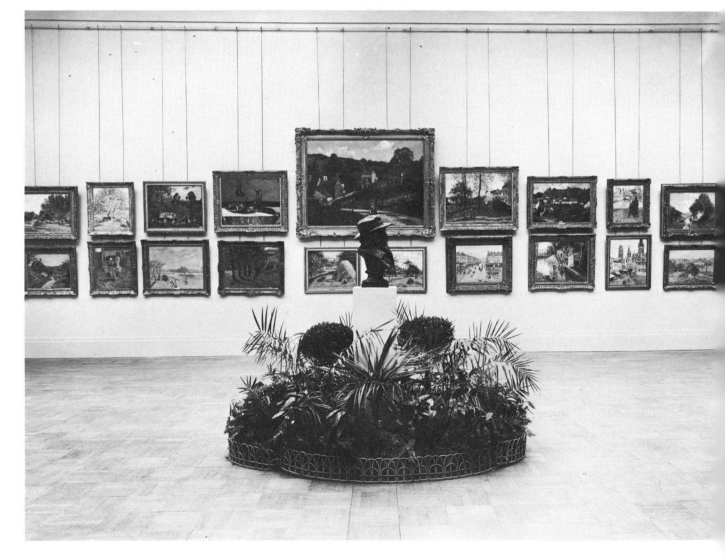

Pissarro Centenary Exhibition, l'Orangerie, Paris, 1930. Photograph © Arch. Phot. Paris/S.P.A.D.E.M.

too large—to become the family archivist, spending years in preparing the definitive *catalogue raisonné* of his father's work. He died in 1952, at seventy-four.

Paul-Emile originally signed his paintings "Paulémile." A landscapist, he worked in his father's tradition, but eventually carried it into the twentieth century, simplifying forms and abstracting the essence of pastoral scenes. His late paintings were expressionist, with distorted forms, thick impasto and rich color. An exhibition of his paintings was held in 1971 at New York's Wally Findlay Gallery. He died in 1972, at the age of eighty-eight.

In 1934, the Marcel Bernheim Gallery in Paris held a group exhibition of "Pissarro et Ses Fils," with an introduction to the catalogue by Gustave Kahn.

The artistic tradition has continued in the third generation of the Pissarro family. Orovida, Lucien's daughter, painting under her first name only, established a reputa-

Julie

tion in England and had frequent exhibitions before her death, in 1968, with work that
was the opposite of her father's: highly decorative, drawing upon authentic Oriental
sources in subject and style.

Claude and Henri Bonin-Pissarro, sons of Cocotte, are part-time painters. Claude is
also a creative graphic designer and illustrator. Félix, the son of Georges, is a painter of
landscapes and flowers. Paul-Emile's sons, Hughes and Yvon, are both painters.
Hughes, who signs his work Isaac Pomié, after Rachel's brother, is an abstractionist
concerned with the interrelationship of order and disorder. Yvon, known as Yvon Vey,
is a graphic artist who does minute figurative drawings with a touch of surrealism.

The year after Pissarro died, Durand-Ruel staged a large retrospective: 178 paint-
ings, drawings and prints, with a preface to the catalogue by Octave Mirbeau, and

Camille

prices ranging from 10,000 to 20,000 francs. Ten years later, in 1914, Manzi and Joyant held a large Pissarro show in Paris. Throughout the years, Durand-Ruel continued to hold Pissarro exhibitions; and retrospectives were held in Zurich and London. Pissarro's first success in London was finally achieved in 1920 at a large exhibition at the Leicester Galleries, where, of the twenty-seven paintings displayed, five were sold for 55,900 francs, which Julie divided equally among the children. In 1928, both the Marcel Bernheim and Durand-Ruel galleries had comprehensive retrospectives.

France finally gave Pissarro full recognition in 1930, the centenary of his birth, when almost 200 oil paintings, gouaches, pastels, watercolors and drawings, as well as seventy-nine etchings he had given the Luxembourg Museum, were exhibited at l'Orangerie of the Louvre Museum. The patrons included the Director of the National Museums, the Director-General of Fine Arts and many officials from the Louvre and

other museums. The Exhibition Committee included some of Pissarro's old friends—Lecomte, Jourdain, Signac, Alexandre, Durand-Ruel, Kahn, Tabarant, Vollard, Luce—and his four sons.

Although Durand-Ruel exhibited 110 of Pissarro's prints in 1907 and the Salon d'Automne held a retrospective of them in 1911, Pissarro's graphic work received little attention until 1923 when Loys Delteil's *catalogue raisonné* appeared. Until then, even print collectors had not realized the extent or unique qualities of his printmaking. In 1927, the Galerie Max Bine had an important exhibition of his etchings.

In 1968, Pissarro's *Jardin des Tuileries, Spring Morning* was sold for $260,000, at that time a world auction record (not necessarily a private sale record, which is frequently higher). In 1975, this was surpassed when his *Afternoon Sunlight, rue de l'Epicerie, Rouen* went at Sotheby's London for $276,000. This figure was doubled in 1978 when Pissarro's *Portrait of Paul Cézanne*, in the von Hirsch collection, was auctioned by Sotheby's for $552,000. Compared with prices paid for paintings by Monet and Renoir, these are "low"; compared with what they were in his lifetime, they are astronomical. A portrait of a peasant woman, painted in the distressed years of 1875–77 when he was selling paintings for 50 to 100 francs, was auctioned in 1977 for $185,000. William Seitz has perhaps best described the incongruity between Pissarro's life and the fate of his paintings today:

> There are moments, in the drawing rooms of affluent collectors, when the Impressionist landscapes on their walls, glowing pink and green within Heydenryk frames and under discreet lights, seem entirely unrelated to the lives, thinking or problems of artists, or of art today. At such times the jewels of the Impressionist movement seem to be a super-chattel, cut off from its origins. Securities literally gilt-edged, they have become bulwarks against inflation and, carefully stationed between Louis XVI tables, velvet divans, Degas bronzes and pre-Colombian idols, they constitute an ultimate stage of what Veblen once called "pecuniary emulation." Could anything be farther from the insecurity, challenge, labor and creative mess of the studio?

NOTES

BIBLIOGRAPHIES

INDEX

Notes

Works frequently cited in the Notes are abbreviated as follows:

Letters—*Camille Pissarro: Letters to His Son Lucien,* edited by John Rewald, reprint ed., Mamaroneck, New York, 1972

PV—Ludovic Rodo Pissarro and Lionello Venturi, *Camille Pissarro: Son Art-Son Oeuvre (catalogue raisonné),* 2 vols., Paris, 1939

Archives—Lionello Venturi, *Les Archives de l'Impressionisme,* 2 vols., New York, 1968 (rep. ed.). Originally pub. by Durand-Ruel, 1939

B-H—Mme. J. Bailly-Herzberg, *Correspondence de Camille Pissarro à son fils Georges dit Manzana et à sa nièce Esther Isaacson, commentaires et étude critique.* Diplôme de troisième cycle, Paris IV Sorbonne, Art et Archéologie, sous la direction de Bernard Dorival

H.I.—John Rewald, *The History of Impressionism,* fourth revised edition, New York, 1973

Charavay catalogue—*Archives de Camille Pissarro,* catalogue of the sale at Hotel Drouot, Nov. 21, 1975, published by Maison Charavay, 3 rue de Furstenberg, Paris 75006

Sources abbreviated:

BN—Bibliothèque Nationale, Paris
Doucet Library—Université de Paris, Bibliothèque d'Art et d'Archéologie (Fondation Jacques Doucet)
Ashmolean—Ashmolean Museum, Oxford
PFA—formerly Pissarro Family Archives. The family's collection of letters has now been dispersed.
PFD—Pissarro Family Documents. (Now at Musée de Pontoise)

Other abbreviations:

P—Camille Pissarro. Other members of Pissarro family are listed by first name followed by P, such as Frédéric P
unpub.—unpublished letter
pr. col.—private collection

All unpublished letters and documents have been translated by the authors; many of the previously published letters and critiques have been newly translated from the original sources.

Chapter 1

For background on St. Thomas, see Matthew D. Bragg, *Journal of Two Months Residence on St. Thomas, Santa Cruz and Porto Rico and of the Voyage Thither and Thence, 1851-52,* ms., New York Public Library; John P. Knox, *A Historical Account of St. Thomas, 1852;* Waldemar Westergaard, *The Danish West Indies, 1671-1917,* New York, 1917: J. Antonio Jarvis, *A Brief History of the Virgin Islands,* Philadelphia, 1939; Patricia S. Murphy, *The Moravian Mission to the African Slaves of the Danish West Indies,* St. Thomas, 1969; Lyonel Paquin, *Historical Sketch of the American West Indies,* St. Thomas, 1970; Gordon K. Lewis, *The Virgin Islands: A Caribbean Lilliput,* Evanston, 1972; files of the newspaper *Sanct Thomas Tidende* in the Public Library, Charlotte Amalie.

For notes on the history of Jews in the Virgin Islands, the following booklets: Isidor Paiewonsky, *Jewish Historical Development in the Virgin Islands, 1665-1959,* and *300 Years of Jewish Culture;* Enid Baa, *Sephardic Communities of the Virgin Islands.* Other sources, helpful but not completely up-to-date in their information, are: John Rewald, "Camille Pissarro in the West Indies," *Gazette des Beaux-Arts,* Oct., 1942; Jules Joëts, "Camille Pissarro et la période inconnue de St. Thomas et de Caracas," *L'Amour de l'Art,* No. 2, 1947. For information on Jews in Bordeaux, Théophile Malvesin, *Histoire des Juifs à Bordeaux,* 1875 (rep. ed., Marseilles, 1976).

Information on Pissarro family history in PFD, and courtesy André Pissarro, Paris, and Prof. Meir Stein, Copenhagen.

Page 18. Trollope: *"Let it be understood . . ."* Anthony Trollope, *The West Indies and the Spanish Main,* N.Y., 1860, p. 6.

18. Petit family's origin in Avignon indicated in Malvezin, *op. cit.,* pp. 189, 193, 207.

18. Rachel Manzana-Pomier's birthplace of St. Thomas listed in marriage contract with Isaac Petit, Jan. 31, 1819, cited in letter from Meir Stein to Ludovic Rodo P, Nov. 6, 1951.

19-20. Information on controversy over Frédéric-Rachel marriage compiled from records in St. Thomas, PFD, State Archives in Copenhagen, and considerable data courtesy Prof. Meir Stein, Copenhagen. Danish customs records listing the arrival of foreigners are on microfilm at the main branch of the Public Library in Charlotte Amalie.

Meadmore and others state that Joseph and Anne Félicité Pissarro arrived in St. Thomas in the early 1800's bringing Frédéric with them and that he grew up there. However, there are no records of them in the Danish customs files. On Feb. 10, 1823, Frédéric was ordered to report by Feb. 25 to the recruiting center in Bordeaux for military service. Obviously he was in France then, not in the V. I. He was rejected because of poor eyesight. He was not licensed to

establish himself in business in the V. I. until Sept. 8, 1825. David Petit's appointment of Frédéric as executor of Isaac Petit's estate is dated July 12, 1824, and is in the Rijsarkivet (State Archives), Copenhagen. Isaac Petit had previously been married to Rachel Manzana-Pomier's sister Esther.

20. For spelling of family name (on Camille's birth certificate, the name was spelled "Pizarro"), see R. Ray, "Pissarro aux Iles Vierges," *Beaux-Arts,* May 1, 1936; letter of Ludovic Rodo P in *Beaux-Arts,* June 26, 1936; and letter from Lucien P to Ludovic Rodo P, March 17, 1936, courtesy John Bensusan-Butt.

20. Frédéric P: *"It is inevitable. . ."* unpub., Jan. 31, 1857, pr. col., N. Y.

21. Meryon: *"large house in the middle . . .";* *". . . acquired some idea . . ."* unpub. ms., Charles Meryon, *Notes particulières relatives aux événements de ma vie,* Cabinet des Estampes, BN.

21. Savary: *"Draw from nature . . ."* and Savary's successors: Tabarant, *Pissarro,* p. 9.

22. Thackeray on Ecole des Beaux-Arts: from his *The Paris Sketchbook,* by Mr. Titmarsh (William Makepeace Thackeray), London and N. Y., 1852, v. I, p. 70.

Chapter 2

The basic source of information on Pissarro's two years in Venezuela is Alfredo Boulton, *Camille Pissarro en Venezuela* (text in Spanish, French and English), Caracas, 1966. A chronology of his wanderings there, based on the dates of his drawings, is in the family documents compiled by Ludovic Rodo Pissarro. We are indebted to Mr. Boulton for providing considerable additional information and photographs of drawings. Also helpful are *Pissarro in Venezuela,* catalogue of exhibition at the Center for Inter-American Relations, N. Y., 1968, with text by Alfredo Boulton and Preface by Stanton L. Catlin; John Rewald, *Camille Pissarro in Venezuela,* illustrated with 52 Venezuela drawings by Pissarro, catalogue of sale by Hammer Galleries, N. Y., 1964; Jules Joëts, "Camille Pissarro et la période inconnue de St. Thomas et de Caracas," *Amour de l'Art,* 1947, no. 2; Michel N. Benisovich and James Dallett, "Camille Pissarro and Fritz Melbye in Venezuela," *Apollo,* July, 1966, v. 84, no. 53; Alfredo Boulton, "Camille Pissarro in Venezuela," *The Connoisseur,* May, 1975. A useful contemporary description of La Guaira and Caracas is in *Sixteen Years in the West Indies,* by Lt. Col. Henry Capadose, 2 v., London, 1845.

Page 25. P: *"and so . . . I quit . . ."* Tabarant, *Pissarro,* p. 47.

25. Frédéric P: *"on the pretext . . ."* unpub. to Rachel, Dec. 31, 1856, pr. col., N. Y.

26. Melbye: *"With great anxiety . . ."* partly unpub., April 29, 1852, pr. col., N. Y.

28. P: *"I was in St. Thomas . . ."* letter to Eugène Murer, 1878, in Tabarant, *Pissarro,* p. 47.

28. P: *"The fact that I can't find . . ."* *Letters,* May 31, 1887.

28. P: *"The country doesn't suit me . . ."* *Ibid.,* June 17, 1899.

30. Cézanne: *"Pissarro had the good luck . . ."* Joachim Gasquet, *Cézanne,* Paris, 1921, p. 90.

31. Palacio: *"I can still see you . . ."* unpub., May 27, 1856, formerly PFA.

31. Melbye: *"I have no masters . . ."* unpub., Jan. 1, 1856, pr. col., N. Y.

Pissarro's sketches of his friends on the Galipán excursion are reproduced in Alfredo Boulton, "Camille Pissarro in Venezuela," *The Connoisseur*, May, 1975.

32. P: *"as a young man . . ." Letters,* Aug. 12, 1898.

32. The studio drawing: Identification of the figures in this drawing has always been contradictory, with Melbye, P and the youth confused with each other in various accounts. Positive identification was made possible by the recent discovery by two elderly sisters of San Estabán, Venezuela, in an old writing desk of a notebook of their grandfather's,

Miguel A. Romer, with notes and sketches. Among the sketches were two by Romer of P and Melbye, labeled and dated Jan. 16, 1853, and two more finished sketches of P by Melbye—the first portraits of P we have. Two drawings in Copenhagen's Staatens Museum can also now be identified as portraits of the young Pissarro—one probably a self-portrait, the other by Melbye. For account of the sisters' discovery, see Alfredo Boulton, "Un error sobre Camille Pissarro," *El Nacionál*, Caracas, Nov. 12, 1972.

33.-34. Letters of Alfred P: col. André Pissarro, Paris.

Chapter 3

Page 35. Emma P: *"We want very much . . ."* unpub., Oct. 2, 1855, pr. col., N. Y.

36. Louis Napoléon: *"I want to be . . ."* A. des Cilleuls, *Histoire de l'administration parisienne au XIXe siècle,* Paris, 1900, II, 208, quoted in David H. Pinkney, *Napoleon III and the Rebuilding of Paris,* Princeton, 1958, p. 3.

37. P: *"a rotten society . . .", Letters,* Dec. 28, 1883.

37. Delacroix: *"That is beauty . . ."* Delacroix, *Journal,* v. II., pp. 167-8.

38. Gautier: *"For the very small sums . . ."* Edmond and Jules de Goncourt, *Journal,* 9 v., Paris, 1935-1936, v. 1, p. 130.

39. Duranty: "visions of Greece . . ." His "Notes sur l'Art," *Réalisme,* July 10, 1856, quoted in Rewald, *H.I.,* pp. 28-9.

38-39. For details of the Fine Arts exhibition at the World's Fair of 1855, see *Guide dans le Palais de l'Industrie et des Beaux-Arts,* Paris, 1855; Minda de Gunzburg, *La Peinture Française et la Critique à l'Exposition Universelle de 1855,* unpub. Mémoire de Maîtrise, Ecole du Louvre, Paris, 1970; A. Tabarant, *La Vie Artistique au Temps de Baudelaire,* Paris, 1963.

39. Nieuwerkerke: *"This is the painting of democrats . . ."* quoted in M. de Fels, *La Vie de Claude Monet,* p. 59, quoted in Rewald, *H.I.,* p. 18.

39. For description of Corot's paintings at the 1855 exhibition, see Alfred Robaut, *L'Oeuvre de Corot, catalogue raisonné et illustré, précédé de l'Histoire de Corot et de ses oeuvres,* par Etienne Moreau-Nelaton, 4 vols. and 2 supplements, Paris, 1905.

40. Critic on Corot is DuCamp, quoted in deGunzburg, p. 252.

40. P: *"Old Corot . . ." Letters,* July 26, 1893.

40. Ingres: *"To form yourself in beauty . . ."* Elizabeth Holt, *A Documentary History of Art: From the Classicists to the Impressionists,* Garden City, N. Y., 1965, v. III, p. 36.

41. Champfleury: *"M. Courbet is seditious . . ."* Letter to George Sand, Sept., 1855, quoted in Linda Nochlin, *Realism and Tradition in Art, 1848-1900,* Englewood Cliffs, N. J., 1966, p. 35.

42. Corot: *"I have only a little flute . . ." Letters,* Feb. 23, 1894.

42. Corot: *"A man ought to embrace . . ."* Robaut, *l'Oeuvre de Corot, op. cit.,* v. I, p. 115, quoting Corot's notebook 65.

42. Corot: *"If we have really been touched . . ."* E. Moreau-Nelaton, *Corot raconté par lui-meme,* Paris, 1924, 2 vols., v. I, pp. 105-106.

42. Corot: *"Go into the country . . ."* Jules Laprade, "Camille Pissarro après des documents inédits," *Beaux-Arts,* April 17, 24, 1936.

Chapter 4

Page 43. Frédéric: *"I am upset . . ."* unpub., March 1, 1857, pr. col., N. Y.

43. P's addresses: These are based on envelopes addressed to P (pr. col., N. Y.) and a calendar drawn by P's son Ludovic Rodo, PFD.

43. P's studying with Picot, Dagnan, Lehmann, cited in Georges Lecomte, "Camille Pissarro," *Les Hommes d'Aujourd'hui,* 1890, v. 8, no. 366.

44. Melbye: *"I hope to God . . ."* unpub., Jan. 1, 1856, pr. col., N. Y.

44. Self-portrait: although the subject is undoubtedly P, possibly it was painted by Fritz Melbye. Ludovic Rodo P referred to it as the "so-called" self-portrait, according to John Rewald, who is including it in the forthcoming supplement to the *catalogue raisonné,* but with a question mark. However, the angle seems to indicate that P was looking into a mirror when the portrait was painted.

44. P: Jacobsen relationship as early as 1856 confirmed in unpub. letter of E. C. Meyer to P, March 13, 1856, pr. col., N. Y.

44. Melbye: "The romantic moderate . . .", unpub., Jan. 1, 1856, pr. col., N. Y.

When Melbye left for New York, he carried with him a bundle of drawings and sketches they both had made in Venezuela. It is a mystery why he had with him so much of Pissarro's Venezuelan work. Melbye left them in New York when his unquenched thirst for motifs carried him to China, where he died in 1869. Miraculously, the drawings turned up a century later when the home of industrialist Cyrus McCormick was torn down. Quite possibly Melbye had left them with Ramón Paez, son of the Venezuelan general and a friend from Melbye's Venezuelan days, and at some point they passed from Paez to McCormick. They are now back in Venezuela. When the Hammer Gallery sold them, they were bought by the Banco Central de Venezuela.

45. Frédéric P: *"I understand . . ."* unpub., March 1, 1857, pr. col., N. Y.

46. Alfred P: *"I have received . . ."* unpub., April 30, 1857, col. André Pissarro, Paris.

47. Frédéric P: *"It may not be wise . . ."* unpub., Aug. 27, 1857, pr. col., N. Y.

47. de Marton: *"crossing fields . . ."* unpub., Aug. 27, 1858, Musée de Pontoise.

47. Frédéric P's unpublished letters to Rachel, Aug. 31, 1858 and Sept. 30, 1858, pr. col., N. Y.

92. Signac: *"They marvelled at . . ." D'Eugène Delacroix au néo-impressionisme,* Intro. and notes by Françoise Cachin, Paris, 1904, p. 80.

92. P: *"I do not think . . ."* Dewhurst, *op. cit.,* p. 61.

92. Monet's acknowledgment of Turner's influence is discussed in W. C. Seitz, *Claude Monet,* N. Y., 1960, p. 24.

92. *Penge Station, Upper Norwood:* The painting is misnamed. The station is actually Lordship Lane station, according to Martin Reid in "Camille Pissarro: Three Paintings of London of 1871," *Burlington Magazine,* CXIX, no. 889, April 1977, p. 253, and letters to *The Times,* May 14, 1977.

92. Constable: *"The landscape painter . . ."* quoted in A. C. Ritchie, *Masters of British Painting,* 1800-1950, N. Y., 1956, p. 24.

92. P: *"Monet and I . . ."* Dewhurst, *op. cit.,* p. 31.

93. Piette: *"You do not dare . . ."* unpub., Jan. 18, 1871, pr. col., N. Y.

93. For description of the Royal Academy's procedure in rejecting artists, see *The Athenaeum,* April 22, 1871.

93. *"By C. Pissarro are two . . ."* "International Exhibition, the French Pictures," *Art Journal,* Sept. 1, 1871, pp. 217-218.

93. John Ruskin: *"to neglect outline . . ." The Athenaeum,* no. 2258, Feb. 4, 1871.

94. Béliard: *"All your friends . . ."* Feb. 22, 1871, formerly PFA, pub. in part in Rewald, *H.I.,* p. 258.

94. Piette: *"If I did not fear . . ."* and "We send our kisses . . ." unpub., n.d., probably Dec. 1870 and Jan. 1871, pr. col., N. Y.

94. Béliard: *"I have no news . . ."* unpub. part of letter, Feb. 22, 1871.

94. Retrou: *"I regret to tell you . . ."* unpub., March 16, 1871, formerly PFA.

95. Félicie Estruc: unpub., March 10, 1871, pr. col., N. Y.

95. Mme. Ollivon: *"You are asking . . ."* partly unpub., March 27, 1871, pr. col., N. Y.

96. Monet: *"a package . . ."* Wildenstein, *Monet,* I, letter 61, p. 428, dated Dec. 21, 1871.

96. Letters of Louis Estruc to P, Feb. 16, 1871 and June 16, 1871, pr. col., N. Y.

96. Monet: *"You have doubtless . . ."* May 27, 1871, letter no. 56, Wildenstein, *Monet,* v. I, p. 427.

96. Piette: *"The ferocity . . ."* unpub., Jan. 30, 1872, pr. col., N. Y.

96. P: *"these letters show . . ." Letters,* May 2, 1887.

96. Piette: *"so no one will come . . ."* unpub., March 1, 1871, pr. col., N. Y.

97. P: *"I am here for only . . ."* "L'Impressionisme et ses précurseurs", *Bulletin des Expositions,* Galerie d'Art Braun, Paris, 1931-32, v. IV.

98. P: *"England, like France . . ." Letters,* June 13, 1883.

98. Durand-Ruel's second purchase of two paintings is recorded in his Stock book, nos. 806 and 805. One of them,

Snow Effect, was sold to the singer J. P. Faure on April 15, 1872, for 350 francs. See *The Impressionists in London,* Arts Council of Great Britain, 1973, footnote 7, p. 77.

101. Rachel: *"Go to London . . ."* Oct. 10, 1870, unpub., pr. col., N. Y.

101. Marriage witnesses: letter of Alexandre Prévost to P, June 5, 1871, formerly PFA. The marriage record is entry no. 29 in the Croydon Register.

101. Lecomte description of Louveciennes destruction in his *Camille Pissarro,* p. 58. It is possible though doubtful that not all of the lost paintings were destroyed by the Prussians. Almost a quarter-century later, P learned from Durand-Ruel that "200" of his pre-war paintings had been acquired by the composer Joncière—either from someone who had stolen them from his house at Louveciennes, or from a "fence." Mme. Jonciere was none other than the "gracious and alluring" Jenny Berliner who had so charmed him in the fifties. Although he was skeptical that there were as many as 200, he wondered how he could recover them. His skepticism was justified; today barely 100 paintings exist for the entire period of 1854-1870. Possibly the paintings were forgeries or Durand-Ruel was mistaken in the artist. There is no record of the outcome of this supposed reappearance of some of the missing paintings. Rumors in the twenties that some of them were appearing in Berlin galleries were never confirmed.

101. P: *"Work is a marvellous regulator . . ."* P-V, I, p. 70.

102. Durand-Ruel payments to P: These and all subsequent records of payments to P, and other Impressionists are in the Durand-Ruel archives. Figures for payments by Durand-Ruel are based on the entries in the Durand-Ruel account books. The receipts at Durand-Ruel signed by Pissarro often total only about half of the payments that Durand-Ruel recorded (with the puzzling exception of the years 1881 and 1885, when Pissarro's signed receipts totalled more than the Durand-Ruel entries). The discrepancy can be accounted for in part by the fact that Durand-Ruel paid some of Pissarro's bills directly and often sent Lucien's "allowance" directly. No receipts from Pissarro would exist for these payments. In any case, Pissarro's handwritten jottings, in the family documents, of payments he received from Durand-Ruel in 1896, 1897, and 1898 coincide with Durand-Ruel's records of payments and total considerably more than Durand-Ruel's signed receipts.

102. Piette: *"see old Pissarro . . ."* unpub., Oct. 8, 1872, pr. col., N. Y.

102. Guillemet: *"I have done . . ."* Sept. 3, 1872, formerly PFA.

102. Claims lawyer letter, from A. Lagier, Aug. 4, 1871, unpub., pr. col., N. Y.

102. Piette: *"you are certainly going . . ."* unpub., Jan. 30, 1872, pr. col., N. Y.

Chapter 9

Page 103. P: "The critics are devouring" "L'Impressionisme et quelques précurseurs", *Bulletin des Expositions,* Braun et Cie, 1932, p. 8.

103. Piette: *"if a certain nucleus . . ."* unpub., n.d., pr. col., N. Y.

103. Monet: *"You will tell me . . ."* Wildenstein, *Monet,* v. I, letter no. 64, p. 428.

105. Geffroy: *"One step more . . ."* Geffroy, "Histoire de l'Impressionisme," *La vie artistique,* 3rd series, Paris, 1894.

105. Piette: *"Here are my impressions . . ."* n.d., probably spring, 1873, pr. col., N. Y.

105. Piette: *"Bold and big-hearted . . ."* unpub., June 16, 1873, pr. col., N. Y.

106. P's charter: *"The purpose of the society . . ."* The steps

leading to the final draft of the Society's charter are discussed in Rewald, *H.I.*, ch. IX. The principal articles were published in *La Renaissance Littéraire et Artistique*, Jan. 25, 1874, p. 20. Contents of the charter are in Rewald, *Histoire de l'Impressionisme*, Paris, 1955, pp. 358-364; Georges Rivière, *Renoir et ses Amis*, Paris, 1921; and Castagnary's article on the exhibition is in *Le Siècle*, April 29, 1874.

106. Monet on the charter, see Wildenstein, *Monet*, v. I, letter no. 69, p. 429, Sept. 12, 1873.

106. Piette: "*It seems to me . . .*" unpub., n.d., pr. col., N. Y.

106. Rivière: "*Pissarro especially . . .*" Rivière, *Renoir et ses Amis*, p. 46.

106. "Société Anonyme, etc." For the artists's different ideas about a title, see Vollard, *Renoir*, p. 64.

106. Monet: "*It's harder than . . .*" Wildenstein, *Monet*, v. I, letters nos. 73, 74, 75 (Nov. 30, Dec. 5, Dec. 11).

106. Morisot's letter of acceptance: Charavay catalogue, no. 136.

106. Corot: "*My dear Antoine . . .*" Louis Vauxcelles, "Une après-midi chez Claude Monet," *L'Art et les Artistes*, Dec. 1905, quoted in Geffroy, *Monet*, p. 259.

107. The first Hoschedé auction: In the painting that sold for 950 francs, a factory was prominent. Was the purchaser who paid such a high price a factory owner? or collector attracted by the verticals of the smokestacks against the sky? Pissarro was not the first to paint the industrial scene, but he did pioneer in using this motif consistently.

107. P: "*The reactions . . .*" Feb. 1, 1874, Tabarant, *Pissarro*, p. 28

107. P: "*You are right . . .*" Feb. 2, 1874, P-V, vol. 1, p. 24.

107. A letter P wrote to Duret Feb. 13, 1874 (Louvre, Cabinet des Dessins), asking for 200 francs promised him because he was not able to "obtain from Durand enough money to take care of my daily needs" has been cited to show that Durand-Ruel was unable to support the artists in early 1874; but the facts contravene this, at least in P's case. Even more than his friends, he had had periods of painful poverty, and the possibility of their recurrence always hovered. Hence, like some of his friends, he had a tendency to project the past or the future of want into the present. In this case, as he mentioned in his letter, he had not been able

to work for a month as his children had been ill—and possibly the weather hindered him. The uncertainty always present with an artist not yet established made his statement to Duret understandable, though exaggerated.

107. Duret: "*I maintain my opinion . . .*" Dec. 6, 1873, P-V, I, p. 36.

108. Duret: "*You have still . . .*" P-V, I, pp. 33-34. Duret's agreement with Manet's decision: Duret, *Manet and the French Impressionists*, p. 124.

108. P: "*I well remember . . .*" *Letters*, May 9, 1883.

109. For list of Impressionist paintings exhibited, see Venturi, *Archives*, II, pp. 255-256.

109. Zola's description from *L'Oeuvre* quoted in Rewald, *H.I.*, p. 328.

109. Castagnary's critique of the Exhibition and of P: *Le Siècle*, April 29, 1874.

109. Some of the sarcastic comments of the critics are in *Bulletin de la vie artistique*, April 15, 1924, pp. 172-173.

109., 110., 112. Louis Leroy's comments on the Impressionist show: *Le Charivari*, April 25, 1874. Other reviews: *L'Opinion Nationale*, April 22; *Paris Journal*, April 29; *La Presse*, April 29; *Le Rappel*, April 20; *La Renaissance*, May 3; *La République Française*, April 25.

112. Castagnary: "*Pissarro is sober . . .*" *Le Siècle*, April 29, 1874.

112. P: on cabbage, letter to Octave Mirbeau, quoted in Kunstler, *Landscapes*, p. 34.

112. P: "*Our exhibition goes well . . .*" May 5, 1874, *Bulletin des Expositions*, Braun et Cie., 1932, "Les Impressionistes et Quelques Précurseurs."

112. For financial results of the exhibition, see Rewald, *Histoire de l'Impressionisme*, pp. 365-367.

112. Père Martin's comment on P is quoted in Tabarant, *Pissarro*, p. 49.

113. Durand-Ruel: "*Guilty of having presented . . .*" Venturi, *Archives*, v. II, pp. 197-198.

114. Duret: "*Personally I would ask . . .*" June 2, 1876, formerly PFA.

114. Société meeting: Procès-Verbal of the Société, pr. col., N. Y.

Chapter 10

Cézanne was in the Pontoise region with P from 1872 to early 1874, again for shorter stays in 1875, 1876, 1877, 1879 and 1881, and for his last visit in 1882.

The account of the ten years that P spent at Pontoise, and his relationship with Cézanne at this time has been constructed from a variety of sources. Most important: *Paul Cézanne: Letters*, ed. by John Rewald, London, 1941; letters from Lucien P to Paul-Emile P and to Ludovic Rodo P in the Ashmolean Museum. No letters from P to Cézanne seem to have survived. Kathleen Adler's 1969 M.A. Thesis for the Courtauld Institute, *Aspects of Camille Pissarro, 1871-1873*, contains interesting information and speculation. Also valuable were Theodore Reff, "Pissarro's Portrait of Cézanne," *Burlington Magazine*, v. 109, November 1967, pp. 627-630; John Rewald, "Gachet's Unknown Gems Emerge," *Art News*, March, 1952, p. 17; Paul Gachet, *Cézanne à Auvers*, Paris, 1952. Richard Brettell has done specialized research on Pissarro and Pontoise for his Ph.D. dissertation, Yale University; he was generous with his discoveries in letters and conversations. The most useful books for the study of Cézanne's life and relationship to Pissarro were Emile Bernard, *Souvenirs sur Paul Cézanne et lettres inédites*, Paris, 1907; Joachim Gasquet, *Cézanne*, Paris, 1921; Gerstle Mack, *Paul Cézanne*, New York, 1935; John Rewald, *The Ordeal of Paul*

Cézanne, London, 1950; Jack Lindsay, *Cézanne, His Life and Art,* Greenwich, Conn., 1969. For the study of Cézanne's style and its relationship to that of Pissarro, the following were valuable: Roger E. Fry, *Cézanne, a Study of His Development,* New York, 1927; Liliane Guerry, *Cézanne et l'expression de l'espace,* Paris, 1950; Kurt Badt, *The Art of Cézanne,* Berkeley and Los Angeles, 1965; Theodore Reff, "Cézanne's Constructive Stroke," *Art Quarterly,* Autumn, 1963; and the *catalogue raisonné* of Cézanne's work, Lionello Venturi, *Cézanne, son art, son oeuvre,* Paris, 1936.

Page 115. Cézanne: *"As to old Pissarro . . ."* Cézanne's interview with Jules Borely in 1902, rep. in "Cézanne à Aix," *L'Art Vivant,* Année 2, 1926.

115. Cézanne's stay at 45 rue de Jussieu described in Lindsay, *Cézanne—His Life and Art,* p. 149.

116. Lucien P: *"He wore a vizored cap . . ."* Letter to Paul-Emile P, probably 1912, Ashmolean.

Lucien P's recollections of Cézanne during this period are in his letters to Paul-Emile P and to Ludovic Rodo P at Ashmolean Museum and collection of John Bensusan-Butt. Some are quoted in part in Meadmore, *Lucien Pissarro.*

116. Cézanne: *"I take up . . ."* Rewald, *Cézanne: Letters,* Dec. 11, 1872.

116. Anecdotes about Cézanne from Mack, *Paul Cézanne,* p. 176.

117. Guillemet: *"I heard your mother . . ."* Sept. 3, 1872, formerly PFA.

117. P: *"My wife asks . . ."* Zola correspondence, BN, v. XIV, no. 48/49.

117. P: *"Béliard is still . . ."* Sept. 3, 1872, in John Rewald, *Paul Cézanne,* N. Y., 1948, p. 93.

117. Cézanne: *"Don't you find . . ."* Ambroise Vollard, *Paul Cézanne,* Paris, 1924, p. 22.

118. Cézanne: *"If Pissarro had continued . . ."* Rewald, *Pissarro,* p. 72.

118. Cézanne: *"You are perfectly right . . ."* Oct. 23, 1866, Rewald, *Cézanne: Letters,* p. 115.

118. The Pissarro painting Cézanne copied is PV 123, *Louveciennes,* 1871. For a reproduction of Cézanne's copy, see *La Renaissance,* May-June, 1936 and XX, 1937, pp. 53-57.

118. Cézanne: *"Only then, when I knew Pissarro . . ."* Bernard, *Souvenirs sur Paul Cézanne et Lettres Inédites,* p. 43.

118. Rivière: *"Doctor Gachet cut . . ."* *Renoir et ses Amis, op. cit.,* p. 215.

119. P: *"Would you kindly . . ."* n.d., Paul Gachet, *Lettres Impressionistes au Docteur Gachet,* Paris, 1957, pp. 38-39.

119. Gachet's aid to Cézanne, see Rewald, *Cézanne: Letters,* footnote, p. 137.

120. The "signatures" of the artists and their printmaking activities are described in *Cézanne à Auvers,* by Dr. Gachet's son Paul Gachet, Paris, 1952.

120. For discussion of Victor Vignon's work, see Claude Roger-Marx's prefaces to catalogues of Vignon exhibitions at Galerie Bernheim-Jeune, Paris, 1894, and Galerie Jacques Callot, Paris, 1927.

121. Piette: *"Has our friend Cézanne . . ."* unpub., n.d., probably winter, 1875-1876, pr. col., N. Y.

121. Julie P: *"Georges and Camille . . ."* unpub., 1875?, Musée de Pontoise.

122. Piette: *"Keep trying to find patrons . . ."* unpub., n.d., pr. col., N. Y.

123. Cézanne: *"Just imagine . . ."* Lindsay, *Cezanne,* p. 168.

123. Pissarro's portrait of Cézanne also discussed by Theodore Reff in *Burlington Magazine,* v. 109, no. 776, Nov. 1967, pp. 627-630.

124. Piette: *"we share your anxiety . . ."* unpub., 1874, pr. col., N. Y.

125. Piette: *"And you, my poor old . . ."* unpub., n.d., pr. col., N. Y.

125. Piette: *"Kiss the children . . ."* unpub., Dec. 1872, pr. col., N. Y.

126. Guillaumin: *"Your letters are truly . . ."* Rewald, *Pissarro,* p. 29.

126. Guillaumin: *"I am very anxious . . ."* Ibid., p. 30.

127. P: *"I haven't worked so badly . . ."* Tabarant, *Pissarro,* p. 31.

128. Lucien P: *"It was then . . ."* letter to Paul-Emile P, Ashmolean.

128. Peasant: *"M. Pissarro, in working . . ."* quoted in Lindsay, *Cézanne,* p. 153.

128. Cézanne: *"I, too, have been . . ."* Gasquet, *Cézanne,* p. 90.

128. Cézanne: *"How I should like . . ."* Rewald, *Cézanne: Letters,* no. XXXI, pp. 96-98.

128. P: *"he was influenced by me . . ."* Letters, Nov. 22, 1895.

130. P to Duret: *"There is nothing more cold . . ."* May 2, 1873, P-V, I., p. 111, entry no. 225.

Chapter 11

Page 131. P: *"What hard times . . ."* 1878, Doucet Library.

131. Piette: *"I have had some details . . ."* undated fragment, unpub., pr. col., N.Y.

131. Meyer: *"I absolutely need you . . ."* these and subsequent letters to P, Sept. 3, Oct. 5, and Nov. 30, 1874, Doucet Library.

132. Duret: *"Monet, rue le Peletier . . ."* n.d., formerly PFA.

132. Wolff: *"lunatics . . . a frightening spectacle . . ."* quoted in Geffroy, *Monet,* v. I, ch. XIV.

135. Cézanne: *"If I dared . . ."* July 6, 1876, Rewald, *Cézanne: Letters,* pp. 102-103.

136. Murer's restaurant described in Tabarant, *Pissarro,* p.

39. For sketch of Murer, see de Fels, *Monet,* p. 128.

136. For Tanguy description: Cecilia Waern, *Atlantic Monthly,* April 1892. Most informative picture of Tanguy is in Mack, *Cézanne,* pp. 219-226, and "Julien Tanguy," *Mercure de France,* Dec. 16, 1908.

136. P's debt to Tanguy: Invoice covering 1874-1880, PFD.

137. P: *"I sent Petit . . ."* 1877, Doucet Library. P's letters to Murer are excerpted in Tabarant's biography of P, pp. 40-53, but very poorly translated. The French edition, Paris, 1924, is more reliable. Many of the original letters are in the Doucet Library.

137. Lottery described in Tabarant, *Pissarro,* pp. 44-45.

138. Piette: *"Don't lose courage . . ."* and *"I learned with plea-sure . . ."* unpub., n.d., probably spring, 1877, pr. col., N. Y.

138. Piette: *"I believe that with your skill . . ."* and *"Can your idea of pottery . . ."* Ibid. Twelve of P's tiles are reproduced in the catalogue of the auction, *Tableaux Modernes*, at the Palais Galeria, Dec. 8, 1973, nos. 66 to 77. The catalogue was published by Laurin-Guilloux-Buffetand, 1 rue de Lille, 75007, Paris. Catalogue courtesy Mme. J. Bailly-Herzberg.

138. Caillebotte: *"The exhibition . . ."* Jan. 2, 1877, Rewald, *H.I.*, p. 390.

139. Piette: *"The gentlemen . . ."* n.d., probably March 1877, pr. col., N. Y.

140. Rivière: *"Nowhere, at any time . . ."* L'Impressioniste, no. 1, April 6, 1877.

140. Cézanne: *"It appears . . ."* Rewald, *Cézanne: Letters*, pp. 106-107.

140. Monet's difficulties: see Wildenstein, *Monet*, v. I, letters nos. 79, 102, 108, 111. Figures for his sales and expendi-tures, *Ibid.*, pp. 71, 74, 80, 87.

140. P: *"What a joke . . ."* Letters, June 5, 1887.

140. Renoir: *"I've got to find . . ."* Tabarant, *Pissarro*, p. 34.

141. Renoir anecdote on competition: *Ibid.*, p. 40.

141. P: *"I have received . . ."* n.d., probably 1878, Doucet Library.

141. P: *"art is a matter . . ."* Ibid.

141. P: *"For a whole week now . . ."* Tabarant, *Pissarro*, pp. 42-43.

142. Moore: *"No one was kinder . . ."* George Moore, *Reminis-cences of the French Impressionists*, Dublin, 1906 (Tower Press Booklets, no. 3), pp. 39-41.

142. Description of P: Félicien Champsaur, *Revue Moderne et Naturaliste*, Oct. 1880, p. 438.

142. Piette: *"Yesterday . . . I was approached . . ."* unpub., Jan. 24, 1877, pr. col., N. Y.

143. P: *"It is no longer bearable . . ."* 1878, Doucet Library.

143. Julie: *"Two weeks have gone by . . ."* unpub., Sept. 9, 1878, Musée de Pontoise.

144. P: *"Your mother believes . . ."* Letters, Feb. 5, 1886.

144. Arosa brothers purchases are reported in Philippe Burty's preface to Catalogue of Gustave Arosa sale, *Catalogue de Tableaux Modernes*, Feb. 25, 1978.

144. P: *"Duret came . . ."* n.d., Doucet Library.

144. P: *"So you see . . ."* Tabarant, *Pissarro*, p. 49.

144-145. P: *"Let Guillaumin reflect. . ."* Pascal Fortuny, "Pis-sarro et Guillaumin," *Bulletin de la vie artistique*, July 15, 1922, pp. 329-331, and *"I hope that friend Guillaumin . . ."* Sept. 1878, Doucet Library.

145. Sisley: *"I believe we must . . ."* March 14, 1879, Duret, "Quelques Lettres de Monet et de Sisley,". *Revue Blanche*, March 15, 1899, quoted in Rewald, *H.I.*, p. 421.

145. Renoir: *"There are in Paris . . ."* March 1881, Venturi, *Archives*, vol. I, p. 115.

145. Monet: *"I am giving up . . ."* March 10, 1879, Wilden-stein, *Monet*, vol. I, letter no. 155, p. 436.

146. Caillebotte: *"If you could see . . ."* Geffroy, *Monet*, vol. II, ch. 7, quoted in Rewald, *H.I.* p. 423.

147. P: *"Renoir has . . ."* May 27, 1879, Tabarant, *Pissarro*, p. 50.

147. Degas: *"Do you invite these people . . ."* letter from Caille-botte to P, Jan. 24, 1881, quoted in Rewald, *H.I.*, pp. 447-448.

148. Caillebotte: *"If there is anyone . . ."* Ibid.

Chapter 12

Gauguin's Impressionist period has not yet been examined carefully. Most of the literature about him concerns itself seriously only with his life and work from the Pont-Aven period onward, when he developed his theories of synthetism and after his friendship with Pissarro had cooled. The most valuable sources for research in the period of the Pissarro/Gauguin relationship, between 1874 and 1885, were the originals of the fifty-one letters from Gauguin to Pissarro in the PFA, excerpts from which were published in the Charavay catalogue. The complete letters of Paul Gauguin, now in preparation by John Rewald, Merete Bodelsen and Bengt Danielsson, will include these letters. Other important sources for Gauguin's early period are the Paris-Pontoise and Osny sections of the *catalogue raisonné* by George Wildenstein, *Gauguin*, Paris, 1964; "Gauguin, ses origines et sa formation artistique," by Ursula F. Marks-Vandenbroucke, *Gazette des Beaux-Arts*, January-April 1956; "Gauguin the Collec-tor," by Merete Bodelsen, *Burlington Magazine*, vol. 112, September 1970, pp. 590ff; "Gauguin et le Danemark," by Haavard Rostrup, *Gazette des Beaux-Arts*, January-April 1956. Robert Goldwater's *Paul Gauguin*, New York, H. N. Abrams, 1957, includes particularly precise biographical information on the early period. Sources for a broad picture of Gauguin's personality and work include: *Lettres de Gauguin à sa femme et à ses amis*, ed. Maurice Malingue, Paris, 1946; *Lettres de Paul Gauguin à Emile Bernard 1888-1891*, Geneva, 1954; *The Letters of Paul Gauguin to George Daniel de Monfried*, New York, 1922; *Paul Gauguin, letters to Ambroise Vollard and Andre Fontainas*, ed. by John Rewald, San Francisco, 1943; Charles Chasse, *Gauguin et le groupe de Pont-Aven, documents inédites*, Paris, 1921. The most interesting books about Gauguin include Charles Morice, *Paul Gauguin*, Paris, 1919; Maurice Denis, *Théories, 1890-1910, du symbolisme et de Gauguin vers un nouvel ordre classique*, Paris, 1920; John Rewald, *Gauguin*, New York, 1938; Pola Gauguin, *My Father, Paul Gauguin*, tr. from the Norwegian by Arthur C. Chater, New York,

1937; René Huyghe, *Le carnet de Paul Gauguin,* Paris, 1952; Bengt Danielsson, *Gauguin in the South Seas,* tr. by Reginald Spink, London, 1965; Wayne Anderson, *Gauguin's Paradise Lost,* New York, 1971. Also invaluable are the journals and notebooks of Gauguin himself, published in many forms and editions.

Page 149. Gauguin: *"You can ask Pissarro . . ."* letter no. LXXIV, Malinque, *Lettres de Gauguin à sa femme et ses amis.*
149. Gauguin: *"An employee . . ."* Charavay catalogue, letter no. 27.
150. Gauguin: *"I accept with pleasure . . ." Ibid.,* letter no. 31.
151. Monet: *"I am an Impressionist . . ."* to Taboureaux in *La Vie Moderne,* June 12, 1880.
151. Huysmans: *"Even though these paintings . . ."* from "L'Exposition des Indépendants en 1881," *L'Art Moderne,* Paris, 1902, p. 267.
151. P: *"For a while he considered . . ." Letters,* May 9, 1883.
152. Huysmans: *"M. Pissarro may now be classed . . ."* "L'Exposition des Indépendants en 1881," *op. cit.,* p. 261.
152. Gauguin-Cézanne clash. See John Rewald, *Gauguin,* p. 8.
152. Gauguin: *"Has M. Cézanne found . . ."* 1881, quoted in part in Charavay catalogue, letter no. 35; also quoted in Rewald, *H.I.,* p. 458.

155. P: *"I'm not rolling . . ."* May 13, 1882, Louvre, Cabinet des Dessins.
155. P: *"Durand-Ruel, one of the . . ."* Jan. 4, 1881, Charavay catalogue, letter no. 140.
155. P: *"I have always thought . . ."* June 1874, Louvre, Cabinet des Dessins.
156. P: *"I shall never do . . ." Letters,* Nov. 20, 1883.
157. Gauguin: *"I think it's time . . ."* Charavay catalogue, letter no. 43, probably 1882.
157. P: *"They are all throwing Millet . . ."* March 12, 1882, Louvre, Cabinet des Dessins.
158. P: *"This canvas . . ." Letters,* May 16, 1887.
158. Huysmans: *"M. Pissarro is entirely rid . . ."* PV, I, p. 49.
158. Degas: *"Millet? His Sower . . ."* quoted in Kunstler, *Landscapes and Cities,* p. 18.
158. Degas: *"these angels . . ."* quoted in Rewald, *Camille Pissarro au Musée du Louvre.*
160. P: *"I am very much disturbed . . ." Letters,* May 4, 1883.
160. P: *"As for my large canvases . . ." Ibid.,* July 22, 1883.

Chapter 13

The most complete discussion of Pissarro's printmaking in the early eighties is Michel Melot's lengthy article, "La Pratique d'un Artiste: Pissarro Graveur en 1880," in *Histoire et Critique des Arts,* June 1977. Among recent useful studies of Pissarro's prints are *L'estampe Impressioniste,* catalogue of exhibition at the Bibliothèque Nationale, with discussion and notes by Michel Melot, Paris, 1974; Jean Leymarie et Michel Melot, *Les Gravures des Impressionistes: Manet, Pissarro, Renoir, Cézanne, Sisley,* with *catalogue raissoné* by Michel Melot, Paris, 1971; and an especially valuable study of Pissarro's methods, Barbara S. Shapiro, *Camille Pissarro, The Impressionist Printmaker,* catalogue of exhibition at Museum of Fine Arts, Boston, 1973. Other discussions include: Comte de Soissons, "The Etchings of Camille Pissarro," *The Studio,* October 1903, pp. 59-60; A. M. Hind, "Camille Pissarro's graphische Arbeiten und Lucien Pissarro's Holzschnitte nach seines Vaters Zeichnungen," *Die graphischen Kunste,* 1908, v. 31, pp. 34-48; Ludovic-Rodo Pissarro, "The etched and lithographed work of Camille Pissarro," *Print Collector's Quarterly,* v. LX, 1922, pp. 274-301; Claude Roger-Marx, *Camille Pissarro, Graveur,* Paris, 1929; Jean Cailac, "The Prints of Camille Pissarro," *Print Collector's Quarterly,* v. XIX, 1932, pp. 75-86; Georges Denoinville, "Les eaux-fortes originales de Camille Pissarro," *Byblis,* 1928, Année 7, fasc. no. 27, pp. 76-80; E. T. Chase, *The Etchings of the French Impressionists and Their Contemporaries,* Paris, 1946. Pissarro's monotypes are discussed in Barbara S. Shapiro and Michel Melot, "Les Monotypes de Camille, Pissarro," *Nouvelles de l'Estampe,* no. 19, January-February 1975.

161. Degas: *"Pissarro is delightful . . ."* Marcel Guérin, ed., *Degas Letters,* Oxford, 1947, letter no. 28, p. 51.
162. Degas: *"No art was ever . . ."* George Moore, "Degas: The Painter of Modern Life," *Magazine of Art,* 1890, p. 423.
162. P: *"without doubt the greatest . . ." Letters,* May 9, 1883.
162. Degas: *"There have been three . . ."* Theodore Reff, *Degas: The Artist's Mind,* N. Y., 1976, p. 39.
162. P: *"I prize them . . ." Letters,* Jan. 22, 1884.
162. Degas on Proudhon: see Daniel Halévy, *My Friend Degas,* ed. Mina Curtiss, Middletown, Conn., 1964, pp. 41-43.
162. Degas: *"I was, or seemed to be . . ."* Oct. 26, 1890, quoted in Jean Leymarie, *French Painting: The Nineteenth Century,* tr. James Emmons, Geneva-Cleveland, 1962, p. 197.

164. P: *"Degas was very fine . . ." Letters,* May 13, 1891.
164. P: *"I continue to jog . . ." Letters,* Jan. 1883.
165. Cassatt's efforts to sell P's paintings: Nancy Hale, *Mary Cassatt,* N. Y., 1975, p. 104.
165. Cassatt: *"Pissarro could have taught . . ."* A. Segard, *Mary Cassatt,* Paris, 1913, p. 45.
166. Degas: *"I compliment you . . ."* Guérin, *Degas: Lettres,* 1880, no. 16, pp. 57-58.
169. Desboutin: *"Degas . . . is no longer"* Desboutin to de Nittis, July 15, 1876, quoted in Melot, *L'Estampe Impressioniste,* p. 78.
169. Degas: *"The aquatint . . ."* Guérin, *Degas: Lettres,* no. 28, p. 51.

169. Degas: *"Miss Cassatt is making . . ."* Ibid., no. 35, 1880.
170. Degas: *"It is opening . . ."* Ibid., no. 33, 1880.
174. For interesting comparison of the different states of

Twilight with Haystacks and *Woman Emptying a Wheelbarrow*, see Barbara S. Shapiro, *Camille Pissarro, The Impressionist Printmaker.*

Chapter 14

Page 176. P: *"I will calmly . . ."* Letters, May 4, 1883.
176. Gauguin: *"Yesterday Degas . . ."* Charavay catalogue, letter no. 34.
176. Gauguin: *"I received your extraordinary . . ."* Ibid., letter no. 37.
177. Gauguin: *"In each epoque . . ."* Ibid., letter no. 55, probably 1883.
177. Gauguin: *"If you put a Cézanne . . ."* Ibid., letter no. 51, 1883.
178. Gauguin: *"If you abandon . . ."* Ibid., letter no. 38.
178. Renoir: *"Let it be understood . . .",* Venturi, *Archives,* vol. I, p. 121.
178. Renoir: *"To exhibit with Pissarro . . ."* Ibid., p. 122.
178. P: *"Do you know, my dear Monet . . ."* n.d., Eragny, 1884-1886, entry #240, *Autographes & Documents Divers,* catalogue of auction at Drouot Rive Gauche, June 15, 1977, pub. by Maison Charavay.
180. Renoir: *"Unfortunately I have one goal . . ."* Venturi, *Archives,* vol. I, p. 122.
180. Clarétie: *"group was composed . . ."* article in *Le Temps,* rep. in *La Vie à Paris,* Paris, 1882.
180. Gauguin: *"Decidedly, a mania . . ."* Charavay catalogue, letter no. 46, probably 1882.

181. Gauguin: *"The love of my art . . ."* Ibid., letter no. 56, October 11, 1883.
182. P: *"Monet's show . . ."* Letters, March 15, 1883.
182. Monet: *"I have difficulty now . . ."* Venturi, *Archives,* vol. I, p. 264.
182. Renoir: *"Around 1883 . . ."* Vollard, *La Vie et L'Oeuvre de Pierre-Auguste Renoir,* p. 135.
182. P: *"Renoir has a superb show . . ."* Letters, April 10, 1883.
182. P: *"I am discontented . . ."* Ibid., April 18, 1883.
183. P's comments on his show to Lucien: *Ibid.,* May 2, May 4, May 9, and May 13, 1883, and footnote p. 32.
184. Durand-Ruel: *"We should try . . ."* Letters, footnote p. 33.
184. P: *"What would it be . . ."* Venturi, *Archives,* vol. II, p. 13.
184. London critics's reactions: Cooper, *Courtauld Collection,* pp. 23-24.
184. P: *"Remember that I . . ."* Letters, Nov. 20, 1883.
184. P's letters to Monet: Geffroy, *Monet,* pp. 162-163.
184. P: *"After having made . . ."* unpub. part of letter to Lucien, June 13, 1883, Ashmolean.
184. Durand-Ruel: *"You cannot imagine . . ."* June 1883, quoted in *Letters,* p. 59.

Chapter 15

Page 185. P: *"Gauguin disturbs me . . ."* Letters, Oct. 31, 1883.
185. P: *"I spoke to you . . ."* Sept. 28, 1882, Louvre, Cabinet des Dessins.
186. Lucien P: *"If you have . . ."* April 13, 1883, collection John Bensusan-Butt.
186. P: *"for your enjoyment . . ."* Letters, March 15, 1883.
186. P: *"try to find . . ."* unpub., June 13, 1883, Ashmolean. On P's vacillation, see also unpub. of April 10, May 7, and May 28, all at Ashmolean.
186. P: *"I think I will . . ."* Letters, July 5, 1883.
186. P: *"He is going . . ."* Ibid., Oct. 31, 1883.
187. P: *"I received a visit . . ."* Nov. 2, 1883, Doucet Library.
188. P: *"I have just concluded . . ."* Letters, Nov. 20, 1883.

188. P: *"I don't believe . . ."* Aug. 8, 1883, Doucet Library.
190. P: *"Results of my trip . . ."* Letters, Dec. 1, 1883.
191. P: *"That crazy Gauguin . . ."* Letters, Nov. 20, 1883.
191. Gauguin: *"Today my trip . . ."* Charavay catalogue, letter no. 67, 1884.
191. Gauguin: *"Your handwriting shows . . ."* 1884, formerly PFA. This section of letter also reproduced in J. Bailly-Herzberg, "Les Autographes," *Connaissance des Arts,* July 1978.
194. Gauguin: *"I wanted, in spite . . ."* quoted in Robert Goldwater, *Paul Gauguin,* N. Y., 1928, p. 22.
195. P's comments on possible places to live: *Letters,* June 4, 1883; Dec. 14, 1883; Feb. 10, 1884.

Chapter 16

Paintings in Pissarro home listed in P's estate, PFD, and also described in Charles Kunstler, "La Maison d'Eragny," *ABC Artistique et Littéraire,* March 1929. Georges's and Felix's paintings: Meadmore, *Lucien Pissarro,* p. 69.

Page 197. P: *"The children . . ."* Letters, April 10, 1883.
197. Walks in garden: unpub. letter to Georges P, May 13, 1890, B-H.
198. P: *"Titi works with me . . ."* unpub., Dec. 17, 1889, B-H.
198. P: *"Titi always draws . . ."* unpub., Jan. 31, 1890, B-H.
199. P: *"He thought the geese . . ."* unpub. part of letter, April 8, 1891, Ashmolean.
199. P: *"She passes her hand . . ."* unpub., n.d., pr. col., N. Y.

199. P: *"One after another . . ."* Letters, Dec. 20, 1890.
199. P: *"Guingasse and Cocotte . . ."* Ibid., Nov. 25, 1891.
202. P: *"Neither Titi nor Georges . . ."* Ibid., May 26, 1894.
202. P: *"Wind, rain, and not a penny . . ."* Ibid., July 10, 1887.
202. P: *"So few things are necessary . . ."* unpub., July 7, 1889, B-H.
202. P: *"You, who are . . ."* Letters, Aug. 25, 1885.
202. P: *"It was not . . ."* Ibid., June 18, 1891.

202. Julie P: *"Titi and Georges . . ."* unpub., n.d., Ashmolean.

204. Guignol described in Charles Kunstler, *Paulémile Pissarro*, Paris, 1928, pp. 11-14, and his *Pissarro: Cities and Landscapes*, Geneva, n.d., pp. 42-43.

205. P: *"We will not send . . ."* unpub., Sept. 29, 1889, B-H.

205. Paul-Emile P: Monet *"seemed like a god . . ."* Kunstler, *Paulémile Pissarro*, p. 16.

206. P: *"Take 8 globules . . ."* unpub., Dec. 25, 1883, Ashmolean.

206. P: *"And above all . . ."* unpub., Nov. 7, 1889, B-H.

206. P: *"But the homeopaths . . ."* unpub., Aug. 18, 1899, Ashmolean.

207. Julie P: *"I find time . . ."* unpub., n.d., Ashmolean.

207. Lucien P: *"your son who . . ."* unpub., July, 1892, Ashmolean.

207. Incident of servant girl: See unpub. letters of Julie to an unknown man (name deleted) and to "Ma chère demoiselle Marie," Musée de Pontoise. They are undated but late 1893 or 1894, since she refers in the letter to the recent death of Georges's wife. The man may have been Murer, since she refers to his sister as "Melle Marie." Murer's sister was always addressed in this manner. The Murers lived in Pontoise, about 30 miles from Eragny.

207. Julie P: *"Always remember . . ."* unpub., n.d., Musée de Pontoise.

207. Julie P: *"if sometimes . . ."* *Ibid.*

207. P: *"The country is magnificent . . ."* *Letters,* April 29, 1897.

208. P: *"I fear above all . . ."* unpub., Nov. 14, 1890, Ashmolean.

208. P: *"I really want . . ."* *Letters,* Oct. 20, 1895.

208. Pissarro's rolling studio: Kunstler, *Paulémile Pissarro*, p. 19.

Chapter 17

The most useful sources for Pissarro and neo-Impressionism were Paul Signac, *D'Eugène Delacroix au Néo-Impressionisme,* Paris, 1964; John Rewald, "Excerpts from the unpublished diaries of Paul Signac," *Gazette des Beaux-Arts,* Juillet-Septembre, 1949; Gustave Kahn, "Au temps du pointillism," *Mercure de France,* April, 1924, pp. 5-23; J. B. Rosensaft, "Le Néo-Impressionisme de Camille Pissarro," *L'Oeil,* no. 223, pp. 52-57, February, 1974; Ogden N. Rood, *Students' Textbook of Color and Modern Chromatics,* New York, 1908 (first edition, 1879); Gustave Geffroy's review of the 1890 exhibition of Pissarro's pointillist paintings reprinted in *La vie artistique,* (1e série), Paris, 1892; Robert Herbert, *Neo-Impressionism,* catalogue of an exhibition at the Guggenheim Museum, New York, 1968; John Rewald, *Post-Impressionism from van Gogh to Gauguin,* New York, 1961; Henri Dorra and John Rewald, *Seurat,* Paris, 1959; John Russell, *Georges Seurat,* New York, 1965; *The Neo-Impressionists,* ed. Jean Sutter, Greenwich, Conn., 1970.

Page 209. P: *"I do not believe . . ."* *Letters,* Dec. 6, 1886.

209. Hayet: *"Very dreamy . . ."* *Ibid.,* Jan. 7, 1891.

209. Roger-Marx: *"without awkwardness . . ."* *Le Voltaire,* May 16, 1884.

212. Seurat: *"I paint my method . . ."* Herbert, *Neo-Impressionism,* p. 15.

212. P: *"romantic extravagance . . ."* *Letters,* July 30, 1886.

212. P: *"To make art . . ."* unpub., 1878, Doucet Library.

213. Impressionist exhibition in New York described in H. Huth, "Impressionism Comes to America," *Gazette des Beaux-Arts,* series 6, vol. 29, April 1946.

213. Martí: *"with fraternal tenderness . . ."* *La Nación,* Buenos Aires, Aug. 17, 1886, tr. Elinor Randal, courtesy Ben Goldstein.

213. *New York Herald* criticism, April 10, 1886.

213. P: *"I told Degas . . ."* *Letters,* March 1886.

213. P: *"Yesterday I had . . ."* *Ibid.,* March 1886.

214. Moore: *"in the hope of giving . . ."* George Moore, *Confessions of a Young Man,* pp. 28-29.

214. Moore: *"The pictures were hung low . . ."* George Moore, *Modern Painting,* London, 1893, p. 89.

214. Adam: *"As much by the . . ."* quoted in Herbert, *Neo-Impressionism,* p. 16.

216. Signac: *"if these painters . . ."* Signac, *D'Eugène Delacroix au Néo-Impressionisme,* ch. III.

216. Fénéon: *"As for the new recruits . . ."* *L'Art Moderne,* Sept. 19, 1886.

216. Signac: *"I left the Exhibition . . ."* 1887, Charavay catalogue, letter no. 171.

219. Signac: *"By their new technique . . ."* "Impressionistes et Révolutionnaires," La Rérolte, June 13, 1891.

219. P: *"The hostility . . ."* *Letters,* Nov. 1886.

219.-220. P: *"we saw Guillaumin . . ."* *Ibid.,* Dec. 3, 1886; *"Zandomeneghi looks at me . . ."* *Ibid.,* Dec. 6, 1886; *"Durand says that Monet . . ."* *Ibid.,* Jan. 9, 1887; *"Who the devil . . .",* *Ibid.,* Dec. 30, 1886.

220. P: of Monet: *"sloppy,"* *Letters,* Jan. 14, 1887; Gauguin—*"a maker of odds,"* *Ibid.,* Jan. 23, 1887; Renoir—*"unintelligible"* *Ibid.,* May 14, 1887; Sisley—*"commonplace,"* *Ibid.,* May 15, 1887; *"I am sure that Monet . . ."* *Ibid.,* Jan. 21, 1887; *"I met Sisley . . ."* *Ibid.,* Feb. 4, 1887; *"My canvases were scattered . . ."* *Ibid.,* May 15, 1887; *"They will try anything . . ."* *Ibid.,* May 20, 1887.

220. Gauguin: *"You see what's happened . . ."* n.d., Doucet Library. Quoted in "Gauguin, ses origines et sa formation artistique," by Ursula F. Marks-Vandenbroucke, *Gazette des Beaux-Arts,* Jan.-April, 1956, 6th période, vol. XLVII.

220. P: [Gauguin's] *"sharp practice"* *Letters,* May 7, 1891.

220. Gauguin: *"Hang Pissarro . . ."* *Lettres de Paul Gauguin à Emile Bernard, 1889-1891,* Geneva, 1954, Letter XIX, 1890.

221. P: *"I do not criticize . . ."* *Letters,* April 20, 1891.

221. P: *"It is a sign . . ."* *Ibid.,* May 13, 1891.

222. P: *"I asked our friend . . ."* quoted in *Letters,* note i, p. 389.

222. P: *"Gauguin is leaving . . ."* *Ibid.,* March 30, 1891.

222. Signac: *"It is so good . . ."* 1886, Charavay catalogue, letter no. 164.

222. Signac: *"There will be a fight . . ."* 1886, *Ibid.,* letter no. 165.

222. Signac: *"Are you working . . ."* summer, 1886, *Ibid.,* letter no. 166.

222. P: *"if your son . . ."* Venturi, *Archives,* vol. II, p. 24.

223.-224. P: *"I am here in Paris . . ."* Letters, Dec. 6, 1886. *"At the moment . . ."* Jan. 21, 1887. *"The more I think of it . . ."* Jan. 25, 1887. *"Monet plays . . ."* Jan. 9, 1887.

224. *"Don't be afraid . . ."* unpub., Jan. 31, 1887, Ashmolean.

224. P: *"Here we are again . . ."* Letters, Feb. 27, 1887.

225. P: *"I am working hard . . ."* Venturi, *Archives,* vol. II, p. 23.

225. P: *"I have been yoked . . ."* Letters, Dec. 30, 1886.

225. Signac: *"In this regard . . ."* Charavay catalogue, letter no. 176.

225. Monet: *"at the last meeting . . ."* Ibid., letter no. 122.

225. P: *"I am very glad . . ."* Letters, May 14, 1887.

225. Desclozeau: *"Camille Pissarro has painted . . ."* L'Estafette, May 15, 1887.

Chapter 18

For general accounts of anarchism in France in the late nineteenth century, see F. Dubois, *Le Péril Anarchiste,* Paris and London, 1894; George Woodcock, *Anarchism,* Cleveland and New York, 1962; and Jean Maitron, *Le mouvement anarchiste en France,* 2 vols., Paris, 1975. Of Jean Grave's works, especially relevant are his *La Société Mourante et l'Anarchie,* Paris, 1893, (English version published in San Francisco, 1899) and *Le Mouvement Libertaire sous la Troisième République.* Proudhon's *Oeuvres Complètes,* 26 vols., were published in Paris, 1867-1870. Especially see his *De la Justice dans la Revolution et dans l'Eglise,* 3 vols., Paris, 1858 and his *Du Principe de l'Art et de sa Destination Sociale,* 1865. A brief anthology of Proudhon's writings is *Selected Writings of P.-J. Proudhon,* ed. by Stewart Edwards, Garden City, 1969. Of Kropotkin's works, the most pertinent are *Anarchist Communism: Its Basis and Principles,* London, 1887, 1905; *Paroles d'un Revolté,* Paris, 1855; *Fields, Factories, and Workshops,* London, 1899; *The Conquest of Bread, London, 1906.* A short anthology of his work is *Kropotkin: Selections from his Writings,* ed. by Herbert Read, London, 1942. The artist as anarchist is explored in Eugenia W. Herbert, *The Artist and Social Reform: France and Belgium,* 1885-1898, New Haven, 1961; R. L. and Eugenia W. Herbert, "Artists and Anarchism, Unpublished Letters of Pissarro, Signac, and Others," *Burlington Magazine,* November-December, 1960; Benedict Nicholson, "The Anarchism of Camille Pissarro," *The Arts,* no. 2, pp. 43-51; Robert L. Herbert, "Les Artistes et l'Anarchisme," *Le Mouvement Sociale,* no. 32, July-September, 1961; Aline Dardel, *L'Etude des Dessins dans les Journeaux Anarchistes de 1895 à 1914,* Faculté des Lettres et Sciences Humaines, Université de Paris. Pissarro's *Turpitudes Sociales* was published in facsimile by Skira, Geneva, 1972.

Page 226. P: *"if it is Utopian . . ."* April 21, 1892, Louvre, Cabinet des Dessins.

226. P: *"I firmly believe . . ."* Letters, April 13, 1891.

226. P as the "first" consistent anarchist: Courbet preceded him, of course, as a disciple of Proudhon, but Courbet's grasp of anarchism was superficial and his interest was never as steady or fundamental as P's was.

226. Lazare: *"The poets descend . . ."* Entretiens politiques et littéraires, April, 1892, quoted in Herbert, *The Artist and Social Reform,* p. 86.

227. P: *"You have read . . ."* unpub. part of letter, May 5, 1891, Ashmolean.

228. Kropotkin: *"In common with all . . ."* Anarchist Communism, Its Basic Principles, p. 3.

228. Kropotkin: *"return to a state . . ."* from *Fields, Factories, and Workshops,* in Read, *Kropotkin Selections,* p. 97.

229. Grave: "There are no inferior races . . ." *Moribund Society and Anarchy,* San Francisco, 1899, p. 102.

229. Grave: *"we also contend . . ."* Ibid., p. 14.

229. Kropotkin: *"You poets, painters . . ."* Paroles d'un Révolté, 1855 edition, p. 65.

229. Kropotkin: *"The best canvases . . ."* Ibid., p. 107.

229. P: *"I have just read . . ."* April 21, 1892, Louvre, Cabinet des Dessins.

230. Hamon: *"An anarchist type . . ."* quoted in Jean Sutter,

The Neo-Impressionists, Greenwich, Conn., 1970, p. 54.

230. P: *"Unquestionably it was opened . . ."* Letters, April 22, 1883.

230. Police dossier of March 22, 1894, Préfecture of Eure, Direction de la Sûreté Générale, Ff12506. Archives Nationales, BN.

230. P: *"If we were plotting . . ."* unpub., Nov. 20, 1892, B-H.

230. P: *"the political situation . . ."* Letters, Feb. 20, 1883.

230. P: *"it is naive to rely . . ."* Ibid., July 5, 1883.

231. P: *"It matters little . . ."* unpub., Dec. 12, 1885, formerly PFA.

231. P: *"Universal suffrage . . ."* unpub., Dec. 22, 1885, formerly PFA.

231.-234. The facsimile edition of Pissarro's *Turpitudes Sociales* includes facsimiles of a letter to Alice and Esther that Pissarro enclosed with the drawings and of another letter to Esther of December 29, 1889, also commenting on the drawings, and tipped in is an eight-page essay by André Fermigier, "Pissarro et l'anarchie." All references here are from the unpaged, hand-written text or from these two letters.

232. P: *"The masses . . . dislike the Jewish bankers . . ."* Letters, Jan. 27, 1898.

233. Jean Grave: *"Is it not the Grand International . . ."* Moribund Society, op. cit., p. 85.

235. P: *"As for the troubles . . ."* Letters, Feb. 7, 1884.

235. P: *"And the coronation . . ."* unpub., June 11, 1902, Ashmolean.

236. P: *"I would like very much . . ."* Lecomte, *Pissarro,* pp. 13-14.

236. P: *"A really true article . . ."* Nov. 22, 1891, Louvre, Cabinet des Dessins.

236. P: *"It is disgusting . . ."* Letters, July 10, 1887.

236. P: *"make works of art . . ."* Ibid., May 29, 1894.

236. P: *"One can hardly conceive . . ."* Ibid., June 5, 1887.

236. P: *"Money is an empty . . ."* Ibid., April 26, 1900.

236. P: *"I am very embarrassed . . ."* unpub. part of letter, Dec. 10, 1895, Ashmolean.

237. P: *"I made a drawing . . ."* Sept. 30, 1892, Louvre, Cabinet des Dessins.

237. Signac on social advocacy in art: *La Révolte,* June 13-19, 1891, letter unsigned but attributed to Signac.

237. Lucien P: *"The distinction you make . . ."* Les Temps Nouveaux, I, 32, 1895.

238. P: *"a better time when . . ."* Letters, July 8, 1891.

238. P: *"only another generation . . ."* Ibid., April 13, 1891; *"The future will bring . . ."* Ibid., June 30, 1891; *"It is easy to see . . ."* Ibid., April 26, 1892; *"Reaction is trying . . ."* Ibid., Oct. 8, 1896.

240. Mirbeau: *"Not only does M. Pissarro paint . . ."* Mirbeau, "Camille Pissarro," *L'art dans les deux mondes,* Jan. 10, 1891, pp. 83-84.

240. Le Club de l'Art Social: description in A. Tabarant, *Maximilien Luce,* Paris, 1928, pp. 32-37.

240. *Cri du Peuple* receipt, PFD.

240. Malato: *"The money will be distributed . . ."* Charavay catalogue, letter no. 137-1.

240. Fénéon contribution: unpub. part of letter to Lucien, April 7, 1892, Ashmolean.

240. Grave contribution: unpub. to Grave, Dec. 12, 1892, Institut Francais d'Histoire Sociale. P's correspondence with Grave is at the Institute.

240. P payment of debts to printers: Jean Grave, *Le Mouvement Libertaire sous la IIIᵉ République,* p. 295.

241. P: *"I am sending you . . ."* Letters, March 17, 1896.

241. P to Mirbeau: July 24, 1891, Louvre, Cabinet des Dessins.

241. P: *"Luce wants to know . . ."* Letters, May 5, 1891.

241. P to Berrichon: undated, Doucet Library.

241. P: *"I am an idiot . . ."* March 16, 1892, in Kunstler, *Les Lettres Inédites de C. P.,* "La Revue de l'Art," April, 1930, p. 226.

241. P: *"all arts are anarchist . . ."* Sept. 30, 1892, Musée du Louvre, Cabinet des Dessins.

241. P: *"Proudhon says in La Justice . . ."* Letters, July 8, 1891.

241. P: *"One must admit that . . ."* April 21, 1892, Louvre, Cabinet des Dessins.

Chapter 19

Page 242. Vincent van Gogh: *"What Pissarro says . . ."* The Complete Letters of Vincent van Gogh, ed. by V. W. van Gogh and J. van Gogh-Bonger, Greenwich, Conn., 1958, Vol. II, p. 579, letter no. 495.

242. Vincent van Gogh: *"After you left . . ."* Ibid., Vol. III, p. 63, letter no. 544A.

242. Vincent van Gogh: *"You will receive . . ."* 1888, Ibid., vol. II, p. 579, letter no. 495.

243. White and White in *Canvases and Careers* estimated that P made "at least 4,500 francs" in 1887, but Durand-Ruel paid him only 439 francs, not 1,100 francs, as the Whites indicate.

243. Effect of neo-Impressionism on P's income: In 1885, he received 9,500 fr. from Durand-Ruel; in 1886, 3,400. In 1887, the payments dropped to 439 francs. In 1888, they rebounded to 6,400 francs, but dropped again in 1889 to 300, and to only 160 in 1890. Boussod and Valadon's payments compensated in part for this drop in income.

243. P: *"This position was offered . . ."* unpub. part of letter, postmarked May 15, 1887, Ashmolean.

244. P: *"My painting* The Cleft *. . ."* Letters, July 1887.

244. P: *"A tremendous discussion . . ."* Ibid., Sept. 20, 1887.

244. Julie P: *"You say to 'wait, wait' . . ."* unpub., Musée de Pontoise.

244. P: *"I can't give you . . ."* Ibid., Aug. 25, 1887.

244. P: *"would be a complete disaster . . ."* Ibid., Aug. 28, 1887.

245. Julie P: *"Your poor father . . ."* quoted in Rewald, *Pissarro,* pp. 39-41.

246. Lucien P: *"It's curious . . ."* unpub., Sept. 22, 1887, Ashmolean.

246. Lucien P's statement that P destroyed 1887 paintings: Lucien to Ludovic Rodo P, March 31, 1936, courtesy John Bensusan-Butt.

246. Seurat: *"If too many artists . . ."* quoted in Signac's letter to P, Sept. 7, 1888, formerly PFA.

246. P: *"It's indispensable . . ."* quoted in John Russell, *Seurat,* N. Y., 1965, p. 230.

247. P: *"It's disquieting . . ."* Ibid., p. 231.

247. P: *"I think continually . . ."* Letters, Sept. 6, 1888.

248. Signac: *"[Pissarro] strives to diminish . . ."* De Delacroix au néo-impressionisme, quoted in *Letters,* footnote p. 135.

248. P: *"I will write him . . ."* Letters, Feb. 20, 1889.

248. P: *"A matter of race . . ."* partly unpub. letter, May 1, 1889, formerly PFA. Excerpt published in Charavay catalogue, entry no. 153.

248. Lucien: *"[Grandmother] is always very fussy . . ."* postmarked April 27, 1889, Ashmolean.

249. P: *"After having skillfully probed . . ."* unpub., May 1, 1889, Ashmolean.

250. P: *"I shall have to keep . . ."* Letters, Jan. 13, 1891.

250. P: *"My exhibition is very successful . . ."* unpub., Feb. 27, 1890, B-H.

250. P's sales to Boussod and Valadon in 1890 reported in his letters to Théo van Gogh of Jan. 29 and Oct. 7, Rijksmuseum van Gogh, Amsterdam, and Théo's letters to P of Jan. 6, July 5, Sept. 30 and Oct. 16, Musée de Pontoise.

250. Geffroy: *"The 26 works . . ."* preface to the catalogue of Feb. 25-March 15, 1890, rep. in *La vie artistique* (1st series), Paris, 1890-1896.

251. Théo van Gogh: *"The exhibition of Pissarro's . . ."* van Gogh, *Letters,* March 19, 1890, no. T29, v. III, p. 566.

251. Vincent van Gogh: *"So old Pissarro . . ."* Ibid., no. 605, v. III, p. 210.

252. P: *"Van Gogh asked me . . ."* unpub., Sept. 28, 1889, Ashmolean.

252. Théo van Gogh: *"I spoke to Pissarro . . ."* van Gogh, *Letters,* Oct. 4, 1889, no. T18, v. III, p. 594.

252. Vincent van Gogh: *"I have seen . . ." Ibid.,* May 21, 1890, no. 635, v. III, p. 273.

252. P: *"he handed his resignation . . ." Letters,* Oct. 18, 1890, p. 388, supplement "e".

252. P: *"Poor lad . . ." Ibid.,* Feb. 1, 1891.

253. P: *"Terrible news . . ." Ibid.,* March 30, 1891.

253. P: *"Yesterday I went . . ." Ibid.,* April 1, 1891.

253. P: *"by the pernicious practice . . ." Ibid.,* Jan. 9, 1895.

254. P: *"I am so sick . . ." Ibid.,* April 8, 1895.

254. P: *"Oh, what theories . . ." Ibid.,* Oct. 23, 1895.

254. P: *"I began to understand . . .",* May 5, 1890, Charavay catalogue, letter no. 146.

Chapter 20

Page 255. Bernheim: *"Your moment has come . . ." Letters,* Dec. 13, 1891.

255. Lecomte: *"obviously a personnage . . ."* Georges Lecomte, "Camille Pissarro," *La revue de l'art ancien et moderne,* March, 1930.

255. Lecomte: *"Often, when the conversation . . ." Ibid.*

255. Natanson description: Thadée Natanson, *Peints a leur tour,* p. 27.

255. P: *"a new abscess . . ." Letters,* May 2, 1891.

256. Monet: *"don't stand on ceremony . . ."* Feb. 7, 1891, Charavay catalogue, June 15, 1977, of Hotel Drouet auction, "Autographes, Documents Divers" letter no. 213.

256. P: *"Just when I least . . ." Letters,* July 14, 1891.

256. Monet: *"there was no urgency . . ."* July 22, 1891, Charavay catalogue, letter no. 129.

256. P: *"My work is going . . ." Letters,* Nov. 5, 1891.

256. It has been assumed that P had not exhibited with the Société because in his letter to Lucien of March 9, 1891, he expressed his objections to exhibiting with them and indicated his refusal of their invitation. However, he had exhibited with the Société in 1890. His dispute with the Superintendent of Fine Arts in 1890 (ch. XIII) arose when the Superintendent selected either two or three of his prints from those on exhibition with the Société at that time. See letter to P from G. Larroumet, the Superintendent of Fine Arts, of Nov. 4, 1890, and Nov. 15, 1890, P's reply of Nov. 15, and P's letter to Durand-Ruel of Nov. 15, 1890, all at Musée de Pontoise.

256. P: *"There you are . . ."* Oct. 28, 1891, Charles Kunstler, "Des Lettres Inédites de Camille Pissarro," *Revue de l'art ancien et moderne,* March, 1930, p. 181.

256. P: *"We open Saturday . . ." Letters,* April 3, 1891.

258. P: *"I would go along . . ." Ibid.,* April 25, 1891.

258. P: *"I only regard it . . ." Ibid.,* Jan. 14, 1891.

258. Avery sale: *Ibid.,* April 26, 1888.

258. P: *"The three biggest dealers . . ." Ibid.,* June 23, 1891.

258. P: *"My prices . . ."* Charavay catalogue, letter no. 148, Dec. 9, 1892.

258. P: *"I am leaving Paris . . ." Letters,* April 13, 1891.

259. P: *"I don't understand . . ." Ibid.,* April 9, 1891.

259. P: *"every painting has already . . ." Ibid.,* May 7, 1891.

259. P: *"I went with . . ." Ibid.,* May 2, 1891.

259. P: *"You should see her . . ." Ibid.,* Dec. 9, 1891.

259. Carrière: *"I come to inform you . . ." Ibid.,* Dec. 13, 1891.

260. Bernheim: *"At the first auction . . ." Ibid.,* Dec. 13, 1891, quoted by P.

260. P: *"You must understand . . ." Ibid.,* Dec. 13, 1891.

261. Lecomte's critique: Georges Lecomte, Préface au catalogue de l'Exposition Camille Pissarro, janvier-février, 1892, Galeries Durand-Ruel, Paris.

261. Mirbeau's review appeared in *Le Figaro,* Feb. 1, 1892.

262. Lucien P: *"When you come to Paris . . ."* unpub., Feb. 2, 1892, Ashmolean.

262. P: *"I consider that the rank . . ."* quoted in Charles Kunstler, "Camille Pissarro," *Les Artistes Nouveaux,* G. Crès & Co., Paris, 1930, p. 3.

263. Julie P: *"conferences it's necessary to have . . ."* n.d., Musee de Pontoise.

263. Lucien P: *"Hey! You are going . . ."* unpub., 1892, Ashmolean.

263. P: *"It's a dream . . ."* July 1892, Louvre, Cabinet des Dessins.

264. "Old French Songs from Eragny's Artists" is at Ashmolean.

264.-266. Lucien's courtship of Esther B. based on letters of Lucien, Esther and Jacob Bensusan at Ashmolean, with additional details in Meadmore, *Lucien Pissarro,* ch. III.

264. Jacob Bensusan: *"Esther unfortunately . . ." Ibid.,* p. 49.

264. Lucien P: *"I do not know . . ." Ibid.,* p. 57.

265. P: *"I'm really astonished . . ." Letters,* Dec. 12, 1890.

265. P: *"Be very prudent . . ."* unpub. part of letter, April 1, 1891, Ashmolean.

265. Esther Bensusan: *"The day we are married . . ."* Meadmore, *Lucien Pissarro,* p. 64.

265. Lucien P: *"Money could never . . ."* unpub., 1892, Ashmolean.

265. P: *"All right. I know you love . . ."* May 10, 1892.

266. Esther Bensusan: *"Papa is very affectionate . . ."* unpub., Sept. 22, 1892, Ashmolean.

266. P: *"observe this boy . . ."* unpub., May 5, 1890, B-H.

267. P: *"I received your letter . . ."* unpub., Dec. 20, 1892, B-H.

267. P: *"the mother is devastated . . ."* Dec. 29, 1892, Louvre, Cabinet des Dessins.

267. P: *"as I wrote you both . . ."* unpub., Dec. 9, 1892, B-H.

267. Julie P: *"He is in desperate distress . . ."* unpub., Sept. 1892, Musée de Pontoise.

267. P: *"I'm glad to hear . . ."* unpub. part of letter, Sept. 15, 1893, Ashmolean.

Chapter 21

269. P: *"What an epoch!"* Letters, April 29, 1894.

269. P: *"The studio is splendid . . ."* Letters, Sept. 18, 1893.

269. P: *"We are at last . . ."* Ibid., Dec. 5, 1893.

270. P: *"Peasant women—in hearty nakedness"* Ibid., Jan. 21, 1894.

270. P: *"there are nudes . . ."* unpub., Dec. 27, 1894, B-H.

272. P: *"What a pity . . ."* Letters, April 8, 1895.

272. P: *"I replied . . ."* Ibid., June 22, 1896.

272. P's print prices at Boussod and Valadon and at Hessele's from PFD.

272. Vollard price offer, Letters, July 16, 1896; German exhibition from PFD; P's gift to Luxembourg Museum, P's notes in the PFD listing the proofs to be donated; Bernheim-Jeune offer, unpub. part of letter to Lucien P, Feb. 4, 1903, Ashmolean.

273. Caillebotte's role in Impressionist dinners, from Marie Berhaut, *Gustave Caillebotte*, Doctoral thesis, Ecole du Louvre, 1947. Details of Impressionist dinners: Geffroy, *Claude Monet*, ch. XXVII; Marthe de Fels, *La Vie de Monet*, pp. 160 *et seq.;* Remus Niculescu, "Georges de Bellio, l'Ami des Impressionistes," *Revue Romaine de l'Histoire de l'Art*, vol. I, no. 2, 1964.

273. P: *"I believe this little . . ."* Ibid., Jan. 21, 1894.

273. Vollard anecdotes: Jean Renoir, *Renoir my Father*, Boston, 1962, and Ambroise Vollard, *Recollections of a Picture Dealer*, tr. by Violet M. McDonald, Boston, 1936.

274. P: *"In Cézanne's show . . ."* Letters, Nov. 21, 1895.

274. P: *"one of the most astounding . . ."* Rewald, *Cézanne*, p. 129.

274. P: *"He is one we can really mourn . . ."* Letters, March 1, 1894.

274. Gérôme: *"We are in a century . . ."* Journal des Artistes, April, 1894, quoted in H. Perruchot, "Scandale au Luxembourg," *L'Oeil*, no. 9, Sept. 1955, pp. 15-19.

275. Evaluation figures for Luxembourg paintings from H. Perruchot. Also useful on Caillebotte legacy are Octave Mirbeau, "Le Legs Caillebotte et l'Etat," *Des Artistes*, première série, 1885-1896, Peintres et Sculpteurs, Paris, 1922, pp. 199-205; and Léonce Benedite, "La Collection Callebotte," *Gazette des Beaux-Arts*, vol. I, 1897, pp. 249-258.

275. P: *"The truth is . . ."* Letters, March 10, 1897.

275. P: *"I shall have to work . . ."* Ibid., March 4, 1894.

275. P: *"I talked with Lecomte . . ."* unpub., May 31, 1894, B-H.

276. P: *"an event which cannot fail . . ."* Letters, June 26, 1894.

276. P: *"What an epoch!"* Ibid., April 29, 1894.

276. Estimate of anarchist membership: Maitron, *Le Mouvement anarchiste en France*, vol. I, p. 130.

276. Mirbeau: *"The worst enemy of anarchy . . ."* quoted in Woodcock, *Anarchism*, p. 313.

276. P: *"You are right . . ."* Letters, March 12, 1884.

277. P: *"I am afraid . . ."* Ibid., July 30, 1894, and unpub. part of ibid., Ashmolean.

277. P: *"remember that I am tied . . ."* unpub. part of letter, Aug. 1, 1894, Ashmolean.

277. Description of evenings at Knocke in unpub. letter to Lucien, Aug. 1, 1894, Ashmolean.

277. P: *"[Rodo] works a good deal . . ."* unpub., Sept. 22, 1894, B-H.

277. P: *"Could I return . . ."* Letters, Sept. 5, 1894.

278. P: *"Between the two of us . . ."* Ibid., Nov. 17, 1894.

Chapter 22

Page 279. Mirbeau: *"What an admirable family . . ."* Le Journal, Dec. 6, 1897, pp. 39-45.

279. P: *"Your mother made me . . ."* Letters, Dec. 23, 1890.

279. Kahn: *"In [Pissarro's] house . . ."* Intro. to catalogue, *Pissarro et ses fils*, exhibition at Galerie Marcel Bernheim, Paris, beginning Nov. 30, 1934.

279. P: *"Lucien and I . . ."* unpub., March 6, 1890, B-H.

281. P: *"Your mother is upset . . ."* Letters, Feb. 17, 1884.

281. Julie P: *"Try . . . to be introduced . . ."* unpub., March 2, 1884, Musée de Pontoise.

281. P: *"It is natural indeed . . ."* unpub., March 13, 1890, B-H.

282. P: *"in France I am a hindrance . . ."* Letters, Feb. 18, 1894.

282. P: *"their pseudonyms have made . . ."* unpub. part of letter, Nov. 22, 1895, Ashmolean.

282. P: *"Let us speak of art . . ."* Letters, Sept. 18, 1893.

283. P: *"if he delays . . ."* unpub., July 7, 1889, B-H.

283. P: *"Nothing should be boring . . ."* unpub., July 18, 1893, B-H.

283, 284. P: *"Draw, draw, draw . . ."* Letters, May 24, 1883; *"You must harness yourself . . ."* Ibid., Dec. 9, 1883; *"Draw everything . . ."* Ibid., July 25, 1883; *"Don't strive for . . ."* Ibid., July 5, 1883.

284. P: *"Beware of your ease . . ."* unpub., Nov. 20, 1889, B-H.

284. P: *"When you find . . ."* unpub., May 13, 1890, B-H.

284. P: *"Curiously enough . . ."* Letters, June 13, 1883.

284. P: *"You will see . . .,"* unpub. part of letter, March 1,

1891; *"Georges has done . . ."* unpub. to Lucien, July 17, 1891; *"What irrationality . . ."* unpub. to Lucien, May 18, 1894, Ashmolean.

285. Julie P: *"He tells me that I am nothing"* unpub., July 7, 1898, Musée de Pontoise. Georges's caricatures of Lucien described in unpub. letter of Julie to P, Oct. 26, 1896, Musée de Pontoise.

285. P: *"Have you seen . . ."* unpub., March 28, 1895, Ashmolean.

285. P: *"Georges and Titi . . ."* Letters, April 8, 1895.

285. Lucien's sale to Goupil reported in unpub. letter to Julie, Feb. 1889, Ashmolean.

285. Pissarro's concern about his sons' military service: On their birth certificates, he registered them as "Danish." When they were of draft age, he was often in touch with lawyers to see if they were entitled to Danish citizenship, or English, because of their long residences in England. There are many references to this in unpublished parts of his letters to Lucien and in his letters to Georges.

285. P: *"You are right . . ."* Letters, Jan. 15, 1891.

287. P: *"Your engravings are accepted . . ."* Ibid., May 8, 1892.

287. For detailed information on *Les Travaux des Champs* and Lucien's printmaking and book design and production, see Alan Fern's doctoral thesis, *The Wood Engravings of Lucien Pissarro*, with a *catalogue raisonné*, University of Chicago, 1960. Between 1895 and 1903, Pissarro occasionally referred, in his letters to Lucien, to preparing drawings for *Les*

Traveaux des Champs. This has created confusion because of the implication that *Les Traveaux des Champs* had not yet been published. However, the British Museum has a copy with an advertisement tipped into it bearing the date 1894. (Information courtesy A. V. Griffiths of the British Museum.) Hence, Pissarro's references are to what was to have been a second series, eventually published as *La Charrue d'Erable*.

287. P: *"It's necessary to prepare . . ."* unpub., May 13, 1890, B-H.

287. For details on the Bing exhibition, see Janine Bailly-Herzberg, "Bing et l'Art nouveau," *Connaissance des Arts,* Sept., 1975.

288. P: *"I think it would be . . ."* unpub., Sept. 11, 1895, B-H.

288. P: *"Your boxes are successful . . ."* and next two quotes, unpub., Dec. 27, 1895, *Ibid*.

288. P: *"Found that you do not . . ."* unpub., Feb. 15, 1901, Doucet Library.

288. P: *"Cocotte is enchanted . . ."* letter to Esther Bensusan P, *Letters*, p. 274.

289. P: *"I believe that I . . ."* unpub. part of letter to Lucien, May 11, 1896, Ashmolean.

289. P: *"Above all, always . . ."* unpub., July 2, 1889, B-H.

290. P: *"What you tell me . . ."* unpub., July 7, 1889, *Ibid*.

290. Georges P: *"Luce has introduced us . . ."* unpub., May 9, 1891, Ashmolean.

290. P: *"One shouldn't neglect . . ."* unpub. part of letter to Lucien, July 12, 1896, Ashmolean.

290. P and sons and the tombolas: P to Jean Grave, Nov. 30, 1899, and May 6, 1900, Institut Francais d'Histoire Sociale. See also *Les Temps Nouveaux*, April 15-21, 1899, and April 22-28, 1899.

290. Mirbeau: *"What an admirable family . . ."* *Le Journal*, Dec. 6, 1897, pp. 39-45.

291. P: *"The deuce; Here is still another . . ."* *Letters*, Dec. 4, 1898.

291. P: *"It's a beautiful . . ."* June 2, 1892, Louvre, Cabinet des Dessins.

Chapter 23

293. P: *"it's terribly difficult"* unpub., 1897, B-H.

293. P: *"When one is old . . ."* *Letters*, Feb. 6, 1896.

293. P: *"I think I shall stay . . ."* *Ibid.*, Feb. 26, 1896.

293. P: *"firm, grey and clear . . ."* *Ibid.*, March 24, 1896.

293. P: *"I don't understand how . . ."* *Ibid.*, April 16, 1896.

294. P: *"What the hell . . ."* *Ibid.*, April 8, 1896.

294. Geffroy: *"it doesn't displease one . . ."* "L'Art d'aujourd'hui," *Le Journal*, April 18, 1896.

295. P: *"It is as beautiful . . ."* *Letters*, Oct. 2, 1896.

295. P: *"I'm working myself to death . . ."* unpub., Sept. 3, 1896, B-H.

295. P: *"reactionary turn of the upper . . ."* *Ibid.*, Sept. 30, 1896.

295. P: *"Beware of the pretty . . ."* *Ibid.*, Oct. 20, 1896.

295. Bracquemond: *"This is not a man . . ."* quoted in *Ibid.*, Feb. 6, 1896.

295. P: *"Damn it, neo-Catholicism . . ."* *Ibid.*, Sept. 30, 1896.

295. P: *"perhaps I am deceiving . . ."* *Letters*, Nov. 11, 1896.

298. Letters to Félix P are at Musée de Pontoise.

298. P: *"I am delighted . . ."* unpub., Nov. 11, 1897, B-H.

298. P: *"Georges tells me . . ."* unpub., Nov. 16, 1897, Musée de Pontoise.

298. Julie P: *"If you go to London . . ."* quoted in unpub. letter to Georges, B-H.

298. P: *"It is inevitable . . ."* unpub., Nov. 26, 1897, B-H.

303. P: *"We were afraid . . ."* *Letters*, Dec. 15, 1897.

303. P: *"weeping for our poor . . ."* *Ibid.*, Jan. 6, 1898.

303. P: *"Silvery, luminous . . . Ibid.*, Dec. 15, 1897.

304. P: *"I am sending you . . . Ibid.*, Nov. 14, 1897.

304. Tabarant: *"Socialism cannot be . . ."* Tabarant, *Socialisme et antisémitisme*, Paris, 1898, p. 2.

306. P: *"Accept the expression . . ."* Jan. 14, 1898, BN ms., no. N.a.Fr. 24523, pp. 48-52.

306. P: *"It is becoming clear . . ."* *Letters*, Jan. 21, 1898.

306. Julie P: *"I was right . . ."* unpub., n.d., Musée de Pontoise.

306. P: *"Naturally everything . . ."* unpub., Feb. 3, 1898, Ashmolean.

306. P: *"I am among those . . ."* Feb. 26, 1898, BN ms. as above.

306. Julie P: *"Doubtless the affair Zola . . ."* unpub., n.d., Musée de Pontoise.

306. P: *"Yesterday at about . . ."* *Letters*, Nov. 19, 1898.

306. P: *"There is a danger . . ."* unpub. part of letter, Jan. 22, 1899, Ashmolean.

307. P: *"Guillaumin thinks . . ."* unpub., Jan. 14, 1898, B-H.

307. Ajalbert: *"When a model in his studio . . ."* *Droits de l'Homme*, Jan. 20, 1898.

307. P: *"the ferocious anti-Semite . . ."* *Letters*, Jan. 21, 1898.

308. Signac's diary: *"[Pissarro] tells me . . ."* Rewald, "Journal Inédit de Paul Signac," *Gazette des Beaux-Arts*, April 1952, 6th period, vol. 39, p. 276, entry of Feb. 11, 1898.

308. P: *"what a real master . . ."* *Letters*, Jan. 23, 1898.

308. P: *"Degas, who constantly . . ."* *Ibid.*, March 7, 1898.

308. Vollard anecdote of Degas and P: Vollard, *Recollections of a Picture Dealer*, p. 90.

308. Natanson: *"Intimates of Degas . . ."* Natanson, *Peints à leur tour*, Paris, 1948, pp. 51, 60.

308. Degas: *"I was in bed Sunday . . ."* Courtesy John Rewald. This note was probably written in answer to an invitation to attend the funeral; of the list of 200 invited to the funeral, Degas appears as no. 199. PFD.

308. Degas: *"All the same . . ."* Guérin, *Lettres de Degas*, letter no. CLXXXIII. Although this letter does not specifically mention P, there is considerable indication that the "X" is he. Rouart had exhibited in seven of the eight Impressionist exhibitions and had always been friendly with P. It would be natural for him to write immediately to his close friend Degas on hearing of the death of an old comrade. Degas implies that he had not communicated with "X" since the Dreyfus affair, which is true of his relationship with P. Although Degas had other Jewish artist friends or acquaintances, none had shared the intimate periods of work he had with P, nor so long an acquaintance. Natanson and others report Degas's emotional response to his break with P and mention no other Jewish artists in connection with Degas. His letter is dated "Sunday," the day of the funeral, and it appears in the *Letters* collection just preceding Degas's letter to Alexis Rouart written in September, 1903, a month after the funeral.

309. Signac: *"When you compare . . ."* Rewald, "Journal Inédit de Paul Signac," *Gazette des Beaux-Arts*, April 1952, 6th périod, vol. 39, p. 276.

309. P: *"The paintings by Hals . . ."* *Letters*, Nov. 1898.

309. P: "*a superb view . . .*" *Ibid.*, Dec. 4, 1898.
309. Pittsburgh exhibition: *Ibid.*, June 18, 1898; other exhibitions, Ibid., Dec. 18, 1898.
309. P: "*Let him be . . .*" quoted in Kunstler, *Paulémile Pissarro*, p. 20.
309. Critic on Tuileries paintings: Félicien Fagus in *La Revue Blanche*, April 1899.
310. Georges P's illness: unpub. letters from P to Lucien P, May 7, Aug. 18 and Oct. 5, 1899, all Ashmolean.
310. P's income: P received 39,416 fr. from Durand-Ruel in 1893, 34,827 in 1894, only 16,007 in 1895, 32,392 fr. in 1896, an almost equal sum in 1897; approximately 35,000 in both 1898 and 1899; 44,656 in 1900; 38,435 in 1901; 26,687 in 1902; nine in 1903. At times he received substantial additional payments from other dealers. P's prices are also discussed in unpublished letter to Dr. Elias, Oct. 12, 1902, Doucet Library.
310.-311. Matisse-P conversation: Georges Duthuit, *Les Fauves*, Paris, 1949, p. 169.

311. Walter Sickert: "*to recast . . .*" Osbert Sitwell, ed., *A Free House* or *The Artist as Craftsman*, by Walter R. Sickert, London, 1949, p. 4.
311. P: "*Unless I am mistaken . . .*" unpub. part of letter, Jan. 6, 1900, Ashmolean.
312. Dispute over Lucien P's purchase of a house: unpub. letter of Julie P to P, Sept. 27, 1900, Musée de Pontoise; unpub. letter of Julie P to Lucien P, May 6, 1901, Ashmolean; and several letters from Andrè Teissier to P, spring 1901, pr. col., N. Y.
312. P: "*it will be necessary . . .*" *Letters*, Dec. 27, 1902.
313. Sale to Gérard: letter to Dr. Julius Elias, Jan. 25, 1903, Doucet Library.
313. P: "*I do not accept the prices . . .*" Jan. 7, 1903, Venturi, *Archives*, vol. II, letter no. 85, p. 52.
313. P: "*I have cut the cable . . .*" letter to Dr. Julius Elias, *op. cit.*
313. P: "*nothing remained . . .*" *Letters*, July 10, 1903.

Chapter 24

Page 315. P: "*I have been fortunate enough . . .*" unpub. part of letter, Aug. 29, 1902, Ashmolean.
315. P: "*Tell Kidi . . .*" *Ibid.*
315. P: "*I have just received . . .*" unpub. part of letter, Dec. 23, 1902, Ashmolean.
315. P: "*I am waiting . . .*" *Letters*, Sept. 22, 1903.
316. Lucien P: "*Dr. Cartier thinks . . .*" Nov. 11, 1903, Ashmolean.
316. Lucien P: "*In spite of . . .*" *Ibid.* Evidence of surgery is bill from Dr. Estrabaut, Dec. 8, 1903, PFD.
316. Lachaise Cemetery, "*a solemn city . . .*": Mark Twain, *The*

Innocents Abroad, London, 1899, vol. I, p. 188.
316. "No one from the Ministry of Fine Arts came": Lecomte, *Pissarro*, p. 104, borne out by list in PFD of those who signed the register at the funeral.
316. Frantz Jourdain: "*He defended the truth . . .*" *Les Temps Nouveaux*, Dec. 19-25, 1903.
316. Jean Grave had first invited Signac to write the eulogy in *Les Temps Nouveaux*, but Signac begged off, saying he was "truly too affected by the death of Père Pissarro" to do it. Undated letter from Signac to Grave at Institut Francais d'Histoire Sociale.

Chapter 25

Page 317. Renoir: "*a man who tried everything . . .*" Vollard, *Renoir*, p. 128.
318. Reaction against "*brilliant brush stroke*": *Letters*, Sept. 8, 1903.
319. P: "*David, Ingres, Delacroix . . .*" *Letters*, Aug. 19, 1898.
319. Cézanne: "*The Louvre is the book . . .*" Emile Bernard, Souvenirs sur Paul Cézanne et Lettres Inédites, Paris, n.d., p. 85.

320. Cézanne: "*Monet and Pissarro . . .*" collector Karl Ernst Osthaus's account of his visit with Cézanne in 1906, quoted in Rewald, *Paul Cézanne*, p. 196.
320. Gauguin: "*If the whole . . .*" Gauguin, *Raconteurs d'un rapin*, Sept. 1902, quoted in J. de Rotonchamp, *Paul Gauguin*, Paris, 1925, p. 237.

Epilogue

Page 322. Pissarro's will and inventory of his collection in PFD.
322. Monet's role as family adviser, Julie P's sale of some paintings, and Cassatt's efforts to help: Meadmore, *Lucien Pissarro*, pp. 101-105. Monet's becoming guardian of Paul-Emile P: *Art News*, April, 1971. Julie P's sale to Bernheim Jeune, Lucien: "*Don't worry about father . . .*" quoted in Rewald, *Pissarro*, p. 158.
323. Prices at sale of Julie's estate, *Art News*, December 22, 1928. For estate sale, see *Collection Camille Pissarro: Catalogue des Oeuvres Importantes de Camille Pissarro*, Galerie Georges Petit, Dec. 3, 1928; *Collection Camille Pissarro: Catalogue de l'Oeuvre Gravé et Lithographie de Camille Pissarro et des Tableaux Aquarelles Pastels, Dessins par Camille Pissarro,*

Bonvin, Cardoze, Delacroix, etc., Hotel Drouot, 7 and 8 décembre, 1928; and *Collection Camille Pissarro: Catalogue de l'Oeuvre Gravé et Lithographie de Camille Pissarro et des Estampes Modernes (par des autres),* etc. Hotel Drouot, 12 and 13 avril, 1929.
323. Georges P's and Ludovic Rodo P's drawings for Grave recorded in Dardel, *L'Etude des Dessins dans les Journeaux Anarchistes de 1895 à 1914, op. cit.,* ch. 18.
323. Laver: "An Impressionist born too late," *Portraits in Oil and Vinegar,* London, 1925, p. 31.
327. Details of Centenary exhibition in PFD.
328. Record prices from *Art at Auction.*
328. Seitz: "*There are moments . . .*" William Seitz, "The Relevance of Impressionism," *Art News,* Jan. 1969, vol. 67, no. 9, pp. 29-30.

Bibliographies

THE SIX following bibliographies deal specifically with the Pissarro literature. For an excellent critical bibliography on Impressionism, see John Rewald's *The History of Impressionism*, 4th ed., N. Y., 1973 and his *Post-Impressionism, from van Gogh to Gauguin*, N. Y., 1962.

For additional references see the *Notes* for each chapter where basic books and articles on the following subjects appear: Virgin Islands (Ch. 1); Venezuela (Ch. 2); the Salon (Ch. 4); the Cafés (Ch. 7); P in England (Ch. 8); P and Cézanne (Ch. 10); P and Gauguin (Ch. 12); P as Printmaker (Ch. 13); P and Neo-Impressionism (Ch. 17); and P and Anarchism (Ch. 18).

I. Catalogues of his works

L. R. PISSARRO and L. VENTURI, *Camille Pissaro, son art, son oeuvre*, 2 v., Paris, 1939. Text volume lists 1,664 paintings, gouaches, distemper, pastels and tiles. Vol. 2 contains 1,632 illustrations. A supplement is being prepared by John Rewald.

LOYS DELTEIL, *Pissarro, Sisley, Renoir*, (Le peintre-graveur illustré, v. XVII), Paris, 1923. P's graphic work.

JEAN LEYMARIE and MICHEL MELOT, *Les graveurs des Impressionistes*, Paris, 1971. P's graphic work, including woodcuts, well produced.

RICHARD BRETTELL and Christopher Lloyd, *Catalogue of the Drawings by Camille Pissarro in the Ashmolean Museum*, Oxford, 1980.

II. Pissarro's letters (principal sources) *Recipient's name listed first*

LUCIEN PISSARRO: *Camille Pissarro, Letters to his Son Lucien*, ed. by John Rewald, rev. ed., Mamaroneck, 1972, includes 477 letters to Lucien and 38 letters from Lucien. These plus 295 additional letters to Lucien are at the Ashmolean Museum, Oxford.

GEORGES PISSARRO: 180 are annotated in J. Bailly-Herzberg, *Correspondance de Camille Pissarro à son fils Georges dit Manzana et à sa nièce Esther Isaacson, commentaires et étude critique*, diplôme de troisième cycle; Paris IV Sorbonne, Art et Archéologie, sous la direction de Bernard Dorival. 14 at the Fondation Jacques Doucet, Bibliothèque d'Art et d'Archeologie, Université de Paris ("Doucet Library").

JULIE PISSARRO: 8 at the Ashmolean.

ESTHER ISAACSON: 31 in J. Bailly-Herzberg thesis, *op. cit.* 17 at the Musée de Pontoise—of these, 15 are excerpted in the sales catalogue, *Archives de Camille Pissarro*, Hotel Drouot auction, Nov. 21, 1975, published by Maison Charavay, referred to hereafter as "Charavay catalogue." Originals now owned by numerous collectors. Two important letters to Esther (one also addressed to Alice) are tipped into P's *Turpitudes Sociales*, facsimile ed., Geneva, 1972. Thirteen of his letters to Esther Pissarro, Lucien's wife, are also at the Ashmolean.

DR. deBELLIO: some in R. Niculescu, "Georges de Bellio, l'ami des impressionistes," *Revue Romaine d'Histoire de l'Art*, v. I., no. 2, 1964, and in Gachet's *Lettres Impressionistes, op. cit.*

DEWHURST: see Wynford Dewhurst, *Impressionist Painting, Its Genesis and Development*, London, 1904.

DURAND-RUEL: 86 in v. II of Lionello Venturi, *Les Archives de l'Impressionisme*, Paris, 1939.

DURET: see Tabarant, *op. cit.*; G. Besson (ed.), "L'Impressionisme et quelques précurseurs", *Bulletin des Expositions*, III, Galerie d'art Braun & Cie, Paris, Jan. 22-Feb. 13, 1932; and in Pissarro-Venturi catalogue raisonné, *op. cit.* Some originals at the Cabinet des Dessins, Musée du Louvre.

JULIUS ELIAS: 18 at the Doucet Library.

THÉO VAN GOGH: 12 at the Rijksmuseum Vincent van Gogh, Amsterdam.

JEAN GRAVE: all at the Institut Français de l'Histoire Sociale.

MIRBEAU: 64 originals in the Cabinet des Dessins, Musée du Louvre. Others reproduced, in part or in whole, in Charles Kunstler, "Des lettres inédites de Camille Pissarro à Octave Mirbeau (1891-1892) et à Lucien Pissarro (1898-1899)", in *Revue de l'Art ancien et moderne*, March, April, 1930, and in Georges Lecomte, *Camille Pissarro*, Paris, 1922.

MONET: some in J. Joets' "Lettres inédites de Pissarro à Claude Monet", *L'Amour de l'Art*, XXVI, no. 3, 1946, pp. 59-65; G. Geffroy, *Claude Monet, sa vie, son oeuvre*, Paris, 1922. Excerpts from 24 letters, some extensive, in *Autographes & Documents Divers*, catalogue of auction at Drouot Rive Gauche, June 15, 1977, published by Maison Charavay, 3 rue de Fursetenberg, 75006 Paris.

MURER: Originals at the Doucet Library. Additional in Adolphe Tabarant, *Pissarro*, Paris, 1924, New York, 1925, and in Paul Gachet, ed., *Lettres Impressionistes au Dr. Gachet et à Murer*, Paris, 1957.

HIPPOLYTE PETITJEAN: see "Souvenirs du peintre Jules Joëts, récueillis par M.-A, Bernard", *Arts et Documents*, Année 4, no. 50, November 1954.

SIGNAC: see Germaine Cachin-Signac, "Autour de la corre-

spondance de Signac", *Arts*, Sept. 1, 1951, and John Rewald, *Seurat*, Paris, 1948. Letters to FÉNÉON and VERHAEREN also appear in Rewald's *Seurat*.

ZOLA and HUYSMANS: see John Rewald, *Paul Cézanne*, N.Y., 1946.

III. Letters to Pissarro *Writer's name listed first*

Letters to CP from his Impressionist friends and other contemporaries that were in the Pissarro Family Archives were auctioned in 1975 and are now scattered. However, the catalogue of the auction, *Charavay catalogue, op. cit.*, contains excerpts from many of the principal letters and is an invaluable source.

LUCIEN PISSARRO: Most (223) at the Ashmolean. The largest source in print is *Camille Pissarro: Letters to his son Lucien*, ed. by John Rewald, (reprint ed., 1972), which contains 38.

JULIE PISSARRO: Scattered, but largest group is at the Musée de Pontoise, which has 75 letters from Julie to Pissarro, their sons, her family and friends. 4 are at Ashmolean.

FRÉDÉRIC PISSARRO, RACHEL PISSARRO, LUDOVIC PIETTE, ANDRÉ TEISSIER, FRITZ MELBYE, ALFRED DE MARTON, EMMA ISAACSON, are in a private col., N.Y., but will be available at the Musée de Pontoise.

ALFRED PISSARRO: 25 are in the col. of André Pissarro, Paris, with copies at the Musée de Pontoise.

MARY CASSATT: 8 letters and 1 postcard are excerpted in *Charavay catalogue.*

CÉZANNE: 8 are excerpted in *Charavay catalogue.* Some are printed complete in John Rewald, ed., *Paul Cézanne: Lettres*, Paris, 1941 and in Rewald, *Paul Cézanne, a Biography*, N.Y., 1968.

DEGAS: 13 are printed in full in Marcel Guérin, ed., *Degas: Letters*, Oxford, 1947 and *Degas: Lettres*, Paris, 1947.

DURAND-RUEL: 110 at Galerie Durand-Ruel.

DR. JULIUS ELIAS: 17 letters and 4 postcards at the Doucet Library, which also has miscellaneous letters to P, including 5 from FÉNÉON, some from EMILE BERNARD, DE MOLINES,

DUBOIS-PILLET, JULES CARDOSE and DAVID JACOBSEN.

GAUGUIN: 51 are excerpted in Charavay catalogue. Several are in Haavard Rostrup, "Gauguin et le Danemark", *Gazette des Beaux-Arts,* Jan.-April, 1956; and in Meret Bodelsen, "Gauguin the Collector," *Burlington Magazine*, v. 112, Sept., 1970.

GUILLAUMIN: 10 at the Doucet Library.

THÉO VAN GOGH: 19 at the Musée de Pontoise.

ALFRED MEYER: 4 at Doucet Library.

MIRBEAU: 56 at Cabinet des Dessins, Musée du Louvre.

MONET: 52 are excerpted in *Charavay catalogue* and 20 are excerpted in *Autographes & Documents Divers, op. cit.,* June 15, 1977 auction catologue also published by Charavay. 17 appear in full in Daniel Wildenstein, *Monet: Biographie et catalogue raisonné*, v. I, Lausanne-Paris, 1974, and 19 in v.II, 1979. Excerpts will also be found in Gustave Geffroy, *Claude Monet, sa vie, son oeuvre*, Paris, 1922.

SIGNAC: 24 are excerpted in *Charavay catalogue.* Also, see John Rewald, "Excerpts from the unpublished letters of Paul Signac", *Gazette des Beaux-Arts*, July-Sept., 1949, 6th ser., v. 36. Many also excerpted in Rewald, *Post-Impressionism.*

WILLIAM THORNLEY: 56 the Bibliothèque Nationale, Paris.

VICTOR VIGNON: 7 at the Doucet Library.

The *Charavay catalogue* also contains brief excerpts from the letters to P by the following: CAILEBOTTE, DEGAS, DURAND-RUEL, DURET, DR. JULIUS ELIAS, FÉNÉON, GACHET, GUILLEMET, HUYSMANS, LUCE, MIRBEAU, OLLER, PIETTE, RAFFAELLI (originals at Bibliothèque Nationale, Paris), RENOIR, RODIN, SCHUFFENECKER, SISLEY, THÉO VAN GOGH, VIGNON, ZANDOMENEGHI.

IV. Biographical material and eyewitness descriptions (in chronological order)

FÉLICIEN CHAMPSAUR, *Revue Moderne et Naturaliste,* Oct., 1880.

GEORGES LECOMTE. "Camille Pissarro," *Les Hommes d'Aujourd'hui,* 8th v., no. 366, Paris, 1890.

OCTAVE MIRBEAU, "Famille d'artistes", *Le Journal,* Dec. 6, 1897. Reproduced in Mirbeau, *Des Artistes*, Paris, 1924, v. II, and discussed in John Rewald, Preface to *Three Generations of Pissarros*, Ohana Gallery, London, 1954.

Henri Duhem, "Camille Pissarro, Souvenirs", in *Impressions d'Art contemporain*, Paris, 1913, reprinted from *Le Beffroi*, Dec., 1903.

H. G. STEPHENS, "CAMILLE PISSARRO, Impressionist", *Brush and Pencil*, March, 1904.

R. DE LA VILLEHERVE, "Choses du Havre: Les dernières semaines du peintre Camille Pissarro", *Havre-Eclair*, Sept. 25, 1904.

GEORGE MOORE, *Reminiscences of the Impressionist Painters*, Dublin, 1906.

THEODORE DURET. *Manet and the French Impressionists*, Phila.-London, 1910, rep. ed., 1971.

J. C. HOLL. "Camille Pissarro", *Portraits d'Hier*, July, 1911.

GEORGES LECOMTE. *Pissarro*, Paris, 1922. Flowery and uninformative, but useful for eyewitness description of CP.

ADOLPHE TABARANT. *Pissarro*, Paris, 1924 and New York, 1925. A short study, especially useful for the period of struggle after the first Impressionist exhibition.

CHARLES KUNSTLER. *Paulémile Pissarro*, Paris, 1928. Includes the son's remembrances of painting alongside his father.

CHARLES KUNSTLER. "La Maison d'Eragny", *ABC Artistique et Littéraire*, March, 1929.

CHARLES KUNSTLER. *Camille Pissarro*, Paris, 1930. Short. No new material.

CHARENSOL. "Notice sur Camille Pissarro", *Dictionnaire biographique des Artistes contemporains*, tome III, Paris, 1934.

GUSTAVE KAHN, *Pissarro et ses Fils*, Preface to catalogue,

Galérie Marcel Bernheim, Paris, 1934.

THADÉE NATANSON, *Peints à leur tour,* Paris, 1948.

THADÉE NATANSON. *Pissarro,* Lausanne, *1950. Brief reminiscences* by Natanson. 53 reproductions.

GOTTHARD JEDLICKA, Pissarro, Berne, c. 1950.

W. S. MEADMORE. LUCIEN PISSARRO, *Un Coeur Simple,* London, 1962. Contains many family anecdotes.

JOHN REWALD. *Camille Pissarro,* N.Y., 1963. Brief but solid and informative introduction to excellent collection of reproductions, with comment on each.

CHARLES KUNSTLER, *Pissarro,* Milan, 1971. Oversize, 96 pages, more useful for reproductions than for superficial text.

RAYMOND COGNIAT, *Pissarro,* Paris, N.Y., 1974. More useful for the reproductions than for the brief biographical data.

KATHLEEN ADLER, *Camille Pissarro, a biography,* London and N.Y., 1978. A brief biography (190 pages), useful as an outline of his life, but unfortunately inaccurate in the first half, lacks interpretation of his art, and gives a one-dimensional view of his personality.

CHARLES KUNSTLER. *Pissarro: Cities and Landscapes,* Lausanne, n.d. Very brief and anecdotal, with 28 reproductions in colors CP may not have recognized.

V. Catalogues of exhibitions (a select list)

Exposition des Oeuvres de C. Pissarro, Galerie Durand-Ruel, Paris, 1883. Checklist of 70 works exhibited. PFD.

Exposition Camille Pissarro, Galerie Boussod-Valadon, Paris, 1890. Preface by Gustave Geffroy.

Exposition Camille Pissarro, Galerie Durand-Ruel, Paris, 1892. Preface by Georges Lecomte.

Camille Pissarro, Galerie Durand-Ruel, Paris, 1896. Preface by Arsène Alexandre.

Camille Pissarro, Galerie Durand-Ruel, Paris, 1898. Preface by Gustave Geffroy.

Catalogue de l'Exposition de l'Oeuvre de Camille Pissarro, Galerie Durand-Ruel, Paris, 1904. Preface by Octave Mirbeau.

Exposition Camille Pissarro, Galerie Eugène Blot, Paris, 1907. Preface by Georges Lecomte.

Le Salon d'Automne, Paris, 1911. Preface by Theodore Duret, "Les Eaux-fortes at les lithographies de Camille Pissarro."

Camille Pissarro, Stafford Gallery, London, 1911. Preface by Walter Sickert.

Camille Pissarro, Memorial Exhibition, Leicester Gallery, London, 1920. Preface by J. B. Manson. Introduction by Campbell Dodgson, "On the etchings and lithographs of Camille Pissarro."

Collection de Mme Veuve C. Pissarro, Galerie Nunès et Fiquet, Paris, 1921. Preface by Gustave Geffroy.

Exposition des Eaux-fortes de Camille Pissarro, Galerie Max Bine, Paris, 1927. Preface by Claude Roger-Marx.

Collection Camille Pissarro: Catalogue des Oeuvres Importantes de Camille Pissarro et des Tableaux, Pastels, Acquarelles, Gouaches par Cassatt, Cézanne et al. composant la collection de Camille Pissarro. Galerie Georges Petit, Dec. 3, 1928. 86 pp., 59 plates of works by CP.

Collection Camille Pissarro (deuxième vente). *Catalogue de l'Oeuvre Gravé et Lithographié* et des Tableaux, Acquarelles, Pastels, Dessins par Camille Pissarro, Bonvin, Cardose, Delacroix et al. Hotel Drouot, 7-8 Dec., 1928. Introduction by Jean Cailac. 54 pp. 18 plates.

Collection Camille Pissarro (troisième vente). *L'Oeuvre Gravé et Lithographié* (deuxième partie)—Eaux-Fortes, Acquatints, Lithographies, Monotypes et des Estampes Modernes par Besnard, Carrière, Gauguin, Luce, Manet et al. Hotel Drouot, 12-13 avril, 1929. 36 pp. 22 reproductions.

Camille Pissarro—Oil Paintings, National Gallery, London, 1931. Foreword by J. B. Manson.

Centenaire de la naissance de Camille Pissarro, Musée de l'Orangerie, Paris, 1930. Introductions by A. Tabarant and Robert Rey.

Camille Pissarro, Leicester Gallery, London, 1931. Preface by Walter Sickert.

Paintings of Paris by Camille Pissarro, Carroll Carstairs Gallery, N. Y., 1944. 8 plates. Preface by G. Wescott.

Camille Pissarro—His Place in Art, Wildenstein Galleries, N.Y., 1945, prepared by Vladamir Visson and Daniel Wildenstein, 44 pp., illus.

Pissarro, Galerie André Weil, Paris, 1950. Preface by G. Huisman.

Three Generations of Pissarros, 1830-1954, Ohana Gallery, London, 1954. Preface by John Rewald.

Pissarro-Sisley, Marlborough Fine Arts, London, 1955. Preface by A. Clutton-Brock. 10 illus.

Camille Pissarro—a Collection of Pastels and Studies, Leicester Galleries, London, 1955. Preface by L. Abdul-Huda.

Exposition Camille Pissarro (1830-1903), Galerie Durand-Ruel, Paris, 1956. Introduction by René Domergue. 32 pp. 17 plates.

Camille Pissarro, 1830-1903, Berne Kunstmuseum, Berne, 1957. Introduction by F. Daulte, 20 pp., 8 plates.

Camille Pissarro, 1830-1903, Galerie Durand-Ruel, Paris, 1962. 32 pp. 17 plates.

The French Impressionists and some of their Contemporaries, Wildenstein Galleries, London, 1963.

Birth of Impressionism, Wildenstein Galleries, N.Y., 1963. Introduction by John Rewald.

Camille Pissarro in Venezuela, by John Rewald. Published by Hammer Galleries, N.Y., 1964. 65 drawings of Venezuela and St. Thomas reproduced.

Camille Pissarro, Wildenstein & Co., N.Y., 1965. Preface by John Rewald. 89 plates (3 in color).

Olympia's Progeny: French Impressionist and Post-Impressionist Paintings, Wildenstein Galleries, N.Y., 1965.

Camille Pissarro, early and other drawings, The Leicester Galleries, London, 1967.

Pissarro in Venezuela, Center for Inter-American Relations, N.Y., 1968. Introduction by Alfredo Boulton, tr. by Stanton L. Catlin and Phyllis Freeman. 10 illus.

Pissarro in England, Marlborough Fine Arts, Ltd., London, 1968. Introduction by John Russell. "Pissarro, The White Knight of Impressionism." 76 pp., 19 illus, 45 pl. (7 in color).

One Hundred Years of Impressionism: A Tribute to Durand-Ruel, Wildenstein Galleries, N.Y., 1970. Of 101 plates, 13 reproduce CP paintings.

Camille Pissarro, the Impressionist Printmaker, by Barbara S. Shapiro. Catalogue of exhibition at Museum of Fine Arts, Boston, 1973. 58 pp., 45 illus. including several states of some of his prints.

Impressionism—Its Precursors, and its Influence in Britain, Royal Academy of Arts, London, 1974. Introduction by John House. 4 pl. of P paintings.

Centenaire de l'Impressionisme, Grand Palais, Paris, Sept. 21-Nov. 24, 1974. Reproductions with comment of 45 Impressionist paintings, including 2 by Pissarro; brief biographies; and major contemporary critiques. Preface by René Huyghe. 280 pp.

Impressionism: A Centenary Exhibition. New York, Metropolitan Museum of Art, Dec. 12, 1974-Feb. 19, 1975. English-language edition of the above. 220 pp.

Camille Pissarro: sa famille, ses amis, Musée de Pontoise, Dec. '76-Feb. '77. 24 pp. Excellent photos of P and family.

Camille Pissarro 1830-1903, Kunstmuseum Winterthur, n.d. Exhibition of 34 prints. Brief introduction by Carl H. Jucker. 8 pp.

Pissarro Drawings, Norton Gallery and School of Art, West Palm Beach, Fla., Dec. 5, 1976-Jan. 9, 1977. Preface and checklist of 18 drawings by Richard Brettell. Three drawings reproduced.

Camille Pissarro au Venezuela, Venezuelan Embassy in France, Feb. 24.-April 21, 1978. 22 reproductions. 32 pp.

Camille Pissarro, Charles-Francois Daubigny, Ludovic Piette, Musée de Pontoise, Nov. 18, 1978-Feb. 8, 1979. Introduction by Edda Maillet. 24 pp.

VI. General Bibliography

The following books and articles discuss various aspects of Pissarro's work. A comprehensive listing of relevant *newspaper* articles for the years 1863-1939 will be found in Pissarro-Venturi, *Camille Pissarro*, v. I, pp. 311-332. Only the more important newspaper critiques are included here. The Pissarro-Venturi volume also lists many of the articles that appeared world-wide on Pissarro's death.

ADLER, KATHLEEN. *Aspects of Camille Pissarro, 1871-1883.* London, 1969, M. A. thesis, Courtauld Institute.

ADLOW, DOROTHY. "Camille Pissarro," *The Christian Science Monitor*, Boston, Sept. 7, 1939.

ALEXANDRE, ARSÈNE. "Vues de Paris de M. Pissarro," *Le Figaro*, June 3, 1898.

———, "Un Mot sur Pissarro," *Comoedia*, Jan. 22, 1910.

ANONYME. "The Impressionist Pictures at the Art Association Galleries," "N.Y., *The Studio*, April 17, 1886.

———, "Impressionists at the Academy," *New York Tribune*, May 25, 1886.

BENISOVICH, MICHEL N. AND DALLET, JAMES. "Camille Pissarro and Fritz Melbye in Venezuela," *Apollo*, July, 1966.

BODELSEN, MERETE. "Early Impressionist Sales, 1874-94, in the light of some unpublished 'procès-verbeaux,' " *Burlington Magazine*, June, 1968.

BOULTON, ALFREDO. *Camille Pissarro en Venezuela*, Caracas, 1966. Text in Sp., Fr., Eng. Includes excellent reproductions of Venezuela drawings and watercolors.

———. "Un Error sobre Camille Pissarro," *El Nacionál*, Caracas, Nov. 12, 1972.

———, "Camille Pissarro in Venezuela," *The Connoisseur*, May, 1975.

R-Br. "Maler des Grunen—La Couleur Verte chez Pissarro," Darmstadt, *Deutsche Kunst und Dekoration*, May, 1914.

BRIDGMAN, FREDERICK A. *L'Anarchie dans l'Art Impressionisme-Symbolisme*, Paris, 1898.

BROWN, R. F. "Impressionist Techniques: Pissarro's Optical Mixture," *Magazine of Art*, XLIII, Jan., 1950.

BURTY, PHILIPPE. Préface, *La Collection de M. G. Arosa, Tableaux Modernes*, vente du 25 Février, Paris, 1878.

CHAMPA, KERMIT S. *Studies in Early Impressionism*, New Haven and London, 1973.

COE, R. T. "Camille Pissarro in Paris: a Study of his Later Development," *Gazette des Beaux-Arts*, Feb., 1954.

DE LA VILLEHERVE, ROBERT. "Les Dernières Semaines du Peintre Camille Pissarro," *Havre-Eclair*, Sept. 25, 1904.

DENOINVILLE, GEORGES. "Les Eaux-fortes Originales de Camille Pissarro," *Byblis*, 1928, Année 7, fasc. no. 27.

DENIS, MAURICE, "Camille Pissarro." *L'Occident*, Dec., 1903. Reprinted in *Théories*, Paris, 1913.

DESCLOZAUX, JULES. "L'Exposition internationale de Peinture," *L'Estafette*, May 15, 1887.

DEWHURST, WYNFORD. "Impressionist Painting: Its Genesis and Development," *The Studio*, London, July 15, 1903.

DUBOSC, GEORGES. "Camille Pissarro à Rouen," *Journal de Rouen*, Jan. 6, 1924.

——— (G.D.) "Le Peintre Pissarro à Rouen," *Journal de Rouen*, Nov. 16, 1903.

DUNSTAN, BERNARD. *Painting Methods of the Impressionists*, N.Y., London, 1976.

DURANTY, EDMOND. *La Nouvelle Peinture*, Paris, 1876.

——— "La quatrième exposition faite par un groupe d'artistes indépendants," Paris, *La Chronique des Arts et de la Curiosité*, April 19, 1879.

DURET, THEODORE. "Camille Pissarro," Paris, *La Gazette des Beaux-Arts*, 46th Année, 3rd périod, Tome 32.

——— *Manet and the French Impressionists*, rep. ed., Freeport, N.Y. 1971. Ch. on CP.

ELIAS, JULIUS. *Camille Pissarro*, Berlin, 1914.

EPHRUSSI, CHARLES. "Exposition des Artistes Indépendants," *Gazette des Beaux-Arts*, Paris, 1880, I, p. 485, No. 1.

FAGUS, FÉLICIEN. "Petite Gazette d'Art: Camille Pissarro," *La Revue Blanche*, Paris, April 1, 1899.

———. "Notes sur Pissarro," *La Plume*, Dec. 1, 1903.

FÉNÉON, FELIX. "L'Impressionisme aux Tuileries," *L'Art Moderne*, Brussels, Sept. 19, 1886.

———. *Les Impressionistes en 1886*, Paris, 1886.

——— (F.F.), "L'Exposition Pissarro," *La Revue Blanche*, 1896, II, p. 480.

FERMIGIER, ANDRÉ. *Pissarro et l'Anarchie*, 8-page pamphlet tipped into CP's *Turpitudes Sociales*, Geneva, 1972.

FONTAINAS, ANDRÉ. "Art Moderne—Camille Pissarro," *Mercure de France*, Paris, May, 1899.

FORTUNY, PASCAL. "Pissarro et Guillaumin," *Bulletin de la vie artistique*, July 15, 1922.

FRANCASTEL, PIERRE. *Monet, Sisley, Pissarro*, Paris, 1939.

GEFFROY, GUSTAVE. "Camille Pissarro," *Le Journal*, June 25, 1899.

———. *La Vie Artistique:* "Camille Pissarro," 6e série, Paris, 1900.

———. *La Vie Artistique*, "Histoire de l'Impressionisme," 3e série, Paris, 1894.

GEORGE, WALDEMAR. "Pissarro," *L'Art Vivant*, Paris, March 15, 1926.

GERBE, LÉON. "Camille Pissarro: Le Rustique de l'Impressionisme," *Le Peuple*, Paris, March 30, 1938.

GOUK, A. "Principle, Appearance, Style," *Studio*, v. 187, June, 1974.

HERBERT, ROBERT L. "City vs. Country: The Rural Image in French Painting from Millet to Gauguin," N. Y., *Artforum*, Feb., 1970, v. 8. no. 6.

HERBERT, ROBERT L. and EUGENIA W. "Artists and Anarchism: Unpublished Letters of Pissarro, Signac, and Others," *Burlington Magazine*, Nov., Dec., 1960.

HIND, ARTHUR M. "Camille Pissarros graphische Arbeiten und Lucien Pissarros Holzschnitte nach seines Vaters Zeichnungen," Vienna, *Die graphischen Kunste*, 1908, v. 31.

HOLL, J. C. *Camille Pissarro et son Oeuvre*, Paris, 1904.

———. "Pissarro," *Art et les Artistes*, Feb., 1928.

HOUSE, JOHN. "New Material on Monet and Pissarro in London," *Burlington Magazine*, v. CXX, no. 907, Oct., 1978.

HUTH, H. "Impressionism Comes to the U.S.," *Gazette des Beaux-Arts*, April, 1946.

HUYGHE, RENE. "L'Impressionisme et la pensée de son temps," *Prométhée*, v. 20, Feb. 1939.

HUYSMANS, J. K. *L'Art Moderne*, Paris, 1883.

JEDLICKA, GOTTHARD. *Camille Pissarro*, Zurich, *Galerie und Sammler*, Nos. 1, 2, Jan.-Feb., 1938.

JOËTS, JULES. "Camille Pissarro et la Période Inconnue de St. Thomas et de Caracas," *L'Amour de l'Art*, no. 2, 1947.

JOURDAIN, FRANTZ. "Hommes du Jour: Camille Pissarro," *L'Eclair*, June, 1898.

———. "Camille Pissarro," Paris, *Les Temps Nouveaux*, Dec. 19-25, 1903.

KAHN, GUSTAVE. "Camille Pissarro," *Le Mercure de France*, March 1, 15, 1930.

———. "Les Maitres d'Hier: Camille Pissarro," *Le Quotidien*, Sept. 6, 7, 1933.

KUNSTLER, CHARLES. "Les Eaux-fortes de Camille Pissarro," Paris, *Le Figaro Artistique*, March 17, 1927.

———. "La Maison d'Eragny," *ABC Artistique et Littéraire*, March, 1929.

———. "Camille Pissarro," *Les Artistes Nouveaux*, Paris 1930.

———. "Le Centenaire de Camille Pissarro au musée de l'Orangerie dea Tuileries," *L'Art Vivant*, Paris, March 1, 1930.

LAPRADE, JULES. "Camille Pissarro après des documents inédits," *Beaux-Arts*, April 17, 24, 1936.

LARGUIER, LEO. "Les Ventes Camille Pissarro," *L'Art Vivant*, Jan. 1, 1929.

LECOMTE, GEORGES. "Quelques Syndiques: Camille Pissarro," Paris, *Les Droits de l'Homme*, June 4, 1898.

———. "Camille Pissarro," *La Revue de l'Art ancien et moderne*, Paris, March, 1930.

———. "Un centenaire: un fondateur de l'impressionisme —Camille Pissarro," *Revue de l'Art*, 1930, tome 57.

LEROY, LOUIS. "L'Exposition des Impressionistes," *Le Charivari*, Paris, April 25, 1874.

LORA, LÉON DE. "Exposition libre des peintres impressionistes," *Le Gaulois*, Paris, April 18, 1874.

LESBATS, ROGER. "Titres de gloire, titres de noblesse de Camille Pissarro," *Le Populaire*, Paris, March 14, 1930.

LETHÈVE, JACQUES. *Impressionistes et Symbolistes devant la presse*, Paris 1959.

LEYMARIE, JEAN AND MELOT, MICHEL. *Les Gravures des Impressionistes: Manet, Pissarro, Renoir, Cézanne, Sisley*, Paris, 1971.

LLOYD, CHRISTOPHER. "Camille Pissarro and Hans Holbein the Younger," *Burlington Magazine*, Nov., 1975.

———. *Pissarro*, (Phaidon Colour Plate Series), London, 1979. Brief but incisive introduction, plus 48 large color plates. Color not always reliable.

LOUVRIER, MAURICE. "Le Peintre Camille Pissarro et les Rouennais," *Rouen Gazette*, 1928.

MANSON, JAMES B. *Camille Pissarro*, London, *The Studio*, June, 1930.

MANTS, PAUL. "L'Exposition des Peintres Impressionistes," Paris, *Le Temps*, April 22, 1877.

MARRIOTT, CHARLES. "M. Vallotton and Mr. Pissarro," London, *Outlook*, Oct. 16, 1920.

MEIER-GRAEFE, JULIUS. "Camille Pissarro," Berlin, *Kunst und Kunstler*, Jahrang II, Heft XII. Sept., 1904.

———. *Impressionismen: Guys, Manet, van Gogh, Pissarro, Cézanne*, Munich, 1907.

MELOT, MICHEL. "La Pratique d'un Artiste: Pissarro Graveur en 1880," *Histoire et Critique des Arts*, June, 1977.

MIRBEAU, OCTAVE. "Camille Pissarro," Paris, *L'Art dans les Deux Mondes*, June 6, 1891.

MONTIFAUD, MARC DE. "L'Exposition du Boulevard des Capucines," Paris, *L'Artiste*, May 1, 1874.

MOORE, GEORGE. *Modern Painting*, London, 1893.

MORISOT, BERTHE. *The Correspondence of Berthe Morisot*, ed. by Denis Rouart, tr. by Betty W. Hubbard, N. Y., 1959.

NEUGASS, FRITZ. "Camille Pissarro: Zentenarausstellung in der Orangerie der Tuilerien," Munich *Die Kunst*, May, 1930.

———. "Camille Pissarro, 1830-1903, 100th anniversary, July 10, 1930," *Apollo*, London, July, 1930.

NICHOLSON, BENEDICT. "The Anarchism of Camille Pissarro," *The Arts*, no. 2.

NOCHLIN, LINDA. "Camille Pissarro: the Unassuming Eye," *Art News*, v. 64, April, 1965.

PISSARRO, LUDOVIC RODO. "The etched and lithographed work of Camille Pissarro." *Print Collector's Quarterly*, XIX, 1932.

"Pointe Sèche." "Le Whistlerisme et le Pissarrisme à l'Exposition des XXXIII," *Le Journal des Arts*, Jan., 13, 1888.

POULAIN, GASTON. "Camille Pissarro, chantre de l'Ile-de-France, et son rôle d'initiateur," *Comoedia*, Feb. 22, 1930.

REFF, THEODORE. "Pissarro's Portrait of Cézanne," *Burlington Magazine*, v. 109, Nov., 1967.

———. "Copyists in the Louvre," *Art Bulletin*, Dec., 1964.

REID, MARTIN. "Camille Pissarro: Three Paintings of London of 1871," *Burlington Magazine*, CXIX, no. 889, April, 1977.

REIDEMEISTER, LEOPOLD. "L'Ile de France et ses Peintres," *Oeil*, no. 124, April, 1965.

REUTERSWARD, O. "The 'Violetomania' of the Impressionists," *Journal of Aesthetics and Art Criticism*, Dec., 1950.

———. "The Accentuated Brush Stroke of the Impressionists," *Ibid.*, March, 1952.

REWALD, JOHN. "Oeuvres de jeunesse inédites de Camille Pissarro," *L'Amour de l'Art*, April, 1936.

———. "Camille Pissarro, His Work and Influence," *Bur-*

lington Magazine, June, 1938.

———. *Camille Pissarro au Musée du Louvre*, Paris, 1939.

———. "Camille Pissarro in the West Indies," *Gazette des Beaux-Arts*, Oct., 1942.

———. "Pissarro's Paris and his France: the Camera Compares," *Art News*, v. 42, March 1, 1943 (corrected March 15, 1943).

———. "The Impressionist Brush," Metropolitan Museum of Art *Bulletin*, v. XXXII, no. 3, 1973/74.

REY, ROBERT, "L'Exposition Camille Pissarro," *Bulletin des Musées de France*, Paris, March, 1930.

———. "Pissarro aux Iles Vièrges, *Beaux-Arts*, May 1, 1936.

RIVIÈRE, GEORGES. "Les Intransigeants et les Impressionistes," *L'Artiste*, Nov. 1, 1887.

———. *L'Impressioniste*, Paris, No. 1, April 6, No. 2, April 14, No. 3, April 21, No. 4, April 28, 1877.

ROGER-MARX, CLAUDE. *Camille Pissarro, Graveur*, Paris, 1929.

———. "Centenaire de la naissance de Camille Pissarro," *L'Europe Nouvelle*, Paris, March 1, 1930.

ROSENSAFT, J. B. "Le Néo-Impressionisme de Camille Pissarro," *L'Oeil*, no. 223, Feb., 1974.

RUTTER, FRANK. "Camille Pissarro and the London Group," *Sunday Times*, London, May 16, 1920.

SAYRE, A. H. "Developments in the Style of Camille Pissarro," *Art News*, v. 34, no. 8, March 14, 1936.

SHAPIRO, BARBARA S. and MICHEL MELOT. "The Monotypes of Camille Pissarro," *Nouvelles de l'Estampe*, no. 19, Jan.-Feb., 1975.

SICKERT, WALTER R. *A Free House*, or *The Artist as Craftsman*, ed. by Osbert Sitwell, London, 1947. Includes reminiscences of CP and much comment on his work.

SILVESTRE, ARMAND. *Portraits et Souvenirs*, Paris, 1891.

———. (Anonyme) "Oeuvres de M. Camille Pissarro," Paris,

L'Art Francais, March 10, 1894.

SOISSONS, COMTE DE. "The Etchings of Camille Pissarro," *The Studio*, London, Oct. 15, 1903.

TABARANT, ADOLPHE. "Pissarro et Guillaumin," *Le Bulletin de la Vie artistique*, April 15, 1922.

———. "Le faux Pissarro du musée de Lille," *Ibid.*, May 15, 1925.

———. ("L'Imagier") "De Pissarro à Sisley," *L'Oeuvre*, Paris, March 1, 1930.

THIÉBAULT-SISSON. "Camille Pissarro et son Oeuvre," *Le Temps*, Jan. 30, 1921.

———. "Le Centenaire du peintre Camille Pissarro (1830-1903), *Le Temps*, Feb. 22, 1930.

THOROLD, ANNE. "The Pissarro Collection in the Ashmolean Museum, Oxford." *Burlington Magazine*, v. CXX, no. 907, Oct., 1978.

VAUXCELLES, LOUIS. "Notes sur Camille Pissarro," Paris, *L'Univers Israelite*, Dec. 16, 1927.

———. "La Gloire de Camille Pissarro," *Excelsior*, Paris, Feb. 22, 1930.

VENTURI, LIONELLO. "Impressionism," *Art in America*, New York, v. 24, July, 1936.

WARNOD, ANDRE. "Avant l'Exposition Pissarro," *Comoedia*, Feb. 20, 1930.

WEBSTER, J. C. "Techniques of Impressionism: a Reappraisal," *College Art Journal*, v. 4, Nov., 1944.

WHITE, H. C. and C. A. *Canvases and Careers*, N. Y. and London, 1965. Includes some material on CP's finances.

ZOLA, EMILE. *Mon Salon*, Paris, 1866.

———. "Mon Salon." III, Les Naturalistes; V. Les Paysagistes. *L'Evénement Illustré*, May 19, June 1, 1868.

———. "Le Naturalisme au Salon," *Le Voltaire*, June 18, 19, 22, 1880.

Index